To Photograph
DARKNESS

CHRIS HOWES

To Photograph DARKNESS

THE HISTORY OF UNDERGROUND AND FLASH PHOTOGRAPHY

SOUTHERN ILLINOIS UNIVERSITY PRESS
CARBONDALE AND EDWARDSVILLE

Published in the United States, its dependencies, and Canada by
Southern Illinois University Press, P.O. Box 3697, Carbondale,
IL 62902–3697.

Published by Alan Sutton Publishing, 30 Brunswick Road, Gloucester,
England.

Library of Congress Cataloging-in-Publication Data

Howes, Chris, 1951–
 To photograph darkness / Chris Howes.
 p. cm.
 "Published by Alan Sutton Publishing . . . Gloucester. England"—
 T.p. verso.
 Includes bibliographical references.
 1. Photography, Flash-light—History. I. Title.
TR605.H69 1990
778.7'2—dc20
 ISBN 0-8093-1622-6 89–21590
 CIP

Typesetting and origination by
Alan Sutton Publishing Limited
Printed in Great Britain by
Dotesios Printers Limited

Contents

	List of Illustrations	vi
	Preface	xi
	Acknowledgements	xiii
	Introduction	xv
Chapter One	Let There Be Light	1
Chapter Two	Magnesium: The Start of an Era	18
Chapter Three	Mammoth Cave	48
Chapter Four	Subterranean Light	72
Chapter Five	Explosive Powders	100
Chapter Six	Beneath the Deserts of France	132
Chapter Seven	Hand-Hewn Rock	162
Chapter Eight	The Gentlemen Cavers	183
Chapter Nine	Lighting the Bat Cave	218
Chapter Ten	Moving Pictures	242
Chapter Eleven	Post-War Underground	257
Appendix One	A Chronology of Important Dates	266
Appendix Two	Glossary	278
Appendix Three	Dating Cave Photographs	289
Appendix Four	Chemical Names	291
Appendix Five	Units of Measurement	293
Appendix Six	Notes & References	295
	Picture Credits	323
	Index	324

List of Illustrations

PHOTOGRAPHS

Ice cave at Grindelwald, Switzerland, *c.* 1860. *Adolphe Braun* xx

Félix Nadar, *c.* 1870. *Nadar studio* 1

Pushing a wagon of bones, Paris catacombs, 1862. *Félix Nadar* 11

A wall of skulls and femurs, Paris catacombs, 1862. *Félix Nadar* 13

The sewer beneath the rue de Châteaudun, Paris, 1862. *Félix Nadar* 14

Alfred Brothers, *c.* 1865. *Photographer unknown* 19

Charles Piazzi Smyth, *c.* 1865. *Photographer unknown* 25

Smyth's miniature camera, *c.* 1980. *Royal Observatory* 28

The Crystallised Cavern, Blue John Caverns, 1865. *Alfred Brothers* 34

The Crystallised Cavern, Blue John Caverns, 1984. *Chris Howes* 34

Inside the Great Pyramid, Giza, 1865. *Piazzi Smyth* 39

The pyramid tombstone on Smyth's grave, 1986. *Chris Howes* 46

A wedding ceremony in Howe's Cave, *c.* 1870s. *Photographer unknown* 51

Beyond the Bridge of Sighs, Mammoth Cave, 1866. *Charles Waldack* 56

The Deserted Chamber, Mammoth Cave, 1866. *Charles Waldack* 58

Group with photographic apparatus, Mammoth Cave, 1866. *Charles Waldack* 61

The entrance to the Long Route, Mammoth Cave, 1866. *Charles Waldack* 62

Dining in Great Relief, Mammoth Cave, 1866. *Charles Waldack* 63

The Grand Crossing in Pensacola Avenue, Mammoth Cave, 1866. *Charles Waldack* 66

A stereo viewer with cards, 1989. *Chris Howes* 69

Bacon Chamber, Mammoth Cave, 1866. *Charles Waldack* 70

Mining the Comstock Lode, Nevada, 1866. *Timothy O'Sullivan* 74

Adelsberg, Yugoslavia, 1867. *Emil Mariot* 76

Adelsberg, Yugoslavia, *c.* 1895. *M. Schäber* 77

The Cask of the Danaides, Grottes de Han, Belgium, 1876. *Armand Dandoy* 79

The entrance to Mammoth Cave, 1877. *Mandeville Thum* 80

Howe's Cave, New York, 1877. *A. Veeder* 85

Luray Caverns, 1881–1882. *C.H. James* 88

The Devil's Coach House, Jenolan, *c.* 1883. *Caney & Co.* 90

Arch Cave, Jenolan, *c.* 1883. *Caney & Co.* 92

Boat on Echo River, Mammoth Cave, 1886. *W.F. Sesser* 96

Crystal Cave, South Dakota, *c.* 1885. *W.R. Cross* 97

Stone huts in Mammoth Cave, 1866. *W.F. Sesser* 98

View in Alabaster Hall, Manitou Grand Caverns, *c.* 1885. *W.E. Hook* 98

The Cave of the Winds, *c.* 1885. *W.H. Jackson* 99

A guide in the Hermannshöhle, Germany, 1888. *Max Müller* 110

A guide with a lantern, the Hermannshöhle, 1888. *Max Müller* 111

The Caves of Bellamar, Cuba, 1899. *Strohmeyer & Wyman* 112

Social gathering in Morrison Cave, 1890s. *N.A. Forsyth* 113

Great Oregon Caves, 1899. *B.L. Singley* 114

Guides in the Cango Caves, South Africa, 1898–1899. *Fred Pfühl* 114

Wyandotte Cave, Indiana, 1889. *Ben Hains* 115

Exit of the Corkscrew, Mammoth Cave, 1892. *Ben Hains* 116

Boats on Echo River, Mammoth Cave, 1889. *Ben Hains* 118

Tourists on the shore of Echo River, Mammoth Cave, 1896. *Ben Hains* 119

Coral Grotto, Jenolan, *c.* 1887. *Henry King* 120

The Ball Room, Nettle Cave, Jenolan, *c.* 1887. *Henry King* 121

Nettle Cave, Jenolan, *c.* 1887. *Charles Kerry* 124

The Procenium, Exhibition Cave, Jenolan, *c.* 1887–1890. *Charles Kerry* 125

Underground bridge in Exhibition Cave, Jenolan, 1887. *Charles Kerry* 126

The Show Room, Imperial Cave, Jenolan, 1887. *Charles Kerry* 128

The Grand Column, Lucas Cave, Jenolan, 1890s. *Oliver Trickett* 129

Caves at Chillagoe, *c.* 1900. *Photographer unknown* 130

The Broken Column in Exhibition Cave, Jenolan, 1888–1897. *J. Rowe* 131

Explorers at Padirac, 1890. *Ernest Rupin* 137

The main shaft of Padirac, *c.* 1900. *Photographer unknown* 141

Canoes in the Salle de la Fontaine, Padirac, 1895. *Ernest Rupin* 144

The caves at Dauphine, Sassenage, *c.* 1905. *E. Guichard* 147

Boats in the Grottes de Betharram, *c.* 1905. *Photographer unknown* 149

The landing stage in Padirac, 1900. *Edouard Martel* 151

Cave guide, Padirac, *c.* 1897. *A. Viré* 152

The Corbelled Columns in the Aven Armand, *c.* 1900. *Edouard Martel* 153

A rift in Padirac, *c.* 1900. *Edouard Martel* 154

Among the formations, Dargilan, *c.* 1900. *A. Lasson* 156

Dargilan, *c. 1900. A. Lasson* 157

The lake in the Grottes de Han, Belgium, *c. 1900. Boyer* 158

The Grottes de Lacave, *c. 1900. A. Viré* 160

Breast 39 in the Kohinoor Colliery, 1884. *George Bretz* 165

The entrance to Breast 39 in the Kohinoor Colliery, 1884. *George Bretz* 166

Coal-mine, Pennsylvania, *c. 1880s. Photographer unknown* 167

Miners with safety lamps, Pennsylvania, *c. 1890s. Photographer unknown* 168

'Croust Time' in the East Pool Mine, Cornwall, 1892. *Charles Burrow* 172

Charles Burrow in Masonic regalia, *c. 1900. Photographer unknown* 172

Underhand stoping in East Pool Mine, Cornwall, 1892. *Charles Burrow* 173

The 180 fathom level in the East Pool Mine, Cornwall, 1892. *Charles Burrow* 174

At the 70 fathom level, East Pool Mine, Cornwall, 1892. *Charles Burrow* 176

Salt mine, Salzberg, *c. 1906. Photographer unknown* 180

Mining in the Ton Pentre level, South Wales, *c. 1905–1910. Stephen Timothy* 181

Miners in Clay Cross Colliery, *c. 1908. Photographer unknown* 182

Descending Lamb Leer, 1900. *Herbert Balch* 187

A group in Lamb Leer, *c. 1899–1900. Photographer unknown* 188

The descent of Eldon Hole, 1900. *H. Eggleston* 190

The canal in Speedwell Cavern, 1901. *Harry Bamforth* 191

The Kyndwr Club outside the Blue John Caverns, 1902. *Harry Bamforth* 192

Lord Mulgrave's Dining Room, Blue John Caverns, 1902. *Harry Bamforth* 193

The Organ and Chimes, Luray Caverns, 1906. *J.D. Strickler* 195

The first descent of Padirac by E.A. Martel, 1889. *Photographer unknown* 197

Caving equipment, *c. 1912. Probably Harry Savory* 200

The Giant's Coffin, Mammoth Cave, 1892. *Ben Hains* 203

The Morgan brothers in Dan yr Ogof, 1912. *Photographer unknown* 204

A guide in Clapham Cave, Yorkshire, *c. 1890s. George Towler* 205

The windlass in Lamb Leer, 6 September 1913. *Harry Savory* 206

Solomon's Temple, Gough's Cave, April 1913. *Harry Savory* 208

Wheeler and Barnes in Wookey Hole, 21 March 1913. *Harry Savory* 210

The Old Grotto, Swildon's Hole, 13 August 1921. *Harry Savory* 211

At Sump One, Swildon's Hole, 3 August 1922. *Harry Savory* 212

Tratman's Temple, Swildon's Hole, 3 August 1922. *Harry Savory* 214

Treak Cliff Cavern, *c. 1926–1930. May Johnson* 216

Postcard of the Grottes de Han, *c. 1906. Photographer unknown* 219

Guano miners, the Bat Cave, Carlsbad *c. 1907. Photographer unknown* 220

The King's Palace, Carlsbad Caverns, *c. 1925. Ray V. Davis* 222

Doh's Kiva in The Big Room, Carlsbad Caverns, *c. 1923. Ray V. Davis* 224

Stalagmites in The Big Room, Carlsbad Caverns, *c. 1923. Ray V. Davis* 226

Postcard of The Big Room, Carlsbad Caverns, *c. 1930. Ray V. Davis* 227

The Golden Stairs, Carlsbad Caverns, 1924. *Willis T. Lee* 228

The Armory, Carlsbad Caverns, 1924. *Photographer unknown* 230

The guano bucket in Carlsbad Caverns, 1924. *Photographer unknown* 231

The Big Room, Carlsbad Caverns, 1924. *Jacob Gayer* 232

The Chinese Wall in Hidden Cave, *c. 1926. Ray V. Davis* 233

Early types of flashbulbs, 1989. *Chris Howes* 235

Robert Nymeyer in Carlsbad Caverns, 1928. *Ray V. Davis* 236

Tex Helm with cameras, Carlsbad Caverns, 1952. *Photographer unknown* 237

Tex Helm setting up flashbulb reflectors, 1952. *Photographer unknown* 238

Used flashbulbs in Carlsbad Caverns, 1952. *Photographer unknown* 239

The Big Room, Carlsbad Caverns. *Tex Helm* 240

Burning magnesium flares for ciné filming, 1927. *Russell T. Neville* 249

Miners in the Spruce Iron Mine, 1926. *Photographer unknown* 250

The Fairy's Door, from the film *Phroso*, *c. 1926. Mercanton* 251

Lowering lamps into Lamb Leer, 1937. *E.K. Tratman* 252

A close-up frame from the Lamb Leer film, 1937. *E.K. Tratman* 253

Filming *Cave of the Outlaws*, Carlsbad Caverns, 1951. *Photographer unknown* 255

Rebreather apparatus at Wookey Hole, 1948. *Photographer unknown* 259

Bob Davies underwater, Wookey Hole, *c. 1956. Luke Devenish* 260

Bridge Cave, South Wales, 1985. *Chris Howes* 262

In the Streamway of Ogof Ffynnon Ddu, South Wales, 1985. *Chris Howes* 263

ENGRAVINGS AND DRAWINGS

Porth yr Ogof, Wales, by Gastineau and Lacey, 1830 xvi

Cwm Porth Cavern (Porth yr Ogof), Wales, by Watson and Radclyffe, 1837 xvii

Wet plate collodion photography, *c. 1862* xix

Henry Fox Talbot, 1864 xix

The Maelstrom, Mammoth Cave, 1859 5

Nadar with his arc lamp, Paris catacombs, 1874 10

Drawing based on one of Nadar's photographs, Paris catacombs, 1862 16

Blueprints of Smyth's miniature camera, 1865 26

Burning magnesium at a soirée, Birmingham, 1865 42

A thumb-wheel magnesium wire burner, *c. 1864* 42

Solomon & Grant's magnesium ribbon lamp, 1864 43

Surface view of the Botallack Mine, Cornwall, 1865 44

List of titles of Waldack's stereo cards, 1866 71

A limelight burner, *c.* 1870s 83
Burning magnesium in Fountain Cave, Virginia, *c.* 1874 86
Reverse of a James stereo card, showing the titles available, 1882 89
Railroad advertisement for Mammoth Cave, 1870 95
Pouring sand mixed with magnesium through a soldering iron flame, *c.* 1885 102
A simple magnesium powder lamp, 1880s 102
A magnesium puff lamp, with alcohol burner, 1880s 103
A triple-headed magnesium powder lamp, 1880s 103
A photogenic pistol, *c.* 1890 105
Müller's flash apparatus, 1888 109
Reverse of two of Hains' stereo cards with lists of titles, 1889 117
A triple Combination Lamp for magnesium powder, *c.* 1880s 136
The Lac de Gours in Padirac, 1894 138
A Nadar lamp, 1891 145
Advertisement for a magnesium lamp, 1902 178
A method for enclosing magnesium smoke, *c.* 1880s 234
Boutan's technique for taking underwater photographs, 1893 234
Reverse of a postcard, Cango Caves, 1923 246

SURVEYS AND MAPS

The Blue John Caverns, showing known passages in the 1860s 31
Mammoth Cave, 1882 54
Jenolan, 1889 122
Carlsbad Caverns, 1924 223

Preface

For more than twenty years I have been involved with cave photography, beginning with a humble photographic trip into Dow Cave in Yorkshire. I found there were problems to be solved before I could produce pictures I was pleased with; how could I improve on my early results? What sort of light was best, how do you get certain effects, how could I protect my camera? Additionally, I was developing a fascination for photographic history. If I was trying to learn how to take pictures underground, and succeeding only with difficulty using modern equipment, how did it used to be done? When were the first underground pictures taken? Ten years ago? A hundred? As the questions arose and meshed together with my new interests, in 1979 the idea for *To Photograph Darkness* was spawned.

My first step was to check photographic textbooks for something about the development of flash and artificial light but, to my amazement, there was very little material published on the subject, only portions of larger texts that were always devoted to photographs or cameras. What of the specialist press? There was certainly very little to be found in caving magazines about the cave photographers of the last century, and even less about their techniques.

Intrigued by now, I visited my local library, and asked for some copies of the only nineteenth-century photographic periodical Cardiff holds. It took ten minutes for the assistant to find the copies, buried deep in the stacks. In every classic tradition, the dust was ceremoniously (and literally) blown away, and I opened a randomly chosen copy of *The British Journal of Photography*. It was for 1865, and almost immediately I found myself in another world, where photographers experimented with changing materials and invented new techniques and apparatus as a matter of course. Then, in the 1866 editions, I found the words 'Mammoth Cave' jumping out of the page, Waldack's tale of underground photography unfolding. I was hooked: by the end of 1980 I had read most of the issues of the *BJ* that were published in the

nineteenth century. It provided me with an invaluable background to the development of artificial light and magnesium that I could build on using other sources.

The research continued with the hunting out of old postcards, books and photographs. I wrote letters, and travelled to other countries specifically to consult archives and libraries. I quickly discovered the number of mistakes perpetuated by relying on 'modern' references and always strove to use primary material whenever possible. For example, I found dates from 1858 to 1865 quoted for Nadar's photography in the Paris catacombs. It took five days, feeling miserably ill in a wet, cold Paris during Easter 1986, before finding a contemporary newspaper report that proved when Nadar began his work. By then, certainly, my search had become an obsession!

I have often wondered if the project would have ever started if I knew how much time would need to be devoted to the research; I have lost track of how many hours it has consumed – it certainly runs into thousands. The end result is *To Photograph Darkness*; however, it does not mean that the story is complete. There are many more photographers that must have produced underground pictures during the course of the last century and I would be delighted to learn of any further details that can be added to the information contained here. That aside, I hope the topic proves as fascinating to you as it has to me.

Chris Howes
Cardiff, 1989.

Acknowledgements

One of the most pleasurable aspects of this research has been meeting new people, making new friends. Almost everyone I know has helped in researching this book in some way at some time; to list everybody that has helped, either in person or by letter, would be impossible. I can only apologise for any omissions.

I would like to begin by thanking the following people for their time and effort in helping identify information sources or photographs, and for sharing their own specialist knowledge so freely. Grateful thanks are due to: Anne Bell for helping tidy up so many 'loose ends'; Steven Craven, for his extensive knowledge concerning Yorkshire cavers and early caving in South Africa; Bobby Crisman and Ron Kerbo of Carlsbad Caverns National Park for their warm welcome and use of the Park archives; William Darrah, for his specialist knowledge of stereo cards; Emily Davis Mobley; Luke Devenish; Kevin Downey, for arranging to copy the Neville films for me; Elery Hamilton-Smith for his information on Kerry; Andrej Kranjc for his help concerning the Yugoslav photographers Mariot and Martini; Ray Mansfield; Art and Peggy Palmer, who were so helpful in New Mexico, and made special efforts to locate information on Charles Waldack; Roger Penhallurick of the Royal Institution of Cornwall; Pam Roberts of the Royal Photographic Society; John Savory for the use of his father's diary entries; Theo Schuurmans, for a great deal of work tracing Waldack's Belgian connections; Tom Sharpe of the National Museum of Wales; Trevor Shaw; Gordon Smith; Gwyn Snelson for information concerning Tex Helm; Mike Thomas for his identification of outmoded chemical names; and Red Watson, who helped so much with his encouragement and promoting the publication of this book in America.

The staff of many institutions and libraries, often unknown by name, have helped a great deal by locating obscure references. Their aid can often go beyond a straightforward reply and involve research on their part. I would therefore like to acknowledge the

help of: Bibliothèque Historique de la Ville de Paris; Birmingham Central Library; Bristol Reference Library; the British Cave Research Association; the British Library; Cardiff Central Library; Carlsbad Caverns National Park Service; Carlsbad Caverns Natural History Association; the local Carlsbad newspaper offices; the George Eastman International Museum of Photography, New York; the Institution of Mining and Metallurgy, London; the Library of Congress, Washington; Manchester Central Library; the National Museum of Wales, Cardiff; the Newspaper Library, Collindale, London; the Royal Photographic Society, Bath; the Science Museum, London; and Wells Museum, Somerset.

Inevitably, the scope of the project meant that many references had to be translated before I could do more than guess at the odd word. For their help in this area I would like to thank: Anne Bell, Judith Calford, Philip Chapman, Wendy Gaisford, Eva Kaplin, Laurent Mabileau, Helga Rother-Simmonds and Peter Smart.

Next, for their encouragement and valuable comments on the draft of the book, I must thank Judith Calford, Martyn Farr, Barry Phillips, Hugh Rice and Trevor Shaw.

Lastly, I must single out two of the people, already mentioned above, without whose help this project could not have reached its present form. Judith Calford has not only supported my obsession, but has actively helped with much of the research. Likewise, Trevor Shaw's generosity in placing his substantial collection of books and photographs at my disposal and willingly giving up a great deal of time helping to find answers to obscure questions, cannot go unthanked. His specialist knowledge has enabled the production of a far more meaningful assessment of cave photography than would have otherwise proved possible.

Introduction

Caves, mines and the world underground – real and imagined – have all fascinated man for centuries. Some of the earliest surviving writings from the end of the Dark Ages describe a spattering of cave exploration, while mining operations began in even more ancient times. However, being hewn from the rock, mines were man-made and known territory. The cave environment was not. What lay beyond the pitch black entrance, around the next beckoning corner? Was this the gateway to Hell? The pathway of the Devil when he came abroad to terrorise mortal man? To superstitious people bound by the teachings of the Church, the possibility of meeting Satan in his own province was taken seriously, and few excursions into the underworld were made.

Most early visitors to caves rarely went beyond the sight of daylight, inspecting the entrance from within, but by Elizabethan times an increased level of curiosity was developing. The perpetrators of some early attempts to discover the true nature of the cave and where it led to did not leave the surface themselves, and had to find other ways to satisfy their search for knowledge. About the year 1600 Robert Dudley, for example, became interested in Derbyshire's Eldon Hole. The main shaft of the cave, plunging from the surface of the moors, was thought to be bottomless – or at least several thousand feet deep. To find out which was true Dudley had a serf, George Bradley,[1] lowered into the dank hole on the end of a rope; whatever he had been offered in recompense, it could not have been enough. Reputedly, the luckless peasant was hauled back to the surface raving mad, his hair white, and he died of shock a few days later.[2]

Incidents such as this did little to dispel the prevalent myths and legends about caves, so when the eighteenth and nineteenth centuries brought an upsurge of reading skills and a corresponding rise in the number of published books, authors were given free rein to describe caves however they wished. For most, this meant using a bare minimum of fact. Who, after all, could dispute their

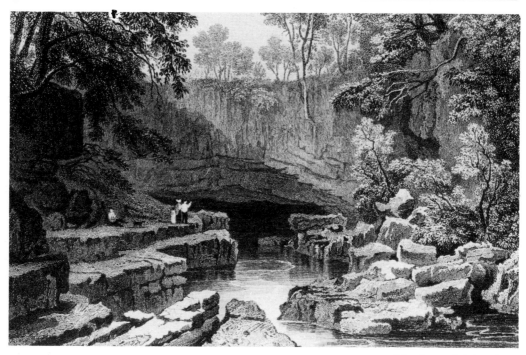

Before the use of photography, engravings were often inaccurate but were the only way of illustrating books. This engraving of Porth yr Ogof by Gastineau and Lacey is extremely accurate, while that by Watson and Radclyffe (opposite) is virtually fiction.

words? Travellers would visit remote regions and write of their experiences 'for the edification and instruction of less venturesome folk', for an insatiable public, and, of course, to make an honest shilling.[3]

Just as today, illustrations helped to sell books and publications of all types. Before the age of photography, these came from woodcuts or engravings, all of which allowed reproductions of a drawing to be sold either separately or bound into a book. By the beginning of the 1800s etching was big business. A publisher would commission new engravings of whatever subject was in vogue at the time. For topographical prints, for example, an artist would visit the area and produce a sketch or watercolour. This was taken back to the engraver, who would use it to make the plate and final print.[4]

Although skillful, these engravers were often limited by the poorly executed artwork supplied to them, so that perspectives were rarely correct. The artist would have varying degrees of control over the finished product, depending on his association with the engraver. Frequently, detail was lost or was added to the view. Cave scenes, in comparison with such subjects as country houses, suffered a great deal. What was the point of accuracy in such cases? In some instances it is probable that the artist did not even visit the cave, let alone allow the local guide to escort him

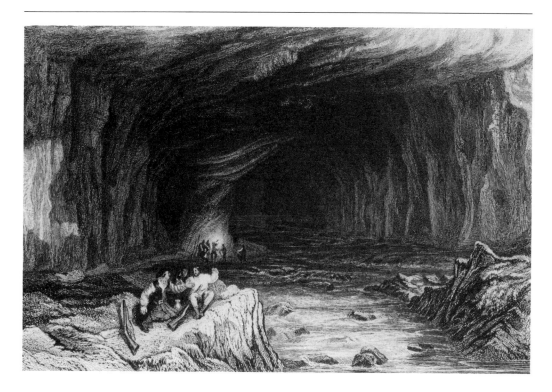

below with a flaming brand held aloft for lighting. Imagination, or plagiarism with suitable alterations, were useful tools – especially for areas rarely visited. The end result of this sequence of events might be a picture far removed from reality.

Many topographical books featured caves; Peak Cavern in Derbyshire was a popular subject, with at least a hundred different engravings known to exist. Mammoth Cave in America commanded a similar interest. Tourist locations and sea caves were often depicted, since these were considered to be of the most interest to the public. Some of these pictures were reasonably accurate, while others did not fare so well. The yawning entrance to Porth yr Ogof in South Wales was so accurately drawn by Henry Gastineau and engraved by S. Lacey that it could have been produced today. In comparison, the 1837 version by Radclyffe and Watson shows a massive cavern with a river flowing in the wrong direction, men looking suspiciously like smugglers sitting beside it.

As the nineteenth century progressed, the general public came to demand more and more variety, as well as volume, of illustrations. Colour was sometimes added to prints, but despite their enhanced appearance there were still disadvantages in the basic processes. In the time allowed for production of the engravings it was impossible to obtain a very high order of accuracy, and in

addition the number of prints being produced was far too low to fulfil demands. The answer to these problems lay with photography, a craze which all but obliterated the engraving industry as it swept the world like a Juggernaut.

By 1839 the Frenchman Louis Daguerre had developed what he termed his 'daguerreotype process', built upon the earlier discoveries of Niépce, and sold it to the French government. They in turn presented it 'free to the world' for the benefit of all. The invention produced an image on a metal plate, the camera being little more than a box with a lens in front. The immediate effect on the public was amazing. Painters and artists were aghast. Paul Delaroche, a Parisian artist, looked around him at the people clamouring for the new daguerreotype apparatus and uttered, 'From today painting is dead!'[5]

It is hard, now, to imagine the furore that was created. It was no longer necessary to learn the skills of the artist or engraver to produce a picture. Anybody could now secure an image of nature rather than fleetingly observe it in a mirror; the appeal was immense. Many artists used the process to aid their painting, and even Delaroche later added that it 'satisfied all the demands of art'. Engravers worried for their livelihood; some religions denounced the invention. In Germany one newspaper said that the whole concept of photography was not only impossible,

> as has been shown by thorough German investigation, but the mere desire alone, the will to do so, is blasphemy. . . Is it possible that God should have . . . allowed a Frenchman in Paris to give to the world an invention of the Devil?. . . one can straightway call the Frenchman Daguerre, who boasts of such unheard of things, the fool of fools.[6]

Nevertheless, Daguerre's process proved successful, as did that of his rival, Englishman William Henry Fox Talbot. Talbot had been experimenting with photographic processes without any knowledge of Daguerre, and when the daguerreotype was announced he hurriedly published his researches. Fortunately for Talbot, who hoped to aid his ailing fortune with his discovery, the two inventions differed. Daguerre produced a photograph directly onto a silvered copper plate, while Talbot used paper to make a negative image of his subject. This was later waxed or oiled to make it translucent, and then placed in contact with a second sensitized sheet, which was exposed to form a normal positive picture.

Talbot named his process the 'calotype', but although it held promise it was often considered to be the inferior of the two and he received little public recognition. Nevertheless, Talbot did encourage his friends and relatives in the Swansea area to try the process

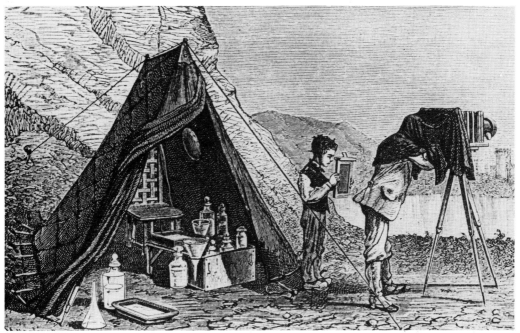

A photographer had to be prepared to carry a great deal of equipment in order to produce photographs away from his studio. In the tent, used as a darkroom, are the chemicals needed to coat the plate with collodion and process it after exposure. The boy is holding a dark slide, which enabled the sensitized plate to be handled in daylight.

out.[7] With knowledge of the technique in the area, and a great deal of archaeological activity in the caves nearby, it is not surprising that some of the earliest attempts to photograph entrances were made on Gower. One of the first was reputedly in connection with excavations at Spritsail Tor Cave by J.W.G. Gutch[8] of the Royal Institution of South Wales in Swansea, and many photographs of Gower sea caves were made by John Dillwyn Llewelyn between 1852 and 1856.[9]

The use of a camera to photograph anything relating to a cave, even an entrance, remained uncommon at this time. Photography largely belonged, not outdoors, but with business. Throughout Europe and America photographic portrait studios were springing up, the new professionals choosing the daguerreotype process in preference to Talbot's invention. The calotype had been patented, which restricted its use, and was also far less sensitive than the daguerreotype, as well as yielding an inferior image. Studio owners made a fortune as people flocked to have their likenesses forever recorded on metal. When he died in 1851, Louis Daguerre became a French hero, and American photographers wore black armbands for a month.

Exposure times for both the daguerreotype and the calotype, even in the brightest of sunshine, were about a minute. Sitters in studios having their portraits made had to be locked into place with neck- and head-clamps, preventing any movement which

Henry Fox Talbot, the inventor of the calotype process.

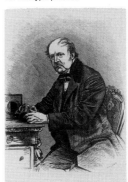

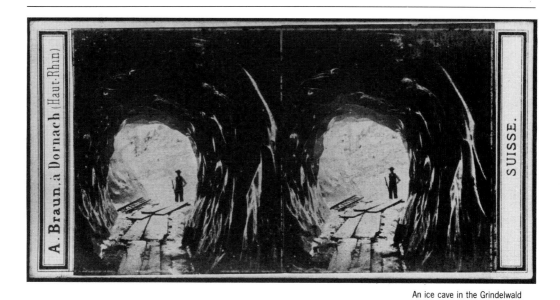

A. Braun. à Dornach (Haut-Rhin)

SUISSE.

An ice cave in the Grindelwald Glacier, Switzerland, photographed by Adolphe Braun c. 1860. Prior to the development of portable sources of artificial light, photographers were limited to recording cave entrances.

would cause a blurred picture. Although lenses and cameras had been made which allowed good rendering of the image on the plate, there was now a need for far more sensitive emulsions to speed up the exposure.

This problem was solved in 1851 when the Englishman, Frederick Scott Archer, announced his new improvements to the calotype process.[10] After a few years these were refined so that exposure times were shortened. Instead of paper, glass plates were used to make the negative. This produced a crisp image that was far superior to the calotype, and had an advantage over the daguerreotype in that many copies could easily be made by printing from the original plate. The invention, named 'wet plate collodion photography', soon ousted the daguerreotype from its position of popularity throughout the world.

However, while the collodion process was in widespread use by the end of the 1850s and professional portrait studios were common, few photographers took their equipment away from their place of work. The apparatus was far too bulky to be easily moved, and in any case there were few incentives to leave what had become a lucrative trade, for the inconvenience of outdoor work. Within the studio, though, there was still one major problem left to be solved.

Portrait studios suffered from a lack of reliable artificial lighting; photography depended on strong sunlight, and when the sun went in photography and business both ceased. Artificial lighting did exist, but even by the close of the 1850s it was still largely undeveloped. The portrait industry badly needed improvements in this field.

The photographic apparatus of the period was so cumbersome that it could be used away from the studio only with difficulty. In addition, without the existence of readily usable artificial light, any idea of photography in mines, caves or other underground or dark places could hardly have been seriously considered, even by such men as Gutch or Llewelyn. But the pressing requirement for light that would serve the portrait studios was yielding results, and such projects were becoming feasible.

In 1844 Fox Talbot wrote that he hoped, one day, photographs could be taken to reveal 'the secrets of the darkened chamber'.[11] His concept envisaged the use of infra-red film,[12] but long before specialist emulsions were invented, with both better cameras and the sensitive wet collodion process, the first attempts could be made to tame the vagaries of sunlight and illuminate the blackest interiors. The secret lay with the production of light; with a suitable light source, the conquest of darkness could begin.

Let There Be Light

The world underground offered an infinite field of activity no less interesting than that of the top surface. We were going into it, to reveal the mysteries of its deepest, most secret, caverns.

> *Félix Nadar, 1900, concerning his 1862 photography in the Paris sewers.*[1]

Gaspard Félix Tournachon was born in Paris in 1820, spent his youth largely in Lyons, where he studied medicine, and returned to Paris at the age of twenty-two. A playwright and journalist, he had already developed a distinctive style, and worked for magazines which he supplied with cartoons. These biting, satirical drawings earned him many nicknames. The 'tourne à dard' he was called, the 'bitter sting'. Tournachon began to refer to himself firstly as 'Tournadar', after his nickname, then the shorter 'Nadar'. A flamboyant extrovert, the distinctive name appealed, and henceforth Gaspard Tournachon took the pseudonym of Félix Nadar.[2]

To help produce his caricatures Nadar began taking daguerreotypes, drawing from them instead of from life as so many of his contemporaries did. His interest grew and by 1852 photography had become important enough to Nadar for him to leave his cartoons and to join his brother's studio in Paris. Unfortunately, Nadar and Adrien Tournachon did not form a workable business partnership. After only a few years Nadar left, following a bitter law suit, to open his own studio on the Boulevard des Capucines. There, Nadar's links with both the literary and artistic fields attracted the photographers, painters and authors of Paris to the ground-floor café, where they could exchange ideas surrounded by exhibitions of Nadar's work.

Ballooning was the second of Nadar's interests, which, as a sport, was currently creating a wave of interest. Being an extrovert, Nadar made sure that all Paris knew of his aerial exploits as he drifted high above the streets. One such occasion was in 1858

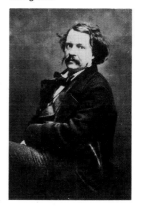

Félix Nadar, the first man to successfully produce photographs underground.

when Nadar took the first ever photograph from the air,[3] an idea he patented for producing maps and surveys. The aerial daguerreotype he produced later earned him a great deal of exposure in the press, for a cartoon depicting him frantically aiming his camera over the edge of his suspended wicker basket duly appeared in the newspaper, *Le Boulevard*. Honoré Daumier, the artist, took the opportunity to mock Nadar, who had jokingly claimed to have 'raised photography to the height of art'.[4] Controversy and bitterness between photographers and artists still raged as the latter saw their livelihood threatened by the incredibly detailed, chemically-produced, likenesses of their former clients.

Although Nadar had learned to use the daguerreotype process with a great deal of skill, its popularity was waning in favour of the new wet collodion process. As this improved in quality, more and more photographers found that it allowed them to produce pictures faster, and to make extra copies of the picture since they worked from a negative on a glass plate. This was the same size as the print that would be produced; to make the final positive the developed plate was simply laid onto sensitized paper and exposed to light, a process that could be repeated as often as was wished.

Collodion itself was used as a coating on the glass plate. This contained the light-sensitive chemicals, forming the emulsion. Collodion did not take part in the reactions with light, but was necessary to hold the other chemicals in place, and was one of the few known materials that was both transparent and would also adhere to glass. Originally, collodion had been developed for medical use on the battlefield. Cotton wool dissolved in a mixture of sulphuric and nitric acid forms a highly inflammable substance, guncotton, the wadding used in guns and cannons. When guncotton, which after all was readily available to soldiers, was dissolved in a solvent such as ether, a thick sticky solution resulted which could be used as a wound dressing. Spread over the skin or a broken limb, the solvent soon evaporated and left a hardened cast that was impermeable to water. This last factor was one that presented many problems for photographers.

Since the emulsion dried and the collodion set in about ten minutes, the plate had to be prepared, used and developed within that time period, otherwise there would be no way for developer to penetrate the emulsion and form the negative, hence the term 'wet' collodion. The process was less convenient than the daguerreotype, but its advantages of repeatability and better quality outweighed this factor, and Nadar followed the lead of his companions and was using wet collodion plates by 1860.

With most of his work in the field of portraiture, Nadar was interested in the idea of taking pictures regardless of the state of the sun. When the sun did not shine, or during overcast winter days, at dusk or dawn, photography had to cease. As others also

realised, the man who could find an adequate artificial light would very quickly make himself a fortune as exposure times shortened and the production of portraits increased. Even if lighting only aided the action of sunlight rather than replacing it, the average person locked into his neck-clamp to prevent movement, eyes watering from the effort involved in trying not to blink, would be certain to show his appreciation.

There were several types of lighting in common use in the late 1850s, perhaps the most popular being coal gas. Since 1807 it had supplied London's street lights, and most towns had had their roads and thoroughfares made safe from footpads and the other less desirable members of society that lurked in the shadows.

Indoors, these crude Bunsen burners were utilized in opera houses and theatres, some of them with complex systems that used many miles of piping. When studio photography began to demand lighting after dark, gas burners were installed but, just as in the opera houses, it was inconvenient and unsafe. Fires started easily, and the light was too hot for the enclosed space. Sitters, protected a little by sheets of blue glass acting as heat shields, suffered in silence as their pictures were taken. In addition, for photographic purposes, gaslight was not bright enough. The gas mantle, which increased both safety and light output, was not invented until 1885.[5]

A second alternative was limelight, also known as calcium light. This illuminant was discovered by Sir Galsworthy Guerney, but first used and developed by Thomas Drummond, a young cadet working for the Government Survey of Ireland, in 1825.[6] At this time, Ireland was being properly mapped for the first time. Col. Thomas Colby had a problem. He was supposed to triangulate the Irish peaks with mainland Britain so as to firmly fix their position, but autumn fog prevented him seeing beacons only a few miles away. He needed a bright light; Drummond tried to find an answer.

After a great deal of experimentation Drummond began using Guerney's light. This was produced by strongly heating a chunk of lime – calcium carbonate – which turned incandescent and gave off a brilliant white light which could be directed using a reflector. The intense heat necessary for the reaction was supplied by an alcohol flame burned in the presence of oxygen. This new limelight was measured as being eighty-three times brighter than the previous best oil lamps,[7] these having been used for abortive photographic attempts as early as 1841. It was successfully used on Slieve Snaght on 9 November 1825, shining a light to Davis Mountain, over sixty-six miles away.

Drummond initially thought that the invention, which he eventually popularised with the result that it was also known as 'Drummond light', would benefit lighthouses. But oxygen

production in the volumes required proved to be too difficult and Drummond turned to the theatre instead, attracting sponsors to pay for installation of the equipment. Before long he met with success; stages were lit by brilliant spotlights for the first time, and the phrase 'in the limelight' came into being. Guerney was rewarded with a medal.

By 1830 the alcohol lamp had been replaced by the even hotter flame produced by hydrogen gas burning in oxygen, and the light was brighter still. The first portrait photographs were taken using this artificial light in 1840, soon after daguerreotypes were available, but the results were poor. Antoine Claudet patented his techniques of portraiture the following year. However, while some studios did make use of limelight, the apparatus required to generate the hydrogen and oxygen gases was expensive and cumbersome, and a lot of preparation was needed before a portrait could be taken. Limelight could hardly be considered convenient, even though in some instances it was in use for temporary illumination of caves for tourism.

In London, Englishman John Moule was also trying to find a solution to the problem of taking pictures whatever the state of the sun, and in February 1857 he patented a pyrotechnic compound which he called 'photogen'.[8] This was a mixture of chemicals – nitre (saltpetre, a component of gunpowder), sulphur and antimony sulphide – that burned with a brilliant blue-white light, and was also known as 'Bengal light' or 'Bengal fire'. In fact, these names had been in use long before Moule applied them to his photogen. In 1812 a physicist, Seebeck, had observed that Bengal light emitted a bright light and, when compacted, it could explode, with the formation of sulphur dioxide and nitrogen. In 1854 the Frenchmen Gaudin and Delamarre mentioned Bengal light in their patent for portrait photography.[6]

In addition, Bengal light was a common illuminant underground. It was commonly burned in 1843 by guides in the Blue John Caverns in England (for which use they charged an extra fee),[9] and in Mammoth Cave to light up the large chambers and pits. In 1863 one traveller to Mammoth Cave described its appearance:

Nick [the guide] said he would show off the pit to advantage, and proceeded to light a blue light. He held it in his hand till it began to blaze, and then threw it well out from the edge. Down it went in a beautiful curve, making the heavy raindrops glitter like diamonds and illuminating to some extent the awful space all round . . . at last we heard it pat very faintly against the bottom. The smoke now began to roll up in great clouds from the mouth of the well below, the bright rays of the blue fire shooting up through them to the roof of the dome above.[10]

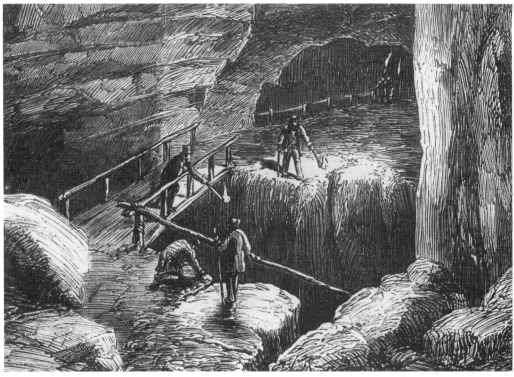

The Maelstrom, Mammoth Cave, one of the many pits that guides threw Bengal light down for the benefit of tourists.

Thus, although Moule is normally associated with Bengal light, it was due only to his patent for its use in photography under the name of 'photogen' rather than for the invention of the chemical formula itself.

However, Moule was responsible – at least for a brief period – for bringing Bengal light into general use in photography. It had the benefit of being fairly cheap at around 2d.[11] an exposure,[8] and was rich in the blue light that wet collodion plates were most sensitive to. This part of the spectrum was normally referred to as 'actinic' light, and there were many attempts to increase this component in all forms of artificial light.

In London, use of the new light caught on in the portrait studios. The chemicals were mixed together and placed within a hexagonal glass lantern. When combustion took place, the copious clouds of smoke and fumes could be taken away through a stove-pipe attached at the top. The conflagration took some fifteen seconds to die down, during which time an exposure of a few seconds' duration was made. This was an improvement over the minutes previously expected in weak winter sunshine. Large screens of blue glass shielded the client from the glare of the burning chemicals, and softened the light slightly. Glass of this colour was

useful since only parts of the spectrum that affected a photographic plate were transmitted, the parts useless to photography (the reds and yellows) being absorbed.

By 1858 Moule was exhibiting ambrotypes – cheap portraits made on glass and sealed in small cases – 'taken at night by artificial light'.[8] Incredibly popular, the novelty value once again drew patrons in flocks. Nevertheless, lighting that was too directional, produced very harsh results, with dense black shadows and burnt out white highlights. Reflectors or sheets of translucent muslin were used to try and prevent this. One critic adversely commented on the results: 'hideous portraits, ghastly and gravelike'.[8] Seemingly, the blue glass and muslin screens were only partially effective in altering the harsh lighting. Despite this, the popularity of ambrotypes continued to increase and in the winter of 1860 an estimated 30,000 portraits were made in London alone.

Apart from the searing light it produced, Bengal light released vast amounts of choking fumes, which made it look like a fire burning – hence its alternative name of Bengal fire. This caused many problems, and was the main reason for burning it inside a lantern. Obviously, Bengal light could have been chosen by Nadar for use in his studio, but he had probably not come across the compound in Paris to any great extent. For photography, its use was restricted by the methods required for burning it, and Bengal light was never a popular alternative to limelight, even in England. Fortunately for Nadar, though, he had a fourth option that had already been used for photographic purposes in Paris: electricity.

Taking portraits by electric light was first suggested around 1851, with ideas for static subjects being considered at an even earlier time. However, although some daguerreotypes may have been attempted at this early date, the arc light was expensive to run, cumbersome, and not well known to the photographers of the time. It was 1857 before the first known successful portrait was produced using its light.[8] Indeed, the arc light was improved and developed only as an indirect result of the requirements of limelight. The gases hydrogen and oxygen could be prepared by chemical reaction, but a much more efficient method was electrolysis. Water, by using electricity, may be broken down into its constituent parts of hydrogen and oxygen. The large amount of power required to accomplish this led first to the development of better generators, and hence to improved arc lights.

An arc light consisted of two carbon rods held at a fixed distance from each other, almost touching at the tips. When an electric current was passed through them a spark jumped the gap, the heat from which caused the carbon to become incandescent and glow. A brilliant white light was emitted, which could be turned into a beam using a suitable reflector. While the resulting portrait was

often poor, it seemed to Nadar that the methods used were at least preferable to using Bunsen burners or limelight. Around 1858 he began his research and found out all he could about the techniques involved.

Nadar soon discovered the major problem with arc lights, that of the power supply. There was no mains electricity, and all the power had to come from batteries. Research into the design of these cells was still in its infancy, and several types were available. The Daniell cell and Bunsen battery were the best known of these, and used alternate layers of carbon and zinc in their construction.

The use of these cells was ruinously expensive, since they were gradually destroyed as power was taken from them. The problem was compounded since a great deal of electricity, and therefore many cells, was required to operate a single arc lamp. Arc lights of this nature work by using either a high voltage and low current, or a low voltage and high current. The latter situation was the only one available to the photographers of the mid-nineteenth century, for Daniell and Bunsen cells were only capable of supplying a low voltage. A means of producing a high voltage and low current was not found until 1879, when the invention became another of Thomas Edison's patents. In the meantime, cell upon cell had to be stacked to produce enough power. The result was a massive battery which ran flat very quickly, and had to be replaced with a new one. In addition, the stacks of cells often released poisonous fumes, hardly ideal in a photographic portrait studio.

Nevertheless, despite the disadvantages, Nadar made his decision and around 1858 an experienced electrician installed batteries, Serrin regulator and an arc light in his red-painted studio. Nadar then began his first experiments in portraiture, using his staff as subjects. Exposure times had to be worked out together with new techniques for lighting, since it would certainly not do to produce poor results with paying clients.

The arc light did nothing to make Nadar's job easy. The lamp certainly gave off a brilliant light, but it came from a point source at the carbon tips. This gave very harsh results, faces burnt white with pitch black eyes in sunken sockets, the classic result already obtained by earlier workers. Nobody in their right mind, he felt, would pay money for a result that looked like a caricature of death! It was obvious to Nadar that he had to soften the effects of the light, allowing an even illumination of the subject.

Nadar made use of every piece of knowledge acquired by his predecessors. A blue screen was fitted in front of the light, and a small mirror was placed just in front of the arc to shield the source itself. The screen protected the client from the glare, heat and small chunks of the carbon rods, which commonly flew off as the tip glowed white hot and shattered. As this happened, the gap widened and the arc failed. The remedy, developed later, was to

use clockwork motors to move the rods inwards as they burned down, keeping the gap constant.

Although the blue screen sheltered the sitter somewhat, the light source was still too direct for good portraiture, and the results gave 'opaque blacks without details on the face, the pupils . . . harshly spotted, like two nails'.[1] Essentially, the effects of the light had to be spread over a bigger area. A secondary light was tried, illuminating the shadow area, while frosted glass screens, mirrors, or anything else that came to hand, were placed so as to reflect light from a direct path. Coatings of chalk were applied to the reflector, further softening the light. Ultimately, Nadar settled on the use of a simple white linen reflector, or sometimes a system of mirrors.

Before long, Nadar was performing limited experiments on the pavement outside his studio at dusk, attracting both curious onlookers and of course more publicity. Bystanders, some of whom were used as models, had never seen such brilliant lights before. Nadar's first formal demonstration of his arc light was given to the newspaper *La Presse Scientifique*, and with persistence and careful experimentation he was able to file a patent for his artificial light photography on 4 February 1861.[12] Over the next few years he was to exhibit a few pictures taken using arc lights, culminating in May 1862 with the display of a 'beautifully-executed study of a hand, both negative and positive having been produced by the illumination from the electric light'.[13] The print won Nadar a medal 'for photographic excellence. . . . For pictures obtained by the aid of electric light' in the International Exhibition held in London.[14] By then, he was obviously adept in the use of artificial light.

Indeed, it was his skill – and publicity – which led Nadar into a new project the same year he filed his patent, 1861. At this time a recital of the work of the novelist Honoré de Balzac was given within the sewers and catacombs of the city, a location used to lend atmosphere to the tale of a 'horrible tableau of dead horses devoured by rats'.[12] The occasion was reported in the Paris press. Nadar was already acquainted with Balzac from his old occupation as a journalist and caricaturist, so had the piece drawn to his attention, which in turn may have suggested the location for his next major undertaking. Having already taken pictures in the air, far above the ground, why should he not also be the first to photograph underground? If such an undertaking were possible, this would be bound to add to his already considerable reputation.

Nadar was, in fact, ideally placed for such a venture. Few other photographers had access to arc lighting equipment; amateurs could not afford the costs involved, and professionals were kept too busy in their studios to think about venturing far from their establishments, let alone going underground. The bulk and weight of all the chemicals and cameras would be enough to put most men off the idea, without adding a set of arc lights to the burden.

His decision made, Nadar chose the Paris catacombs for his demonstration. These were passages hewn through the rock below Paris by quarrying, and converted to burial purposes during the eighteenth century. Locals, frightened of pestilence from over-used cemeteries, had demanded the removal of the health risk. Some of these surface burial grounds had so many bodies in them that the land was some 8 ft higher than the surroundings. Accordingly, between 1786 and Nadar's time, ossuaries were prepared and the mortal remains of the Parisian dead were exhumed and transferred to their new resting place. One paupers' grave alone yielded some 2,000 corpses.[15] Workmen still toiled in the early 1860s, stacking bones along the wide passages, skulls positioned carefully in crosses and other designs between the walls of femurs. Other bones were thrown behind these barriers. Many were still strewn across floors, disembodied and stark white in the gloom of the oil lamps. Both location and subject matter were ideal for Nadar, since the macabre and ghoulish were fashionable amongst the well-to-do clientele that came to him for their portraits. Added to this was the novelty and unique value of the pictures; success was bound to bring its own rewards. A sound businessman, Nadar knew that any publicity was worth-while.

As a first step, Nadar had to obtain permission to enter the catacombs.[16] This was accomplished late in 1861,[17] the suggestion being welcomed by the authorities since prior records of the interred bones had only been maintained by employing artists to make drawings; the greater accuracy that would result from photographs would be an advantage. Indeed, there may have been an approach made by the municipal authorities themselves. Nadar's work with electric lights was well known, and also patented, and the mining engineers certainly required the pictures. Around the middle of December 1861, Nadar was able to assemble his apparatus and begin work.

Initially, the fifty Bunsen cells had to be carried from Nadar's studio to the entrance to the catacombs, along with the camera, tripod and arc lamp. Nadar did consider using a generator, but this proved impracticable. For transport underground, Nadar attempted to load his equipment onto one or two small carts, but soon ran into difficulties: 'All the attempted plans failed due to the narrow-ness of one or other of these underground ways, constricted at certain places like mole-hills',[1] he wrote. Henceforth the batteries were left on the surface, with long cables being run down through service shafts – used for depositing the bones – into the dank tunnels beneath the streets. Within the normally Stygian darkness, the cables and equipment finally in place 'in the bowels of the harmless earth',[1] Nadar could finally erect his lamp and compose the picture.

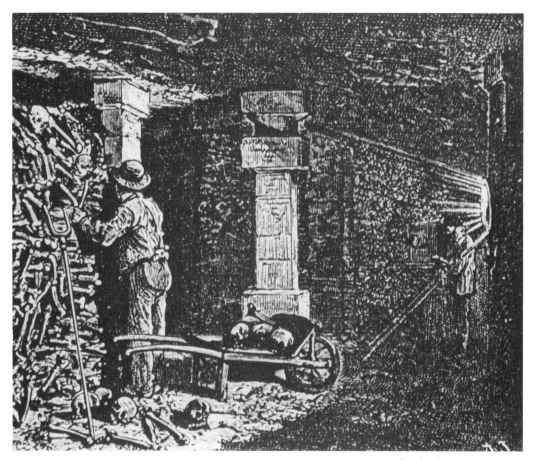

One of Nadar's pictures was used as the basis for this illustration. The left side is based on a photograph, reversed left to right. The right-hand part, showing Nadar with his camera and arc light, has been added by the artist.

Most of the chemicals for the wet collodion process would have been prepared in the studio and kept in well-stoppered bottles until required. When he was ready to take the photograph, Nadar took the collodion mixture and poured it over the cleaned glass plate, tilting it back and forth to flow the thick liquid evenly over the surface. As the ether evaporated, the collodion was left behind as a transparent coating, which was then sensitized by dipping it into a bath of silver nitrate. From that point, Nadar expected to have ten minutes at the most before the emulsion hardened – he had to expose and develop the plate before then.

However, he found that the subterranean world was a very different one from his studio. Here, there was not even a glimmer of sunlight. Instead of aiding the sun, arc lights had to totally replace it. This meant that longer exposures would be necessary, and from the outset Nadar expected failures. One factor, though, was in his favour. In the cool, damp atmosphere the collodion did

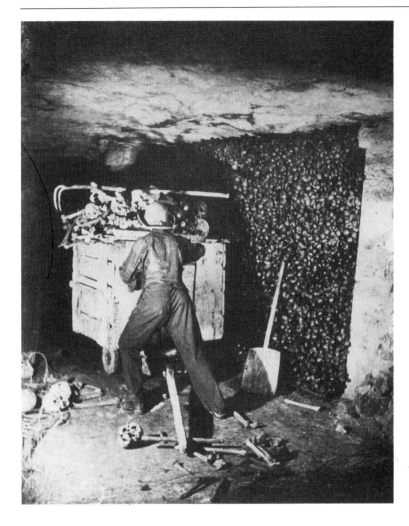

A mannequin 'pushes' a wagon of bones in the Paris catacombs, one of Nadar's photographs produced in 1861–2.

not dry as fast as it would have done on the surface, so that exposures of around eighteen minutes were easily possible – the time Nadar soon found was needed to obtain a printable negative. With his previous experience of studio lighting, it did not take Nadar long to work out not only the best exposures to use but also the best lighting angles. Instead of being a failure, it appeared that the venture was going to be a success.

However, although he had shown that pictures could be taken, there were still many difficulties to be overcome, not least the lack of space in which to work with the lenses he possessed. Difficulties arose due to the Bunsen elements still being left out on the street, and the communication difficulties between those tending the cable and power source, and Nadar underground:

Many times, in our burrows, where we had already been too long – 'one grows old here!' said one assistant – it was necessary to send a messenger by the shortest route to inform us whatever unexpected stop had forced us to painfully begin again what was an already inconvenient operation just at the moment when it was drawing to a close.[1]

Nadar also wished to use some of the workmen as models, but with exposure times of eighteen minutes and only the light from a single arc lamp illuminating the passage, it was obvious this was impossible. Human subjects could not stand still long enough to allow an exposure to be made. Nadar not only needed to add scale to the photographs, but also a counterpoint to the bizarre location. A person amongst the bones, surrounded by the remains of hundreds of dead, would make a far stronger picture than just the bones alone. Eventually, to solve the problem, he used manne-quins, suitably dressed and posed; sitting, standing, carefully sweeping up the skulls or pushing laden wheelbarrows along the stacked rows, they proved ideal.

The effect was dramatic, and under the harsh lighting it looked incredibly lifelike. With the lighting softened a little by reflectors, 'men' went about their gory tasks, backs arched against the weight of the bones they appeared to move. However, the Bunsen batteries proved dangerous, while remaining indispensable. The newspaper *Le Moniteur Universel* reported on Nadar's work:

Nadar found great difficulties of more than one type . . . half-asphyxiated by the noxious gases from the electric battery under these suffocating vaults. In spite of these difficulties, in which he had to manage without several assistant operators who had returned to the surface ill, and whom he soon replaced, Monsieur Nadar has already managed to assemble about twenty perfectly successful negatives.[18]

Major work on the sewers of Paris had just been completed by an engineer, Belgrand, to avoid the discharge of sewage directly into the Seine. The river water was traditionally used for waste disposal, with the result that deadly epidemics had periodically swept the city. Now, both rivers and sewers were kept meticu-lously clean by municipal workers. Nadar noted that he never even saw a rat in them, and later they were even opened for public tours. Following the culmination of four years' work cleaning and renovating the drains, and with Nadar's undoubted successes in the catacombs still growing, the civic authorities approached Nadar with a view to produce photographs. The sewers caught his imagination:

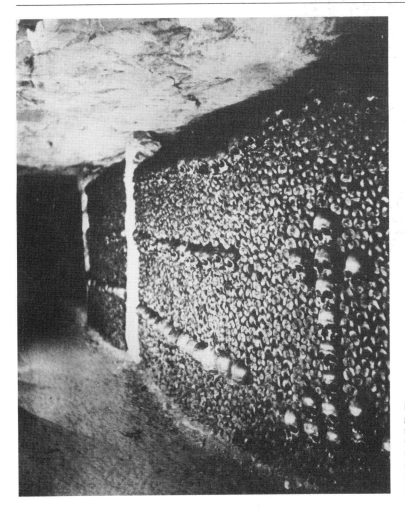

Femur bones in many of the galleries were stacked in walls, skulls forming patterns such as this cross on a hill. In places these walls are some 15 ft from the rock, the intervening space being filled with other human bones.

The world underground offered an infinite field of activity no less interesting than that of the top surface. We were going into it, to reveal the mysteries of its deepest, most secret, caverns.[1]

In these words he captured the essence of many a generation of photographer to come, venturing into the underworld to expose their plates. However, he found not only 'mysteries' and 'secret caverns', but also new problems. While the cold atmosphere of the catacombs had helped him, the subject matter of the sewers did not.

I cannot tell you how many times our work was interrupted, held up for one reason or another. Must I spell out again how we were let down and angry when after several attempts at a tricky

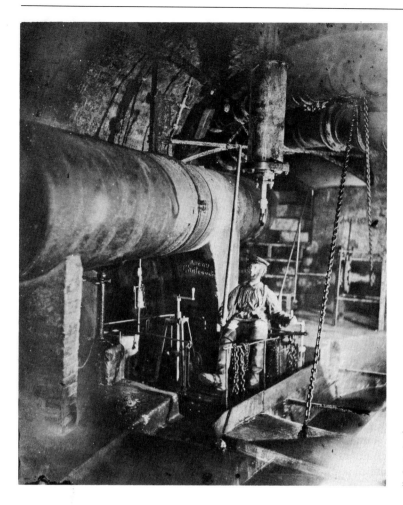

The sewer beneath the rue de Châteaudun. Nadar used a mannequin to show the operation of this machine, used to control sluices and clean the channels.

shot, at the moment when all precautions had been taken, all impediments removed or dealt with, the decisive moves being about to take place – all of a sudden, in the last seconds of the exposure, a mist arising from the waters would fog the plate – and what oaths were issued against the *belle dame* or *bon monsieur* above us, who without suspecting our presence, picked just that moment to renew their bath water![1]

Nadar persevered. Smells did not appear to bother him. Arched roofs and subterranean watercourses were all recorded by his camera. Using what he had learned in the catacombs, he again used mannequins whenever a human figure was needed for scale, or to show the workings of the cleaning machines which travelled the rails. Yet, despite his increasing prowess, Nadar found the continuing project unpleasant:

It needs to be mentioned that this miserable occupation, in sewers or catacombs, had not lasted for us less than some three consecutive months. I would not wish these three months on my worst enemy, if I had one. I had passed beyond resignation, and had arrived at the bottom of the bag of my patience. I stopped with one regret however, that the project was not quite as complete as I would have dreamed. I returned to the studio and to other necessities which had become even more urgent after such a long absence.[1]

Evidently, Nadar's studio work had fallen by the wayside during his three months working on the underground pictures. He finished on or about 15 March 1862.[18] His final tally of pictures was some seventy-three from the catacombs and about twenty-three in the sewers. Due to his early difficulties in laying cables and setting up his equipment, which was very time consuming, most pictures were taken during the latter days of his experiment. Overall, the venture was a complete success.

Nadar's work immediately captured the public's imagination, causing an immense reaction that outstripped even his own expectations. The first of his results were presented to the Paris authorities, and to the sewer engineer, Monsieur Belgrand, who had helped him with the work. Others were placed on display. The photographs of the catacombs and the gory subject they contained easily proved the most popular. People were amazed that photography could penetrate the darkness of underground passages, and the images became the talking point of Paris when shown in an exhibition of the French Photographic Society. 'Monsieur Nadar', reported the *British Journal of Photography*,

> . . . has been "down among the dead men," and has electrified the mortal remains of past generations in a remarkable manner . . . He has brought to light, in two senses, the gloomy masses of sculls [sic] and bones built up in the galleries of the old gypsum quarries, in all their horrible picturesqueness. He shows them in grinning regularity, and in disorder . . . He exhibits *Skulls and Bones Selected to Decorate a Façade*! He also shows a heap of bones just pitched down a well-hole into the Catacombs – these are the result of recent alterations; the mortal remains exhumed in the old *rue Tombe Issoire*, during the excavations made the other day for the improvement of the city; and he gives us a view of the famous spring in which a few little fishes manage to continue a gloomy existence.[19]

Nadar was delighted with the effect he had produced, and capitalised upon it whenever he could. His photographs were published as wood engravings, and later as prints, throughout the

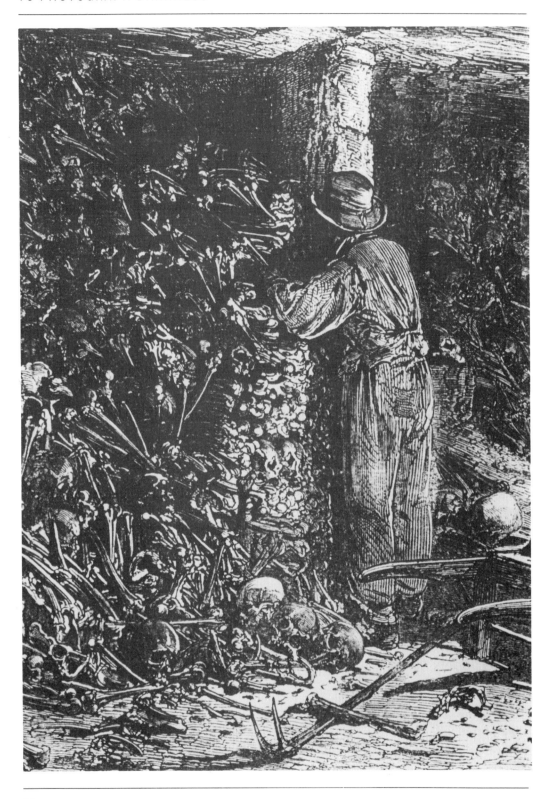

remainder of the century.[20] The intellectual society that met at Nadar's studio encountered his name emblazoned across 50 ft of wall in giant letters; Nadar was not going to miss a chance for further publicity, and even took to wearing red clothes to match his studio colour and proclaim his liberal-left political affiliations.

Nadar's work produced precisely the effect that he wished for, a sensation in the midst of the sunlight-seeking studio photographers. For most people, who would never have seen anything as bright as an arc light and were used to the feeble illumination of candles, oil lamps and gas lights, the pictures were nothing short of miraculous.

Following his success, Nadar returned for a while to his other love, that of ballooning. Ever the showman and extrovert, in 1863 he constructed the world's largest balloon, 'Le Géant', three times the size of anything else in existence, and equipped with a two-storey 'cottage' made of wickerwork in place of the customary basket. Inside this was a refreshment buffet, lavatory and, of course, a darkroom! After losing a fortune in an experiment where he fitted a propeller to his balloon, constructing a steam-powered balloon and flying to Hanover, only to be arrested as a spy when he landed, Nadar retired to his studio.

The business prospered – Nadar now employed twenty-six full-time staff – and he became one of the most influential portrait photographers of his era. Some of his underground pictures went to Louis Ulbach for inclusion in the Paris guide-book, while in Brussels the editors Lacroix and Verboeckhoven produced a publication entitled *Paris en l'air et sous terre* – 'Paris in the air and underground' – with eight illustrations. 'Looking for Nadar?' asked a cartoon. 'He's either up above or down below.'[12]

Nadar revelled in the publicity. It mattered not how successful he had become, Nadar still loved to boast that he was the first man to take photographs above ground in the air, and below it in the subterranean passages of Paris.

LEFT, Many of Nadar's underground photographs were converted to engravings or woodcuts and used to illustrate newspaper reports around the world. The two-pronged rake at the bottom was used to drag bones into place.

Magnesium:
The Start of an Era

*We can not only light up the deep places of the earth, and make day
in the depths of the mine, or in the fairy halls of the stalactite cavern,
but we can also daguerreotype the effect, and bring away a
nature-painted picture of the subterranean scene.*

Journalist, The Standard, *writing on the uses
of magnesium in 1864.*[1]

As might be expected, Nadar's experiments with arc lights and
underground photography remained unrepeated elsewhere for
many years. It was bad enough that a photographer had to carry
his camera, tripod, glass plates and all the chemicals and darkroom
equipment required to prepare, coat and develop the wet collo-
dion negative, without also having to contend with heavy arc
lamps and cumbersome, unmanageable Bunsen cells as well.
Clearly, using cable-bound techniques was a trying enough process
in a catacomb or sewer, both of which were relatively accessible.
In remote locations such as a cave passage, any such idea was out
of the question. A light source that was cheaper and more usable
by a single operator was required before any real advance could be
made in conquering the absolute darkness that only occurs under-
ground. The solution once again lay with the portrait photo-
grapher, this time with a chemical totally new to photography.

The same incentives that had spurred on Nadar and Moule to
find better light sources still existed. Artificial lights, especially
Bengal fire and arc lights, all too often produced an unflattering
result for the client. Being more used to the flattery made possible
by an artist's brush, patrons had difficulty in understanding that
blemishes and wrinkles would be recorded as easily as their more
desirable features. To produce good images took a lot of care, and

capital outlay was high. The search continued for a new alternative light source. Due to circumstances that developed around him, the English photographer Alfred Brothers found himself in a position to make full use of the eventual solution, the newly refined metal, magnesium.

Alfred Brothers was born in Sheerness, Kent, on 2 January 1826. The son of a chemist, he was born into a family of ten children, and received a poor schooling supplemented by his father's teaching. From him, the young Alfred gained an undying interest in astronomy, electricity and drawing, the last of which led to photography. Sadly, his father died in 1835 before his education was complete, the same year that they saw Halley's comet together. Brothers left school four years later to work in a book-shop.[2]

While he was employed as a clerk, he began to teach himself more about photography. In Britain, Fox Talbot's calotype process was not widely known, and the daguerreotype was far too expensive for Brothers to use. A popular parlour trick was to use sensitized paper to make 'sun pictures', images of objects such as leaves placed on the paper, now known as 'photograms'. Brothers went one stage further and built a small camera out of cigar boxes and experimented by himself. Then, after several jobs as a clerk, he married in 1853 and began work as a secretary for the Anchor Insurance Company. The newly-married couple barely had time to settle down before Brothers was transferred to the company's Manchester branch.[2] Here, with a new home and outlook, photographic interests reasserted themselves and changed Alfred's life.

In a shop window Brothers saw a photograph by Lachlan McLachlan, a local studio owner and professional photographer. Standing there in the sunshine in the centre of the city, Brothers studied it carefully. Could he achieve such quality himself? He soon visited an optician's shop, and purchased a quarter plate camera. Cameras were named after the size of plate they would accept, the 'whole plate' standard being 8 in × 6 in. His interest increased still further, and then the Anchor Insurance Company collapsed.[3] In the spring of 1856 Brothers went to work for McLachlan as an assistant. Later that year he became a full-time professional in his own right when the older man left, allowing Brothers to buy the studio.

Brothers prospered, most of his work being with portraits either on collodion paper, or in the form of the recently-introduced carte-de-visite. These were small portraits mounted on card, the name of the sitter printed underneath and the studio name advertised on the reverse. The idea was spreading around the world from Paris, where the inventor had found a demand for cheap portraits, recording the likeness of the common man at a price he could afford. Eight exposures were normally made on a

Alfred Brothers, FRAS, from a carte-de-visite.

single plate to keep the cost to a minimum. The craze for giving and collecting cartes soon reached the stage where pictures of the famous were being reproduced for sale to the public by many an entrepreneur.

With his photographic business established, Brothers joined a local club, the Manchester Photographic Society. This was formed in 1855, one of the earliest of its type in the country. Many of the influential and academic men of the city belonged to it, Brothers meeting them when he became a member. He never felt totally at ease with these men, having a much poorer education, yet he did admire his companions. James Nasmyth was working with industrial inventions. John Benjamin Dancer was the inventor of a stereo camera, among other things. The picture it produced gave a three-dimensional illusion of depth when placed in a stereo viewer.[4] Thornton and Pickard were members of the society, joining forces to begin camera manufacture. Together with Mudd, Sidebotham and the other members, the society's general outlook towards photography influenced Brothers greatly as, for a time, Manchester became the world centre for photographic innovation.

In 1858 in Heidelberg, Germany, Professor Bunsen had succeeded in making small quantities of magnesium by electrolysis. By the following year he was collaborating with Henry Roscoe of Owen's College, Manchester, researching the photochemical properties of the metal. After their experiments were finished, the two men made a report to the Royal Society of London in 1859.[5] They believed magnesium, with its extreme brightness and highly actinic properties, would be eminently suitable for photography. The metal could easily be lit with a match or candle, after which it burned on its own without problem.[6]

William Crookes,[7] editor of the London-based *Photographic News*, heard of the work and was impressed enough to attempt a few exposures in a darkened room, using the new magnesium for lighting. He was unsuccessful due to insufficient quantities of the metal. With no more magnesium available, the experiment had to be abandoned. Crookes was well aware of the power of magnesium, however, for he published a letter in his journal in October 1859 concerning a proposed tour of America by a correspondent who signed himself 'V.C.':

> . . . the great Mammoth Cave, of Kentucky, will receive our earliest attention. You may be aware this cave is several miles in extent, containing rivers, waterfalls, many lofty and extensive caverns, from 30 to 80 feet in height, but all in total darkness, and only imperfectly seen by the aid of torches, each visitor carrying one.
>
> Can you advise any artificial light that would sufficiently illumine such an interior as would enable us to take views?

Would the light called photogen cast brilliancy enough over the scene, that negatives could be taken?[8]

Crookes was aware of all the latest photographic advances and, following his experiment with magnesium, already had some personal experience with artificial light. He ruled out magnesium on grounds of cost and availability, although this would have been his first choice. His advice was also to avoid the use of photogen, only two years after Moule had introduced it, the chemicals producing too much smoke. Instead he suggested burning phosphorus in jars of oxygen, several being dotted about the cave. In fact, such an attempt would have been doomed to failure, in the unlikely event of it ever having been made.

The paper that Roscoe and Bunsen published was also noticed by Edward Sonstadt, an Englishman with a Swedish name. He wondered if it would now be possible to produce magnesium on a commercial scale. Obviously, if Crookes thought it useful there was money to be made. Early in 1862 Sonstadt, working first in Nottingham and then in Loughborough, began experimenting with magnesium ore.[9] He soon reached the stage where he could exhibit specimens of the metal ranging in size from a pin-head speck to a lump the size of a hen's egg.[10] On the strength of this the first of his patents, 'Improvements In The Manufacture Of The Metal Magnesium', was granted to him in November of the same year.

Over the next few months Sonstadt further refined his process and presented Professor Michael Faraday of the Royal Institution with a lump of purified magnesium. 'This is indeed a triumph', Faraday exclaimed. Later, in 1864, he was given a larger mass to handle. Gingerly holding it, his next comment was, 'I wonder it does not take fire spontaneously'.[11] Indeed, such was the known power of magnesium in the laboratory, when one old Edinburgh professor first saw a large mass he was ecstatic. 'Bottled sunshine! – portable daylight!' he chortled.[12] Magnesium was dazzling its observers in more ways than one. It seemed that Sonstadt was on the right path for fortune, although initially he wrongly thought it could be used as a replacement for silver in jewellery manufacture.

To obtain these larger quantities of metal Sonstadt had improved his patents and begun experimental operation of full-scale industrial techniques at the close of 1863. Not everybody was initially happy, however. In 1857, in the French journal *Comptes Rendus*, two men, Deville and Caron, had published an account of their preparation of magnesium.[13] Sonstadt was accused of copying their method. The closing part of his patent concerning the properties of the metal was almost identical with that of Deville and Caron, showing his familiarity with it as well as with Bunsen and Roscoe's. 'If such a patent as this can stand for a moment', it

was said in the photographic gossip columns, 'consisting as it does of scarcely anything but wholesale appropriations of other persons published discoveries, there is little doubt that the patent laws require amendment'.[14]

Sonstadt's patents stood, however, and in spite of the accusations he was soon hailed by the photographic world for his achievements in bringing the commercial production of magnesium to fruition. His process was in three stages. Firstly, chloride of magnesium was made by dissolving the ore in acid, the precipitate being recovered and washed. This was then mixed with salt and dried, placed with sodium in a crucible, and heated until red hot to reduce it. During this final stage the metal was condensed into a more or less coherent mass within the resulting slag, and could be reclaimed by washing away the waste.[15] The crude metal could be purified by distillation, heating it in a hydrogen atmosphere until magnesium vapour was given off. This was condensed to obtain pure metal.[9]

Lumps of the solid were inconvenient, since they did not burn evenly or with much control. Thin strips were needed. As a solution, a hollow iron block was used, filled with magnesium before being heated. Softened magnesium was forced through small holes in the end by a hydraulic ram; care had to be exercised, of course, to prevent the magnesium from bursting into flames. The final effect was much the same as that produced by a kitchen mincer – long threads of magnesium wire were extruded, ready for use.

Using Sonstadt's patents, a Mr Mellor began operations in Manchester as manager of the newly-formed Magnesium Metal Company. He slowly started to build up supplies of magnesium for sale. The obvious market was photography. It was usual to compare the power of any light with some standard, usually a candle, as this was a common illuminant known to everyone and found in every home. Measurements showed that seventy-four candles ('of which 5 go to the pound') were needed to give out the same light,[16] a huge improvement on the other known forms of artificial illumination. With light of this power and quality, Sonstadt and Mellor expected to sell lucrative amounts of the product.

Two problems remained for the company. The product had to be sold, and therefore advertised. The first sales to the public were through the firm of Johnson, Matthey and Co., which began advertising the metal in February 1864. In addition, it was decided that local photographers should be given demonstrations, and hopefully be convinced that magnesium was worth its rather high price. Roscoe, who had kept an eye on the progress of magnesium production since he first suggested its uses, obtained some for an exhibition of the power of its light before a meeting of many of Manchester's prominent photographers.[16] Many of the members of the Manchester Photographic Society, including Brothers, had

left the society after a disagreement early in 1864, and formed a new photographic section within the auspices of the Manchester Literary and Philosophical Society.[17] At this time regular meetings were being held, although the new group had not yet been formally convened. In its George Street meeting rooms, the audience was impressed when Roscoe publicly ignited the greyish-silver metal on 9 February 1864.[16] The light was blinding, and before he left the meeting Brothers asked for and received a small sample for further experiments.

Taking the lump home, Brothers first hammered it into a flat sheet and then cut it into crude strips with scissors. Lighting one end, the magnesium burned with ease. Even with his poorly-formed lengths of metal, Brothers was able to begin exposing photographic plates. He soon informed his colleagues in the Philosophical Society that,

> The result of an experiment I have just tried is that in 50 seconds with the magnesium light I have obtained a good negative copy of an engraving – the copy being made in a darkened room.[18]

To help burn the magnesium wire, two employees of the Magnesium Metal Company, William Mather[19] and Mr Platt, invented a magnesium lamp. They used a thumb-wheel to propel the wire from a spool into the flame of a spirit lamp in front of a reflector, where it burned. At this time, production of the wire was slow and the product costly – about 2s. 6d. a foot – and in addition the quality was low. Impurities in the wire meant that it would often break as it unwound from the coil. Because of this factor, even though magnesium would burn on its own, it was usually kept in the flame of an alcohol lamp. If the burning tip of wire did break off, the lamp would automatically relight it.

Brothers was supplied with more of the wire as soon as production allowed, and he went on to be the first man to take a portrait by its light on 22 February 1864.[20] He used a bundle of wire, bound round with an extra strand to make a taper,[21] thus burning more metal at one time, although he noted that there was not as much light as if the wires were burned separately. With this success, Sonstadt's gamble came to fruition. Until now, the whole enterprise had been based on theory alone; his tenacity and experimentation finally brought their rewards.

Not using a spirit lamp, Brothers had some problems with the wire in his taper breaking and falling to the floor, although the other strands helped to relight the one that had gone out. This problem had not occurred with the flat sheets that Brothers had previously made. They had been easy to roll, were less likely to break, and burned consistently since their larger surface area could react easily with the air.

Brothers felt that flattened strips were a much better form to use and, taking a length of wire, he fed it through the rollers he normally used to burnish prints. Magnesium being quite soft, it emerged as a flat ribbon which was far superior to wire. Brothers went to see Mellor and told him the results. William Mather redesigned the machinery, and henceforth the Magnesium Metal Company produced magnesium in the form of ribbon as well as their normal wire,[22] using an ingeniously modified textile machine borrowed from the cotton-making process.

Continuing his experiments with magnesium, Brothers tried to find the best reflectors and lighting angles to use, just as Nadar had done in Paris. Again, like Nadar, Brothers would have a commercial advantage over his rivals if he could take portraits at any time, independently of sunlight, though his natural curiosity would have probably led him to experiment further even without this incentive.

Brothers was meticulous in his trials, making use of concave reflectors and mirrors, initially deciding to use a simple construction of two lengths of ribbon bound together with a length of wire. Later, he added a simple reflector with a tray to catch falling magnesium ash.[23] By moving the burning metal during his exposure, shadows could be softened to give a much more pleasing effect, avoiding the harsh light that was so easily obtained with static arc lamps.[20]

Brothers' prints were also painstakingly produced, involving a degree of effort not often encountered in modern photography. The collodion plate was first placed in contact with recently-prepared sensitized paper. Initial developing was done using sunlight, the image slowly darkening until it turned a purple-black, following which it was further darkened in poisonous mercury and ammonia fumes before fixing in sodium hypochlorite solution, or 'hypo'. The print was then toned in gold chloride, turning the image a dark brown, washed for forty-eight hours, and finally mounted on card using gelatine as a glue.

Joseph Sidebotham and James Nasmyth, both colleagues of Brothers and amateur photographers in the Literary and Philosophical Society, were interested in astronomy, as was Brothers and several other members of the Society. As such, both had become acquainted with the Astronomer Royal for Scotland, Professor Charles Piazzi Smyth. During 1864, Smyth was preparing for an expedition to Egypt, an undertaking which was gaining little support from either the scientific community or the general public. This upset Smyth, for he had earlier commanded a great deal of personal respect. For example, with his wife Jessie, he had visited the Canary Islands in 1856.[24] The photographs of stars that he took from the clean island air brought him acclaim from both the government and learned societies alike. However, his views on

the Great Pyramids of Egypt labelled him as a fool in the eyes of many laymen and academics.

As an astronomer, Smyth had been interested to read about measurements taken in the pyramids which could be interpreted to show that the ancient Egyptians had a working knowledge of the sun and stars. John Taylor, editor of the *London Observer* and a partner in the publishing firm of Taylor & Hessey, had propounded the original theories in 1859. He gave them a religious bias, claiming that the pagan monuments were built with divine guidance[25] – something unacceptable to the bible-fearing public of the Victorian age. Smyth often corresponded with Taylor, and was bequeathed all Taylor's notes upon his death in 1864. Smyth checked Taylor's maths, pronounced them to contain elements of some merit, and entered the controversy. He was also led to believe that the pyramids might be a primitive 'Metrological Monument'.

At this time attempts were also being made to standardize units of measurement, the British inch being under attack by the French metre. Smyth favoured the inch, of course, stating that he was sure the metre was part of a communist plot.[24] He was supported in his opposition to the metric system by the astronomer John Herschel, a close friend.

As part of his argument for retention of the inch, Smyth looked closely at the metric system. The length of a metre was defined as being a divisible portion of the distance between the pole and equator. Smyth found that the inch would also fit into the Earth's polar axis a convenient number of times and, furthermore, the measurements obtained by Taylor in the pyramids were divisible to give a value very close to the inch.

Smyth went to London to apply for grants for his intended Egyptian visit. In the hope of raising support for his campaign Smyth also presented his theories to learned societies, showing the need to check his findings at first hand. By the time Smyth finished he had also linked the 'sacred cubit' of measurement with both the pyramids and the inch, and further noted that the measure Noah used to build his ark was involved. The scientific community laughed Smyth back to Edinburgh. He was not given a penny in the form of grants, and was further incensed when he later found out that the Royal Society, of which he was a member, had even returned funds to the government as it felt there was nothing worthwhile supporting that year.[24]

Charles Piazzi Smyth wearing an Egyptian tarboosh, about the time of his photography of the pyramids at Giza in 1865.

Not to be put off, Piazzi Smyth continued his preparations for the expedition, paying for it out of his own pocket. To bring back proof of his findings he decided to include photography as part of the study of the pyramids at Giza.

While Smyth had not previously been to Egypt, some of the conditions he would be working under were known to him. Egypt

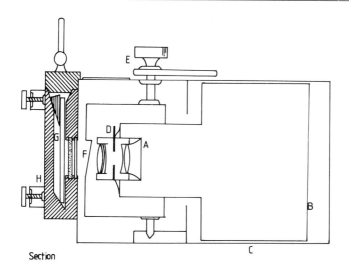

Section

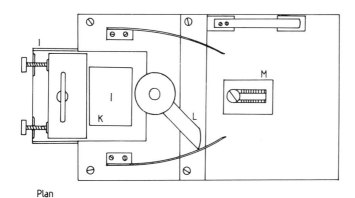

Plan

Bath

Shutter

Smyth's miniature camera was produced from these working drawings. The glass plate (G) was a microscope slide, held in place by a wedge. The bath was able to keep the plate moist, avoiding having to coat the slide just before exposure. The shutter was controlled by spinning knob (E), the aperture (N) giving more exposure to the foreground than the sky.

was a popular country in the mid-nineteenth century; the relics of long-dead Pharaohs caught the imagination of the Victorians, and photographs were much in demand. Any photographer-adventurer who could bring back views of towering pyramids and the sand-swept Sphinx could make a fortune in sales. One of the first to do this was Francis Frith. The money he made from the venture enabled him to set up a printing firm that specialized in sales of stereoscopic views and, later, postcards.

Frith found wet collodion photography to be extremely difficult in the arid conditions. His developing tent became so hot it felt like a furnace, the sand prevented his cameras from operating correctly and insufferable clouds of flies stuck to his collodion plates as he prepared them. At times the liquid collodion boiled in the heat.[26] Smyth would have to face all these problems, and more, before he could hope to accomplish his project. Careful planning was required.

Smyth had to consider both the camera equipment and the emulsion that he should use. Later, calling his work 'A Poor Man's Photography',[27] he began to develop a range of apparatus that would be able to deal with the conditions he could expect to find, and, in so doing, he pioneered a number of innovations.

He considered the emulsion first. By now, collodion was in widespread use and the daguerreotype all but abandoned, but two forms of plates existed. The original wet collodion plates developed from Scott Archer's invention were the most popular, but were also extremely messy and would be far from ideal to use on an expedition in the midst of heat and sand. New on the market and relatively unknown in 1864 were factory-prepared collodion dry plates.

As was normal, the plates were made with collodion prepared from guncotton and ether. Although experimenters had tried many strange materials such as slime exuded from snails, a more convenient replacement had yet to be found. All that could be hoped for was to coat the collodion with some material which would prevent it from drying out. Albumen, prepared from egg white, was the sealant finally used. This was the best material found for the purpose so far, being cheap, sticky and transparent. The price to be paid for convenience was that the dry plates were even more insensitive than their wet counterparts. They were also less reliable, showed less detail in the finished image and never became very popular.

In order to cut down on the chemicals and darkroom equipment that he would have to carry, Smyth nevertheless decided to use dry plates for his photography. However, another idea was presenting itself to him. Would it be possible to photograph within the Great Pyramids themselves?

Due to Brothers' work with magnesium in Manchester, word of

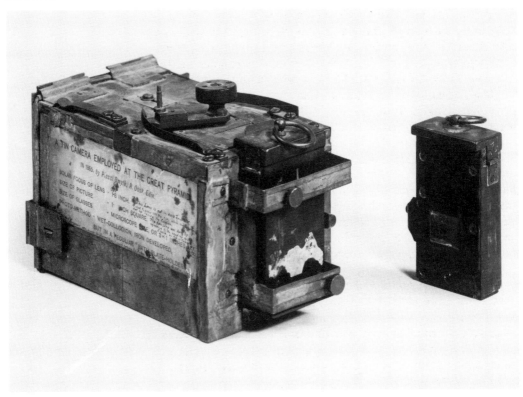

One of Piazzi Smyth's cameras, used at the pyramids. The removable wet plate collodion back is clearly visible, with a spare to the right. Exposure was controlled by the speed of turning the knob on top. The original 1.8 in lens is now missing.

the possibility of taking pictures in darkened rooms had spread. Formal news first reached Edinburgh on 8 March 1864,[20] when the Photographic Society of Scotland held its meeting. It was a distinguished company that heard the first reports of Brothers' photographs, including Fox Talbot, inventor of the negative-positive system of photography. Joseph Sidebotham from the Manchester Literary and Philosophical Society may also have been present; he had several mutual friends, and is known to have sometimes attended.

A small amount of magnesium was burned at the meeting, letters and papers concerning the metal were read and several prints that Brothers had produced were shown. In his annual report a few weeks later, the secretary of the Scottish society suggested the use of magnesium to light the interior of the Great Pyramids,[28] but it is likely that Smyth had already begun to consider the idea. If he had not been present at the actual meeting, his friend Sidebotham or Fox Talbot would surely have spoken with him about the new type of light.

Sidebotham gave Smyth a great deal of help in preparing for the expedition,[29] including suggestions for using well-seasoned

wooden textile measuring rods, made from old organ pipes, for scale in the pictures.[30] In the event the carpenter that made them oiled the rods, and they eventually warped in the Egyptian heat. Sidebotham also helped to obtain supplies of magnesium from Manchester. The price was still very high, about £6 a pound in England, rising to £30 after being exported to Paris,[31] although the price was rapidly dropping. Nevertheless, a large quantity of magnesium was delivered from the company's Salford works early in November 1864.

While these arrangements were being made, Smyth planned how he would tackle the underground pictures. For example, it seemed prudent to reconsider his earlier decision of only using the rather insensitive dry collodion plates. There was little point in burning expensive magnesium for a poorer result if half the amount would suffice for a wet plate. Rather than use a normal camera, Smyth began to design a new, miniature, wet plate camera which he hoped would avoid some of Frith's problems.

In principle, Smyth still wished to keep his equipment as small, lightweight and as foolproof as possible to make its operation and transportation as easy as he could. Remembering the dust, flies and heat that troubled Frith, Smyth decided to build his camera in such a way as to seal the plate and collodion inside it. He chose the dimensions of 3 in × 1 in for his plates, both to save on size and weight and because he had a ready supply of glass cut to size: microscope slides.

The finished system, constructed for Smyth by Edinburgh carpenter John Air, was a masterpiece, perfectly suited to Smyth's needs.[32] The lens, protected by a long lens hood, gave minute square negatives with each side just under 1 in long. An ingenious focal plane shutter could be spun by hand, the speed of which controlled the exposure as a pre-shaped aperture passed behind the lens, springs damping any vibration as the shutter closed. This could be removed for underground work, but would be useful for surface photography. The aperture was shaped to give the foreground more exposure than the sky, since it was darker in tone and required more light to yield a correctly exposed negative.

The rear of the camera possessed screws that clamped onto a waterproof, ebonite box containing a ready-prepared collodion plate. At the front of the container was an optically-perfect glass window exactly 1 in square, covered with a sliding sheet of metal, or 'dark slide', made from blackened tin. In use, the box was clamped to the camera, the slide removed and the exposure made, then, with the slide replaced, the structure could be exchanged for further ready-prepared containers and plates.

The beauty of the system was Smyth's ability to keep the collodion plate sensitive for long periods of time. The top of the ebonite box was hinged for replacing the plate, held in place by a

small wedge, and, since the box was waterproof, sensitizing chemicals could be kept within it so that the collodion never dried out. It was perfectly possible to prepare the plate in the morning, expose it during the day and process it at leisure that night by simply pouring in a developing solution. Frith's problems were overcome. Sand and flies could not gain access. Drying of the plate was avoided. Convenience was maximized. Smyth even included a ring on the backs so they could be carried on his finger, once a dark slide had been attached. The final addition was a metal bar connected to the shutter; Smyth had two cameras made, and this bar enabled them to be operated together for stereograph production. The system worked without a flaw, an incredible innovation, although Smyth himself made no such extravagant claims.[32]

With his new camera system perfected and his magnesium safely packed away, Smyth and his wife were finally able to depart from Holyhead for Egypt early in November 1864. The ridicule of his fellow scientists followed him, ringing in his ears. The *Telegraph* newspaper pushed in the final thorn:

> Was it a wild fancy to imagine the granite gods and goddesses of Misraim walking down Oxford Street, or writing explanations of themselves to a London editor? Not much more, at any rate, than that which is upon the point of fulfilment – a scientific 'savage' of Britain burning a metal that Egypt never heard of, to take, by a process that Moses with 'all the wisdom of the Egyptians' never dreamed of, a picture of a secret of secrets . . .[33]

Smyth, although his project was well publicized along with his intentions to photograph the interior of the Great Pyramid, received little support. His departure was a quiet, unattended, lonely affair. On the other hand, magnesium was applauded. Prompted by the basic idea of photographing underground, as stated by Smyth, *The Standard* newspaper wrote:

> *Only the fairest and clearest of our English days can compete with the magnesium light in utility to the photographer.* Thus it is quite practicable to obtain *better* photographs at night-time than were formerly procured by the light of day . . . The London fog – that terror of the photographic studio – is thus disarmed of its power to hinder. So that, when the heavens are unkind, the artist has only to light his wire and "business will proceed as usual." . . . One thing is palpable – that henceforth it will be next to impossible for a mortal man to hide himself from the lens of the photographer. Formerly we were safe after sunset, but that is so no longer.[1]

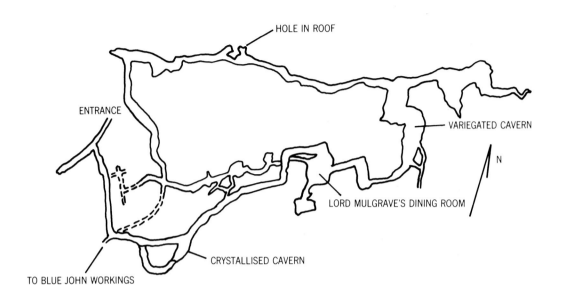

HOLE IN ROOF

ENTRANCE

VARIEGATED CAVERN

N

LORD MULGRAVE'S DINING ROOM

CRYSTALLISED CAVERN

TO BLUE JOHN WORKINGS

0 50m

A sketch plan of the Blue John Caverns, showing the approximate extent of the passages known in the 1860s.

While not agreeing with some of the comments, photographers did indeed see that magnesium was the answer to many problems. Its light was bright, and though very expensive, the price was sure to drop. Magnesium was easily transportable. Expensive or cumbersome apparatus was not needed for its use and exposure times were shorter than with Moule's photogen. While Smyth was sailing on the first stage of his voyage to Egypt, back in Manchester Alfred Brothers continued his experiments in artificial lighting.

By September 1864 Brothers had perfected his techniques of portraiture by the light of magnesium, but thought that a more ambitious demonstration of its power might be accomplished. Smyth had announced his intention to photograph the interior of the pyramids, but why should the metal not be used underground rather nearer to home? In addition, it is likely that Brothers had maintained his relationship with the Magnesium Metal Company, and would have been encouraged to perform any experiments that would further demonstrate the usefulness of the light.

An attempt at underground photography could, of course, have been made somewhat earlier using Bengal light, which was sometimes used to illuminate cave interiors for paying visitors. In Wookey Hole either Bengal light placed on rocks and stalagmites, or petrol poured on water, was burned for the benefit of tourists.[34]

This produced a thick, viscid smoke and coated the roof and walls with grime. That factor alone would have made any idea of photographing underground using Bengal light appear ridiculous, for the scene would soon become obscured by fumes.

Indeed, photography in general found little use for Bengal light outside the studio due to the attitudes of the professional photographers of the time. There were few amateurs – photographic apparatus required time, dedication and money before it could be mastered. For those that had the skill, there was little incentive to leave the studio as Nadar had done. Portraiture was a business; photography usually stayed where there was money to be made. Amateurs, such as those who attended the Photographic Society meetings in Manchester, normally concentrated on landscape subjects when outdoors.

However, Brothers' prime reason for making the attempt was not the production of an underground picture, but to demonstrate the superiority of the magnesium light he was already using. Whatever it was that gave Brothers the idea to do more than this and photograph underground – be it Smyth's announcement of his intentions, Sonstadt and Mellor looking for publicity, newspaper reports or Brothers' own ideas for proving the worth of magnesium – he chose the Castleton area of Derbyshire for his site of operations.

The area was a familiar one to Manchester people and represented the nearest convenient location where an underground photograph could be taken. Around the village of Castleton there are now four caves used as tourist attractions, but in 1865 not all of these suited Brothers' needs. The Treak Cliff Caverns had yet to be discovered and remained hidden until 1926, while Speedwell Mine had a long, flooded canal to negotiate. In any case, both it and Peak Cavern were relatively inaccessible by train from Manchester, the railway not yet having been built past Edale.[35] The easiest route for Brothers was to travel by train to Chapel-en-le-Frith, a journey of an hour from his home, then hire a horse and carriage to take him and his two companions up the steep, winding hillside to the fourth site, the Blue John Caverns.[36]

The caverns were already in use as a tourist attraction by 1865, the Blue John mineral which gave them their name having supposedly been worked out. Blue John, which exists in the limestone of the Treak Cliff Hill in which the caverns lie,[37] was in fact still present in reasonable quantities. Local guides have often denied this as part of their sales pitch for the visitors, increasing the supposed rarity of Blue John. The name of the caverns had changed many times during the history of the caves; early references call it the 'Treke Cliff Back' or 'Waterhole',[38] while later the names 'Water Hull' or 'Water Hull Pipe' were used. Early in 1865 it was known as the 'Blue John Mines', which was supposed to

appeal to tourists more than previous names. In fact, the tourist route followed natural, winding cave passages, the old mine workings leading off as a series of low crawls.

On 27 January 1865,[39] Brothers arrived at the entrance with his two friends, camera, chemicals and all the paraphernalia required to use the wet collodion photographic process underground. Unfortunately, the gate was firmly locked and the men were forced to wait in the cold. When the custodian was eventually found – he had left the cave, expecting no visitors that day due to the inclement January weather – Brothers, William Mather and his other companion (either Mellor,[11] the Magnesium Company manager, or a friend, Mr Pownall[40]) unlocked the entrance and began the descent of the steep stone steps inside. Twisting and turning back upon itself, the passage led the men downwards past the old mine workings, the photographic equipment carried with difficulty. They finally reached a chamber that was large enough to suit Brothers' purposes. Placing the tripod and camera firmly upon the uneven floor, they examined the scene.

Before them was a vaulted chamber, reminiscent of the domed shape of ore-smelting furnaces, called 'cupolas'. This term was used to name the chamber as the 'Cupola Cavern', although nowadays it has been changed to the 'Crystallised Cavern' in one more attempt to appeal to tourists.

An old chandelier hung from a pulley in the roof, covered with the burnt-down stubs of candles.[41] In the tourist season, this would be hoisted above the glittering calcite crystals. Underfoot, uncleared boulders lay strewn about, while the wall ran with wavering curtains of flowstone.

Brothers was using a stereoscopic camera. This had two lenses, each making a separate exposure alongside the other onto the same plate. Since each lens took a slightly different view, being separated from each other by a few inches, they could be made to match the different images normally formed by each human eye. It is this difference that the brain detects and uses to interpret distance and depth. When the print was made, it was placed in a special viewer that only allowed one picture to be seen by each eye, reproducing the result obtained by viewing the original scene. The resulting image appears three-dimensional, and can be incredibly lifelike.

Brothers composed his picture, laid out his magnesium tapers and then prepared his plate. Pouring the collodion from its bottle, he swirled it over the glass until it was well coated and becoming sticky then, with lights extinguished, the sensitizing solution was added. Inserting the plate into the camera, Brothers was ready to make the exposure.

The lens uncapped, one of the triple-stranded tapers of magnesium was lit to the left of the camera. It spluttered into life, casting

 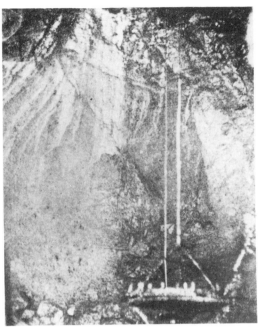

The first cave photograph, taken underground in stereo by Alfred Brothers in 1865, shows a chandelier in the Crystallised Cavern in the Blue John Caverns. The chandelier was subsequently lost, buried under rubble, but, as the modern picture (below) shows, it has now been restored to its old position.

moving, flickering shadows across the flowstone draperies on the wall.

The mine being brilliantly illuminated, a first rate negative was anticipated. The exposure was continued for five minutes, and the negative was then developed; unfortunately, however, it was found to be fogged, owing, as it was found on careful examination, to the difference in the temperature of the mine (which lay 300 to 400 feet below the surface) to that of the atmosphere, having caused a damp film to settle on the lens. It was unfortunate that this had been overlooked.[39]

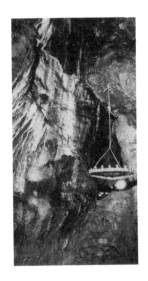

Evidently, Brothers had not allowed his lenses to settle at the same temperature as the cave, which was warmer than that of the cold winter weather outside. However, this theory cannot account for the mistiness obscuring the left side of each picture. Since the two halves of the stereo pair were made by different lenses, it would be unlikely to find that warm air condensing on the cold glass had created similar effects on each. What is more probable is that the lens was obscured by condensation in the air coming from Brothers' breath (or that of his companions) during the long exposure time, or from the encroaching fumes of the slowly burning magnesium tapers. In any case, due to the dense smoke formed 'by the burning of wire necessary for an exposure of so lengthened a period',[39] it was impossible to see across the chamber

or to expose a second plate, and the party was forced to return to the surface.

Less than a week later, Brothers showed the resulting print to fellow members of the Literary and Philosophical Society at their monthly meeting. While the quality of the picture was not all it could have been, due to the humid, smoke-filled atmosphere, they noted that Brothers had '. . . proved that the attempt was perfectly successful'.[39] Having demonstrated that magnesium did indeed have the power to produce such a picture, Brothers considered that the experiment was concluded.

Very little publicity was attached to the event outside the society, and initially it was only Brothers' fellow members, and local people that he may have known via his city-centre business, that knew of it. The Magnesium Metal Company's manager would probably have used the photograph for advertising had he felt it was to the company's advantage, but the quality may have dissuaded him. With representatives present at the caverns they were certainly conversant with the attempt. It was only slowly, via a brief report in the *British Journal of Photography*[39] and word of mouth, that news spread to the other local societies and eventually caught the attention of the Manchester Geological Society's members.

Between them, they decided to attempt an underground photograph of their own. Among the society members were Thomas Livesey, and his relative W.C. Livesey who lived and worked just outside Walsall at the Bradford Colliery in Bentley.[42] With the help that Livesey could give in arranging a visit, the mine was chosen in preference to any others closer to hand.

Another member of the Geological Society was an Oldham-based professional photographer, Henry Jackson. The obvious choice for photographer, he was also elected the leader. In March 1865 Jackson, his brother, and W.C. Livesey descended the pit, miners helping them carry the cumbersome camera and chemicals.

At the working face Jackson erected the tripod in an area with little more than 4 ft of headroom. Movement was difficult in the cramped confinement of the hand-hewn passage and, when the magnesium was lit, fumes swirled about the miners as they laboured with fans to disperse the smoke. Each exposure was continued for a choking, unpleasant six to seven minutes.[43] After four plates had been taken, everybody was thankful to leave.

Due to the density of smoke in the air the quality of the pictures was poor, although they were exhibited to the fellow members of the society on 28 March 1865.[42] Again, just as with Brothers' picture, publicity was slight and further underground photography was not contemplated.

Brothers had taken the first underground picture using magnesium as a light source, and the world's first cave photograph; now,

Jackson had produced the first mining picture. The general public, with little or no interest in the subject of caves or mines, neither knew of the photographs nor would have been very excited if they had. The results remained of interest only to those involved and their fellow photographers. As to the public, Nadar had captured their imagination with his gruesome bones, skulls and the novelty of underground pictures. By comparison, the pictures that both Brothers and Jackson produced were rather boring. Yet, while neither man sought nor gained acclaim, Charles Piazzi Smyth possessed different motives and was by now hard at work in Egypt.

Smyth arrived in Alexandria early in December 1864, and spent his first weeks in the country haggling with customs and government officials until he obtained permission to investigate the pyramids. Alexandria was ruinously expensive – the cotton boom begun by the American Civil War[24] and the near-completion of the Suez Canal made prices even higher than they would otherwise have been. Inflation was rampant. Smyth went first to Alexandria, then to Cairo. It took a month to obtain what he wanted: the documents granting him access, and a few native helpers, paid for by the government. By 8 January 1865 his party was at Giza. The first surface pictures were taken on 5 February using Smyth's dry plates, commercially produced by the Dr Hill Norris Co. The quality was poor and exposures at midday took some four minutes using an aperture of f20, even in the scorching sunlight.

In April, Smyth finally turned his attention to the interior of the Great Pyramid at Giza. Here was one of his major objectives, to find proof that would enable him to substantiate claims for divine influences creating the inch. But Smyth was working to a carefully constructed and fixed schedule, and only had a little time left before he was due to depart for Scotland.

Photographing the King's Coffer in the King's Chamber was the first objective. Smyth was accomplished enough with a camera, but was unfamiliar with magnesium. He had a huge quantity of the metal with him, probably supplied either at a nominal rate or free, for he had previously burned it without concern, demonstrating the light on board boat to help relieve the monotony of the journey. Since his arrival he had burned it within the pyramids, and by March had already found some of its advantages over the more usual wax candles used by tourists. He soon wrote of his experiences to John Spiller of the Royal Arsenal Chemical Department at Woolwich:[44]

There come parties – often many parties – of visitors to see the Pyramid every day without fail, and they come amply provided, too, with all sorts of means and appliances to enjoy the sight, i.e., with everything but the needful magnesium wire; and one

waistcoat-pocket full of that would be worth a whole donkey-load of what they do bring.[45]

But, while Smyth was obviously enthusiastic about the use of magnesium, how much would he need to expose his plates correctly? At what distance should he use it, at what angle? Brothers' experiments in the studio, which Smyth would have known about, were under ideal and carefully controlled conditions – a far cry from Egyptian desert heat and the dry, dust-laden air of the pyramids. Of the underground attempts in England he knew nothing, for both had taken place since his departure. Nevertheless, he believed the pictures were perfectly feasible and, laying aside the work needed to finish his other projects, he gathered his cameras and measuring rods and set off across the sand with his wife and Egyptian porters. It was 17 April 1865.

When the party drew near the pyramid they saw, to their dismay, the whole area swarming with tourists. Photography in the cramped inner chamber, interrupted by the bustle and noise of the sightseers, would be impossible. Thwarted, Smyth withdrew in disappointment.

On the next morning our party was organised again; and with my wife in the company we started at 6 a.m. hoping now to have all the interior of the Pyramid to ourselves . . . We placed measuring bars around the coffer to give, at first, its outside proportions. Then erected the camera and operating box at the other end of the room; poured out all the solutions; appointed who was to appear in the picture, and who was to light the magnesium wire when the nick of time came, enjoined sombre silence and the utmost quiet on all of them, lest they should raise the fine dust; looked again into the cameras to see that they were both nicely focussed and truly directed; and then stepping carefully lest I should break my own rules, began to pour the collodion on to the first glass plate that had ever been prepared for photography within the Great Pyramid.[46]

Clearly, even though he could have prepared his plates at the camp and kept them safely in his ebonite camera backs, Smyth intended to process the negatives on the spot so that he could immediately benefit from the results of the experiment. The first exposure was made using a bundle of wire in the form of a taper, exactly as Brothers had done, setting fire to it with an alcohol burner. The sixty grains (about four grammes) of magnesium was too little, the negative being poorly defined. Smyth increased the quantity of magnesium to 100 grains, then to 120 grains, but instead of making the negative denser, it got fainter and fainter.

Smoke from the magnesium was filling the chamber, obscuring

the light. Ether and oil fumes from the collodion and dimly flickering lamps, white ash falling from the smoke-laden air, all combined to make the room a miserable place. That day, Smyth persevered for a total of five hours in order to find the right balance of magnesium for his photographs, before giving in to the choking atmosphere. Every single exposure was a total failure.

Undeterred, he tried again the next day, and for the rest of the week, to find a way of burning the magnesium quickly enough to prevent the fumes from encroaching into the picture. Eventually, he was using great bundles of the wire. Burning sparks from his 'magnesium fountain lights'[47] rained upon the floor, as at last Smyth produced a usable image. Finally, his plates showed measuring rods and coffer standing out in the darkness, clearly delineated on his minuscule negatives. It was his last scheduled week in Egypt.

> The interior of the Great Pyramid did not prove a good space for developing the excellences of the magnesium light. The ventilating passages opened by Colonel Howard Vyse in 1837 have been completely stopped up with stones and sand by the Arabs. Hence the air in the interior of the Pyramid has no visible means of being changed or purified; and as the said interior is visited every day through six months in the year by numerous parties of visitors bearing candles, the oxygen is so deficient, and the carbonic acid so abundant, that my surprise is that the magnesium burnt at all.
>
> It did burn, but in a languid sort of way, and the smoke it threw off remained suspended in the motionless air for twenty hours or more, so that only one picture could be taken in twenty-four hours. If a second was attempted the illuminated smoky air intervening between the camera and the object desired to be pictured was the only result on the photographic plate.[30]

As well as measuring rods being used for scale alongside the coffer, Smyth attempted to use people. Jessie, his wife, appears on one of the underground plates he made, Smyth also ordering some of the Arabs to squat beside the sarcophagus. It was a mistake. In the unpleasant surroundings, able to understand little of what was required of them, the Egyptians would not remain still. After the first taper had burned down they believed the picture was finished and would get up and walk off, ignoring Smyth's pleas. The photograph being unrepeatable for another twenty-four hours due to the smoke, he was powerless. The negatives showed ghostly outlines of the Arabs, harsh rock visible through their clothes.

The ghost-like figures of the Arabs might as well have been

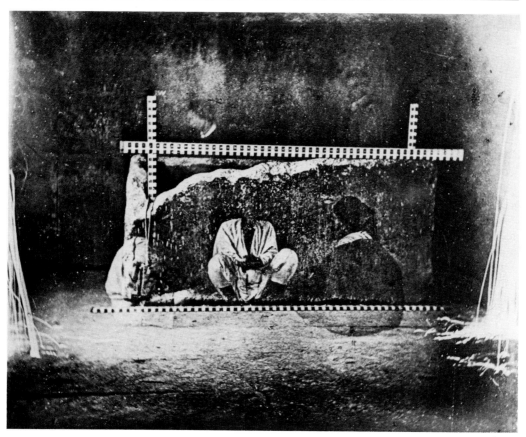

Inside the Great Pyramid, Giza. Smyth's picture shows the ghost figures of two Arabs and his wife, Jessica, in the background. At each side magnesium flares trail burning sparks on the ground.

omitted, for with their black unphotographiable faces they make very bad ghosts; and besides the modern Arabs of Egypt are so ephemeral occupiers of the soil, that they have no right to any place amongst the more ancient monuments of Egypt . . . [They are] profane and adulterous.[47]

Clearly, Smyth found the circumstances surrounding the whole attempt exceedingly trying. The Arabs, whom he regarded as heathens and not worth bothering with more than he was forced to, just added to his magnesium smoke problems. Despite his long hours of perseverance Smyth only succeeded in producing a few underground plates during this final week. Only four prints survive today. By 29 April he was packing for his return, with twelve boxes of negatives amounting to 166 surface views crated for shipment. Waiting for his boat in Alexandria on 10 May 1865, Smyth sent his first communication about the results of his underground photography to William Mather of the Magnesium Metal Company.

Dear Sir,

– I have the pleasure now of giving you the earliest information . . . of the successful taking of photographs under the Great Pyramid by aid of the light produced when burning the magnesium wire you took so much interest in supplying me with last November.

. . . the powers of that brilliantly burning metal were such as to enable me to secure some very fair negatives of several features of interest in the Grand Gallery and Queen's Chamber, as well as in the King's Chamber. In the latter, the celebrated "coffer" was photographed from a variety of positions . . . Every subject having been simultaneously photographed in duplicates by two cameras, the full means will be afforded, I trust, with the aid of the stereoscope . . . to form a good idea of the proportions and size of that remarkable vessel. At all events, if they do now by such means get a true and satisfactory notion of it, let them thank magnesium and the wholesale manufacturers thereof.

Mather made immediate use of the letter, and it was henceforth published in both *The British Journal of Photography*[48] and *The Photographic News*.[49]

On his arrival back in Britain, Smyth was greeted with mixed reactions. Departing, he had been mocked and jeered, but now the fickle public was avid to hear of his adventure. Once his pictures had been printed, disseminated and seen, photographers hailed him as a genius. Reports appeared in every photographic publication and journal. Lectures were delivered. James Nasmyth, inventor of the steam hammer and a member of Manchester's Literary and Philosophical Society, wrote to Smyth with his congratulations.

My dear friend Sidebotham has told me of the magnesium light inside the King's Chamber! What a scene it must have been to see the most ancient of man's great works brought again to light by the most modern of his scientific aids. Photography and Light-par-magnesium, both well worthy of the place & occasion![50]

The size of Smyth's plates was very unusual for the time. To make prints from small negatives – they were only 1 in square – an enlarger was needed to project the image onto sensitized paper. This procedure was normally used only if a large print was required as a reference for painting. In the 1860s it was much more usual to contact print, producing a print the same size as the plate. Sometimes 20 in × 16 in sheets of glass had to be carried and exposed in huge cameras to get large prints. The larger the

required print, the larger the plate, and the larger the camera. Yet Smyth lost little by using his miniature negatives; the quality of the photographs was astounding. When they were turned into lantern slides, by contacting them onto another glass slide, they could be used in limelight or acetylene projectors, and every detail examined. One of the members of the Edinburgh Photographic Society wrote that:

> They were all magnified by the limelight and lantern on the screen up to about fourteen feet square; in some instances they were the size of life, and in others larger. The wonderful delicacy, beauty, and sharpness of these pictures have never before been equalled . . .[51]

The subject proved to be so popular that Smyth eventually had to stop using his original set of slides, since they began to suffer from the frequent 'roastings' they received in the projector.[52]

The photographic community and the public were obviously highly impressed, not only with the quality that Smyth had produced but also with the fact that pictures had been made underground without the benefit of sunlight. Using magnesium was far preferable to electricity and allowed freedom of movement without an arc light's batteries and cables. In Manchester, the Magnesium Metal Company exhibited thirty of Smyth's pictures, hoping to benefit from the advertising. Lecture tours started, although it was not initially Smyth that gave them but a friend, John Nicol.[32] Smyth himself was preparing his first book, *Life and Work at the Great Pyramid*.[52] Lecture proceeds often went to charity. Across the country, the wave of interest Nadar had produced in his native Paris was now being repeated for Smyth on a similar scale. The Egyptian pictures and the subject of mystic pyramidology became the main item of discussion in many a soirée or society meeting.

'Why', William White plaintively asked in September 1865, 'may we not have photographs of caves, catacombs, crypts, mines, and of every dark and wonderful cavity?'[30] The thirty-fifth annual meeting of the British Association listened attentively. Why not indeed? It was a grand affair, running for a full week at various venues throughout Birmingham, packed with lectures and demonstrations. White, from Putney in Surrey, was speaking on 'The Employment Of The Magnesium Light In Photography', and was using Smyth's underground pictures to illustrate the points he made. Other experiments of the same nature, he noted, were being attempted in the Catacombs of Rome.[53] Brothers' underground picture was not mentioned, although some of his portraits were exhibited elsewhere during the conference. Mellor and Sonstadt must have been pleased at the advertising and publicity

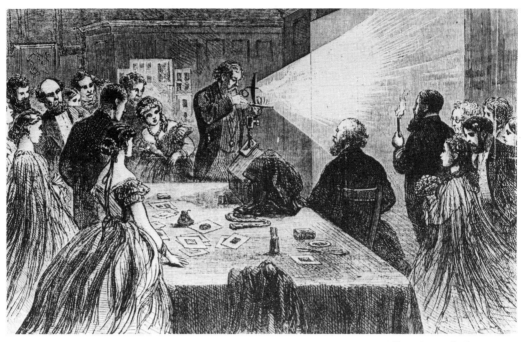

Magnesium was freely demonstrated at soirées held during the course of the British Association meeting in Birmingham, September 1865.

gained for their product by White, who went on to summarize what was known concerning magnesium.

White's published paper covered every aspect of burning magnesium, including the forms of lamp available. Mather and Platt's simple thumb-wheel lamp had been superseded by an improved manual version patented by F.W. Hart. J. Solomon and Alonzo G. Grant, an American at that time residing at Worksworth in England, had patented a clockwork version in 1864.[54] Instead of the wire being pushed forwards by hand, the clockwork motor advanced it into a reflector, where it was burned. A glass cover could be fitted when necessary to protect the flame from wind, or the reflector changed for a white disc when a more diffuse light was needed. With improvements in magnesium manufacture the strands of metal were less likely to break during use, but the lamp could nevertheless use two or more ribbons or wires at once and had been operated in this way 'for two hours without cessation'.[30] Brothers' own version was very simple, being little more than a tin dish with a funnel to carry away fumes, but one patent by a Mr Aldis used compressed hydrogen and oxygen gas outlets at the point of ignition as well as a variety of attachments.[55]

Aldis' design was far too complex, and it was Grant's that became virtually the standard which was used for several decades. He publicized his subsequent improvements and manufacture of the machine,[56] and found that it sold well even though the cost of

An early thumb-wheel magnesium wire burner. A reel of wire or ribbon was held on the spool on the left, and fed through to the reflector by pushing on the thumb grip in the centre.

magnesium was still high. Grant intended to present a paper to the British Association alongside White's, but 'circumstances prevented him from reaching Birmingham in time to get this accomplished'.[57] Nevertheless, a few days later, his paper was published in the photographic press. This detailed his latest experiments, conducted during August in the Mill Close Mine near Matlock, Derbyshire.

The mine had been worked intermittently since before 1720, lying abandoned for much of the first half of the century. Then, in 1859, a Mr Wass began operations again, installing a new pumping engine the following year and bringing out his first ore in 1861. Access being relatively easy, Grant used his lamp to photograph the working face of the mine, his picture showing a drill projecting from a hole bored ready to accept an explosive charge. He used a Lerebour portrait lens on a half plate camera, his lamp with two strands of ribbon giving an exposure of one minute.

> Although there was a considerable quantity of smoke present, owing to the blasting operations which were going on in various parts of the mine, I could not perceive that it had any effect when the magnesium lamp was burning . . . The miners were much interested in seeing by what means I was going to take a photograph of a place so far removed from the light of day, and their astonishment was great when they saw the magnesium lamp burning. They were not slow to express their disgust at the feeble light emitted by the halfpenny candles which are stuck into a lump of soft clay and carried about by each man . . .[58]

Several photographs were taken '. . . showing the end of two pipe-veins now yielding an amount of lead per week value £250. The [photographic] cards show a surface of about four by six feet of the richest part of the vein', he wrote on 15 August 1865.[59] Even with the poor reflectivity of the dark rock found in the area, his magnesium light pictures were considered 'as perfect in photography as could have been produced by bright sunlight' by the editor of *The Photographic News*.[59] They were the first pictures of their type, showing as they did details of a metal mine.[60]

By September 1865 magnesium ribbon as well as wire was readily available across the country, but the price of using it was high. Cost factors prevented potentially valuable experiments from being performed. Magnesium was still very new and little understood by the layman. Being shiny, it was thought it might make interesting jewellery and experiments in soldering it were made. Others applied for permission to use it for street lighting. During soirées the ribbon was lit as a novelty. Serious lectures on its properties were given to the public. On one occasion at the Plymouth Mechanics Institute J.N. Hearder connected bars of

Solomon and Grant's magnesium ribbon burner. A clockwork motor (A) carried magnesium through a tube (B) into the centre of the reflector at the same rate as it burned. Ash fell into the dish at the bottom (C). By pressing the lever (D) the magnesium stopped moving, thereby extinguishing the flame. The basic design of this lamp was used for over thirty years.

magnesium to a battery. Due to the expense involved, he had not tried the possibly lethal experiment before, and concluded that it possessed 'much scientific interest' after he and his audience had lived through the ensuing detonation.[61] However, photography was the major use for magnesium and, partly due to the publicity accorded by Smyth's pictures, it captured the imagination of the general public.

Having seen the potential for artificial light in photography, some photographers tried their best to find a substitute which would be as good, but cheaper. In October 1865 James Wilkinson of Chelsea, London, produced what he hoped would be a rival light made by mixing phosphorus and nitrate of potash. Heaping a quarter of a pound of the chemicals in his garden one night, he set fire to them and was delighted when they burned for over six minutes with a cost of 'a fraction over fourpence'. The fire brigade was not so impressed, and they 'hurried their engines to the spot. On finding no trace of the fire they returned rather chagrined'.[62]

Unfortunately for experimenters such as Wilkinson, and Moule with his photogen, chemical fires were not the way forward. However, for cost considerations alone a good reason had to be found before the use of magnesium could be seriously considered. For the next underground photograph, this was supplied by the Prince and Princess of Wales.

During the summer of 1865, the royal couple visited the Botallack tin mine near St Just in Cornwall,[63] and 'boldly descended to its lowermost depths [and] have also thrown a halo of celebrity round it [the mine] by performing a feat which, to many, is more interesting than its natural and artificial features'.[64]

For royalty to accomplish such a visit in passages which, at that time, extended nearly a third of a mile out under the ocean, was evidently a thing to be wondered at. Many photographs were taken on the surface before they entered the shaft, but none underground. Here was the ideal commercial opportunity. Pictures showing scenes that the prince and princess had inspected would be sure to sell well. William Elliot Debenham, with photographic studios in Regent Street and Haversack Hill, London,[65] took his opportunity in November 1865 and travelled to Cornwall.

Debenham managed to produce two photographs out of the many more that he attempted. Both were on 9 in × 7 in wet plates, and showed a cavern with the roof supported by a pillar of stone. A posed group of miners stood in the foreground, with instructions to stay very still lest they blurred the negative during the long exposure. As it was,

The vapour from the magnesium wire, burnt in recesses at both sides, curls along the roof in fleecy clouds, giving a weird-like appearance to the whole scene . . .[64]

The Royal visit to Botallack in the summer of 1865 was well attended by photographers and the press.

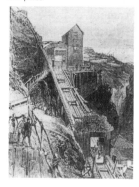

About half an ounce of magnesium was used, cut into about fifty lengths. A contemporary report stated that these were burned together without the use of either a reflector or a lamp, although Debenham later stated that he tied the ends together to aid lighting it and pressed the ribbon into a lump of clay stuck onto a piece of tin to act as a crude reflector.[66]

Although Debenham was evidently successful with his pictures, it was Smyth that captured the public's main interest. But, despite the novelty of his photographs, the scientific community continued to shun his work. Smyth was rejected from Royal Society publications,[24] and never received any official recognition for his work. This was due partly to his increasing religious fervour, and partly to his unacceptable theories concerning the pyramids. He had several academic encounters with his colleagues, among them Sir James Simpson, who stated that Smyth's 'logic was most wretched'. On another occasion Simpson mockingly 'proved' in a lecture that the brim of his hat was 'one 20 millionth of the Earth's polar axis', to Smyth's annoyance. The culmination of this and many other similar disagreements was Smyth's resignation from the Royal Society of London in 1874.

Smyth began to publish his work on the pyramids himself, hitting back at those colleagues and societies he perceived to be his enemies. He steadily lost friends over the succeeding years, although he continued to produce valuable scientific papers concerning astronomy. Even his closest companions, Nasmyth and Sidebotham, drew away and shunned him. When he died at Ripon near York in 1900, Smyth was buried beneath a tombstone shaped like a pyramid. His final wish of being interred with a camera strong enough to survive until Judgement Day, so that he could photograph the arising of souls, was ignored.[67]

Smyth left behind a legacy in his Egyptian photographs which would otherwise have remained almost unrecorded. Sadly, though, the original negatives of the King's Chamber were lost after being lent to Sidebotham for copying to use on lantern slide evenings.[24] Much of Smyth's learned work was eventually upheld, although not that concerning the metre and inch controversy. His camera design was ahead of its time; it would be many years before true miniaturization of cameras became common, for with the wet collodion process there was little incentive to produce minute apparatus when bulky bottles still had to be carried.

However, Smyth saw the effects of the publicity he had granted to the new metal, magnesium. The Magnesium Metal Company made all the use it could of his photographs in exhibitions advertising the power of the light he had used, and it became acknowledged as the premier artificial light source.

At the beginning of February 1865, Grant's lamp cost about 15s. an hour to operate. By the end of 1866 the price of magnesium was

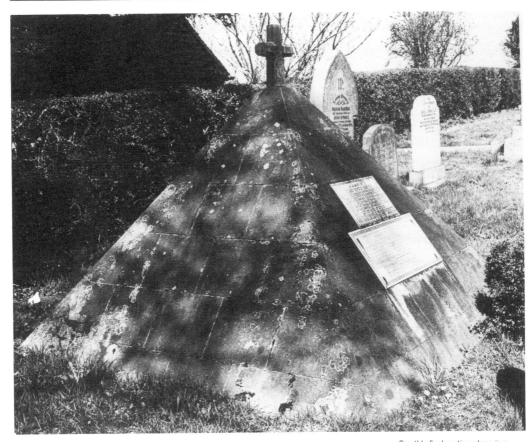

Smyth's final resting place is a churchyard near Ripon, a pyramid for his tombstone. His last wish, to be buried with a camera so that he could photograph Judgement Day, was ignored.

plunging as more and more customers bought it and production levels rose. Instead of £6 a pound the price became 12s., from 3d. a foot to under 1d. a foot for the ribbon.[68] With prices fluctuating wildly it became common practice for the photographic journals to try and predict the value of the metal for the following week or month, not always with much accuracy. However, the price to be paid in the shops for usable amounts when compared to a normal wage was still incredibly high, and there had to be a good reason for burning metal at even 12s. a pound when, for comparison, silver cost 5s. an ounce. Some of these uses lay outside the field of photography.

Both the government and independent mining concerns were becoming interested in magnesium for their own purposes. For example, a Capt. Bamber RN was busy producing his version of a magnesium lamp with a 'bulls eye' lens on the front, with the intention of using it to illuminate mines, tunnels and railways. Enclosed in an 18 in long mahogany box, magnesium wire was

wound off a roll by a series of clockwork-driven small wheels 'much resembling those of a musical box'.[30] A public demonstration at Paddington railway station in London showed that 'though the thinnest ribbon manufactured was used, the time was easily read off a watch at the distance of 250 yards'.[30] Since magnesium was found not to alter colours, silk merchants began to burn it to determine shades of material when working at night.[30]

By September 1865 a Capt. Bolton was also involved with magnesium and its uses.[30] He had already developed a limelight signalling device in 1862 which was in use by the navy, and had begun to use magnesium powder in signal lamps to indicate port and starboard sides during foggy weather. Following suggestions from the Mercantile Marine Association of Liverpool for a red light to indicate danger, Bolton joined forces with a Capt. Colomb and produced magnesium mixed with chemicals to produce this effect, at a cost of 1s. 6d. for fifteen minutes of light. Safety rockets were made with powdered magnesium, and fireworks became a popular spin-off from the new chemical technology. Across Europe, experiments began in using the metal in lighthouses, and in coastal and marine signals.[69] The lights produced were bright enough to be seen twenty-six miles away. Overall, however, it was with photography that the best uses for magnesium remained, building on the foundations laid by Brothers and Smyth.

CHAPTER THREE

Mammoth Cave

You will agree with me that photographing in a cave is photographing under the worst conditions.

Charles Waldack, 1866.[1]

Following the photographic successes that magnesium had permitted in Britain, it was inevitable that manufacture of the metal would soon spread abroad. By the close of 1865 the American Magnesium Company began production in its Boston-based factory, and, as reported in *The Photographic News*, much was expected of the Americans who used it:

> . . . from the men of Massachusetts, who are said as babies to lie awake and scheme improvements and patents in the construction of cradles, we are likely to hear of some novel applications of the metal.[2]

Certainly, compared with Britain, the market was immense. Photographic studios in New York alone easily outnumbered those in the whole of England, and the Magnesium Company's proprietors hoped that trade would be brisk. Boston theatres soon replaced limelight with magnesium, burned in a clockwork lamp which itself cost $100. The inventor was overwhelmed with orders. 'How Americans delight in what is good and new!' said one journal.[3] However, at the colossal price of $6.50 for tapers[4] of magnesium ribbon or wire wound with soft iron wire (used to hold the magnesium together), sales began slowly and only those with a specific interest in the metal bought any of these flares. In addition, much of the country was in no condition to buy anything of such a luxurious nature.

The whole of North America was in a state of flux. State lines in the 'wild' west were flexible and ill defined, with most of the population living on the eastern seaboard. The north-eastern states took the majority of immigrants entering the country, and

with cheap labour and resources available the north developed many of the industries.

Lines of communication had been expanding, with new roads and railways being developed, when in 1861 the issue of slavery plunged the continent into civil war. For the next three years the Yankees fought the Confederates, until the demoralized south surrendered in May 1864. Slaves were set free, yet they had nowhere to go and their future was uncertain. The southern Confederate states were bankrupt; paper money blew untouched in the dirt streets and many banks closed their doors in the face of hostile clients.[5]

The north still had its resources, manpower and capital, but this was of little help to the devastated southern farmers who found their fields untended as ex-slaves deserted them. The price of food and raw materials soared – cotton was $125 a bale (partly the cause of Smyth's delay in Cairo) – and many a family starved. President Lincoln was shot in the back of the head in 1865. The Confederate states could barely afford food, while the affluent northern Yankees were able to consider burning magnesium to illuminate huge areas of night sky, in order to catch blockade runners.[6] After the fighting had ceased, the citizens of many southern towns were left to look around themselves and count the cost of the war, and wonder if their lives would ever be the same again.

Kentucky was a border state trapped between the Yankee north and Confederate south and, while its inhabitants kept slaves, they had attempted to compromise with both sides in the war. The state of neutrality did not last, and both open and guerrilla warfare broke out. When hostilities ceased, Kentucky was left with ruined industries and plundered farmlands. Most hotels and businesses had been commandeered by one side or the other. The area around the celebrated Mammoth Cave was no exception. The Cave Hotel, just outside the entrance, had itself been sacked by Johnny Morgan, a rebel guerrilla. Although a slave owner, the landlord of the hotel had Yankee affiliations and was considered fair game for the southerners to attack. After hostilities had finished, the tourist business was almost non-existent, and the Cave Hotel was desperate for custom.

Mammoth Cave was first known to eighteenth-century settlers along the Green River by the name of Flatt's Cave, when it was mined for saltpetre to make gunpowder. The first reference to the name 'Mammoth Cave' occurred in 1810, shortly after which mining of saltpetre reached massive levels to supply the American cannons of the 1812 war against Britain. Parts of the cave were henceforth progressively explored until the outbreak of the Civil War, but maps of both the cave and the surrounding area were poor and the roads rough. The railroad reached no nearer than the closest town, Cave City, ten miles distant.

There had been many changes in the ownership of the cave during the years since its discovery; in 1866 the manager was Larkin J. Proctor of Maysville, Kentucky. He obviously had a difficult task ahead of him in the post-war depression; money was scarce, and business was poor. Few travellers made the effort of coming by stage-coach to the hotel, and Proctor's income from overnight stays was low. Some form of advertising was required, capital had to be raised, and perhaps then the hoped-for tourists would return to the area.

Photography was the key to the problem. If pictures could be produced there was the possibility of selling the views, and also obtaining free advertising when the photographs were shown to friends far afield. What better way of informing the public of the delights of the cave than to sell them the information? Such advertisements were common in this age of stereo cards, where details of the site could be printed on the reverse. However, for underground photography to take place a suitable light source was needed.

Knowledge of artificial lighting techniques for photographic purposes away from the studio was, in general, even worse in America than Europe. However, it is possible that attempts to take photographs at Mammoth Cave had been made before 1866;[7] magnesium was available following the Civil War, when the Boston Magnesium Company began production, and limelight was used by guides to illuminate a chamber in the cave, Gorin's Dome, as early as 1850.[8] Collodion plates were insensitive to limelight, and magnesium supplies were both insufficient and ruinously expensive. There is no evidence that William Crookes' 1859 suggestion of burning phosphorus in jars of oxygen ever took place.[9]

Although there was obviously some interest in the idea of photographing Mammoth Cave, Larkin Proctor had no evidence to show that such a project could succeed. Brothers' success was unknown in Kentucky; it was barely publicized in Britain. A single photograph was reputedly taken before this time, that of a wedding ceremony in Howe's Cave in 1854,[10] but it is technically too good to have been taken by limelight or Bengal light (the only form of illumination available at that time), and must have been produced later. Essentially, then, Proctor may have witnessed attempts to photograph the cave, but had no personal knowledge of how to produce the required product. The idea was certainly a speculative venture requiring a lot of capital and a successful outcome was not guaranteed.

Larkin Proctor had a nephew, John R. Proctor,[11] who in 1866 was working as a clerk in Cincinnati. While there he befriended a bookkeeper, John H. O'Shaughnessy, a resident of the city. Either these two men approached the manager of the Cave Hotel with the idea of photography or Larkin suggested it to them. However the

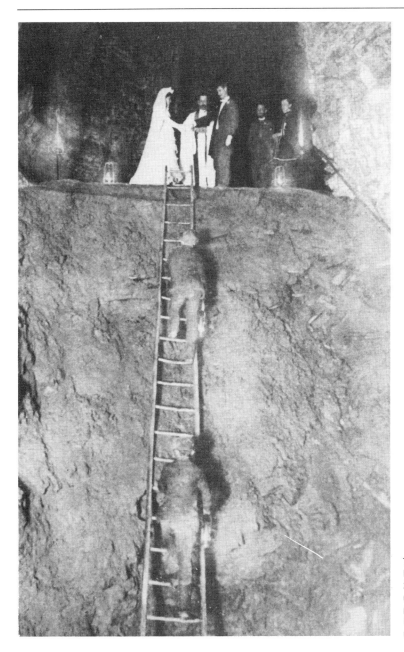

The wedding of Elgiva Howe and H.S. Dewey took place on 27 September 1854, the first of many in Howe's Cave. This photograph, supposedly showing Elgiva's marriage, was taken much later.

decision was finally made, John Proctor and John O'Shaughnessy became partners when they secured the photographic rights to Mammoth Cave, the agreement to run for five years. With a new political climate and changing conditions in the country, money could be made with enterprising schemes such as this, even allowing for the attendant risks.

The two men had one major difficulty that prevented them from immediately taking their pictures: they lacked experience when it came to using a camera. Proctor and O'Shaughnessy therefore approached Charles L. Waldack, a 35-year-old 'photographic chemist' in Cincinnati.[12]

Waldack, a Belgian immigrant, was a respected member of the community and experienced at his trade but, like everybody else at the time, he had limited practical knowledge of magnesium as used for artificial light. However, while supplies of the metal from the American Magnesium Company were still expensive and scarce, he was well acquainted with its properties through the photographic journals, and he had used small quantities in his studio:

> Ever since the introduction of the magnesium light as a photo-graphic agent, it has been one of my pet projects to test its capabilities as such in the celebrated Mammoth Cave. A short time ago the opportunity presented itself to me to do so. Two gentlemen, who had secured the exclusive right to make photo-graphs in the cave, applied to me to make a number of negatives of the principal objects of interest to be found there.
>
> As my experience with the magnesium light was very limited, having only made a few portraits by its means, I proposed to these gentlemen that I should make an experimental trip to ascertain what could be done, after which I would contract with them for any number of negatives they should wish.[13]

Accordingly, Waldack prepared for his trip to the cave. For his first photographs he decided to use a pair of 4½ in focal length carte-de-visite lenses on his French stereoscopic camera. He then selected the diaphragm he should use.

The diaphragm controlled the amount of light that was allowed through the lens to expose the plate and could be altered by removing a ring of metal and changing it for one with a different aperture. Outdoors in bright light, for example, a small aperture could be used as this conferred a greater depth of focus. Better quality pictures were also obtained, because lens defects were usually confined to the edge of the glass, which was obscured by the ring. When shorter exposure times were required, or when there was little light available, a large ring was used to admit all the light possible. Clearly, this applied to cave photography, so Waldack chose the largest diaphragm he possessed, of 1⅜ in diameter. This compared to the larger 2 in diameter ring used by Debenham at the Botallack Mine in Cornwall.

Chemicals had to be prepared in the studio ready for later use, as it would be more convenient to mix the collodion and developer before leaving, rather than also taking extra bottles of ingredients.

The collodion solution had to be made and then iodized, so that it would accept the sensitizing silver nitrate solution just before exposure. As can be appreciated, a photographer not only had to know how to take pictures, he needed to be something of a chemist as well:

The collodion was made as follows:

Ether	48 ounces
Alcohol	48 ounces
Helion [gun]cotton	1 ounce

Six ounces of the collodion were iodised with two ounces of the following solution:

Iodide of ammonium	3 ounces
Bromide of cadmium	1 ounce
Alcohol	66 ounces

The silver solution was made with twenty-four ounces of Ohio river water, and 2 ounces of pure nitrate of silver. Half of it only was iodised. It was sunned for a short time, filtered again, and acidulated with one drop of nitric acid.

The developing solution was made as follows:

Sulphate of iron and ammonia	2 ounces
Acetic acid	4 ounces
Water	60 ounces

The hyposulphite solution was one which had been used for fixing prints, and had been concentrated by evaporation.[13]

Finally, everything was checked over and packed. A full set of equipment, including the chemicals and developing dishes, weighed over 120 lb. Many photographers were forced to resort to using a wheelbarrow or wagon for transport, one of the main reasons that few pictures were made in the countryside, and Waldack probably had the aid of his employers in carrying all the boxes and bags.

As he set off, Waldack was confident that he would be successful in producing the required pictures. But would his two employers be pleased with the results? Indeed, would they be able to afford his fees? The cost of the magnesium alone might be so high as to realistically cause the total failure of the venture. He could but perform his tests, and see what the outcome brought.

I started from Cincinnatti [sic] by the 12 o'clock Louisville boat, took the train at 7 a.m. for Cave City, and from there, after three hours' riding in the stage, arrived at the Cave Hotel, within a few hundred yards of the Mammoth Cave.[13]

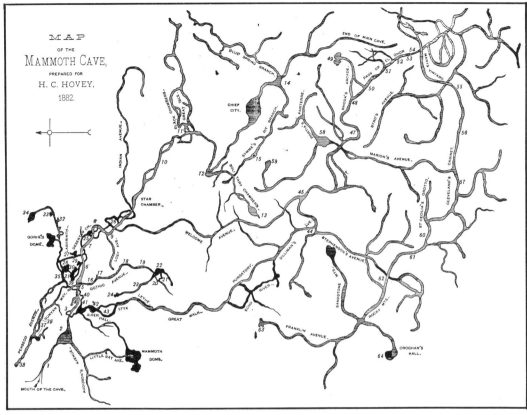

An 1882 map of Mammoth Cave.

His journey by road, rail and water left him tired and hungry. River boats and railways were fairly comfortable compared with the jostling stage-coach ride, surrounded by bulky cameras and delicate glass chemical bottles. At least the journey had been a safe one; further west the Plains Indians were beginning their bloody uprising as settlers invaded their lands and slaughtered their buffalo. Waldack supervised the unloading of his luggage, and with John Proctor and O'Shaughnessy retired to the hotel.

Guided tours through the cave were normally made with a black slave guide, but, with the abolition of slavery, there were few available. Mat and Nick Bransford were the principal guides following the death of the renowned Stephen Bishop in 1857; the two men were unrelated, but being previously owned by Thomas L. Bransford they had taken his name. In their position as guides they were well known in the locality, and indeed, when Mat had his portrait taken at George H. Brown's Daguerrean Saloon in 1863, the event was reported in the *Louisville Journal*.[14]

After the war some of the men that had worked in the cave, including the slaves, stayed in the area and were employed as the

need arose. On this occasion Waldack and his two employers did not intend to venture far into the cave and relied on John Proctor as guide. Mat Bransford aided them on their later excursions.[15]

Tourists were normally dressed in special 'cave costumes', Waldack and his companions being no exception. These were thick, coarse, woollen jackets and overalls with heavy boots to protect both legs and feet, although much of the cave was well-trodden along the 'long' and 'short' routes. Both routes were so named for the length of the tour; for appropriate fees either or both of the journeys could be undertaken.[16]

There was a great deal of confusion about the actual length of passages within the Mammoth system. For example, the explored length of cave was supposed to be over 200 miles. It was common for cave owners throughout the history of the cave to use such false data for advertising and propaganda. Surveys were deliberately kept inaccurate in case they showed the cave extending beyond the confines of the owner's property; rivals might open up their own entrance if they knew where to dig! The truth was that no more than about thirty miles of passage had been explored, although this was enough to make Mammoth Cave the longest known system. The tourist routes covered some ten miles or so. Today, Mammoth Cave, linked as it is with the nearby Flint Ridge system, still holds the record at over 300 miles as the world's longest cave.

Waldack's first objective when he entered the cave was to explore some of the cave passages near the entrance and select the sites he would use for his subsequent photographic attempts.

> The light we had – that of a few lard-oil lamps – was, however, so weak that to make a selection was exceedingly difficult. In the afternoon I began operations. As the object was not so much to make pictures of the most important parts as to test the capabilities of the magnesium light and the quantity of the metal to be used, it was unnecessary to travel very far in the Cave, where, however, the most interesting spots and objects are to be found.[13]

The lights Waldack used, simple wicks in a cup of lard-oil suspended from four wires twisted to form a handle, evidently caused some difficulties, but they sufficed. Once the sites had been selected, the three men left the cave to gather the photographic apparatus.

As well as the usual cameras and chemicals to be carried, there was the additional burden of magnesium. The American Magnesium Company had furnished Waldack with half a pound's weight of magnesium tapers for the venture. There were about 200 in all, each made with two magnesium ribbons and a length of magnesium wire bound together with two twisted strands of iron wire. This was intended to make the magnesium burn more slowly, but

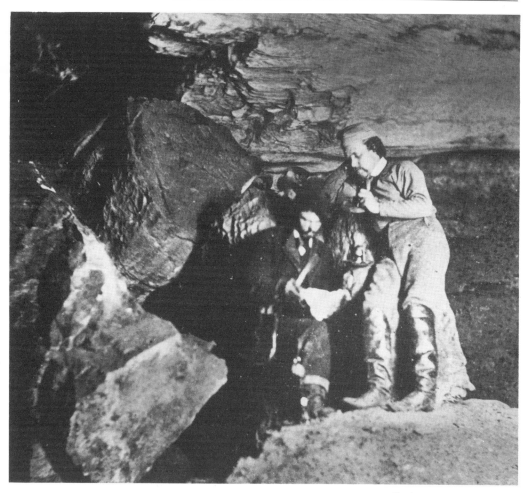

Number twenty-one of Waldack's series of stereos is titled 'Beyond the Bridge of Sighs'. The men are dressed in the standard 'cave costume' issued to visitors at the hotel. The man on the right is carrying one of the lard-oil lamps used by the guides.

with more regularity, than if the ribbons and wire were burned on their own. Waldack had his doubts.

> I was . . . inclined to think that it interfered with the intensity of the light. The intense light of the burning magnesium being caused by the state of white heat to which are brought the small particles of oxide of magnesium which are formed, it may be that the caloric expended on the heating and melting of the iron is so much taken away from the magnesia.[13]

Despite his fears that the heat lost would reduce some of the light output, Waldack nevertheless retained the use of the wire, for he found that without it the magnesium broke as it burned, and fell guttering to the floor.

Waldack had also been provided with several 'so-called

photographic screens or reflectors'.[13] These were made of tin, and had a short spike set into the top part of the concave surface. The taper was hung from the spike and lit so that it burned upwards, light being cast out in a beam by the polished metal behind. Carrying both these reflectors and all the tapers, chemicals and cameras, the three men returned to the cave.

> In the afternoon . . . I began operations in what is called the "Gothic Chamber," situated about one mile and a-half from the entrance. . . The first picture I attempted was of a stalactite, about six feet in diameter in its widest part. I used eight tapers, which were found to be insufficient, and another trial was made with fifteen. These gave a fair negative. A third trial being made with about twenty-five tapers used in two reflectors, I obtained a negative with which I was quite satisfied.
>
> The second subject was a group of stalactites, situated at about sixty feet from the first. Quite a good negative was produced by lighting with about twenty-five tapers.
>
> The success obtained so far made my companions, the gentlemen who employed me, quite enthusiastic and ambitious, and they induced me, somewhat against my judgment [sic], to attempt a large subject. The one we picked out was a large hall in the main Cave, with rocky sides, and large rocks covering the ground. One of these of tremendous size had, when seen from a certain point by the dim light of torches, the appearance of a coffin, and is, for that reason, called the "Giant's Coffin." The resemblance to a coffin is not quite so striking, however, when seen by magnesium light.
> In this place we made two exposures. For the first exposure we used thirty tapers, and obtained only an image of the high lights. The second exposure was made by the light of fifty tapers. This gave us an under-exposed positive. We left the place in disgust, promising ourselves to try again under better conditions.[13]

Despite having already used over half his tapers, Waldack was persuaded to keep on trying in other locations before they left the cave. So far, only one plate had been produced that he felt fully pleased with, the others being underexposed. Further photography seemed pointless until he could have a chance to prepare more suitable equipment, but Proctor and O'Shaughnessy would not hear of it.

> I went on and made five more negatives. One of these would have been excellent as to illumination and exposure if the magnesium had burned all at one time; but I was obliged to apply the light several times, thus giving time to the smoke to collect on the ceiling, and giving to the person who is

One of Waldack's earliest photographs, the 'Deserted Chamber'. Clouds of magnesium smoke from the tapers drift overhead.

represented as coming through a narrow passage the appearance of having his head in a cloud.[13]

Photography under these conditions was far from pleasant. With the extended exposure times and repeated burning of tapers, the person depicted in the picture was forced to remain perfectly still while being enveloped in choking, pungent, magnesium fumes. White ash drifted down over not only him, but everything else, including the camera. No wonder there was rarely a second chance to take a photograph.

With the last of his tapers, Waldack attempted a photograph of the infamous Bottomless Pit, then the group gathered their packs and left the cave. He had used a total of twelve plates, of which four were poor in quality and the remainder usable although not perfect.

However, when the plates were printed, Proctor and O'Shaugh-nessy were delighted, and began arranging for the sale of copies of the stereo views. Copyright laws in the modern sense did not exist, so on 24 June the first action of the newly-formed Mammoth Cave Photographic Company was to register seven of the pictures. To do this a copy of the photograph had to be submitted, or 'entered', in a court registry. This theoretically prevented anybody else from rephotographing the print and selling copies themselves, although theft of pictures by these means remained easy to accomplish and difficult to prevent. Some of the Mammoth stereo cards would, in fact, be copied and sold illegally in later years.[7]

Waldack judged the expedition to be a success; while not many plates had been successfully exposed, he now had the information he needed both to make modifications to his apparatus and to plan future trips. By 8 July he had packed his belongings and returned home. The prints he made were mounted on card; Proctor and O'Shaughnessy would have been able to sell copies to the public the same month. Coincidentally, a government tax on photo-graphs was ending. This had been introduced in 1864 to help funds following the war, and ranged from two cents for stereo cards priced under twenty-five cents, to five cents for those costing a dollar. Payment was made by affixing a stamp. The practice was abandoned at the end of July and few, if any, sales of Waldack's pictures were affected.

On 14 July 1866, soon after the remaining pictures were registered, Waldack wrote an account of his experiences. He sent this, with photographs, to the editor of the leading American photographic journal, the *Philadelphia Photographer*. While Wal-dack remained critical of his own efforts, he took the photographic press by storm. Edward L. Wilson, the editor, was overcome:

We think that, if Daguerre and Niepce were here, they would weep. These pictures now lie before us, and are the *most wonderful* ones we have ever seen. We can scarcely remove our eyes from the instrument, or lay them down to write, for perfect wonder. Oh! is not photography a great power? What else could creep into the bowels of the earth, and bring forth such pictures therefrom, as these? It hardly seems possible. Daguerre never dreamed of it. Five years ago we would have laughed at it; and to-day we can scarcely believe what we see. Great rocks, giant stalactites, wondrous caves within caves are here before us almost as plain as though we were near and in them. If Mr. Waldack modestly considers these mere experiments, we have much to hope for from his next trials.[17]

Wilson's comments were soon repeated on the other side of the Atlantic, where Waldack's intention to return and 'secure from

fifty to a hundred negatives of the magnificent rock and caves and giant stalactites within this mammoth cavern' was noted.[18]

By July, Waldack had indeed been employed to take further pictures, and was busy preparing and modifying his equipment in the light of his experimental visit. The Ross stereo lenses he previously used had proved unsuitable, having too narrow an angle of view. In the cave passages there was frequently little room to step backwards from the subject, preventing Waldack from obtaining a good composition, so instead he chose a pair of Dallmeyer stereo lenses.[1] These had the shorter focal length of 3 in, giving a wide angle of view, and could be used with a larger aperture. This meant that he would not only have more freedom in positioning his camera, but would also be closer to his subject and would not need to burn so much magnesium. Waldack hoped his choice would prove more suitable. In addition, he planned to take a second stereo camera, and a normal one with a single Voigtlander lens.

The camera equipment decided upon, he next turned his attention to collodion.

> I never felt the want of a very sensitive process more than when photographing in the Cave. A more sensitive collodion than the one I used, or a developer which would bring out a picture with a shorter exposure, would have greatly lessened our difficulties. Before starting, I made several samples of collodion according to different formulae, and with different samples of cotton, but did not succeed in obtaining one which was more rapid than . . . [before]. I also tried samples of different makers, all with the same results. This and my previous experience lead me thus to believe that extra sensitive collodion is a delusion.[1]

Forced to use his previous formula, Waldack could do nothing to increase the sensitivity of his plates. His final modifications therefore concerned the reflectors supplied to him by the American Magnesium Company.

Waldack found that light from the reflectors was being thrown out over much too wide an angle. Even with his new wide angle lens, only the centre portion of the light beam was used, much of the magnesium being wasted. Clockwork lamps would not permit enough metal to be burned before clouds of smoke enveloped the scene, so Waldack decided to redesign the old reflectors. Retaining their basic shape and method of construction, the new ones were also concave, but with the sides extending further outwards so as to throw the light in more of a beam. Several were made of differing sizes.

The second expedition to the cave began at the end of July, assistance being given as before by Proctor and O'Shaughnessy,

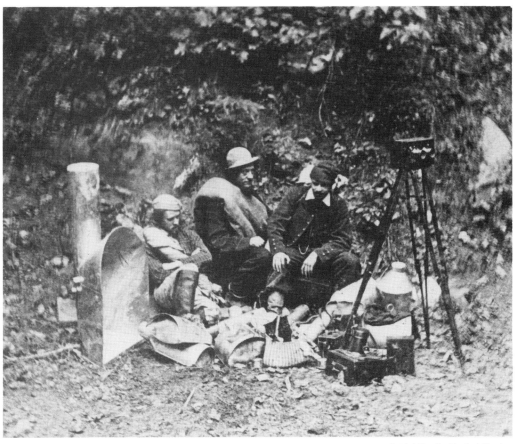

with cave guide Abe Meredith being employed to help. Abe soon earned the nickname 'Man Friday' due to his abilities in route-finding and portering the bulky apparatus. The size of the reflectors that Waldack brought caused some problems, but the largest – a monster, thirty by forty inches at the mouth and referred to as the 'pet' – proved to be the most useful. The smaller ones soon lost their reflectivity when magnesium oxide from the smoke coated their shiny surfaces. A tall tin chimney was fitted to the top to carry the magnesium fumes away for a short distance so they did not occlude the tapers themselves.

Entitled 'Out For The Last Time', this stereo view became number four in Waldack's series. The caption on the reverse of the card states that it shows 'the gentlemen who conceived and executed the project of Photographing the cave, with the reflectors &c., used'. Proctor and O'Shaughnessy are on either side. Waldack's 'pet' reflector and chimney stand on the left.

Our *pet* can be seen represented in the very imperfect stereograph of the *personnel* of the expedition ready to start on a two days' excursion. The great objection to it is its great size, which makes it very inconvenient to carry and drag through such narrow and low places as "Fat Man's Misery" and others.

All lamps and apparatus in which the magnesium is burned slowly, and with more regularity than in the tin screens, are

MAGNESIUM LIGHT VIEWS

IN MAMMOTH CAVE.

Entered according to Act of Congress in the year 1866 by Proctor & O'Shaughnessy in the Clerk's Office of the District Court of the U. S. for the So. Dist. of Ohio.

The entrance to the 'Long Route', a narrow opening through which 'visitors have to stoop almost to the ground'.

useless for Cave photography, for before all the magnesium required is burned, the picture is obscured by the smoke.[1]

Before long, Waldack had settled into a routine of entering the cave, taking his pictures and coming out to rest and replenish his stocks of magnesium and plates. Many of his excursions were long ones over several miles of cave, the party remaining underground for as long as thirty-five hours. A major problem turned out to be the time taken burning the magnesium, which gave the fumes too much of an opportunity to enter his picture. This was solved by removing the iron wire from the tapers; speed had become more important than uniformity of burning.

We have even found it inconvenient . . . to use the tapers twisted with iron wire, which take four or five times as long to burn up as the others, and have to run the risk of part of the magnesium melting and falling to the bottom of the screens for the sake of giving short exposures; even then we could not get rid of the smoke entirely, as will be seen by the fogginess of parts of some of our pictures . . .

Certain parts of the Cave – such as the regions near Lethe and Echo Rivers, the Bottomless Pit, Gorin's and Mammoth Dome, &c. – are very damp; it takes but a short time for the dampness to permeate everything. The dusting-brush makes streaks on the glass; the slides of the plate-holders draw out with difficulty; the back-end of the camera does not obey the rack-and-pinion. Lucky you are if the water does not drop on your lenses, for you can find nothing dry to wipe them with . . .

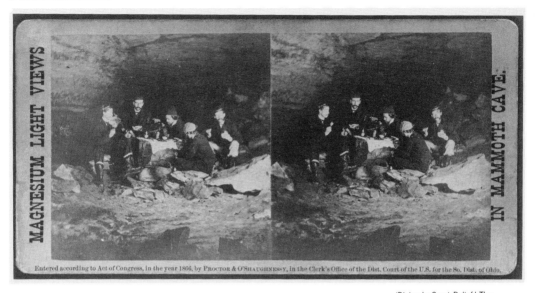

MAGNESIUM LIGHT VIEWS IN MAMMOTH CAVE.

Entered according to Act of Congress, in the year 1866, by PROCTOR & O'SHAUGHNESSY, in the Clerk's Office of the Dist. Court of the U.S. for the So. Dist. of Ohio.

'Dining In Great Relief.' The caption on the back of the stereo card notes that, 'One of the guides is pouring out some of Kentucky's unrivalled beverage, Bourbon Whiskey, for the relief of his companions.' Meals were often eaten in the cave during the longer expeditions.

Working under such conditions proved very troublesome. No means of warming the plate; the whiskey sold at the hotel was so weak that it would not burn. A wood fire could not be made on account of the smoke, and our supply of alcohol was hardly sufficient to set fire to our magnesium. We managed finally to get some alcohol in Cave City. Having no lamp, we were obliged to burn it in a reflector, and dry the brush and warm the plate over it; this plan we adopted after this, even in the dry parts of the Cave.[1]

This pervading moisture greatly hindered progress. Before coating the glass plates with collodion they had to be scrupulously cleaned, otherwise dust and dirt would ruin the image. It was necessary to dry the plate by warming over a flame before the cave dust could be brushed off. Guarding against contamination by water and mud took a great deal of care.

On account of the dampness, and the sand and mud, which, whatever precaution was taken, would get in everywhere, we were obliged to take out, every evening, cameras, plate-holders, and glass boxes; these had to be dried before the fire, and cleaned before starting the next morning. The glass, owing to the difference of temperature in the Cave . . . and outside, would, as soon as it was brought in the warmer medium, condense the moisture of the air, and the small particles of wood and dust coming from the box would stick to it, thus requiring to be cleaned again. To guard to some extent against dampness

and sand, a bag of india-rubber cloth, to hold the cameras and plate-holders, would be useful; the seams should be made tight with india-rubber cement, and the bag closed tightly by means of a string . . .

Our trip over the river is one that I shall always remember. We started at nine in the morning – four of us – . . . all loaded down with cameras, tripod-stands, chemicals, reflectors, and two days' rations. Passing the Giant's Coffin, Bottomless Pit, Scotchman's Trap, Fat Man's Misery, and the Dead Sea, we arrived at Lethe River, which we crossed in the boat. From there, passing over the "Long Walk," which at high water is submerged, we come to Echo River, which is from a half to three-quarters of a mile long. Through this we paddled, and passing to Silliman's Avenue, we came to Ole Bull's Concert Hall, of which we made two negatives; then, entering the rocky "Pass of Elghor," we stopped to make two negatives of "Hanging Rocks," and continued our journey until we reached Martha's Vineyard.

Here we took supper, after which we went to look for a convenient place to pass the night; this we found, half a mile further, in a side avenue, very low at the entrance, but high enough a little further to stand up. We made our beds in the soft sand, and, wrapping ourselves in our blankets, soon went to sleep.

At six in the morning rose for breakfast, and after this went immediately to work . . .

Arrived at the spot of operation, two or three tapers are burned to ascertain the features of the picture; choose the place for the cameras (of which we generally use two), and decide from where the view has to be illuminated. We generally place two-thirds of the lights on the right hand side of the camera, and one-third on the left, or *vice versa*, taking care not to have the reflectors too near it, so as to avoid flatness. Only when we cannot do otherwise do we place them on the same line of sight, and then we try to raise them as high as possible . . . The rule is to have the light as near as possible to the object, without allowing it to come in the field.[1]

Waldack soon found that lights placed too close to the camera produced an uninteresting picture which lacked both relief and shadows, a problem he was conversant with as a portrait photographer. In addition, with the cave air containing so much dust and water droplets, light was reflected straight back into the lens, degrading the overall image. Placing lights well to one side has remained one of the most basic guiding tenets of cave photography to this day.

With the lighting angles and camera position chosen, the camera

was focussed. Waldack equipped each of his helpers with a small lard lamp, and sent them into the picture area. By moving them about he could not only focus on their lights, but also find the confines of the picture to help refine his composition.

Next, the plates for his two cameras were warmed and dried over an alcohol fire burning in a reflector, and then finally cleaned. The collodion could only then be poured over the glass and, when sticky, dipped into the sensitizing solution. Lastly, dark slides were inserted into the cameras and Waldack was free to finish preparation of the magnesium. Tapers were tied together at the top using a thin iron wire which kept them about half an inch apart. The bottoms were tied together, ready for lighting, and the assembly suspended in the reflector.

A rag dipped in alcohol is put in each reflector, and, at a given signal, is set on fire by means of a small piece of sponge also dipped in alcohol. The monster reflector holds from ten to twenty-five tapers; the small ones five to ten. We have used from twenty to one hundred and twenty tapers for one picture; some pictures would, with the means at our disposal, take a pound of magnesium.[1]

The exposure made, amidst clouds of billowing smoke, there still remained the matter of developing and washing the plate. Cave water had to be used, taking care not to damage the soft collodion with sediment; further washing could take place outside the cave. The plates were then stored safely in the packs, and all the equipment was shouldered once again as the men set off for their next location.

[We made] two pictures in Martha's Vineyard, two of the ceiling in "Snowball Chamber," two of some beautiful gypsum formations, two of the "Cross," and one of the "Last Rose Of Summer." These spots are all the one near the other, which allowed us to do so much in one day; the furthest spot, the "Last Rose Of Summer," is seven and a half miles from the entrance of the cave. About five o'clock we started on our homeward journey, and reached the entrance at eight, thus having passed thirty-five hours in the Cave.[1]

In contrast to Smyth, who had encountered difficulties with the heat of Egypt, Waldack found that Mammoth Cave's humid air actually helped with his processing, just as it had with Nadar. For example, fixing was normally undertaken back at the hotel, which cut down on the amount of chemicals that needed to be carried. Fortunately, in the cold damp air the collodion did not dry out as

MAGNESIUM LIGHT VIEWS

IN MAMMOTH CAVE.

Entered according to Act of Congress in the year 1866, by Proctor & O'Shaughnessy in the Clerk's Office of the District Court of the U. S. for the So. Dist. of Ohio.

The rocks around the Grand Crossing in Pensacola Avenue were already covered in graffiti in 1866. At this point, about two miles from the entrance, four passages branched off.

fast as expected. High humidity within the cave was one of the few factors that helped rather than hindered him. However:

> If to all the inconveniences mentioned . . . you add the bodily discomfort to which one is exposed in the climbing, creeping, and squeezing through all kinds of uncomfortable places, the fatigue of the march over rocky and slippery roads, loaded as one is with the implements of the profession, and, in some cases, the danger to life incurred in placing instruments and reflectors in the most suitable spots, you will agree with me that photographing in a cave is photographing under the worst conditions . . .
>
> The imperfections of the negatives we obtained are mostly caused by insufficiency of light. In some cases, the objects were too distant from the source of light; at others, they were of a brown or yellow tint, or covered with a mud or clay strongly coloured by iron. Such subjects as the last-mentioned present difficulties by sunlight; of that nature are a group of huge stalactites in Mammoth Dome, called the "Corinthian Columns." We succeeded, however, in getting a fair picture of them with ninety tapers.[1]

In common with other early types of emulsion, to a large degree collodion was insensitive to all but blue colours. Green and, especially, red light recorded as dark featureless areas on prints. Indeed, this was why magnesium was so convenient and powerful a light source since it was rich in the actinic blue rays of light which

reacted so well with the photographic emulsion. When the subject matter was reddish, however, there was little blue light reflected and a poor image was recorded on the plate. To overcome this massive amounts of magnesium had to be burned.

Although in 1866 the cost of magnesium tapers was steadily dropping, Waldack would have been trying to conserve the metal whenever he could without resorting to the false economy of deliberate under-use of its light. Underexposure would only have led to a waste of time and money, and the necessity of repeating a photograph at a later date.

To add to the problem, not only were up to 120 tapers being burned for each picture, more were used just to see the scene before work began. The process was phenomenally expensive. After his first visit, Waldack had suggested the use of Bengal light to examine the chambers, but if he tried to use this chemical he soon stopped, probably because the fumes it produced were even worse than those of magnesium. Alternatively, he thought it would be possible to use a dynamo near the entrance and light the cave with electricity, as Edward Wilson of the *Philadelphia Photographer* reported:

> Mr Waldack is not satisfied. He seems inclined to make some experiments with electric light, by having a steam engine and electro-magnetic battery at the entrance, and conducting the light inside. No one shall say this is impossible.[17]

In 1866 this might not have been impossible, but it was certainly less feasible than using magnesium, as Nadar had already found. Waldack's other ideas were more sound.

Apart from india-rubber bags to help carry his equipment, Waldack suggested the use of a special large-diameter lens and a 'division of focus', something being experimented with in England at the time. The lens would accept a large-diameter diaphragm, or aperture, which, in turn, would admit the maximum amount of light. It would also retain a good depth of field to keep both foreground and subject in focus at the same time. Waldack felt that such a lens '. . . would be a great boon, not only to subterranean photographers, but also to those who wish to make instantaneous pictures by natural light'.[1]

Waldack worked at Mammoth Cave for three months on this second expedition. In all, about forty scenes were considered to be worthwhile copyrighting, with an unknown number being un-usable. He is reported as having produced about eighty negatives, although he had intended to produce one hundred.

The long period Waldack spent at the cave would not have been taken up with underground work each day – there would be plenty to do in maintaining the reflectors and equipment, fixing and

washing the plates, and sometimes attempting to chemically intensify underexposed images. Printing would be done using sunlight rather than artificial light at the hotel. Early production of the prints enabled the registration of stereo views by Proctor and O'Shaughnessy in June, before the first expedition ended. Printing was a simple matter, only involving contacting sensitized paper with the plate. Indeed, enlargers were comparatively rare at this time and it was usual to rely on contact printing for all forms of photography.

The work could probably have been completed well within the three months spent at the cave, but Waldack apparently chose to remain at the hotel rather than return to Cincinnati, where there was a cholera epidemic.[7] In the wake of the Civil War, disease in the impoverished southern states was not uncommon, and it was prudent to temporarily remain in the countryside.

By October the men were back in Cincinnati. Waldack was later reported as having consumed $500 worth of magnesium,[19] a colossal sum of money. Nevertheless, it was less than might be expected considering the level of his consumption of tapers, suggesting the possibility that Waldack had some form of financial arrangement with the Boston factory. The price of magnesium was certainly falling rapidly during the course of the year.

The money spent on the project had to be recovered by sales of the stereo views; Waldack was possibly paid a royalty on sales. The backs of the cards were printed with a description of the picture, while on the front the copyright holders recorded the registration of the picture, and their names: 'Entered according to Act of Congress in the year of 1866, by Proctor & O'Shaughnessy in the Clerk's Office of the District Court of the U.S. for the So. Dist. of Ohio.'[20]

In November 1866, Waldack once again sent some of his stereo views to Edward Wilson, who considered the pictures important enough to pass on to his colleagues in the British press. They published Waldack's account before it appeared in America.[1] The very idea of underground photographs remained incredibly novel, and they were considered nothing short of a miracle. The editor of *The British Journal of Photography* remained puzzled at the 'absence of clouds of smoke which must have arisen' – in fact the cave roof was high enough to contain the fumes until the exposure was finished – and stated that several of the views were 'quite equal to good photographs of sunlit scenery'.[21] No pictures could be published in the journals – half-tone reproductions such as those used in modern newspapers had not been invented yet, and 'publishing' photographs in 1866 consisted of selling an original print. Wilson, in America, described his impressions:

It would be the vainest presumption for us to attempt to

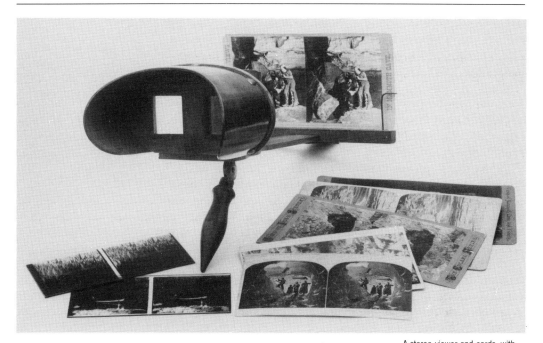

A stereo viewer and cards, with one of Waldack's pictures ready for viewing. The two photographs on the left are glass stereographs of the Cueva del Drach on Majorca. At the bottom right are two stereo view postcards; when the postcard craze began in the 1890s some stereo cards were reprinted as postcards.

describe these amazing pictures. When we think that Mr. Waldack has been down in the bowels of the earth, six or seven miles from sunlight, and returned with pictures of the wondrous [sic] and fearful places therein, we can hardly realise that it is so. It is a greater triumph of photography than anything yet accomplished, and more than any one would have imagined it ever possible to secure. . . *Photography forever!* Lay the descriptive pen and the delusive pencil upon the shelf! Their prospects are all shattered by the camera, and its giant powers have won the mastery. Mr. Waldack deserves the thanks of the world of science and art, and we hope his views will sell immensely. It is *our duty* to buy them.[17]

The British had somewhat more reserve, although they were just as impressed:

Mr Waldack has . . . with stored sunlight in the shape of magnesium, brought to daylight the secrets of one of the greatest natural wonders of the world. . . . Many of these [photographs] strike us as more perfect than the photographs which we have seen of those secured of the interior of the Pyramid. . . . Mr Waldack has . . . succeeded far beyond legitimate expectation.[22]

Nevertheless, at the close of the year there was additional praise

when Waldack's work was compared with Smyth's as being 'the greatest exploit hitherto recorded . . . with magnesium'.[23]

By January 1867 interest in the cards was high, and the stereograph publishers E. & H.T. Anthony & Co. of New York[24] took over publication of a set of forty-two views. This represented most of the forty-eight that had been copyrighted. By May, news of their availability from that source was well known on both sides of the Atlantic,[25] and was reported in detail once again. A New York newspaper reported:

> If any nervously disposed person wants to become acquainted with the mysteries of the Mammoth Cave, without actually going underground, he should visit the photographic establishment of Messrs. E. & H.T. Anthony & Co. . . . These pictures are in every respect wonderful. Taken by the magnesium light, with an exposure of only four or five seconds, they exhibit all the delicacy and minuteness of detail of pictures taken in the sun. . . the photographer showed excellent taste in the selection of subjects that exhibit the romantic and gloomy character of the cavern, and at the same time suggest the grandeur that was beyond his power.[26]

Despite copyright protection, at least eight publishers would eventually produce versions of the stereo views, not all of them legal. For the partnership of John R. Proctor and John H. O'Shaughnessy, as well as for Charles Waldack, the venture had been a success. Sales of the cards continued to bring in revenue for at least the next six years.[27]

Of those involved, Larkin Proctor must have been relieved to find new publicity bringing custom to his hotel. John Proctor became the owner of nearby Diamond Cave, later selling it to his father George[16] and working first as State Geologist and later as Director of the Kentucky Geological Survey and Bureau. No more was heard of his partner, John O'Shaughnessy.

'Bacon Chamber' in Mammoth Cave. This illustration, from Forwood's 1870 guide-book, was produced by the Duval Steam Lithograph Company of Philadelphia from Waldack's original picture.

Charles Waldack returned to his studio in Cincinnati to reap the rewards of his work. Already well known and the author of an almanac and a book on photography,[28] his reputation increased still further as reports on his pictures spread across America and to England via the *British Journal of Photography*. Many illustrations taken from his views graced the pages of guide-books, for example Forwood's in 1870.[16] He never did return to attempt improvements over his earlier results at Mammoth Cave, as he had suggested in the *Philadelphia Photographer*. Perhaps he never had the opportunity, or he found that there was no need to do so in the face of the many compliments he received. He later returned to his native Belgium to live in Ghent, and became a founder member of

the Association Belge de Photographie in 1874.[29] He returned to Cincinnati at the end of the 1870s, and died there in 1882.

Waldack's praise was richly deserved; the quality of his work was excellent, his technique meticulous. During his two visits, Charles Waldack had succeeded in overcoming the difficulties of taking pictures in an alien underground environment, working out for the first time many of the necessary basic techniques. More than any of the early pioneers, he laid the foundations of the cave photographic techniques of today.

1. Cave Hotel
2. Curious Sand-Stone Rock.
3. Path leading to the mouth of Cave.
4. Out For The Last Time.
5. Mouth of the Cave.
6. Mouth Of The Cave.
7. Gothic Chapel.
8. Column Of Hercules.
9. The Altar.
10. Devil's Armchair.
11. End Of "Gothic Avenue."
12. Wandering Willie's Spring.
13. "Standing Rocks."
14. Entrance To "Rocky Hall."
15. Giant's Coffin.
16. Entrance To "Long Route."
17. "Deserted Chamber."
18. Gorin's Dome.
19. "Bottomless Pit" And "Bridge Of Sighs."
20. View From "Bridge Of Sighs."
21. Beyond The "Bridge Of Sighs."
22. Pit Beneath The Bridge.
23. Wild Hall.
24. Snowball Archway.
25. Grand Crossing.
26. Angelica's Grotto.
27. Scotchman's Trap.
28. Dining In Great Relief.
29. Bacon Chamber.
30. "Bandit Hall."
31. Pillars in "Mammoth Dome."
32. Corinthian Columns.
33. Cliffs Over The Dead Sea.
34. "Ole Bull's Concert Room."
35. Hanging Rocks.
36. Martha's Vineyard.
37. Grape Clusters.
38. Snowball Chamber.
39. Mary's Bower.
40. Rosa's Bower.
41. "Cross" and Flower Garden.
42. The Last Rose Of Summer.

N.B. Two versions of no. 27 were issued, one of them an enlargement of a portion of the photograph. Full stops and quotation marks vary between different editions.

A List of Waldack's Mammoth Cave Views. The 1866 Waldack stereo views were first published by E. & H.T. Anthony in 1867. Each card had a label pasted to the back with a description of the view but, unlike many other series, did not carry a full list of all the views in the series.

Subterranean Light

A few days ago . . . an experiment was successfully made for the purpose of obtaining an accurate picture of some underground workings in a coal mine, the process being effected by means of the oxy-hydrogen light, generally known as the limelight, in combination with magnesium riband [sic] in combustion . . . That preliminary investigation was attended with some amusing incidents in consequence of the surprise of the colliers at seeing so brilliant a light in the mine where nothing but the light of a halfpenny candle had ever been seen before. One of the miners, with a startled expression of alarm, gave vent to the exclamation that 'the devil had come.'

The Walsall Observer, *1876.*[1]

The mid-1860s saw a tremendous rise in the popularity of magnesium as photographers began to use it both above ground to aid the action of natural daylight, and below, where it remained indispensable. In Marseilles, Nadar continued his work by recording subterranean canal construction taking place in the sewers, forsaking his former arc lights for the superiority of magnesium. At Vienna, the sarcophagus of the Empress Maria Theresa in the Imperial Vaults was the subject of another photographer, Leth.[2] In December 1866 von Treisinger also succeeded in photographing the tombs beneath the city of Lemberg.[3] As news spread of these and other successes, sales of ribbon and wire rose and the price of magnesium continued to fall, making it more affordable.[4]

At first it seemed that the metal would prove ideal for illuminating portrait studios, which badly needed a light to enable business to continue whatever the weather. Magnesium was both powerful and convenient, but an efficient means of burning it was first required. Usually, two ribbons were burned in a pair, so that if one went out the other would relight it. However, there was obvious scope for the invention of special magnesium lamps.

Grant's clockwork lamp, which used a removable reflector and air-vane governor to regulate its speed, was joined by several

other makes, some of them quite ingenious. Many of these versions could burn for long periods, in excess of the two hours claimed by Grant. This was of use to theatres in Boston, which received good supplies of the metal from the nearby magnesium factory for lighting their stages. Public meetings in Britain continued to burn the metal as a novelty, delighting ladies and gentlemen alike.[5]

However, fumes remained a problem. Attempts were made by theatres to retain the smoke in lanterns, but this was not very successful. Grant, who caught falling ash from his lamp in a small tray, experimented with dissolving the magnesium oxide in acid. The dangers involved with such a device attached to the lamp were great and caused too many problems; the apparatus was never marketed. F.W. Hart also experimented with condensing the fumes, but this time patent laws and insufficient funds prevented a successful outcome.

The American Magnesium Company also tried to find a solution to the choking smoke. One idea was immediately tested out by both photographic studios and theatres. Hoops supported tubes of calico, which allowed lamps to burn inside them and light to get out, but guided the gases away. Stove-pipes were installed in some studios, pumping the ash-laden air into the streets, while others contained the fumes in muslin bags.

George Proctor (no relation of Proctor of Mammoth Cave) of Salem, Massachusetts, patented a 'cave-like studio' in 1868.[6] he intended to reflect light onto the sitter from the curved walls and ceiling. As did so many other entrepreneurs of the time, however, he fell prey to the drifting, opaque ash. Both the studio and the technique were failures. The inconvenience of magnesium smoke proved too great for the light to become the main source of illumination in the confines of a portrait studio, and both then and in the future there was not a single example of a successful business using magnesium alone.

On the other hand, the use of magnesium underground enabled hitherto unimaginable photographs to become possibilities. Waldack produced his stereographs of Mammoth Cave in 1866, proving the greater suitability of magnesium over other artificial lights for this type of work. His technique was taken up by fellow photographers in equally difficult and unusual situations around the world.

In 1867 the US Government decided to make a series of geological surveys across the largely unknown western territories. At the same time, the opportunity was taken to use photographs to document the area. Clarence King was placed in charge of the survey of the 40th Parallel and, in order to accomplish the secondary objective, he obtained the services of photographer Timothy H. O'Sullivan.

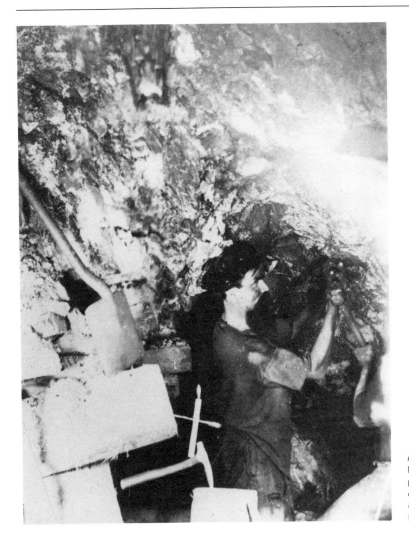

A miner in a Comstock mine, Nevada, 1867. O'Sullivan's photograph shows the working conditions and the normal lighting of a candle impaled in a wooden block.

O'Sullivan was a professional photographer of some note, largely engaged in government work. During the Civil War he recorded battle scenes between the Yankees and Confederates, although, in common with accepted practice, he generally worked with carefully placed dead men and posed soldiers after the fighting had finished. Setting up the insensitive collodion camera was considered too risky if attempted during an engagement; twice, though, O'Sullivan showed his bravery when his camera was hit by shell fragments.[7]

With the survey party, O'Sullivan went to the Comstock Lode mines in Virginia City, Nevada,[8] during the winter months of January and February 1867. These gold mines were a cluster of

shafts and levels that followed mineral veins into the ground. Mining here was a dangerous profession; accidents were common.

In front of O'Sullivan's camera, miners chipped away at the rock. Magnesium tapers were burned with care in the sweat-laden atmosphere and the awkward, cramped working conditions that men laboured under were documented for the first time. Compared to Waldack, very little magnesium was required as the subject was closer and the passages narrow, reflecting the light onto the subject. O'Sullivan produced photographs of the Curtis Shaft cages, the Savage Mine workings and miners in the Gould and Curry Mine.[9] His results added a great deal to his professional standing, and helped publicize the value of magnesium.

O'Sullivan has on occasion been wrongly granted the distinction of taking the world's first mining pictures. Jackson, Grant and Debenham had all preceded him in Britain. The claim for priority is nevertheless understandable, considering the lack of publicity accorded to the British results. Jackson produced the earliest coal-mining pictures, Grant the first photographs in a metal mine. O'Sullivan gained the distinction of being the first to produce mining pictures in the United States.[10] He went on to record much of the scenery of the western states, later becoming the chief photographer of the US Treasury Department until he died of tuberculosis in 1882.

Locations like sewers, burial vaults and mines were comparatively accessible. Usually, pictures taken in them portrayed small areas which presented little more difficulty than producing photographs in a studio. Magnesium was capable of far more than this, but not all attempts were successful. The Cathedral Cave at Wellington, New South Wales, proved too difficult for the efforts of an unknown photographer, who failed to produce a picture of the large chambers 'by means of the magnesium light' in 1867.[11] As Waldack had shown, large amounts of magnesium were required. The cost was prohibitive unless some return for the finished pictures was expected. This principle became a common one with professional photographers over the next few years: take underground pictures, and sell copies to tourists as either stereo views or prints. The demand for such photographs was great, for the novelty of the subject appealed to the curiosity both of the photographer in taking the pictures, and the customer who bought them.

At the Caves of Adelsberg, now named Postojna, in Yugoslavia, an extensive system of passages had been visited for many years by tourists. Mindful of the commercial possibilities of underground photography, Emil Mariot decided to try using magnesium to produce a set of photographs inside the cave.

Born on 7 January 1825 in Moravský Krumlov, now part of the Soviet Union, Mariot's real name was Schielbhabl. In 1867 he was

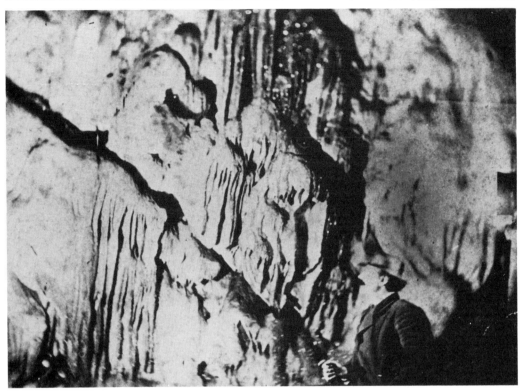

One of the surviving 1867 photographs taken by Mariot in Postojna Jama, then known as Adelsberg.

living under his new name in the town of Graz in Styria, now part of Austria, which was close enough to the cave for him to travel there with ease.

At Adelsberg, the caves were managed by a 'Grotten-komission'. These cave authorities controlled all commercial aspects of the caverns, so Mariot wrote to them on 14 March 1867 for permission to enter the tourist section and take pictures, with a view to selling copies.[12]

The Cave Commission met on the thirtieth of the month and discussed Mariot's proposition. The idea seemed a good one. Anything that might increase advertising was welcome, and in any case a fee was chargeable for Mariot's access to the caves. In addition the commission could earn a profit from sales of the pictures. The authorities decided on the charges and granted Mariot the permission he sought, but the photographer was unhappy. The fees were so high Mariot stated he would be forced to sell at least a thousand prints before even starting to make a profit. His only consolation was that the commission had acceded to his request that no other photographer was to be accorded the same privilege. His monopoly, at least, was secure.

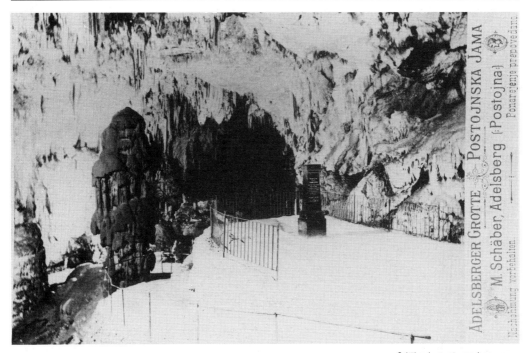

Schäber began to produce photographs at Adelsberg, c. 1895. The high-quality images were sold mounted on thick card with the photographer's name in gold letters.

Compared with Waldack's stereo views, which almost certainly had not yet reached this part of Europe, Mariot's results were poor. However, the concept of underground magnesium views was totally new to tourists in the area, and the Grottenkomission was impressed when Mariot sent it copies on 24 May. Mariot also wrote, on 5 May 1867, that 'foreign newspapers, English ones, will write about my photographs from the cave'.[12] No such reports have been traced, although Mariot's apparent awareness of foreign literature raises the question of his possible knowledge of Brothers' or Smyth's successes. In fact, it is unlikely that any techniques reached Mariot, at least with regard to Brothers.

While the Grottenkomission studied the five photographs he had taken, Mariot geared up his studio to produce between two and three hundred prints per day. A Grottenfest, an 'underground celebration with dancing', was held at the cave every Whit Sunday, and would provide an opportunity to sell copies. Mariot considered it to be such a good outlet, he prepared stocks of some two thousand prints.

Realizing that the quality of his original set of five plates was unsatisfactory and ought to be improved, Mariot stated he would be taking 'better ones' the following year. There is no evidence that he ever did so. His sales continued for some six years when, in 1873, he was superseded by a photographer and painter, Joseph

Martini.[13] Martini, from Celje, wrote to the Cave Commission on 7 March of that year, also requesting the sole franchise. He was certainly granted permission to take pictures, if not the monopoly, and produced at least one set of prints, and probably more, continuing Mariot's lucrative trade.

Mariot died in Vienna on 7 August 1891, the year before Martini relinquished his twenty-year control of photography at the caves. In 1892 Martini's guide-book to the caves, *Adelsberg Und Die Grotte*, was published, using his own text and photographs. Between 1881 and 1900 five other photographers enquired as to the possibility of taking their own pictures in the cave; the amateur architect and painter R. Hammel was chosen to succeed Martini in 1892.[13] By 1895 another photographer, M. Schäber, was also producing pictures in Adelsberg, as well as other Yugoslav caverns.[14] He used his views to illustrate guide-books, and sold postcards and original prints to tourists.[15]

Other European caves seem to have been managed along the same lines, with permission to take pictures for commercial gain being sold to photographers. The Grottes de Han management at Han-sur-Lesse in Belgium granted Armand Dandoy the exclusive concession to photograph the caves at its conference on 23 October 1876, a monopoly he controlled for several years.[16]

Dandoy was a founder member of the Association Belge de Photographie, as was Charles Waldack. The men certainly knew each other, and it would be surprising if Waldack did not have some influence on Dandoy's work. Dandoy used a specially-equipped gypsy caravan to transport 2,500 kg of equipment to Han for the fifteen days he spent there. He was awarded a gold medal at the 1878 Paris International Exhibition for the results he produced.

Where concessions were involved it is inevitable that different photographers succeeded each other, in the same manner that Martini replaced Mariot. Photographs that had sold well for years could also go out of fashion. For example, Waldack's forty-two views of Mammoth Cave continued to be marketed by E. & H.T. Anthony & Co. until, in February 1877, some rather inferior stereo cards by Dr Mandeville Thum of Louisville were introduced for sale at the cave.[17] Philip Frey & Co. of Frankfurt-am-Main produced a dozen prints of similar quality in 1880.[18] Evidently, tourist sales did not rely always on the quality of the product, but also on the new and novel. Waldack's fine stereos had served their photographer well, but a changing product was essential if the whims of the public were to be accommodated. Mammoth itself proved an incredibly popular venue for cave photographers, with what must have been dozens of attempts being made over successive years, all essentially aimed at an eventual commercial product.

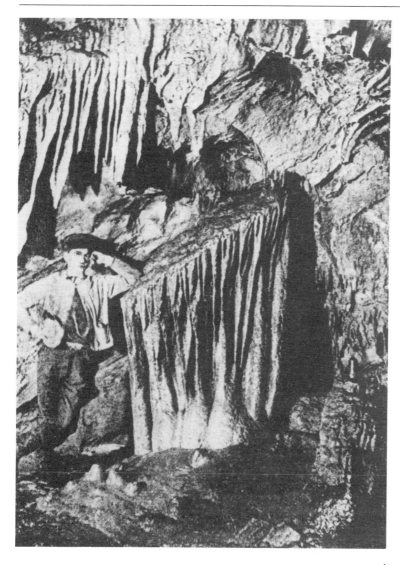

The 'Cask of the Danaides' in the Grotte de Han, Belgium. The original photograph was taken by Armand Dandoy in 1876 and later used to illustrate guide-books of the cave.

There was a huge rise in the popularity of photography during the latter half of the 1860s and early 1870s, with more and more portrait studios opening and opticians specializing in producing lenses. However, the wet collodion process remained slow, insensitive and cumbersome. Photographers badly required a means of speeding up the process, and new apparatus that was less bulky to transport and easier to use for their professional work.

The most obvious method of accomplishing this was to improve the sensitivity of the wet plate. If the plate could be prepared at home, or commercially in a factory, and kept in a sensitive, dry state, much of the equipment could be left behind in the

Views of Mammoth Cave and Vicinity.

Entered according to an act of Cogress, February, 1877, In the office of the Librarian of Congress, Washington, D. C.

The entrance to Mammoth Cave, registered in February 1877 by Dr Mandeville Thum. The set of twenty-six views replaced Waldack's series, although most were of inferior quality.

darkroom. The photographer would be released from the chore of preparing collodion and sensitizing plates just before use, and from having to develop them immediately afterwards. Landscapes and street scenes would come within easy reach, as the processing tent and chemicals could be left behind. Only when these difficulties had been overcome would underground photography itself become more common.

The basic problem was to keep the collodion sensitive. The best way was thought to be to arrest the drying process at the 'sticky' stage, just before the plate would normally be used. To date, all attempts to coat the collodion had failed. The result was usually the production of a poorer image, and a much longer exposure time. This had been the result of the collodion 'dry' plates, such as those used by Smyth for his outdoor work at the Pyramids of Giza. These plates had shown that some form of retention of sensitivity was possible, but not easy to attain. However, there was the evidence of 'positive' paper.

Positive paper was used to produce the final print directly from the plate; in other words, to produce a positive paper image from the glass negative. The paper had been made commercially for some time, and was supplied in a dry state. The manufacturing process coated the paper with egg white (albumen) rather than collodion, giving it a glossy surface which could hold the photographic chemicals. The size of the industry was immense. In 1862, for example, half a million eggs disappeared into a single London

firm. Later, such was the growth of photography, the number rose to some 60,000 eggs each day in Dresden.[6] The unused egg yolks were consumed in confectionery, leather tanning, or simply thrown away.

The paper still had to be sensitized with silver nitrate solution before use. The final picture usually had a gold tone derived from the chemicals used in its production, although other toners could also be used to aid permanence and provide a pleasing colour. Virtually all photographs were printed on this albumen-coated paper, giving rise to the term 'albumen print'. If a plate could be produced in the same way, even though it would still need sensitizing before use, the messy, complex business of using collodion would be ended forever.

If applied directly onto glass, albumen simply dried, cracked and peeled off. A substance like collodion was needed: sticky, transparent, and capable of holding the sensitizing chemicals but, unlike collodion, allowing water to permeate it when dry. In 1871 an English medical doctor, Richard Leach Maddox, found the answer.

Initially, Maddox's experiments had not looked hopeful. He found that gelatine, produced from animal hide or hooves, could be used as a chemical carrier instead of albumen or collodion. Gelatine would stick to glass, but the resulting plate was 180 times less sensitive than the collodion wet plate it was supposed to replace. But the way forward was clear, and for the next few years other photographers continued to experiment with gelatine. Eventually, they found that heating the plate 'ripened' it, and after a few years, using heat and other refinements, gelatine was made about forty times *more* sensitive than collodion. Incidentally, it was the move to dry plates and the possibility of developing them later which led to the need for knowing the sensitivity of the plate. Mistakes in exposure on collodion plates could be immediately rectified by taking another picture or adjusting development at the time; with dry plates, accuracy of exposure was important since the photographer would have left the scene and could not repeat his work.

The change-over to using the new dry plate was a slow one. Initially, the plates were of poor quality and had to be produced at home. The usual method of preparation was to clean the glass thoroughly, melt the gelatine and then pour it from a teapot onto the centre of the plate. This was tilted back and forth until evenly covered, then left to cool and set. Many photographers used to the older methods carried on using them, while others immediately converted to the new invention. Nevertheless, the market did not support commercially prepared dry plates in any quantity until 1878.

It was during this transition period that the professional photographer Frederick Brown, 'Artist & Photographer' of Walsall,[19]

near Birmingham, was approached and asked to undertake a form of work he had not considered before, that of underground photography. A firm of solicitors, Duignan & Co., was involved in litigation on behalf of the Bradford Colliery, just outside the town, and required photographs of the coal-face.[20] Could Brown take them, they wondered? Accordingly, at the beginning of November 1876 Brown went to make some tests, to see if such a project was possible.

Brown decided to use both magnesium and limelight, intending to supplement the one with the other. His decision to use limelight appears a strange one. Magnesium was generally acknowledged to be a far superior light, possessing more of the actinic rays that both wet and dry plates were sensitive to. Conversely, limelight was cheap to produce and most professionals either had access to, or owned, the apparatus, and were conversant with its light. In addition, heating the sphere of calcium carbonate did not produce any smoke. One possible use of limelight was to illuminate and soften the harsh shadows produced by magnesium, and this seems to have been Brown's intention, for it was known that limelight alone was too poor a photographic light to rely upon.

When the magnesium ribbon flared into life, harsh shadows danced on the stark walls. One of the miners, alarmed by the light, believed that 'the devil had come'. Other colliers were surprised and delighted 'at seeing so brilliant a light in the mine, where nothing but the light of a halfpenny candle had ever been seen before'.[20]

Brown pronounced the test a success, and the following day went into the mine with Mr Chidley, a representative of Duignan & Co., to show him what was required. With them were representatives of the mine.

The men carried the camera and lighting units through the shallow mine passages, past the ponies which hauled the coal, until finally they arrived at the working face. With his stereo camera mounted on a wooden tripod, Brown focussed with difficulty in the cramped and confined space, and prepared his wet collodion plate; he had opted not to use the new dry plate, in favour of the wet collodion process which he was fully conversant and confident with. Eventually, with the plate coated, sensitized and inserted into the plate holder, he was ready to make his first exposure.

Brown exposed his plates for twenty-five to thirty minutes each to give the limelight a chance to have some effect, during which time his main problems arose from the collodion drying out. Nevertheless, the resulting prints sufficed for Chidley's purposes, and Brown proudly sent copies to the editor of the *British Journal of Photography*, Henry Greenwood. On 24 November 1876, Greenwood wrote of his impressions:

The picture received from Mr. Brown is one of the most successful of the kind we have yet seen. . . . The drying of the plate during the long exposure found necessary . . . affords only another example of the great utility arising from the employment of rapid dry plates, which . . . would bear an indefinite prolongation of exposure without becoming in the slightest degree deteriorated.[21]

Brown's photographs raise several interesting points. Greenwood's comments show that he himself was in favour of the new dry plates, and he was quite correct in his prediction that they would enable pictures to be taken in such circumstances with greater ease. Claims were made for the photographs being 'the first underground pictures of their type', which totally ignored the work of men such as Brothers, who promptly responded with counter claims.[22] Later, Greenwood himself acknowledged the work of Smyth and Brothers, adding that Brown 'deserves his meed of praise for any successful effort out of the usual rut into which most workers run'.[23]

It can be seen that the number of photographs taken purely by artificial light underground was still slight; the colliers themselves appeared to know nothing of the prior pictures taken in the same mine by Henry Jackson. Greenwood himself had probably seen very few other examples, possibly limited to the more popular ones taken by Smyth or Waldack ten years previously. This may be partially attributed to a recent fall in popularity of commercially produced stereo cards in Britain. In any case, it was journalists who were most impressed by the idea of lighting underground features, and they gave free rein to their imagination concerning this new use for limelight. It was thought that:

The possibility . . . of introducing a powerful and steady light completely under control, which may be fed from the surface by means of flexible tubing, and which would enable a light rivalling that of day to be sent into dangerous places from a convenient and safe distance, appears to us to open a pathway to a very important practical application.[20]

Limelight was considered by many laymen to possess far greater properties than it in fact held. It was a well-known light source, and the public might be excused the thought that the brilliant light would readily affect photographic emulsions. Few of them realized that both wet and dry plates were only sensitive to blue 'actinic' rays, the very portion of the spectrum that limelight lacked. Brothers himself was swift to comment on the idea of piping gas into mines in order to light them up.[22] Obviously, places that already suffered the ravages of firedamp would hardly benefit from

An example of a commercial limelight burner. Oxygen and hydrogen gases combined to produce an extremely hot flame, which impinged on the cylinder of calcium carbonate. This was turned by hand or clockwork, the spent calcium oxide dropping into the tray below.

the addition of more inflammable material and a naked flame. It was a journalistic suggestion that never came to fruition.

With the advent of dry plates and the low cost of limelight production (it remained far cheaper than magnesium ribbon), it is inevitable that an attempt such as Brown's would be made to use limelight underground. While previous attempts had been made, and failed, the improved sensitivity of both wet and dry plates now permitted a limited measure of success. Brown's pictures are the first known successful use of limelight underground, albeit using magnesium for the main exposure.

Commercial limelight lamps could be readily purchased. These burners utilized a sphere of calcium carbonate, which was revolved in a flame by a clockwork motor. This avoided pitting due to uneven heating. The former fuel used as a heat source, hydrogen burned in a jet of oxygen, had largely been replaced by the more convenient coal gas which was now delivered to many homes. A jet of oxygen to produce a hotter flame was still retained. This gas could be prepared at home either from chemicals or by electrolysis of water, both of which could be incredibly risky ventures. If the chemicals or gases were contaminated, explosions or the release of poisonous fumes could result. Several fatal accidents had occurred when druggists sold impure supplies. Indeed, in this new sphere the photographer often knew more than the fully-trained chemist.

Using limelight away from the studio necessitated carrying not only the limelight burner, but also supplies of oxygen and hydrogen if there was no town gas supply. One method was to purchase cylinders of compressed oxygen and hydrogen, but these were expensive and many photographers used a more basic approach. India-rubber bags were prepared, filled with the gas in the studio, then sealed with a clip. In the cave a board was placed on top of the bag, and rocks then weighted it down to put the gas under pressure. When a supply was required, the clip was eased off and oxygen or hydrogen could then make a controlled escape. Once again, it seems that safety was not the prime consideration; gas leaks or punctured bags must have been common, and hydrogen used next to a naked flame was an obvious hazard.

With the long exposure times needed with limelight, and the trouble it took to set up, it is not surprising that attempts to use the apparatus underground were few. The earliest known pictures produced solely using limelight were made at Howe's Cave near New York around 1877 by the 'Photo-Artist' A. Veeder of the nearby town of Albany,[24] the result being a series of about twenty poor quality stereo views for sale to tourists. Veeder no doubt used limelight as he had a ready supply of gas at hand; the tourist part of Howe's Cave was already lit by gas jets.[25]

Around March 1878, William Brooks photographed the man-made 'caves' at Reigate, England,[26] this time using a combination

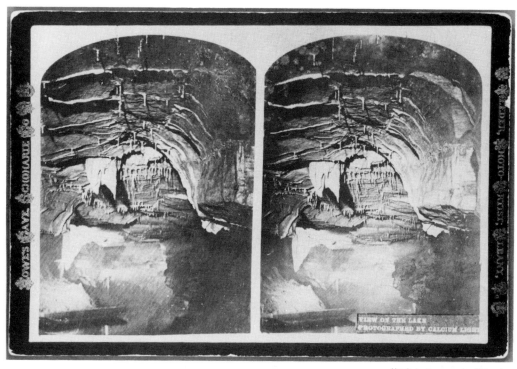

Veeder's stereo cards of Howe's Cave near New York were 'photographed by calcium light' in 1877, the first known underground photographs to be taken using limelight alone.

of limelight and about eighteen paraffin lamps. The hollowed-out sandstone caverns were quite spacious and reputedly the 'Barons' cave' had been the location of clandestine meetings by those opposed to the signing of the Magna Carta. Now, they were used to store beer, and Brooks was employed to produce advertising pictures for the owner, Charles Mead. He succeeded where others 'did not get any impression whatever on the plates',[26] the pictures being printed as Woodburytypes.

The operation seems to have been a cheap one – magnesium was avoided because of its cost. Instead, coal gas was piped in to provide the limelight flame and oxygen was supplied from india-rubber bags. Brooks' exposures indicate the sort of time that would also have been spent at Howe's Cave – from one to five hours for each photograph – which did not worry him as he was able to pass his time sampling the various casks.

Although there was the attraction of the low cost of limelight production, it was nowhere near as convenient as that of the more powerful magnesium light, and the limelight apparatus was far more expensive. Magnesium burners were cheap, light and portable, and magnesium could be burned without their use, when formed into a taper. Magnesium ribbon remained the first choice for most photographers who required pictures taken in dim light or

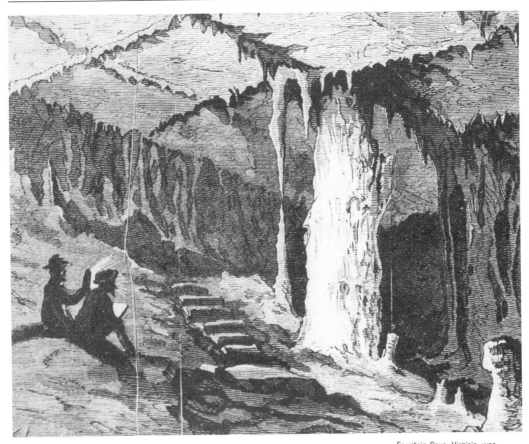

Fountain Cave, Virginia, was discovered in 1870 and opened for tourism by 1874, when this illustration was produced. One figure is burning magnesium in a reflector, a common form of illumination in tourist caves, for which an extra charge would be made.

in the dark. Yet even now, although cave photographic techniques in accessible tourist caves were becoming established, knowledge and skills were scarce.

For example, 1878 also saw the discovery of Luray Caverns in Virginia by the professional photographer, Benton Pixley Stebbins.[27] Even though he was short of money and desperate to raise capital, Stebbins never attempted to take any pictures underground. He had the necessary camera, and tourists were sold magnesium to burn in special reflectors. Seemingly, knowledge of photographic techniques with artificial light was lacking in this case, although 1878 also found H.D. Udall producing forty-four photographs of Pluto Cave in the nearby state of Ohio.[24]

Stebbins' wife painted parts of the cave between August 1878 (the year the caverns were discovered) and 1879, when the paintings were copyrighted and commercial copies produced.[28] Photographs would have helped Stebbins' cause without a doubt, for advertising the cave would have brought tourists and added revenue; in the end Stebbins lost title to the property, partly due to

a lack of finance, and it was not until 1881 that the first underground pictures in Luray Caverns were taken.

In the same way that Veeder took advantage of the gas supply at Howe's Cave, electricity was available at Luray. Thirteen electric arc lights for use by the tourists had already been installed, an unusual feature for this time. Power was run up the hillside to the caverns from a steam engine and generator in Luray town. This, the wire running in a circuit of seven miles, was supposed to be the longest single wire carrying current yet attempted with a single engine.[29] Its installation permitted the retirement of the cave's candle-lit chandeliers which, on one occasion, burned ten thousand candles, and finally protected the formations from dripping tallow and smoke.

Taking advantage of the new arc lights, the photographer C.H. James of Philadelphia took some seventy pictures in visits late in 1881, and again early the following year. When seen at work by the famous cave explorer Horace C. Hovey in February 1882, James was said to have ' . . . succeeded perfectly'.[30] Hovey must have come across many cave photographs on his travels, and further commented that:

> The experience of those who have hitherto attempted underground photography has not been very encouraging, but this gentleman has overcome many of the difficulties in the way, and hopes to get good pictures. Those he has already secured certainly surpass any taken by calcium or magnesium light, both in sharpness of outline and distinctness of detail.[29]

The price to be paid was in the length of exposure, which was too long to permit any people to appear in the picture. The set of photographs, while popular at the time, shows formations or passages with their wooden steps and railings, but no visitors.

James may have found the electric lighting superior to magnesium, for it did nothing to occlude the atmosphere with fumes, but obviously arc lamps were a luxury that few caverns possessed. At Adelsberg electric lights were installed in 1884, and Martini wrote of his intention to use them for some new photographs,[12] though the result is unknown. Many tourist sites, and some of the metal mines in Germany,[31] still used magnesium for general lighting, and for photography it was still the only viable material. Both within the USA and abroad, improved technology, magnesium and the new dry plates enabled further work to take place. The 1880s witnessed a succession of photographs being produced.

For example, the first South African underground photographs were made around 1881 in the Cango Caves by C. Mason, who had a studio at the nearby town of Oudtshoorn.[32] The first Hungarian cave photographer was Károly Divald, a professional landscape

ELECTRIC LIGHT

VIEWS IN THE CAVERNS OF LURAY,

AT LURAY STATION (Page Co., Virginia),

Shenandoah Valley Railroad.

TOURISTS' GUIDE.
From New York and Philadelphia, take Pennsylvania R. R.
" Baltimore, take Western Maryland R. R.
" Washington, take Baltimore & Ohio R. R.
" Southern and South-western points, take Norfolk & Western R. R. and Connections.

SUBJECTS.	Serial Numbers.		SUBJECTS.	Serial Numbers.	
	Stereo-scopic.	7x9 Views		Stereo-scopic.	7x9 Views
Grand Entrance,	1	2	Skeleton Gorge,	71	72
Washington's Column,	3	4	Brand's Cascade,	73	74
Stebbins' Avenue,	5	6	Entrance Avenue,	75	76
Natural Bridge,	7	8	Amphitheatre,	77	78
Fish Market,	9	10	Gallery in Amphitheatre,	79	80
Side Wall in Pluto's Chasm,	11	12	Crystal Spring,	81	82
Ball-Room,	13	14	Pluto's Chasm,	83	84
Side View in Ball-Room,	15	16	Pluto's Chasm (South),	85	86
Coral Spring,	17	18	Pluto's Chasm (North),	87	88
Collins' Grotto,	19	20	Hovey's Hall,	89	90
Campbell's Hall,	21	22	Hanging Rock,	91	92
Entrance to Campbell's Hall,	23	24	Round Room,	93	94
Entrance to Ball-Room,	25	26	Hall of the Lost Blanket,	95	96
Double Column,	27	28	Into Hades, from the Lost Blanket,	97	98
Giants' Hall,	29	30	Interior of Saracen's Tent,	99	100
Drapery in Giants' Hall,	31	32	Hollow Column, from Saracen's Tent,	101	102
Lost Blanket,	33	34	Entrance to the Cathedral,	103	104
Titania's Veil, from Hollow Column,	35	36	Diana's Bath,	105	106
Empress Column,	37	38	Balcony of Skeleton Gorge,	107	108
Leaning Tower,	39	40	Grotto in Skeleton Gorge,	109	110
Saracen's Tent,	41	42	Drapery Hall,	111	112
Fallen Column,	43	44	Stonewall Avenue,	113	114
Angel's Wing,	45	..	Twin Lakes,	115	116
Cathedral,	47	48	Five Points,	117	118
Throne in Cathedral,	49	50	Cave Formation,	119	120
Broaddus' Lake,	51	52	Miller's Hall,	121	122
Castles on the Rhine,	53	54	Hawes' Column,	123	124
River Rhine,	55	56	Approach to Titania's Veil,	125	125
Frozen Fountain,	57	58	Grand Partition,	127	128
Titania's Veil,	59	60	Cave Hill,	129	130
Helen's Shawl,	61	62	Stony Man,	131	132
Oberon's Grotto,	63	64	Luray,	133	134
Proserpine's Pillar,	65	66	Luray Inn,	135	136
Spectre Column,	67	68	Hall of Luray Inn,	137	138
Imperial Spring,	69	70	Cave House,	139	140

N. B.—In ordering copies, please state whether Stereoscopic or 7x9, and give serial numbers as per this list.

Address
THE LURAY CAVE AND HOTEL COMPANY,
Luray, Page County, Virginia.
C. H. JAMES, *624 Arch Street, Philadelphia, Pa.*

The Caverns are brilliantly illuminated with the ELECTRIC LIGHT.

The reverse of James' cards carried a list of views available for sale, either in stereo or 7 in × 9 in formats.

LEFT, C.H. James used the electric lights installed in Luray Caverns for his stereo views made in 1881 and 1882. None of his pictures depict people, due to the length of his exposure and the consequent problems of movement. This view is of Saracen's Tent, No. 41.

photographer based in Eperjes (now Prěsov, Czechoslovakia). Divald photographed the Szepesbéla Cave of the Béla Tatras, a tourist attraction, the resulting prints going on sale in 1887. He went on to visit Baradla Cave, the longest in Hungary, on 6 June 1890, publishing a set of thirty-two photographs in 1890 under the title 'Pictures from the Aggtelek Cave'. Hungarian cave photographs were also taken of Szepesbéla Cave by the owner, János Blitz, who produced postcards from them for sale to tourists.[33] Clearly, while such photographic attempts were still not common, they were increasingly being seriously considered.

In America, as in other parts of the world, caves and mines were privately owned and the prime motive for producing pictures was commercial gain. For example, those taken by James at Luray were to provide some 8 per cent of the cave's total income from sales.[34] A slightly different situation existed in Australia. Here, during the late 1870s and 1880s, the government was taking an increasing interest in any site that might possibly become a tourist attraction or could be important for mineral exploitation, and was appointing men to survey and explore any caves that were known. Geologists' reports had to be filed, and photographs taken to record the finds. In this way the government became the driving force which caused cave photographs to be produced.

Due to confusion over their exact location, the Jenolan Caves of New South Wales were originally called the Fish River Caves, in the belief they were a part of that district. The Jenolan area, about eighty miles west of Sydney, has many cave entrances, all of which were being actively explored. Jeremiah Wilson had been the official guide and caretaker there since 1867, showing tourists around the caverns, although travel to the area was not easy.[35] Nevertheless, in 1879, or just before, a Mr Hart produced 'admirable photographs by the magnesium light'.[36] A hotel was opened in 1880, and increasing numbers of visitors no doubt aided the opportunities for further photographic attempts.

Hart's photographs remained unpublished,[17] but more pictures were taken by the Mount Victoria (New South Wales) studio of Caney & Co. between 1883 and May 1884.[37] They are of superb quality for the time, especially considering the immense chambers being photographed. Other photographs were used as the basis of wood engravings, published in *Scientific American* magazine in October 1884 with an article by J.E. Richter.[38]

As levels of tourism rose, more crude trails and ladders were installed, government interest and control increased, and the number of photographs for guide-books and stereographs rose in turn. In 1887 an immense 22¼ in × 17½ in red-bound book of pictures was published by the New South Wales government, as part of its increasing support for tourism. One page of text within this volume was by the government geological surveyor in charge

LEFT, Looking into The Devil's Coach House, Jenolan Caves. The photograph was made by the studio of Caney & Co., Mount Victoria, prior to May 1884.

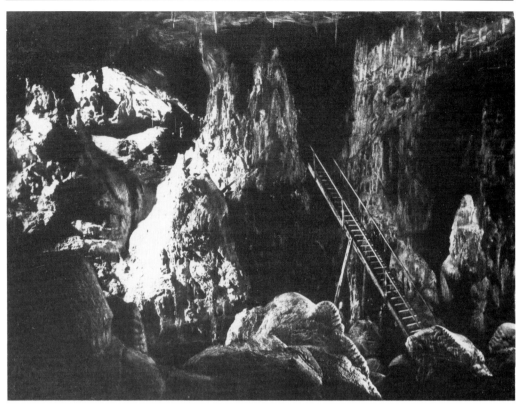

The ladder leading to Arch Cave at Jenolan, photographed by the studio of Caney & Co. The purchaser labelled the mount 'May 2nd & 5th 1884'.

of the area, C.S. Wilkinson.[39] The prints, themselves some 11½ in × 9½ in, were uncredited but, according to Wilkinson, a certain Mr Dyer took at least some (if not all) of what was possibly a joint effort. The main photographer used by the government printer during this period was John Sharkey, who may have been involved in some of the photographic projects.

This period saw many government surveys completed in Australia, both at Jenolan and elsewhere. The caves at Buchan were photographed by the professional photographer Frederick K. Cornell of Victoria, then again in 1889 by J.H. Harvey of Melbourne. One of the founder members of the Amateur Photographic Association of Victoria, Harvey produced four prints for the surveyor's report.[40] There are probably several more Australian underground photographic attempts made during the last century yet to be discovered, especially in Jenolan by private individuals or those working for the stereograph companies.

In New Zealand the year of 1889 also saw a government survey, this time of Waitomo Glow-Worm Caves on North Island, by Thomas Humphries.[41] The caves had been discovered in 1884 and first explored on Boxing Day 1887.[42] This showed the site to be an

important one, worthy of further study, and the government instructed the Department of Crown Lands to conduct an expedition. Humphries was Chief Surveyor of the province of Auckland, and was placed in charge.

Humphries was directed to provide not only a description of the cave, but also photographs. To avoid publicity, and the possible subsequent vandalism of the formations, Humphries was told to keep the venture as secret as possible. On 22 May 1889 he contacted the local official, Judge Mair, and arranged for the hire of guides, while he organized his party. Beside himself there was to be an assistant, a Mr Allom, who would help with the surveying. James Stewart, an engineer, was to investigate the possibility of installing a dynamo in the stream for hydro-electric power. The photographer chosen for the expedition was J.R. Hanna, who was well known in Auckland, and his assistant, a Mr Bain.[41]

A train took the party to the nearest station, Otorohanga, on 31 May. The next day they left, together with other officials, for the cave. The eleven-mile journey on horseback took them over rough ground, and lasted 1¾ hours. Once at the cave, with little time to spare, they began work almost immediately. The main guide was Taane Tinorau, a Maori. He took the men into the arched entrance by canoe to land in a spacious chamber. It was evident to Humphries that a lot of work had already been accomplished by the Maoris, who had constructed paths and ladders in preparation for tourism. Indeed, one chamber was not only decorated with ferns and lit with candles, it had a log table upon which was served a hot meal.

Photography was granted an important place in the report. Hanna and Bain worked extremely hard over the next three days, camping outside between their underground expeditions. Humphries wrote that:

The first day, after having ridden from Otorohanga, we were at work inside until midnight and on to 2AM of the following morning; after a few hours sleep and breakfast we went in again until 11.30 PM; the last day from 7 AM until 3 PM, when we left for Otorohanga. Nearly the whole of this time was taken up with the photographing which was very tedious as we were greatly impeded by the smoke from the magnesium burning, which hung about so much. The whole party suffered more or less for some days afterwards through inhaling its fumes so continuously.[41]

Hanna produced only twenty-two photographs in his time spent at the cave, an indication of the difficulties he faced. He required more time to complete his work, but had to leave as there was not another train for a week. The report that Humphries submitted,

together with photographic evidence, recommended the appointment of a government caretaker who would act as a guide and prevent vandalism.[42] Certainly, despite the problems that were faced by the early photographers, with the work of Hanna and others, it can be concluded that underground photography throughout Australasia was exceptionally well advanced by the close of the 1880s, with numerous fine pictures being produced by many workers.

These were boom years for cave photography, nearly all of it being directed in some way towards commercial profit, with perhaps the exception of the Australian government-sponsored pictures. In America, one of the main forms of entertainment was to view stereo cards, and literally millions were being published. Photographers would produce pictures of the mundane and the exciting, the street scene and the mountain top. In the absence of newsreels, stereo cards formed a method of recording news as well as preserving images of the unusual. Cards were sold either individually, or more usually in boxed sets. Pictures might be produced for direct sale to the public by the photographer, to sell to one of the large publishing concerns like E. & H.T. Anthony & Co., or for use by a business for advertising.

In America, cave photographs found a ready market in the form of stereo cards. The main incentive was always to find new views for sale to the public. Waldack's stereos are a classic example. Cabinet cards, larger than stereo cards at around 4½ in × 6½ in, carried a single image and formed another outlet. There was, in addition, one further source of revenue that could be tapped: guide-books such as that which Wilkinson had helped produce. In the United States, though, there was a different impetus to that supplied by the Australian government.

The railroads had followed a policy of expansion during the 1870s, and new track was being laid throughout the continent of America. These concerns were all privately owned and depended on freight and passengers for their capital. Communities were dependent on the railway as the fastest and most efficient form of transport available, supplying a means of communication to the outside world and the carriage of goods and materials for business. The presence of a railway in a sleepy cattle valley could bring prosperity; those neighbours not so lucky were forced to travel long distances by horseback. Iron tracks could be laid wherever the company wished, and if a cave could be used to attract tourists into travelling on the railway, then the cavern was duly advertised and made use of. Such a reason was frequently a prime cause for the choice of route.

In this way, the railroad finally arrived at Mammoth Cave in 1886, the track being laid from Glasgow Junction (now Park City), some nine miles away. This perhaps made the journey safer; the

EXCURSION TICKETS

TO

MAMMOTH CAVE.

DURING THE SUMMER SEASON THE

PENNSYLVANIA CENTRAL

RAILROAD

WILL ISSUE EXCURSION TICKETS

FROM THE FOLLOWING POINTS

TO MAMMOTH CAVE

AND RETURN AT

GREATLY REDUCED RATES:

NEW YORK,	PHILADELPHIA,
LANCASTER,	HARRISBURG,
ALTOONA,	CRESSON.

Excursionists selecting this route pass through the finest farming land of Eastern Pennsylvania, through the beautiful valley of the Juniata River, and cross the Alleghany Mountains at a height of 2200 feet above the level of the sea. No other route affords the tourist the same variety of river and mountain scenery.

HENRY W. GWINNER,
General Passenger and Ticket Agent.

A. J. CASSATT,
General Superintendent.

Advertising caves by the railroad companies was common. This 1870 advertisement failed to point out that the last part of the journey would be by stage-coach, the railway to Mammoth Cave not being completed until 1886.

outlaw Jesse James had held up and robbed the Mammoth stage-coach in 1880, and in any case the coach would not have been a comfortable way to travel. Elsewhere, railroad routes or the placing of stations might be influenced by scenic attractions along the way. Posters advertising the cave might be made not by the cave owners, but by the railroad, which usually had more money to spend than local entrepreneurs. Books of photographs

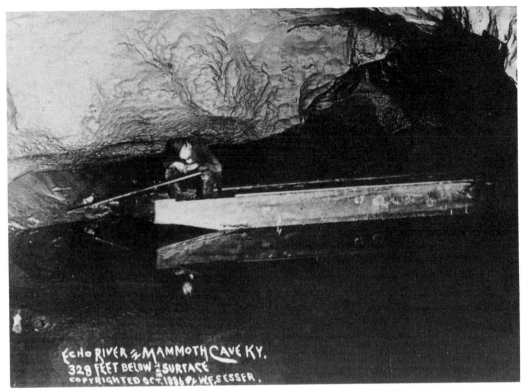

Boats were used to carry tourists along Echo River in Mammoth Cave. Sesser's picture had a slow enough exposure to permit the boatman's face to blur, an indication of his use of magnesium ribbon. Movement of any form while the picture was taken posed great problems for photographers.

which freely advertised the services of the railway were produced and sold to the tourist, again profits often going to the railroad company.[43]

W.F. Sesser of St Joseph, Michigan, was one photographer whose pictures were used by the railroad for a volume of prints on Mammoth Cave. Sesser may have been specially comissioned for the task, judging by the level of advertising involved. Using his Collins camera[44] and magnesium for lighting, Sesser took photographs in the caverns during the year the railroad was completed and the stage-coach service discontinued, in September and October 1886. These were published by the Louisville & Nashville and the Mammoth Cave railroads in 1887.[45]

The resulting book on Mammoth Cave was a huge volume, with twenty-one original albumen prints mounted on thick card pages. 'Stop over checks allowed on all through routes North and South', proclaimed the railway at the bottom of every page.[45] Photographs of Crystal Cave, taken about 1885 by W.R. Cross from Hot Springs, South Dakota, were treated in the same way with 'The Switzerland of America, reached by the North-Western Line' emblazoned across the mount. Other Cross views of Crystal Cave and Wind Cave advertised two more railways, while H.W. Stormer

Views in the Black Hills and in Montana.
On the B. & M. Railway.

W.R. Cross produced a number of views in Crystal Cave, South Dakota. This one is typical of his underground pictures, as is the associated railroad advertising.

of Manitou, Colorado, mentioned no less than five different railroads on his stereo views of the Cave of the Winds.

Some of Sesser's pictures were also published in guide-books,[46] and as boudoir cards. The boudoir format used an 8¼ in × 5 in print, larger than the cabinet card (6½ in × 4½ in) or carte-de-visite (usually 3½ in × 2¼ in print on a 4 in × 2½ in mount), and was placed on display rather than mounted in books. It first appeared in the late 1870s, with its popularity increasing through the 1880s. William E. Hook of Manitou Springs used this format, as well as stereographs, for his photographs of the Cave of the Winds. Hook was a prolific photographer, with 2,000 views in his trade collection.[47]

Further examples of American cave photographs produced in the 1880s are provided by J.G. Burge, 'portrait & scenic artist' of Kingston, New Mexico, who photographed the nearby Coffee Cave, and Roberts & Fellows of Philadelphia, who worked in the Cave of the Winds. This latter site was a particularly popular one; W.H. Jackson of Denver, Colorado, produced pictures both there

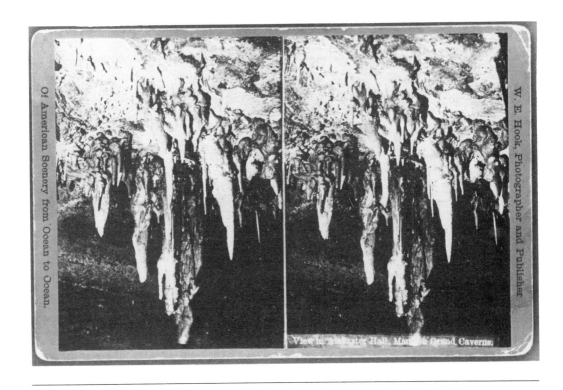

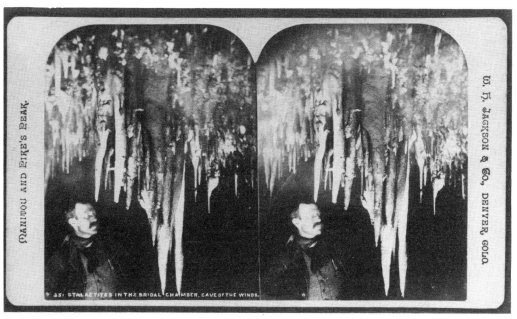

A scene in the Cave of the Winds, taken by W.H. Jackson *c*. 1885.

and in Manitou Grand Cavern, as did the photographer, Thurlow. The entrances to these caves, opened for tourism in 1881 and 1885 respectively, were close together, being parts of the same system. Several other photographers are known to have produced pictures in them in the latter half of the decade.[48]

From the foregoing it might be concluded that underground photography was becoming common during the 1880s. Numerically, there was an increase in both the pictures produced and the number of people involved, especially in America. Cave photographs were certainly becoming easier to take, with cheaper supplies of magnesium and the new dry plate, but in reality there was still little work being undertaken worldwide, with only a handful of professionals involved. For all these men, commercial reasons such as the production of stereo cards, book illustrations, government reports or railway advertising were the driving force. Changes were taking place during the 1880s, however, which produced even easier methods of light production. In addition, a changing attitude towards the underground world was leading to a further increase in the volume and quality of work being accomplished.

LEFT TOP, Stone huts were built within Mammoth Cave in 1843 for the use of 'consumptive patients': tuberculosis victims. It had been believed that the cave air would help their recovery. The experiment was an utter failure, as was the attempt to make 'trees and shrubbery grow around their dismal huts'. Only a few of the original nine huts were still standing when Sesser photographed them in 1886, releasing the results in the boudoir format.

LEFT BOTTOM, 'View in Alabaster Hall, Manitou Grand Caverns', photographed by W.E. Hook *c*. 1885, and sold by his 'Stationery and Book Company' in Colorado Springs. Hook boasted a range of 2,000 views of Colorado for sale to tourists.

CHAPTER FIVE

Explosive Powders

Wonder upon wonders, an instantaneous view inside the Cave!
Who now shall doubt the abilities of magnesium?

Edward L. Wilson, 1866.[1]

The idea has got abroad that there is great risk and danger involved
on account of the explosive nature of the blinding, smoke belching,
evil smelling flashlight powder. . . The flashpan was a piece of
equipment which the wise photographer kept in his cupboard, and
only took out when there was no other way to get the job done. . .
The unsavoury reputation of this disgusting powder still clings to the
name of flash.

Photo-Flash in Practice, *1947.*[2]

The 1880s not only saw an increasing amount of travel on the
improved railroads of America, with a corresponding rise in
tourism, but also an upsurge in numbers of photographers
throughout the world. With dry plates, cameras had become
smaller, more efficient and easier to operate and, with an increase
in the use of magnesium, the price fell still further. By 1887
improved manufacturing techniques enabled the price of 12d. an
ounce to be attained, a vast change from the 1866 price of 12s. for
the same weight.

However, ribbon was no longer considered an ideal form for
burning magnesium. In daylight, dry plates allowed much shorter
exposure times for the portrait photographer, but in dim light
magnesium smoke still caused problems, and had to be removed
or contained. Studios requiring artificial light obviously had diffi-
culties. Fumes were still capable of ruining a photograph as they
filled the room, and the full potential of dry plates was not being
realized when tapers had to be burned for up to half a minute to
obtain correct exposures. Electricity in the studio was perhaps the
best answer: Henry Van der Weyde in London opened his

photographic studio in 1877, using only arc lights.[3] He made a fortune, but for other applications away from a source of electricity a better method of burning magnesium had to be found. A few relevant experiments had already taken place.

In September 1865 William White, who had been so impressed by Smyth's pyramid pictures when they were exhibited at Birmingham, noted that:

It is a question whether magnesium in filings has met with due attention. It would not be difficult to deliver a stream of metal as sand from an hour-glass into a jet of gas or other flame, and thus maintain a light with a certainty equal to that obtained by wire and clockwork.[4]

Henry Larkin constructed such a device, which was in use by August 1866. His lamp used magnesium powder (produced by grinding), mixed with sand to help control its flow with precision. This was then blown into an inflammable gas, which supported burning as the magnesium/sand mixture entered a reflector. The flame was given a reddish tinge by adding other chemicals to correctly render 'the delicate pink of the ladies' complexions' on the insensitive collodion plates.[5] Larkin and White later collaborated on the preparation of magnesium in 1870.[6]

Larkin's lamp did not find lasting approval since it was so much easier to burn magnesium wire or ribbon, and White's suggestions were never seriously taken up until the 1880s. However, by the middle of that decade, the use of pure magnesium powder was a well-known technique. One method was to pour powder mixed with sand in a ratio of 1:2 through a funnel into the horizontal flame of a soldering lamp. By varying the proportion of sand a jet of burning magnesium up to 7 ft long could be obtained,[7] which must have been dangerous in a well-furnished household parlour, to say the least. However, having such a large flame was an advantage as it softened the otherwise harsh shadows. If a smaller or weaker flame was needed, more sand was used.

This basic technique was applied in many ways, all depending upon some means of blowing magnesium powder into a flame, usually supplied by a spirit lamp. The duration of flash produced could be very short, or long, depending upon the use of either pure powder or a powder/sand mixture. With powder alone the smoke had less effect on the photograph, since the flash was of shorter duration and the picture was finished before the subject was enveloped, but the technique was less accurate and some powder was often left unburned.

Once the principle had been established, public demand created a huge market for commercially produced magnesium powder burners. Dozens of types, all claiming to be better than their

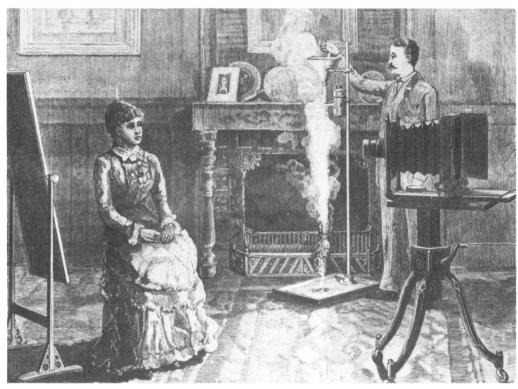

One technique of using magnesium powder was to mix it with sand and pour it through an acetylene flame, usually provided by a soldering lamp.

rivals, flooded the market. All used the same principle, the reservoir of powder being blown into the flame of a spirit burner by a puff of air. This was usually created by squeezing a rubber bulb,[8] although blowing by mouth into a tube was common.[9] The new forms of apparatus were termed 'puff lamps', 'insufflator lamps' or 'powder lamps'. Some had double or triple heads to fire more powder at a time.

Studios and amateurs alike made use of the invention and puff lamps were soon in use underground, for example in Buxton's Poole's Cavern in 1888.[10] The Australian cave photographer Charles Kerry first used magnesium the same year,[11] and later had a huge six-headed powder lamp built for him.[12] One town hall in which it was used had to be cleared for fifteen minutes while the smoke dispersed. It is possible that powder lamps were used for cave photography elsewhere, but magnesium ribbon was the normal choice.

For portraiture, in particular, fumes remained a problem, preventing a second exposure until they had cleared. Cans of magnesium powder could easily be bought in chemist's shops. Cheap 'Heath Robinson' techniques were developed by amateurs

A powder lamp, in its simplest form, enabled magnesium powder to be blown through a flame into a tray.

for burning the metal, one of which made use of a churchwarden clay pipe. The outside of the clay bowl was wrapped in wool or cotton, soaked in alcohol and lit. Magnesium powder was then blown through the pipe to ignite in the flame[13] – a novel way of searing the photographer's eyebrows! Other home-made powder units contained the fumes in some way, such as in a calico bag. Other amateurs constructed tin lanterns, releasing the smoke outdoors after the flash had finished.[14]

More sophisticated magnesium lamps used a reservoir for the powder, controlled by a tap. A puff of air sent the powder into the flame of an alcohol burner. In this version a copper plate was used to spread the resulting blaze into a fan shape.

Obviously, this use of powder could have been accomplished some twenty-five years earlier. All the parts of the invention were known; magnesium powder could be easily produced by careful grinding, and a form of powder was made during early production processes, only afterwards being converted to a solid mass. Spirit lamps were utilized to help keep both wire and ribbon burning when impurities caused them to break. Why was the principle not established earlier?

A definitive answer is hard to give. Perhaps the original cost of the metal was so high that experimentation by photographers only proceeded along narrow paths, using the wire or ribbon alone. The 'prohibitive price of magnesium' in the 1860s was given as a reason by *Scientific American* magazine.[15] Certainly, the earlier use of powder would have helped solve many early problems arising from the magnesium smoke and fumes – at least for a single picture where the flash was finished and the plate exposed before clouds of magnesium oxide descended.

In fact, magnesium powder *had* been used without the aid of a lamp in one instance, soon after production of the metal had begun. That ribbon only burned of its own accord when sufficient oxygen was present had been quickly recognized. A heap of powder refuses to burn evenly as the outer layers of magnesium ignite and smother those inside, starving them of oxygen. To use powder without a lamp, therefore, a means of supplying oxygen had to be found.

Made by Adolf Holzt, this lamp used three heads connected to the same air supply so that more magnesium could be burned with each 'puff'. Petrol or alcohol could be added to the air stream via the attached containers, to aid ignition.

The first attempts to do this had been by none other than Charles Piazzi Smyth, of Egyptian pyramid fame. Before he left England he had discussed the problems of underground photography with his friend, Joseph Sidebotham, who suggested 'flashing off a mixture of magnesium filings and nitre'.[16] Nitre, or saltpetre, was a constituent of gunpowder, and was used to sustain the reaction. Once in Giza, Smyth followed Sidebotham's suggestion, and began experimenting in the King's Chamber.

On 28 April 1865 he 'tried the explosion of 1 oz of magnesium mixed with a small powderhorn . . . of gunpowder', this making up about a quarter of the bulk. The mixture burned rapidly, but the results were poor. Smyth later commented, 'Picture shows little rockets coming over indicating that something else might have been used with adv[antage]'.[16]

The mixture was effective in igniting the magnesium powder and producing light, but had evidently not burned evenly. The gunpowder caused the magnesium to spurt outwards, leaving tracks of the glowing sparks on the negative. The picture, and the technique, were considered failures by Smyth, yet he had produced the first crude flashpowder.

The same thought of inventing a mixture capable of a self-sustaining reaction occurred to J. Traill Taylor, and he gave a demonstration of his compound before the South London Photographic Society in November 1865. It consisted of four parts chlorate of potash, two parts sulphide of antimony and one part each of sulphur and magnesium filings.

As can be seen, very little of the mixture consisted of magnesium. The inclusion of most of the chemicals was designed to support the reaction, functioning in a similar way to the oxygen-rich chemicals in Moule's photogen and gunpowder. Traill Taylor's preparation was effective. 'The light emitted by the combustion of the above', he commented, 'is exceedingly brilliant and highly actinic.' He was lucky not to have caused an accident; the mixture was highly explosive. Few people knew of Smyth's prior use of gunpowder with magnesium, and Taylor was later (wrongly) credited as the inventor of the first flashpowder.[17]

The following year, 1866, Charles Waldack performed a similar experiment during his second Mammoth Cave expedition. He sent the resulting picture to Edward Wilson, editor of the *Philadelphia Photographer*, who wrote in evident excitement:

> Wonder upon wonders, an *instantaneous view inside the Cave!* Who now shall doubt the abilities of magnesium? This was made by exploding ¾ ounce of magnesium filings and ¼ ounce of pulverized gunpowder in reflectors. . . The picture shows the sparks spirting out in all directions, and a picture has been made of the light which made it.[1]

Even though these early experiments successfully produced light, magnesium was still expensive in the years just after manufacture began, and magnesium ribbon itself had hardly been exploited. Both Taylor's compound and the use of gunpowder proved to be uncontrollable, and a long period followed until the next experiments to find an efficient mixture took place.

In January 1883, G.A. Kenyon tried burning magnesium ribbon in oxygen before a meeting of the Liverpool Amateur Photographic Association. Finding the result superb, with an even more brilliant light than he expected, Kenyon then tried mixing magnesium powder with a chemical that contained its own rich supply of oxygen, potassium chlorate. The amount of smoke was incredible: the mixture went off with a brilliant flash, but the fumes it

generated caused him to cease his experiments. Anyone repeating his process, Kenyon said, should wear dark glasses 'otherwise injury to the sight is inevitable'.[18] It was four years before the experiment was eventually repeated by two Germans working in Potsdam, Adolf Miethe and Johannes Gaedicke, although without the suggested dark glasses.

The two men also used potassium chlorate, but sealed the reaction inside a lamp to contain the smoke. A tube allowed air in, the fumes and ash being puffed out using bellows after the exposure was completed. Further experiments soon determined that other chemicals added to the magnesium could produce coloured flashes, and different mixtures determined the different characteristics of the flash.[19] The burst of light was so instantaneous that the photographic journals of 1887 thought that here, at last, was a method for taking sharp photographs of moving objects for the first time. They were right. Flashpowder, and the term 'blitzlicht', or 'flashlight', had arrived.[20]

The ability to produce instantaneous photographs at night, or to arrest motion during the day with the short-duration flash, transformed photography. Very little apparatus was required. All the photographer had to do was set light to the powder, and the rest was automatic. One reporter for the New York *Sun* newspaper, a Danish immigrant named Jacob Riis, read a report of the Germans' findings one morning, and realized the inherent potential in this 'instant light'. He was involved with the housing problems of the poor of the city and employed two photographers to take pictures of the squalid dwellings at night. By February 1888, his employees having failed to produce the photographs he wanted and proving themselves untrustworthy, Riis bought a camera and entered the city slums, intent on photographing the wretched immigrants.

> Our party carried terror wherever it went. The spectacle of strange men invading a house in the midnight hours armed with [magnesium] pistols which they shot off recklessly was hardly reassuring.[21]

The pistols created havoc. These were similar to guns, firing magnesium cartridges 'which could be handled without danger', asserted E. & H.T. Anthony's illustrated catalogue.[22] Although not flashpowder, these cartridges produced an explosive light that had the same effect. Yet, while they were supposedly 'safe', one group of blind beggars were lucky to keep their lives as the flash not only exposed the plate but set fire to their room. A policeman thought them fortunate indeed, for 'the hovel had been just too dirty to burn'.[21] Riis was using a novel method of igniting his powder, throwing a match into a heap of it in his old frying pan.

A photogenic pistol, used to fire magnesium cartridges. It was advertised as being useful 'for instantaneous photography at night'.

Riis's evocative pictures were reproduced as line drawings in the *Sun*, both helping him further his cause and drawing flashpowder to the attention of many.

Incidents where powder was burned uncontrollably were commonplace. Flashpowder made from magnesium and an oxidizing agent was essentially an explosive mixture. The power of an explosive can be measured by the amount of gas it generates when it instantaneously burns. One kilogramme of gunpowder generates about 200 litres of gas inside a cannon, propelling the cannonball out of the barrel. In comparison, flashpowder produced almost twice as much, 356 litres, and for the next few years accident followed accident, fires and explosions causing loss of life and limb – literally.

In Philadelphia the city's photographic society soon warned its fellow photographers of three accidents that had occurred during the production of flashpowder. If the ingredients were produced as a fine dust the reagents, with their increased surface area, ignited more readily. The grinding process took place in a mortar and pestle, and was one of the riskiest parts of the preparation.

The first accident occurred when some flashpowder exploded while being ground, the second while the ground powder was being sieved. In each case the photographer died. The third and most serious accident happened when a bottle containing several pounds of old powder was being flushed down a drain. It was thought that the chemicals were

> . . . detonated by an accidental blow, and from thence the entire mass was detonated. No smoke or burns appeared upon the bodies of those killed, or surrounding objects, thus proving the absence of fire.[23]

Wiley and Wallace's laboratory, where the accident occurred, was totally destroyed, along with three men.

To minimize risks, flashpowder manufacturers suggested mixing the chemicals just before use, and in front of audiences they hammered the separate ingredients to show how safe they were. Other chemicals, such as lithium and barium, were sometimes mixed in to produce coloured flashes. It was hoped that these would produce a stronger effect on the blue-sensitive plates: in fact the chemicals added little to the sensitivity of the light, but a great deal to the pungent, poisonous fumes.

One item of information that was not well publicized was the action of flashpowder when used in dry or damp states. Experiments showed that dry chemicals mixed together and immediately ignited were prone to detonate, but if allowed to take up moisture from the air for a few moments would burn with a controllable flash. However, if dampened and then re-dried, flashpowder

became even more explosive and unstable.[23] Before this was fully understood many photographers were frightened by the numerous explosions and deaths that resulted from incorrect use of magnesium flash, and refused to use the compound. However, flashpowder had already proved so indispensable that its overall use grew and, as precautions were ignored, the accidents continued.

Flashpowder lamps quickly appeared. The commonest methods were to light the compound with a taper or match after it had been spread out in a pan or tray or sprinkled onto guncotton. Both techniques gave a large, diffuse light source. Using guncotton, which did not explode, because it was not compacted, allowed easy ignition of the powder. This was especially important if the constituents had not been ground or mixed thoroughly.

Other techniques used percussion caps fitted in striking mechanisms similar to a pistol hammer, sparks struck from flints, or an electric charge from a battery which heated a platinum wire fuse.[24] Commercial lamps were sometimes quite complex. One utilized a tray into which a cord was inserted. Pulling this struck a match which automatically passed through a hole in the reflector to light the powder. One delighted MD, Henry G. Piffard, terrified his subject with his Photogenic Pistol, aiming it at his victim before pulling the trigger. The variations were endless and Piffard's technique was easily improved on, fortunately for his subjects. Indeed, experimentation with mechanisms for firing the powder would later lead to crude synchronizers where the flash explosion triggered the camera shutter.[25]

Most flashpowder preparations that were marketed were described as 'smokeless flash compounds', a statement which did not indicate the clouds of smoke that nevertheless appeared. Their advantage, and the 'smokeless' reference, referred to the duration of the flash and exposure; it was only after the picture was finished and the shutter closed that the room filled with fumes. Also, the duration of the flash was even shorter than that of a pure magnesium lamp, about an eightieth of a second compared to about a seventh, and was ideal for use with dry plates. However, fumes still limited the use of flashpowder to a single exposure and, while it gained in popularity, 'the blinding, smoke belching, evil smelling flashlight powder' also established a fearsome reputation. Photographic manuals later commented that:

> The idea has got abroad that there is great risk and danger involved on account of the explosive nature of the powders. Sitters having a startled expression or eyes closed altogether have helped to make artificial light photography unpopular. . . When all went well, its action was disagreeable and alarming. When things went badly, as they often did, a burned hand or a burned building resulted. The flashpan was a piece of equipment

which the wise photographer kept in his cupboard, and only took out when there was no other way to get the job done.[2]

Bengal light, the cheap and ever-present alternative to magnesium, still found favour among a few amateurs, who now contained it within a lantern. However, its low cost was the only reason for its continued use; magnesium was still too expensive for the amateur to experiment freely with.[26] Bengal light remained unsuitable for photographic use underground. Flashpowder, with due care, allowed the consistent production of a flash of light, and it was not long after the formula was published before it was used in caves. With a near-instantaneous flash, many problems with fumes could be avoided.

Dr Max Müller in Germany was ideally placed to receive news of Gaedicke and Miethe's discovery, and in 1888, the year after their announcement, he used the 'magnesium blitzlicht' to good effect in the Hermannshöhle. One of the best-known tourist sites in Germany and situated conveniently near Berlin, the location was an obvious choice. In 1889 Müller published a set of twenty albumen prints (sixteen of them underground) in a monograph on the caves,[27] some of the earliest taken in a cave using flashpowder. Along with the pictures he included detailed notes and tables on the techniques he had used. Müller tabulated apertures and distances for different lenses, and showed how amounts of flashpowder could be calculated for specific distances. Previously, it had been left to the individual to estimate the necessary quantities of ribbon or powder required for any given photograph. Even the information supplied by manufacturers was poor when applied to caverns, which did not reflect light in predictable ways.

Damp flashpowder was difficult to ignite with a simple match. In the humid atmosphere found underground, flashpowder was difficult to keep dry and other problems arose when choosing the best place to set off the flash. The light had to be well to one side of the camera to add relief to the picture: so that it could still be fired efficiently a reliable flashlamp was required. Müller devised a novel apparatus to counter both these basic difficulties of placement and ignition.

Müller wanted to use the technique of pouring flashpowder onto teased-out guncotton. Lighting the cotton would initiate a large, diffuse flash; more sophisticated flash trays and lamps were neither developed to any extent, nor were they readily available. The difficulty lay with lighting the guncotton; something more reliable than a match was needed. The system also had to operate when the apparatus was held at the end of a pole well above Müller's head. To solve his problem, Müller used an adaptation from a pure magnesium powder lamp. These typically used an alcohol burner into which powder was blown. The same action using

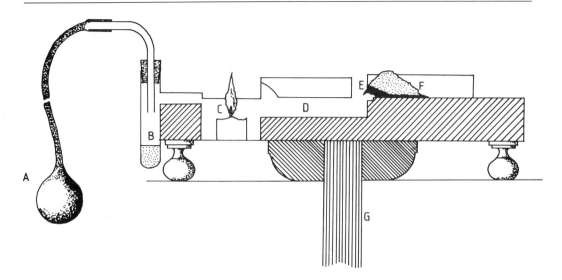

Müller's flash apparatus used a blast of air from a bulb (A) to blow lycopodium spores (B) into a candle flame (C). These glowed and were directed down a tube (D) to light a twist of guncotton (E) which fired the flashpowder (F). This was used successfully, on the end of a pole (G), in the Hermannshöhle, Germany.

flashpowder was not considered safe. With an oxidizing agent in the compound it would be possible for the mixture to explode while still within the reservoir or to shower the operator with viciously-hot sparks.

To transfer heat from the flame to the guncotton, Müller used lycopodium spores in a storage reservoir. These came from a fungal puffball, and formed a very fine organic dust. This was injected into a candle flame when a rubber bulb was squeezed. Not hot enough in themselves to set light to the flashpowder, the glowing spores were directed through a tube to ignite a fuse of guncotton. The resulting blaze of light was reflected towards the subject by a sheet of white card.

The apparatus was accurately made and well designed, if somewhat complex. Müller suggested that if more light was required, further units could be attached using 'T' pieces in the tubing. However, simpler methods of firing flashpowder were soon produced and the complicated nature of Müller's flashgun consigned it to obscurity.

The mixture of flashpowder that Müller tried seemed to be thought worthy of general use, with its much higher proportion of magnesium. The formula of 'potassium chlorate three parts, potassium perchlorate three parts, and magnesium powder four parts' became known for a while as 'Müller's powder'. His photographs were immediately accepted by his fellow photographers as being among the best ever produced underground.[28]

Photographers now had the opportunity to choose the best lighting for their needs. Limelight, Bengal light and arc lights had been superseded by magnesium ribbon, pure magnesium powder

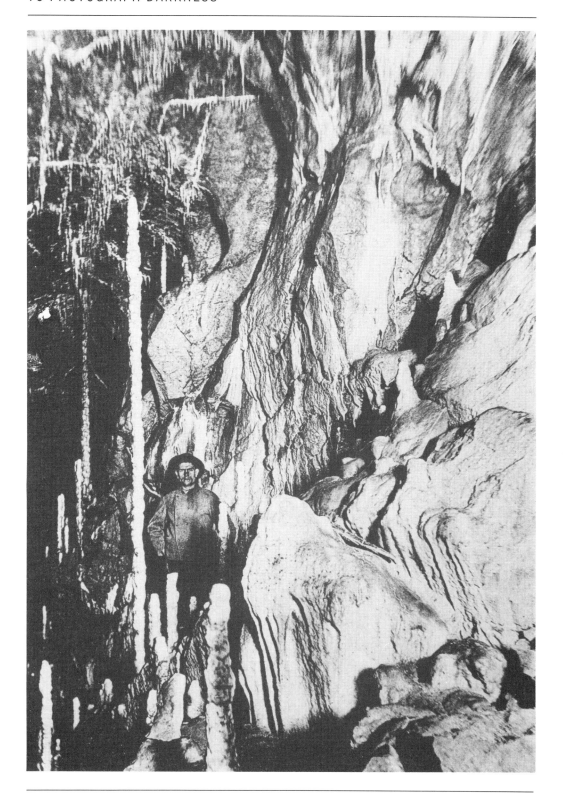

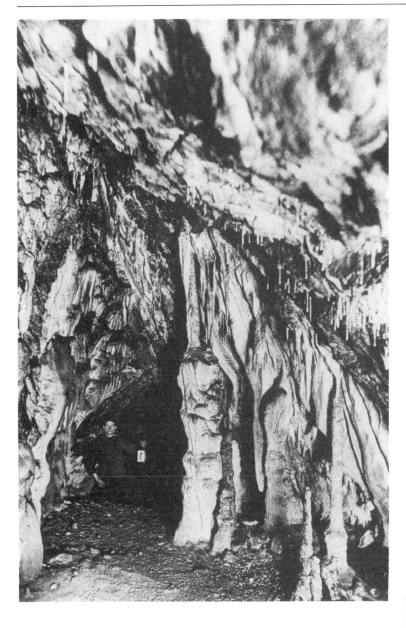

and flashpowder. The latter could now be bought in cans with two ingredients for mixing just before use. Paper soaked in potassium nitrate – similar to that used for fireworks – could be purchased for use as a fuse. Flashbags were marketed; these were large paper sheets, impregnated with acid and dried, becoming virtually identical to guncotton, before coating with flashpowder compounds. This was then hung up inside a bag of fireproofed cotton

Müller was assisted in his photography by the cave guide, who appears in several of the pictures. This picture (far left) in the Hermannshöhle, Germany, was produced in 1888. With flashpowder, shadows became more pronounced, but there was less chance of movement occurring during the exposure. The guide (above) used a hand-held lamp, prepared by Müller, to enable him to focus before firing the flash.

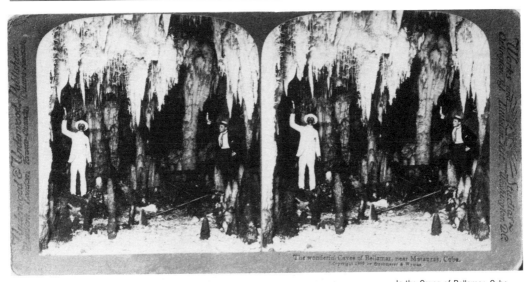

In the Caves of Bellamar, Cuba. This popular 1899 Strohmeyer and Wyman stereo card was published, as were many others, by the huge firm of Underwood & Underwood. Many such cards were produced for the tourist boom of the 1890s.

and lit, the fumes being trapped inside. Treated and coated tissue paper could be suspended as a sheet and produced a large diffuse flash due to the enormous area it came from.[29] Yet, while flashpowder was extremely popular, it was still not used by every photographer. Many retained their tried and tested ribbon or pure powder, and there was a degree of dissent concerning the best methods to use. There was still no obvious place to seek advice concerning the use of magnesium underground.

The last decade of the century saw a resurgence of public interest in stereo cards. Many photographers were taking pictures of all types of tourist attractions and at least 400 stereo cards of the Jenolan Caves were estimated to have been produced, for example.[30]

Selling original photographs in this way was not the only outlet. Methods of reproducing photographs using dots of ink on a printed page, known as half-tone reproduction, had been discovered towards the end of the 1870s and first used in the New York newspaper the *Daily Graphic* in 1880.[31] Earlier illustrations depended upon the production of drawings, sometimes based on photographs, with varying degrees of realism. Examples are those taken in 1876 in the Belgian caves of Han by Armand Dandoy, which were used to illustrate guide-books around 1883.[32] This use of pictures was common practice; Waldack's classic Mammoth Cave photographs were also converted to drawings to illustrate guide-books, for example.[33] One of the earliest half-tone reproductions of a cave in book form was a picture of the caves at Urdon in Spain, published in 1885.[34] The new technology allowed the production of photographic guide-books, which soon became

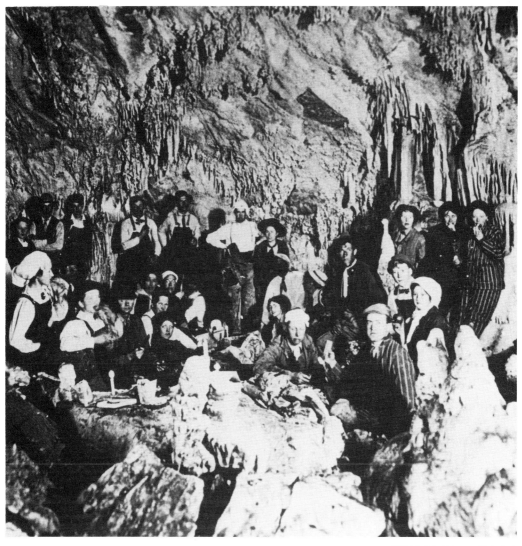

Caves in America were often used for Sunday gatherings, where the summer heat was exchanged for the cool of the underground. This stereo card was produced by N. A. Forsyth in Morrison Cave. Forsyth, of Butte, Montana, also photographed underground copper-mining operations between 1906 and 1912.

major money-spinners at tourist caves. In 1890 the Louisville commercial photographer C.G. Darnall published a guide-book containing twelve underground views of Mammoth Cave using half-tone reproductions,[35] although not all were his own work.

In addition, magazines were making use of the half-tone process to replace their previous wood engravings. General interest magazines, in particular, required pictures of the unusual. In 1891 *Demorest's Family Magazine* commissioned Frances Benjamin Johnston, the 'first woman press photographer',[36] to photograph Mammoth Cave.[37] Johnston used flashpowder to produce a set of

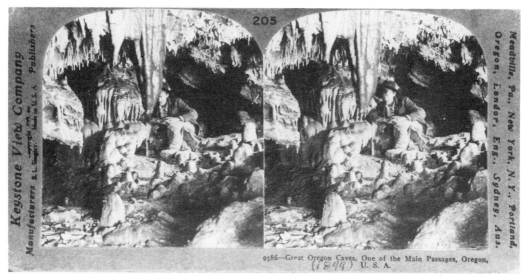

B. L. Singley copyrighted this Keystone stereo photograph of Great Oregon Caves in 1899. The principle of the stereo card, with different viewpoints for each picture, is clearly seen.

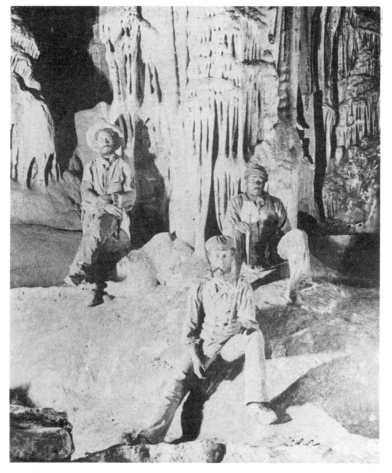

Fred Pfühl photographed Cango Caves, South Africa, in 1898 and 1899, selling the set of twelve views at the local newspaper office. This photograph, number four in the series, shows the chief guide, van Wassenaar, with two assistants.

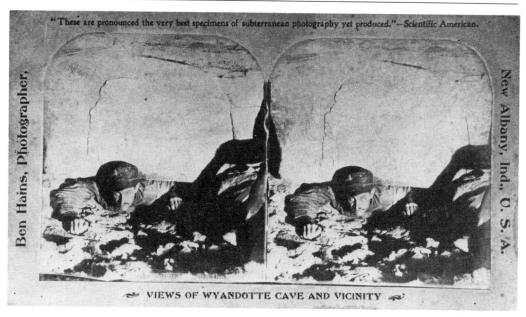

"These are pronounced the very best specimens of subterranean photography yet produced."—*Scientific American*.

Ben Hains, Photographer,

New Albany, Ind., U. S. A.

❧ VIEWS OF WYANDOTTE CAVE AND VICINITY ❧

A Ben Hains stereo card from Wyandotte Cave, taken in 1889, with the quotation from *Scientific American* that he used on many of his cards: 'These are pronounced the very best specimens of subterranean photography yet produced.' Guides to the cave supplied 'candles and a few bengal lights', but visitors were advised to also bring magnesium ribbon for the three tourist routes, one of them ten miles long.

photographs, one showing tourists drifting in a long narrow boat along Echo River; *Demorest's* published the photographs in 1892. Her pictures, together with other photographs by Darnall and Ben Hains, were reprinted in 1893 in a small Mammoth Cave guide-book by the Louisville and Nashville Railroad. The railroad concerns were evidently still attracting tourists to their services by such methods. The change-over to half-tone was a slow process. For example, photographs by C.E. DeGroff in the Marble Cave of Missouri, taken in 1893 specifically for magazine use, were nevertheless converted to drawings.

Out of the millions of stereo cards and pictures reproduced in magazines every year, the number of underground photographs taken remained few, and the subject unusual. Yet the results obtained during the 1890s were numerically on the increase and largely of good quality. Commercially instigated underground pictures were being taken around the world in such locations as Czechoslovakia, Cuba, Barbados and South America as well as Europe, Australasia and America.[38] Amateur photographers were also more numerous. George Eastman introduced the innovative Box camera, which was commonly used in the 1890s to make simple records and snapshots of family life without resorting to bulky and time-consuming plate cameras. Certainly, amateurs such as Bert Leck, who recorded picnics in McKittrick Cave (USA) around 1890,[39] showed the ease with which such cameras could be used with artificial light.

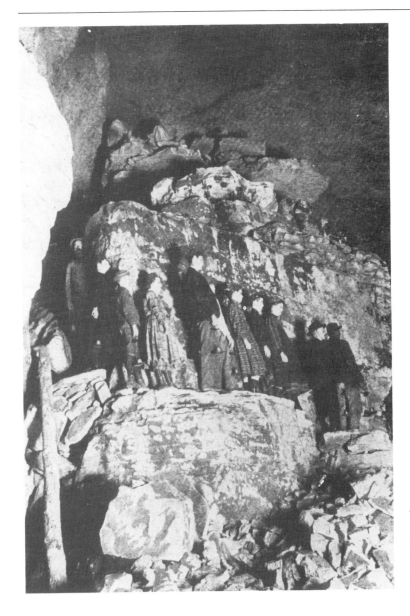

The 'Exit of Corkscrew into Main Cave' in Mammoth Cave, photographed by Ben Hains in 1892. The picture was copyrighted in 1896 by H.C. Ganter, manager of the cave, and used as a postcard.

However, most underground photographs still involved a great deal of experimentation by the photographer. Guidance from such items as Müller's tables, which remained obscure, was not readily available. Nevertheless, magnesium in some form, usually flash-powder, was universally the chosen light common to all those venturing underground.

There are numerous examples of photographers taking pictures for book illustrations, stereo cards or advertising during this period, most of them only interested in monetary returns from

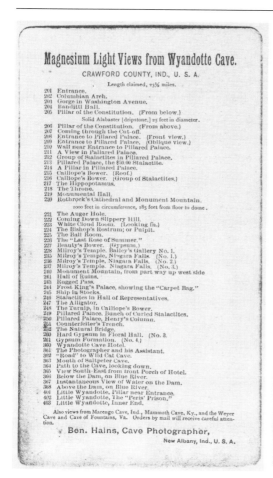

Magnesium Light Views from Wyandotte Cave.

CRAWFORD COUNTY, IND., U. S. A.

Length claimed, 23½ miles.

201 Entrance.
202 Columbian Arch.
203 Gorge in Washington Avenue.
204 Banditti Hall.
205 Pillar of the Constitution. (From below.)
 Solid Alabaster [dripstone,] 25 feet in diameter.
206 Pillar of the Constitution. (From above.)
207 Coming through the Cut-off.
208 Entrance to Pillared Palace. (Front view.)
209 Entrance to Pillared Palace, (Oblique view.)
210 Wall near Entrance to Pillared Palace.
211 A View in Pallared Palace.
212 Group of Stalactites in Pillared Palace.
213 Pillared Palace, the $50.00 Stalactite.
214 A Pillar in Pillared Palace.
215 Calliope's Bower. (Roof.)
216 Calliope's Bower. (Group of Stalactites.)
217 The Hippopotamus.
218 The Throne.
219 Monumental Hall.
220 Rothrock's Cathedral and Monument Mountain.
 1000 feet in circumference, 185 feet from floor to dome.
221 The Auger Hole.
222 Coming Down Slippery Hill.
223 White Cloud Room. (Looking in.)
224 The Bishop's Rostrum; or Pulpit.
225 The Ball Room.
226 The "Last Rose of Summer."
227 Beauty's Bower. (Gypsum.)
228 Milroy's Temple, Bailey's Gallery No. 1.
235 Milroy's Temple, Niagara Falls. (No. 1.)
236 Milroy's Temple, Niagara Falls. (No. 2.)
237 Milroy's Temple, Niagara Falls. (No. 3.)
240 Monument Mountain, from part way up west side
241 Hall of Ruins.
243 Rugged Pass.
244 Frost King's Palace, showing the "Carpet Bag."
245 Ship in Stocks.
246 Stalactites in Hall of Representatives.
247 The Alligator.
248 The Turnip, in Calliope's Bower.
249 Pillared Palace, Bunch of Curled Stalactites.
250 Pillared Palace, Henry's Column.
251 Counterfeiter's Trench.
252 The Natural Bridge.
300 Hard Gypsum in Floral Hall. (No. 3.
301 Gypsum Formation. (No. 4.)
360 Wyandotte Cave Hotel.
361 The Photographer and his Assistant.
362 "Road" to Wild Cat Cave.
363 Mouth of Saltpeter Cave.
364 Path to the Cave, looking down.
365 View South-East from front Porch of Hotel.
366 Below the Dam, on Blue River.
367 Instantaneous View of Water on the Dam.
368 Above the Dam, on Blue River.
401 Little Wyandotte, Pillar near Entrance.
402 Little Wyandotte, The "Perm' Prison."
403 Little Wyandotte, Inner End.

Also views from Marengo Cave, Ind., Mammoth Cave, Ky., and the Weyer Cave and Cave of Fountains, Va. Orders by mail will receive careful attention.

Ben. Hains, Cave Photographer,
New Albany, Ind., U. S. A.

Magnesium Light Views

—FROM—

MARENGO ✶ CAVE

CRAWFORD COUNTY, IND., U. S. A.

501 Statue of Liberty.
502 The Tobacco Sheds.
503 "Adams Express Co"
504 "The Church Organ."
505 Wall in Crystal Palace.
506 Roof in Crystal Palace.
507 In Crystal Palace Gallery. (West end.)
508 In Crystal Palace Gallery. (East end.)
509 The "Bridal Curtains."
510 The Visitor's Wonder.
511 Stalactitic and Stalagmitic Columns.
512 Hains' Alcove.
513 "Cave Hill Cemetery."
514 Washington's Monument in Cave Hill Cemetery.
515 Vault in Cave Hill Cemetery.
516 "Tallow Dips" in Vault.
517 Hovey's Column.
518 Tower of Babylon.
519 The Obelisk.
520 Mount Marengo.
521 The Golden Gate.
522 The "White Caps."
523 The Gnome's Doorway.
524 Cupids Net.
525 The Prison Bars.
526 Mount Vesuvius.
527 Garfield's Monument.
528 Crystal Palace–View from North End.
529 Washington's Plume.
530 The Marble Table.
531 Psyche's Spring.
591 Entrance of Old Cave.

Also views from Mammoth Cave, Ky., Wyandotte Cave, Ind.. and Weyer Cave and Cave of Fountains, Va. Orders by mail will receive careful attention.

Ben. Hains, Cave Photographer,
New Albany, Ind., U. S. A.

Hains advertised his series of views on the back of each card, for example those from Marengo Cave and Wyandotte Cave.

publications and sales. Successful or not, they typically went underground once, then never returned again to the subterranean world. But the emphasis was changing. In the caverns of America and Australia, in particular, some photographers were beginning to exploit the new technology, sometimes with different interests.

In America the Revd Horace C. Hovey had become interested in the study of caves, and increasingly encouraged the production of photographs. He was influential in the journalistic field, acting as a correspondent to *Scientific American* magazine.[40] He spent many of his annual holidays examining caves and writing accounts of them for the popular press, although he did little original exploration and overall added scant knowledge to speleology as a science. He was, though, directly involved with the photographers Harry A. House and Ben Hains.

In 1889 House accompanied Hovey to West Virginia, where a

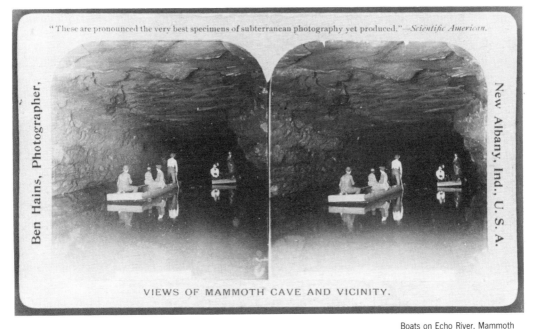

"These are pronounced the very best specimens of subterranean photography yet produced."—*Scientific American.*

Ben Hains, Photographer,

New Albany, Ind., U. S. A.

VIEWS OF MAMMOTH CAVE AND VICINITY.

Boats on Echo River, Mammoth Cave, in 1889. The lack of movement, compared with pictures taken by Sesser in 1886, is a sure indication that Ben Hains was using flashpowder for his photographs.

study of the Jewell Cavern was to take place.[41] The cave was a tourist attraction, originally discovered when the Chesapeake and Ohio Railroad (under the command of a Capt. Jewell) laid a line through a cutting, exposing the entrance. Having 'explored' the chambers and passages, Hovey and House decided to take a picture of the Cyclopean Hall, a large decorated cavern. At one end was an area with overhanging ledges and a pool of water, which they named 'Harry's Laboratory' due to its 'facilities for the mysterious processes of subterranean photography'.[42] Their approach was typical of those with limited experience in the field.

Experiments elsewhere in instantaneous photography by artificial light hardly prepare one for the absolute blackness. . . The cavern atmosphere is naturally very pure and clear. But if any smoke is made, it may take hours, or even days, for it wholly to escape. We had, therefore, to find the points most desirable to be taken, fix our instruments, and get the proper focusing, with as little torchlight as possible.

For the most part we relied on coach candles. We were annoyed daily by troops of visitors, who would insist on carrying big torches, each emitting its mass of smoke, and who would want to stand around and watch our operations. Finally, we got rid of this annoyance by circulating word through the neighborhood that, if they would keep entirely away from us till our

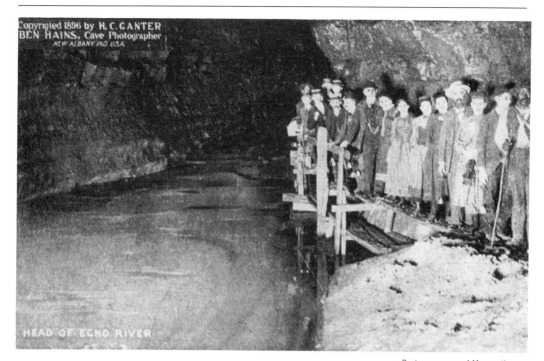

Copyrighted 1896 by H. C. GANTER
BEN HAINS, Cave Photographer
NEW ALBANY IND. U.S.A.

HEAD OF ECHO RIVER

Ganter, manager of Mammoth Cave, copyrighted many of Ben Hains' photographs for use as postcards. This photograph was registered in 1896. In it, a black guide leads his party of tourists along the shore of Echo River.

last day there, we would reward them by a grand illumination with fireworks; but if they persisted in hindering us, there would be no display of pyrotechnics. The plan worked admirably, and we had the cavern to ourselves.

Having selected our point of view, and made ready for the exposure, our plan was to burn, first, several yards of magnesium ribbon, and then fire off six or more magnesium cartridges placed so as to secure as many details as would comport with a good general effect. Before disturbing the camera, the artist would take several duplicates, so as to have them to choose from. We also tried a mixture of green fire and magnesium dust; but with less satisfactory results. Our conclusion was that, on another visit, we should take with us portable cylinders and depend on the calcium light, which, while less vivid than the magnesium light, makes no smoke and could be freely used at less expense.[42]

By 1882 manufacturers had discovered that by putting a dye on the plates they could increase the emulsion's sensitivity to green light. The resulting blue-green sensitive plate was termed 'orthochromatic', hence the attempted use of 'green fire' – Bengal light mixed with chemicals to tinge it green, rather than the normal blue-white. With the fumes it produced the mixture would have been of little assistance.

One of Henry King's stereo cards, number 100 in the sequence: Coral Grotto, Jenolan.

The outcome of this photographic attempt is unknown, and House's attempt was presumably less than perfect due to both his and Hovey's inexperience. The foregoing procedures certainly show a lack of knowledge of even established underground techniques. However, Hovey had another friend, Ben Hains, who was somewhat more proficient.

Hains was a professional photographer from New Albany, Indiana, who became interested in subterranean photography when approached by Hovey late in 1888. Hovey often gave lectures to various societies, and wanted a new set of lantern slides to add to or replace the older ones he had possessed since the beginning of the decade. These original slides had probably been produced from parts of stereo pairs.

The first of Hains' new pictures were taken in Wyandotte, Marengo, and Sibert's Caves, and by all accounts he was highly successful. In March 1889, following one of Hovey's lectures, *Scientific American* magazine stated of Ben Hains' stereos: 'These are pronounced the very best specimens of subterranean photography yet produced.'[43] Hains, as possibly the first photographer to specialize in this type of work, perhaps deserved the title he proudly bestowed upon himself and wrote on his stereo cards: 'Ben Hains, Cave Photographer'.[44]

In April 1889, Hovey took the 23-year-old Hains to the area around the Bottomless Pit of Mammoth Cave.[45] Hovey still required photographs from various parts of the complex of passages, but on that occasion, noting measurements as he went, Hains became only the second person to undertake any exploration

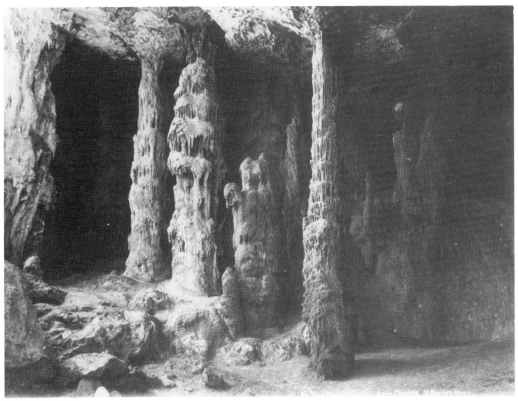

The Ball Room in Nettle Cave, Jenolan, taken by Henry King. Nettle Cave was so named for the many groups of nettles that grew near the entrance. The picture was made with the aid of daylight.

there. Using a plumb line, the shaft depths were measured, and sketch maps drawn. Later, he was also involved in the early exploration of the Colossal Cavern of Kentucky, soon after its discovery in 1895.[46]

Hains continued with his underground photography, marketing many of his views as stereo cards. Most of these were from tourist caves in or near the state of Indiana, many of which he had been shown by Hovey. Using magnesium he produced more than 250 pictures in the next few years.[29] Apart from Wyandotte Cave near New Albany, Marengo Cave yielded some thirty-two stereos. The Cave of Fountains (now named Fountain Cave) and Weyer Cave (Grand Caverns) in Virginia, and of course Mammoth Cave itself with over 140 views, made up the majority of the set. The Mammoth Cave photographs proved extremely popular, and were published not only as stereos by Hains, but also as lantern slides following their use by Hovey. Some were copyrighted and sold as postcards by H.C. Ganter,[47] the manager of Mammoth Cave. It seems that over the succeeding years the two men often worked in close collaboration, Hains producing the pictures,

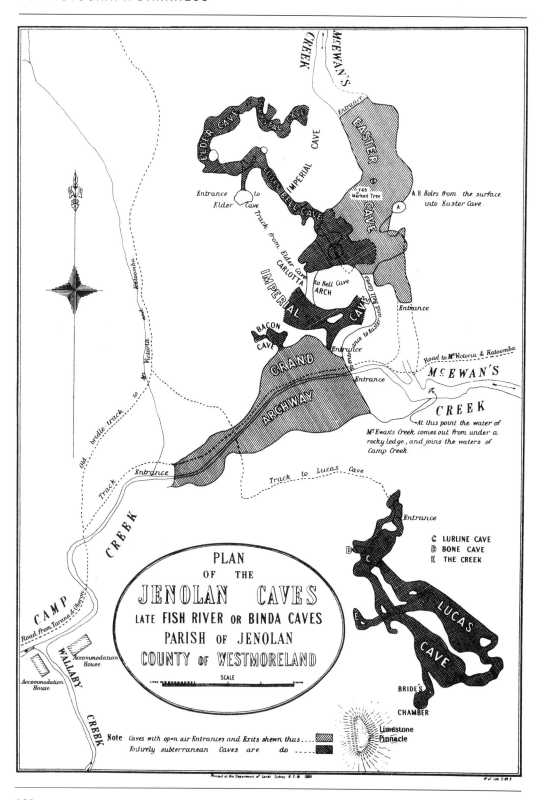

PLAN
OF THE
JENOLAN CAVES
LATE FISH RIVER OR BINDA CAVES
PARISH OF JENOLAN
COUNTY OF WESTMORELAND

Ganter publishing them and presumably paying a fee to Hains for their use.

Ben Hains was able to depict his subjects crawling and squeezing through narrow clefts, or boating down subterranean rivers, with equal skill. The cards were labelled as 'Magnesium Light Views' and, while some were certainly taken using magnesium ribbon, many appear to have made use of the instantaneous light given by flashpowder. Shadows on these are well defined, light coming from a single point, whereas those taken with ribbon are more diffuse due to the wavering, slowly burning metal. Rafts on Echo River in Mammoth Cave are crisply lit, the occupants without a trace of movement in either body or reflection. Hains was so prolific, it is difficult to find a contemporary American book concerning caves which is not illustrated by at least one of his pictures.

A similar interest in caves was to be found in the Australian photographer Charles Henry Kerry of Sydney. Towards the end of the 1880s he became interested in the Jenolan area. Kerry had begun his photographic career in 1875, aged seventeen, by buying into a business. He was soon abandoned by his partner, who ran off with the assets and left Kerry with the debts, but Kerry worked to pay these off and establish his own reputation.[48] He soon employed a large number of people to take pictures for him, to the extent that many photographs credited to Kerry were in fact taken by his staff.[49] It was, unfortunately, common practice in Australia for a photographer to imprint his studio name on a picture, regardless of who made the exposure.

Kerry was not the only photographer resident in Sydney. One of his rivals, Henry King, had been established at 316 George Street since 1880. King produced a number of views of Jenolan during the latter part of the 1880s, but while it has been said that King's landscapes were superior to Kerry's,[50] once underground Kerry was the master.

Kerry was deeply interested in the 'great outdoors'. He was not only a photographic pioneer but was also involved with cave exploration, especially in the Yarrangobilly and Jenolan areas. With his known interest in these caves, any underground photographs bearing the Kerry imprint were undoubtedly taken by Kerry himself.

It was partly King's use of flashpowder that drew Kerry's attention to it, his experiments with magnesium beginning in 1888. Soon after, he began photography at Jenolan, where increased tourism provided a ready market. Conditions to be found at the caves were still crude. Travel from Sydney was by pack-horse, the exploration by candle-light or magnesium ribbon burned in clockwork lamps, although some areas were lit by electricity. Nevertheless, some of Kerry's caving was original in nature, for

LEFT, This survey of Jenolan was printed in 1889. Several caves were not then known; others have not been depicted. For example, Imperial Cave extends below the level of Elder Cave and Bell Cave. The portion of Imperial Cave to the south was known as Left Imperial, while that to the north was Right Imperial. Easter Cave was an alternative name for the Devil's Coach House.

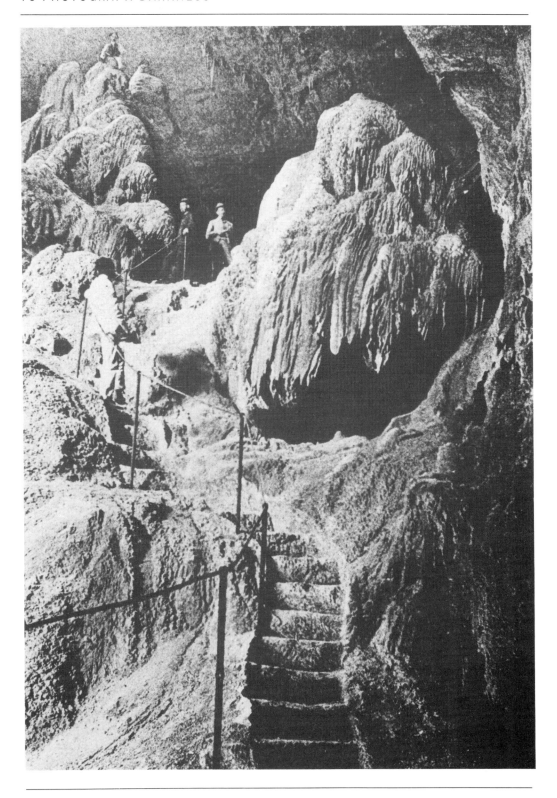

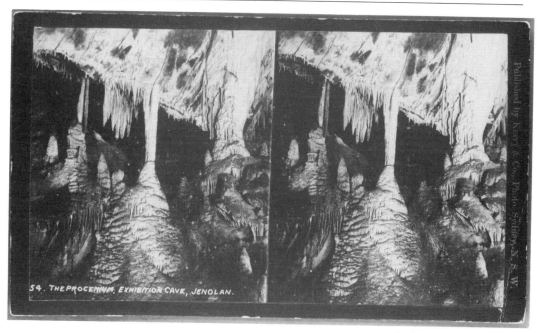

The Procenium in Exhibition Cave, Jenolan. Kerry's stereo views were mounted on deep red card, his name in gold letters.

example when he discovered and named Jersey Cave in 1890.[51] The cave was photographed during its exploration.

To descend the various pitches at Jenolan, men and cameras were lowered by ropes when necessary. Kerry's work was not easy:

> The man who would systematically explore the caves and make records should be of muscular build and have great strength and endurance. One is forced to place himself in the most awkward positions and places, perhaps himself and his camera on an extremely narrow ledge where it is necessary to remain for some time. In my climbing about, I have had many falls, and have, in cave working, smashed up three cameras beyond repair.[52]

Correct exposure was difficult. The heat encountered on travelling to the caves could affect the sensitivity of dry plates, increasing it so that about a quarter of the expected exposure was needed. Clouds of smoke from Kerry's magnesium ribbon burner took up to a day to settle, so new locations were chosen for each shot.

The pictures from Jenolan and elsewhere were released as stereo cards, and then in 1889 eighteen of the prints were published in book form. This volume, *The Jenolan Caves: An Excursion In Australian Wonderland*,[53] was written by Samuel Cooke with the photographs credited to Kerry & Jones of Sydney,

LEFT, By the late 1880s the caves at Jenolan had been prepared for tourist visits, with handrails and steps. Kerry's photograph in Nettle Cave, taken *c.* 1887, shows four people. The man at the top has been drawn onto the plate before printing.

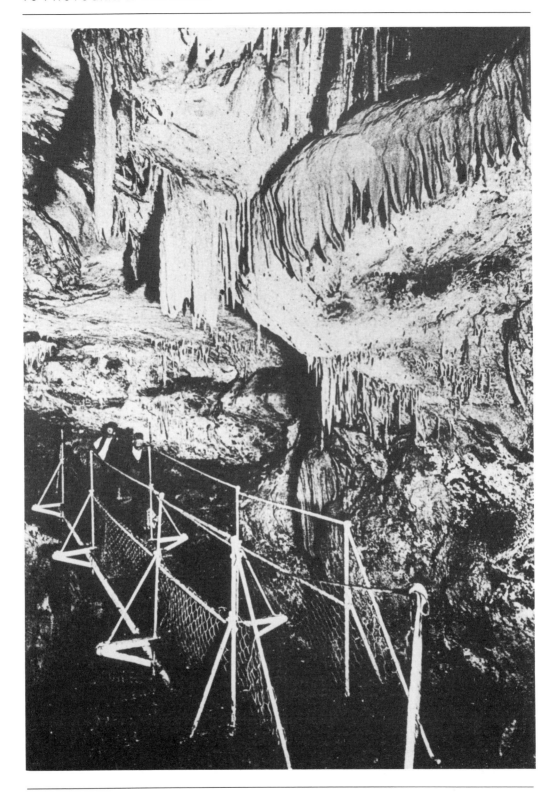

C.D. Jones partnering Kerry from 1885 to 1892 at his George Street studios.[49] This was the first time that cave photographs had been printed on normal paper for distribution in a book devoted to caves, rather than by the more usual technique of gluing original albumen prints to a page.[30]

Kerry's interest in caves was strengthened by his friendship with Oliver Trickett. A Yorkshireman, Trickett was named after Oliver Cromwell due to his father's great admiration for the man, and was brought to Australia around 1860, aged thirteen. He became first a draftsman, then, in 1868, a surveyor, beginning work with the Department of Lands in Sydney in 1876. This led to his appointment as government surveyor of the caving areas.[54]

Trickett was a capable photographer, and often seems to have worked alongside Kerry; indeed, many later pictures published by Kerry were in fact taken by Trickett, although not always identified as such. Many of Trickett's own photographs were used in the official guide to the caves.[55] Between them, Kerry and Trickett photographed many cave interiors, and were often able to depict passages soon after their discovery, before paths were laid and access improved. Kerry's cave photography ceased by about 1895, his attention turning towards mining by the end of the decade.

Kerry was not the only photographer to show an interest in Jenolan during the 1890s. Apart from King, W.F. Hall of Sydney produced a series of stereo cards.[56] J. Rowe was a resident photographer at the caves from 1896 to 1897,[49] although it would appear that some of his stereo views were taken before this date, probably around 1888.[57] Rowe was a prolific photographer, with at least five series of cards and forty-eight different underground views. Between 1897 and 1902 the Perier brothers made over 100 stereo negatives of the caves, developing and washing their plates in the cave rivers and pools.[58]

Charles Kerry was an outstanding photographer and businessman; few survived the depression of the 1890s as well as he did, and although several other photographers recorded the caves as part of their work, a debt is owed to Kerry for the record he left. He was one of the first pioneers that took an active interest in the caves themselves, finding more in their beauty than the commercial reward alone. Kerry and the various government photographers dominated the production of pictures from the Jenolan area for many years to come, and photographs credited to 'The Agent-General for New South Wales' are to be found alongside Kerry's in many publications.[59]

With dry plates, smaller cameras and the new flashpowder, underground photography under adverse conditions had become relatively easy, many of the problems associated with slowly burning magnesium ribbon being neutralized. One noticeable effect was the inclusion of more people in pictures, something

LEFT, By 1889 it was noted that this underground bridge in Exhibition Cave, Jenolan, had already fallen into disrepair with several of the wooden planks being broken. In the chasm it crossed was a group of stalactites named 'The Piano', because of 'the resonant qualities of its separate parts. Each stalactite gives out a note... As stalactites they are very fine, but as melodious instruments they are frauds. They refuse to harmonise, and their music is about as entrancing as that of a discordant "upright grand," mounted on one leg and played with a handle.' The photograph was taken by Charles Kerry.

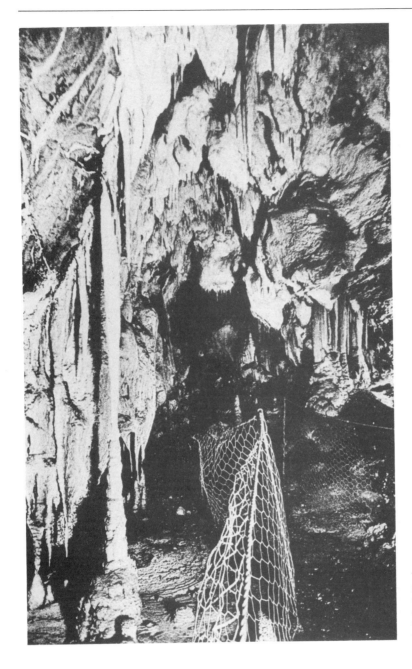

The Show Room in Imperial Cave at Jenolan. Kerry's photograph is typical of many that showed the crude pathways that guided visitors and protected the formations.

which had previously caused difficulty due to movement during long exposure times. Another was the presence of shadows, since there was less movement of the light source. Burning magnesium ribbon could be moved around to soften dark shadow areas: flashpowder could not.

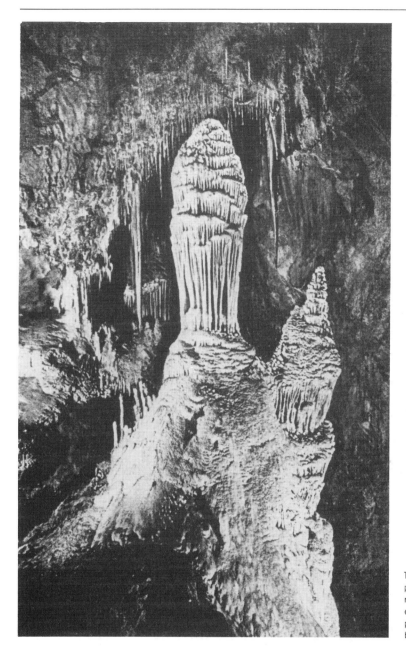

The Grand Column, Lucas Cave, photographed by Trickett. With restrictions on government employees, many of Trickett's photographs are thought to have become part of Kerry's collection.

Even allowing for the increasing ease with which pictures could be produced underground, few people other than Hains and Kerry showed a genuine interest in the caverns to the extent of exploring as well as photographing them. In America, just as Waldack's cave views had dominated the 1860s, Hains' photographs eclipsed those

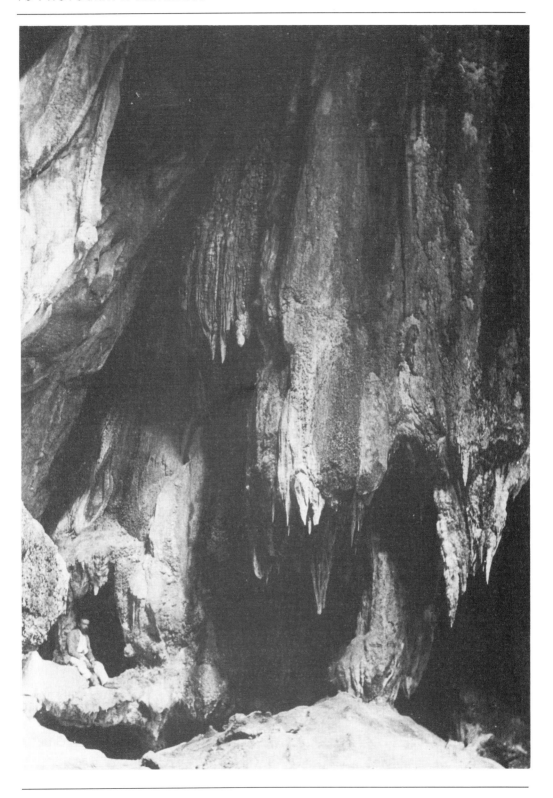

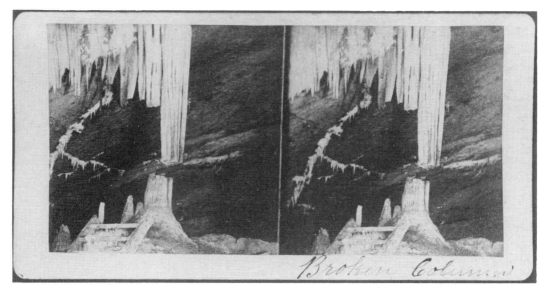

The Broken Column in Exhibition Cave, Jenolan. This stereo view is by J. Rowe, the resident photographer, and is typical of the many pictures he produced in that they lack people and are low in contrast.

of other cave photographers in the closing years of the century. Charles Kerry in Australia had, if anything, an even greater reputation. In particular, both deserve recognition for their outstanding photographic work and continuing interest in the world they helped discover.

It is perhaps to be expected that with flashpowder and the freedom to produce instantaneous views which it conferred, there would be a general upsurge in underground photography, and indeed Müller, Hains, Kerry, and probably Rowe, Hall and many others, all independently began their work within months of each other. With flashpowder and dry plates, 1888 proved to be a watershed of sorts, and it became easier than ever before to photograph with artificial light. By 1900 most cave photographers were making use of the compound, aided by the availability of simpler and cheaper cameras. However, it would be on terrain far removed from established tourist paths that the next advancements in both caving and underground photography were made.

LEFT, At least eleven views of the caves at Chillagoe were taken c. 1900 by an unknown photographer. The sepia-toned prints were possibly sold at the caves, most of them being produced with the aid of daylight.

Beneath the Deserts of France

The new ideas . . . the real discoveries provided by speleological research, can only show their value and credit when enhanced by the addition of this marvellous and irrefutable scientific auxiliary termed photography.

Edouard Martel, 1903.[1]

Explosive flash-powder must be absolutely banned from caving expeditions. . . . If by misfortune a bottle of flash powder was to break and explode, the resulting explosion could have the most terrible consequences.

Joseph Vallot, 1890.[2]

For much of the nineteenth century any interest that existed in the subject of caves was limited to archaeology, exploitation of some kind such as the extraction of minerals, or the development of tourism. In this latter field photography had been successfully accomplished by professional photographers such as Ben Hains of America and Charles Kerry of Australia. However, by the beginning of the 1880s, a change in attitude was developing in Europe. Some of the tourist caves then in use had been known for a long time. For example, those at Postojna, Yugoslavia, in what was then a part of the Austro-Hungarian Empire, had been utilized for tourism for over a century. Here, as elsewhere, there was an incentive to explore the system and extend the tourist routes. Bigger, more exciting, caves meant more visitors and more money. With the increased exploration came a general rise in curiosity and, eventually, an interest in studying the caves for their own sake.

The first of the cave exploration societies began in Vienna in 1879,[3] and was aimed at studying the Postojna cave system. This was a reasonably obvious beginning as the caves were well known, part of the same empire, and they had already been the subject of successful studies. In the 1850s Adolf Schmidl discovered many

kilometres of passage, not while extending the tourist routes but during scientific research. Indeed, as a result of his work, Schmidl became the first true speleologist. The work and exploration of the Viennese *Verein für Höhlenkunde* added impetus to investigations beginning elsewhere.[3] Soon, other groups and societies were being formed across the continent.

These societies included men from various professions and, as their primary aim was exploration and scientific study, disciplines such as photography took second place. However, a photograph is a powerful recording tool, and while he was studying the limestone landscape – or 'karst' – around Sloup in Czechoslovakia in 1881, Martin Kříž made use of it. The formations within the Eliščina Caves fascinated him, and he took successful pictures of the twisting calcite structures using a stack of sixty Bunsen batteries and an arc lamp.[4]

This arrangement must have been very clumsy, expensive and far from ideal for Kříž. Yet it was the beginning of a different use of photography underground: that of recording for scientific or personal reasons rather than commercial interests. Few of these early speleologists were likely to have owned both cameras and lamps, and understandably the cost of supplying expensive chemicals and apparatus limited the amount of work that could be accomplished.

Only the larger societies could even contemplate producing the underground photographs they knew to be possible. Even then the obvious difficulties, lack of experience, cost and the anticipated lack of return must have been very off-putting. It was not until 1886 that the *Società Alpina delle Giulie* (Alpine Club for the Julian Alps, Italy), based in Trieste, began to plan the production of some pictures in the Grotta di Trebiciano.[5] Being bright, rich in actinic rays and portable, magnesium was easily the best choice for lighting, and the society considered the use of a special magnesium ribbon lamp at one of their meetings. The cost, however, seems to have been too great, for in spite of detailed planning the attempt was never made. Nevertheless, it was the structure of the caving societies and the contacts that were forged between them that led to further development and advancements in underground photography.

In France during 1866, the same year Waldack took his classic photographs in Mammoth Cave, a small boy aged seven was taken for the first time to see some tourist caves in the Pyrenees. He was fascinated by the pendulous stalactites, and the impression he gained of soaring caverns and echoing halls remained with him for the rest of his life. As a tourist, he later visited Postojna and then, in 1883, a region of Central and Southern France known as the Causses. There, a limestone plateau rose from the surrounding plains. This was known as the Desert of Southern France:

... in winter a Siberia; in summer a Sahara; and [in] this bleached, ghastly waste, . . . [lie] caves with immense stalactites, stretching for many miles into untraced subterranean rivers, unmapped underground lakes.[6]

His imagination was fired. The vast caves at Han-sur-Lesse in Belgium were the final stimulus. For Edouard Alfred Martel a lifelong fascination with the subterranean world had begun.[3]

Martel was a lawyer in Paris, having finished his training in 1887. His profession naturally took up most of his time, so when he made the decision to explore the beckoning shafts of the Causses, Martel was forced to begin during the brief, but hectic, weeks of his summer holiday. His first expedition, the first of what he later termed his annual 'campaigns', began in 1888.[7]

A total newcomer to underground exploration, Martel persuaded his cousin Gabriel Gaupillat to accompany him, along with other friends. They were well prepared, taking ropes, a collapsible canoe made of canvas and a supply of magnesium for use in lighting the lofty chambers they hoped to discover. Martel's planning was well founded, for the men succeeded in exploring the three systems of Dargilan, Baumes-Chaudes and the Gouffre de Bramabiau, none of which had previously been examined in any detail. Using the canoe they were able to follow the rivers, penetrating the caves, measuring and taking notes as they went. For example, at Bramabiau, which was explored on 28 June 1888, Martel managed to follow the passages down into the earth, searching the large halls with the aid of magnesium ribbon for a way along.[6] The results of the venture were published in the form of detailed descriptions and surveys soon after the men returned to Paris.[8]

Martel was certainly an innovator with his exploratory techniques. To coils of rope ladders and the collapsible canoe were added lengths of manilla rope, sectioned wooden ladders and a host of other items which had to be carried in case of need:

... big stearine candles 3 to 4 cm in diameter (less easily extinguished than ordinary candles), small hunting horns and whistles for signalling, a pot of white colouring to mark the way back, iron rods for anchoring ladders when no rocks are available, a heavy hammer and dynamite . . .[8]

The hammer and dynamite were used to help break up stalagmites which barred the way. With later experience, Martel would add other 'vital' apparatus and materials, such as a barometer to ascertain his depth below the surface, a flask of rum, a thermometer, medicines, and 'some incense or Armenian paper, which is burned in case there are any dead animals putrefying in the depths'.[9]

Indeed, Martel set high standards from the start. He was exploring new systems for the first time, not just for the sake of it but also to survey, scientifically study and publish full descriptions of them. One facet of this latter aim worried him. Were his reports credible? As a lawyer, Martel's training told him that he should do everything possible to ensure that they were. How many men would follow him into the unknown, lowered on ropes or climbing and clambering downwards into the chasms that appeared so unimaginably deep? If few men were able and willing to do so, how might the rest of France be expected to believe his reports? Stories of underground rivers and crashing cascades could all too easily be dismissed; Martel required incontrovertible proof of his claims. He later wrote:

> The new ideas, . . . the 'real discoveries' provided by *speleological* research, can only show their value and credit when enhanced by the addition of this marvellous and irrefutable scientific auxiliary termed photography. The ideas assume a guarantee of authenticity, all the more necessary as their ascertainments revealed phenomena or aspects sufficiently fantastic as to become suspect or considered improbable if one was satisfied with reproducing them by drawings.[1]

In other words, photography could be used to support and authenticate Martel's claims for the massive chambers and subterranean passages he traversed. After reporting on their 1888 expedition, Martel and Gaupillat decided that photographs should definitely be included with future descriptions. While Martel busily planned the next year's campaign, Gaupillat was left to develop the required photographic techniques. He already had some experience with a camera, but using magnesium was another matter entirely. True, the expedition had burned the metal to illuminate caves for route-finding, but for photography more information on the subject was required.

In Paris, the theatre was a popular source of entertainment, and in this field several photographers such as Albert Londe, Balagny and Boyer had experimented with magnesium to take pictures.[10] Details of their techniques were readily available in published form, and the metal was common in shops that dealt with photographic supplies. Gaupillat purchased the necessary materials, and prepared for the next summer's campaign. Any relevant source of information on artificial light was consulted, but for underground work this was scarce.

During the great French International Exhibition of 1889 there was a display of a series of underground photographs in the Mexican section, depicting an American cave. There were no details of how the pictures had been produced.[11] Neither Gaupillat

A combination lamp for increasing the amount of magnesium that could be used at one time. Powder, stored in canisters, was blown into the three alcohol lamps by the action of the bellows. Monsieur Roger of Nancy, France, first used this lamp for theatre scenes, but the principle was later extended to caves. To ensure the magnesium burned easily, Roger sieved the powder through silk before loading the containers.

nor other would-be cave photographers could discover how they had been taken. The techniques of photography underground, even some twenty-three years after Alfred Brothers first showed the worth of magnesium, were still not widely known.

Although professional photographers had taken underground pictures for stereo cards or advertising, copies were uncommon in Europe. Notes made on the subject by such men as Waldack were never publicized, other than when originally published. Certainly, when French cavers made exhaustive references on caves and cave photography they were never mentioned. Max Müller took his set of prints in the Hermannshöhle in 1888, but the portfolio was not published until the following year, and it apparently took several more years before coming to Martel's attention. Gaupillat and his companions were on their own when it came to developing the necessary techniques for their underground work. In short, while materials and equipment for producing pictures in caves were available, only a few people had any experience, and none of them were active in France.

However, there was a major difference in the techniques that would be required in French caves, when compared with previous work elsewhere. Until now, cave photography had followed fairly well-defined patterns. Initially, underground passages were considered as convenient yet spectacular places to test the power of artificial light. Secondly, once the feasibility of such a venture had been proved, a cave could be photographed for commercial exploitation in the form of advertising, or for sales of prints to tourists. Now, explorers were faced with problems of photography

Some of the explorers of the underground river of Padirac were photographed by Rupin in 1890. Martel is in front, with Gaupillat, Armand, Launay and Foulquier in the back row.

in caves of a different, more demanding, nature. Lakes, canals, deep chasms and climbs all barred progress; these caverns were totally unsuited to the casual visitor. Cameras, plates and equipment often had to be transported over much more rugged and hostile terrain than normal tourist locations possessed. Ben Hains, the American 'cave photography specialist', was just beginning his interest in the subject, but even then he limited his work to far more accessible passages than Martel was contemplating.

By 1889, Martel had interested two more men, Louis Armand and Émile Foulquier, in joining himself, Gaupillat and the rest of the team, who had already begun their systematic exploration of the Causses. On this occasion they descended the massive shaft of the Gouffre de Padirac for the first time. This dropped 225 ft to the bottom, belling out so that the rope ladders swung free and landed on an immense rubble slope.

The impression was fantastic; one might have imagined oneself at the bottom of a telescope, looking up at a patch of blue sky. The vertical light, strangely sifted, almost violet, illumined the walls of the well with reflections; these walls were hewn precipitously or in corbelled projections, joined by the

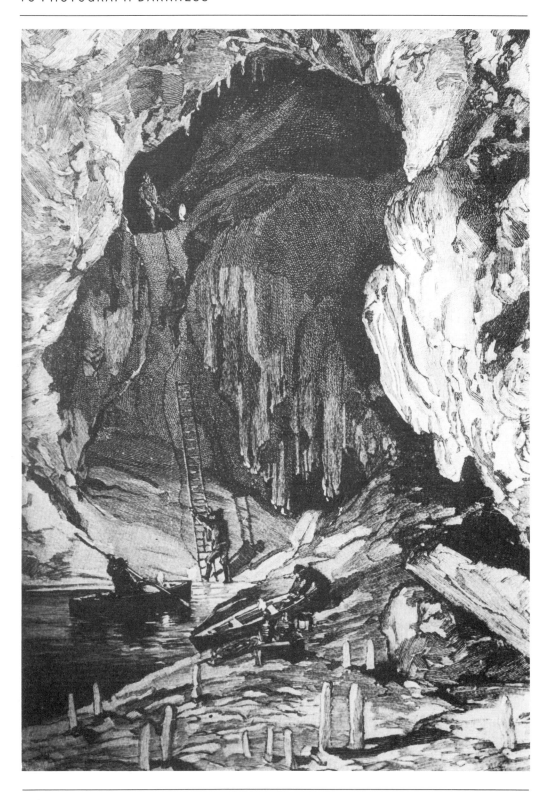

calcareous stratification. . . Above appeared the tiny heads of my companions, who were lying flat on the ground watching me.[6]

A river disappeared into the hillside, with long canals and vertical walls, so boats and equipment had to be lowered before Martel and his comrades could set off. Gaupillat transported the cameras, for he intended to make a photographic record of the attempt.

Gaupillat chose a magnesium ribbon lamp for illumination, something also considered by Joseph Martini at Postojna.[12] This consisted of a reflector and small tray to catch the falling ash. Based on Alonzo Grant's design, the metal itself was supplied from a roll held behind the reflector, and fed automatically through a hole by a clockwork motor. In comparison with Waldack's work at Mammoth Cave, much less magnesium was required to make an exposure. This was due to the benefits gained from better, more sensitive emulsions on the dry plates, which were also easier to use. Having tested the lamp in Paris, and knowing the successes that magnesium had produced in dimly-lit theatres, an early success was hoped for.

Once underground, Gaupillat began his first pictures. The beam of light given off by the lamp was passed over the surfaces being photographed for some ten minutes for each exposure but, while Gaupillat made several attempts, the results were poor. Degraded, patchily-lit and underexposed views were his reward. No people could be posed within the picture, for each exposure was far too long to allow them to stand still, and voluminous clouds of magnesium smoke obscured the view. In disgust at his failure, Gaupillat abandoned the attempt. Twenty-three hours had been spent underground by the time the explorers returned to the surface, nevertheless elated with their discoveries in the richly-decorated caverns.[6]

As well as Gaupillat, another man had become interested in photography. Joseph Vallot was a well-known mountaineer and botanist. A friendly, affable scholar, he spent much of his time climbing and researching the flora of the Pyrenees, and was well respected in his field. He had climbed France's highest peak, Mont Blanc, conducting physiological experiments on himself and his companions over a three day period in 1887.[13] Later, he would become Director of the Mont Blanc Observatory. Now, he was expanding his range of interests, and the notion of exploring below ground as well as above clearly appealed to him. Influenced by Martel, he began to prepare for his own subterranean excursions.

Having also decided to take photographs underground, Vallot considered all the available methods. He dismissed electric lighting, just as Gaupillat had, because it required too much

LEFT, The Lac des Gours in Padirac. The drawing, used as a book illustration, was possibly based on a photograph by Gaupillat.

cumbersome equipment. Bengal fire was also rejected, as Vallot thought it 'must be absolutely condemned',[2] for its black acrid smoke polluted the caves and coated the fine calcite formations with a layer of grime, effectively preventing photography. Even for normal exploration resin torches, straw fires, fireworks, naphtha and petroleum lamps were prohibited because of the smoke. For photography, flashpowder was the obvious, rather more tempting, choice. The objection this time was due to a fear of accidents.

> Explosive flash-powder must be absolutely banned from caving expeditions. Often a group of men will drop a packet or will fall with their burden. If by misfortune a bottle of flash powder was to break and explode, the resulting explosion could have the most terrible consequences. The shafts and fissures and passages which link the rooms together are often cluttered with enormous piles of blocks fallen from the roof, between which it is necessary to slide whilst crawling or climbing. The disturbances produced by the explosion could dislodge the unstable rocks, thus blocking the return route. Furthermore, flashpowder produces toxic fumes.[2]

In this final statement, Vallot was perfectly correct. Flashpowder was often made very crudely, containing sulphur and saltpetre (an ingredient of gunpowder) to act as oxidizing agents in order to sustain combustion of the magnesium powder. Sometimes, cheaper mixtures were adulterated with zinc powder, which not only caused less light to be emitted, but also produced a greenish hue. Fumes of both types were poisonous and could be extremely dangerous in any confined space. Burns were extremely painful and easily occurred when white-hot powder splattered from the charge as it exploded, which was an all too common occurrence. When such an accident happened, the advised treatment was to use damp compresses of linseed oil and limewater to counteract the caustic magnesium oxide, which could approach 1,000°C in temperature as it burned.[1]

While Gaupillat used magnesium ribbon burners, Vallot finally chose magnesium powder for his light, which at least avoided the production of the more poisonous fumes. His lamp was designed and built for him by one Dr Regnard, and was based on a model normally used for signalling at night. The major problem was that it would only burn about half a gramme of powder at a time – not enough to provide the light required for cave photography.

In theory, magnesium powder was blown into an alcohol flame, causing an instantaneous flash of light. Modifications were needed so it could burn more powder, creating a brighter flash. However, if extra magnesium powder was simply put into the reservoir,

when the lamp was fired this passed unburned through the flame and the light output was unaffected. When construction of the new lamp was finished, it had an alcohol burner in the centre, the flame from this surrounding a small tube, the lower part of which was bent into a 'U' shape. Magnesium was added to the widened tube with a funnel, then kitchen bellows were attached via a rubber tube. With a brisk movement of the bellows, powder was blown into the flame to ignite and give a searing flash about two metres in height.

After tests, Vallot found that the maximum of 2 g of powder was the ideal amount to use.[1] He settled on a standard lamp design and this quantity of magnesium; it proved ideal. With one of his first pictures in 1889, Vallot obtained an image of the Obelisk in the depths of Mas de Rouquet,[14] with a person dressed in flat cap and old clothes standing beside the formation, bemusedly peering upwards.

The advantage of using pure powder rather than ribbon was the production of an instantaneous flash of light, allowing people to be posed within the picture. As long as they stood relatively still there was little chance of blurring the negative. There were also far less fumes to contend with. Smoke was still produced, but only after the flash had finished would it spread into the picture area. These advantages also applied to flashpowder, of course, but Vallot felt that pure powder was safer, as it was less toxic and non-explosive.

By the time Vallot perfected the use of the powder lamp, Gaupillat had abandoned his attempts. Failure after failure had convinced him that a magnesium ribbon burner was not the answer. Then, in May 1890, Vallot addressed the annual conference of the Photographic Society of France.[2] His pictures and the information on how to produce them were well received, and from then on knowledge of his techniques was readily available to other pioneers. Vallot also told Gaupillat of his methods,[10] and by the summer of 1890 Gaupillat was also taking successful pictures using powder in a similarly modified Regnard lamp. Then, on 9 September, Padirac was once more the focus of interest as Martel began his third campaign. This entailed a great deal of effort for Gaupillat, as he not only had to take his place as an exploratory team member, but also record the expedition using photographs. The conditions he worked under were admirably described by Martel.

The weather was magnificent, water everywhere very low, after a long drought, and everything promised success. We had with us 186 feet of rope ladder, three boats, two photographic apparatuses, and an electric lamp; in a word, the most perfect *matériel* to ensure success. Our programme was to pass a night underground, since at least twelve hours were requisite to accomplish the complete exploration.

Before the end of the century, following Martel's discoveries, Padirac was being developed for tourism. Between April and November 1898 stairs were installed in the 75 m shaft.

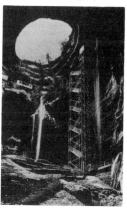

At 7.30 [p.m.] MM. Pons and de Jaubert, who had accompanied us to the bottom of the well, ascended, or rather were hauled, to the surface of the soil. It was dark already, and it was by magnesium light that this manoeuvre was executed, a manoeuvre rendered complicated by the cords of the ladder becoming entangled.

At 8 o'clock, delighted to be alone, we began our real work, unembarrassed by the presence of the curious. A look upwards revealed to us the starry sky like a ceiling set with golden nails. Four watchmen were to pass the night at the edge of the cave, near the telephone, which I had just laid out.

At 12.45 the three boats started. . . The departure was indeed majestic. The little illuminated flotilla produced a striking effect on the subterranean river, the colossal vault above illumined by the electric light and magnesium.[6]

The boats moved slowly on, passing the 'Lac des Gours', which had been discovered the previous year. Boats and equipment alike had to be ported over a succession of ridges and barriers. Finally, tired and wet through, they reached a point two kilometres from the entrance.

The boats were very heavy. The thirty-sixth ridge was of clay, like an ass's back. When I set my foot on it, I slipped and fell into the water up to my neck. I could feel no bottom. I laid hold of the yielding clay, but my brother-in-law drew me out. I was not more wet than I had been, for the vaults drip, and we had been soaked for some time.

The flotilla pushed on with difficulty. Then, suddenly, the river disappeared. . . We disembarked and walked along this passage for 600 feet, and came on water again – the eleventh lake. Fagged out, we flung ourselves on the ground, and called the lake 'Le Lac du Découragement'.

It was now 6.15 A.M.; we gave ourselves some rest, plucked up heart, and pushed forward. . . Armand and Foulquier went back after one of the boats, and on its arrival I got in along with Armand. The lake is 399 feet long, and the vault is hung with magnificent stalactites. A contraction, then a twelfth lake, 180 feet long, at the end of a sandy beach; the vault lowers a little farther, and then comes a *cul-de-sac*. We looked for a crack, an opening of any sort, and found none. We had reached the extreme end of Padirac. The hour was 6.45 A.M. It took three hours to get back to the point of embarkation. Then time was spent in measuring and in photographing.[6]

Gaupillat erected his camera, focussed the lens and inserted the dark slide. The Regnard lamp was charged with powder. Choosing

his field of view carefully, the slide was withdrawn, the lens cap removed and, with a burst of air from the bellows, there was a violent flash of light. Gaupillat's success rate was low, but at last after several attempts some good negatives were made. One view showed a man with a boat on the cascades of the Lac des Bouquets, but of the fifteen taken only four or five plates were reasonable. The rest were useless.

Martel's second expedition to Padirac ended successfully, twenty-six hours after it had started. Gaupillat had shown that it was perfectly possible to produce pictures on exploratory expeditions, albeit with mixed success.

Other cavers beside Gaupillat and Vallot soon became interested in photographing the scenes to be found beneath France, among them Messieurs Renauld, Blanc and Rupin. Renauld began taking pictures in the Jura, while Blanc, a member of the team that had tackled the original 1888 Causses explorations with Martel, concentrated on Switzerland. When a new cave, the Gouffre de la Fage, was discovered in woods just outside his home town of Brive in 1890, Ernest Rupin was at hand to take part in some of the first explorations and take pictures among the stalagmites.[15] He used a magnesium ribbon burner similar to the one that gave Gaupillat so much trouble and, though many of his results were occluded by smoke, Rupin insisted on continuing with its use.[16] By the following year, 1891, he had joined Martel and his companions as part of the team for their next campaign.

During these early attempts at photography many usable negatives were produced, but there were limitations as to the exact type of picture that could be attempted. The amount of light being produced by Vallot's magnesium burner was ideal for subjects relatively close to the camera, between 5 and 15 m away, but it was still too weak to be of use in exposing distant scenes at 30 m or more. A stalactite or stalagmite group within this range was the normal choice, but often Martel wanted to use a photograph in his reports that showed a vast cavern with many formations in the background. Vallot, once again working on his own, attempted further modifications to his lamp.

Vallot needed to find a method of producing more light. The obvious way was to use more powder, but once again most of it passed through the flame unburned. Perhaps, he thought, setting off the lamp twice would be the answer. However, while successive charges did give more light, the advantage of using a pure magnesium powder lamp was lost. Instead of finishing the exposure before any smoke encroached, fumes from the first flash filled the chamber and the picture was ruined. A single flash produced an underexposed negative, a second one only illuminated the swirling smoke. Exactly the same problem arose with the use of two lamps, as they could not be accurately synchronized to fire

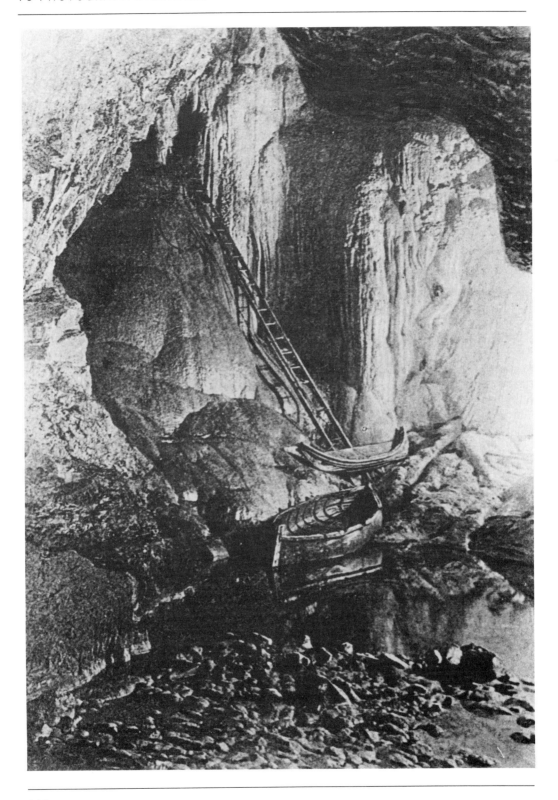

together. However, by increasing the diameter of the tube used to supply magnesium to the flame, Vallot succeeded in using up to 4 g of magnesium powder in each flash. This allowed him to produce more light, but some powder still escaped unburned. Then, in 1891, while Vallot was still experimenting with methods of burning the extra magnesium, a new type of lamp was introduced to the photographic market.

Félix Nadar, the photographer who had produced the first underground pictures in the Paris catacombs, had a son, Paul.[17] Also a photographer, Paul Nadar had continued with his father's interest in artificial lighting. He designed a powder lamp[18] which allowed an uninterrupted jet of magnesium powder to be burned for as long as was desired. Any quantity of magnesium could be used from a large reservoir. For more light, powder was fed into the spirit flame for a longer time; this increased the exposure time, but also greatly increased the available illumination. Air was supplied from a previously-inflated rubber bulb, dispensing with the cumbersome bellows. Opening a valve allowed a controlled escape of the air, while shutting it turned off the flash lamp.

Vallot found that this Nadar lamp used about 1 g of powder every second, and began to experiment with it in large chambers in the Jaur Cave. Four grammes of magnesium proved the ideal amount to use for more distant cave photographs. This was no more than he was experimenting with in his modified Regnard lamp, but the effect was greater because in the new device all the magnesium was burned.[10]

Vallot, with the Nadar lamp, had found an answer to his requirement for more light, and thus for Martel's need for pictures of the more spacious caverns. For the first time it became feasible to consider using a range of smaller diaphragms, rather than only the largest available, to admit the maximum amount of light into the lens. This permitted control of depth of field for the first time; a small diaphragm admitted less light, but kept more of the scene in focus irrespective of the distance from the camera. The actual diaphragm used was still chosen by guesswork, the lens cap used as a shutter by uncovering the lens before the flash and capping it again afterwards.

Using a Nadar lamp quickly became the norm for Vallot's cave photography, and it was invaluable for all his underground work during the summer of 1891.[10] However, in 1892, Vallot was faced with a rather different photographic problem which could not be solved with his new acquisition.

Vallot was asked to produce an album of prints depicting the Paris catacombs (previously photographed by Félix Nadar) and quarries. Previous attempts by the foreman of mines, Monsieur Vallet, had met with only limited success.[10] For lighting, the foreman had used petrol lamps, the exposure continuing for hours

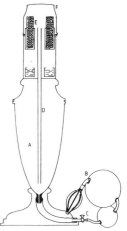

The Nadar lamp was used by Vallot from 1891. Magnesium powder in a container (A) was blown by air from a reservoir (B) when a clip (C) was opened, through a tube (D), into an alcohol flame at (E). A cap (F) extinguished the flame when finished. Multiple flashes were possible without recharging the container with powder, the size of the flash being controlled by the diameter of the tube (D).

LEFT, The Salle de la Fontaine, Padirac, showing two of the canoes used by Martel. The scene was photographed by Ernest Rupin on 29 September 1895.

or even whole days. Vallot began work with his usual Nadar lamp, but to no avail. In the lofty chambers and rifts of the French caves he had previously photographed, smoke from the magnesium could rise out of the way, but now the passages were too confined and the fumes being produced curled their way into the picture area. After a maximum of three seconds he was forced to cover the lens cap before the negative was ruined. Using his preferred quantity of 4 g of powder he produced a print that showed nothing but dim subjects in a grey smog. His lamp was able to provide him with more light, but only at the expense of a longer exposure. Vallot's only recourse was to return to a substance he had previously banned – flashpowder.

By now, 1892, flashpowder was in widespread use. During the few years since Vallot had first rejected it, the quality of the ingredients had been improved and modified so that flashpowder fumes were now far less toxic. Vallot tried it for the first time.

My attempts have made me see that the use of flash-powder pushes back many of the limits which one could attain with artificial light. The operating materials were obligingly given to me by M. Brichaut, who makes the flash-powder that I used. This is how you operate it.

You obtain some thick glass tubes, ten centimetres long, closed at one end. Fill them with flashpowder, seal them with a cork bung and then arrange them in a box. Have some charges of five grammes of powder, ready prepared and protected from the underground humidity. The camera being put into place, you take a piece of firework maker's *bengal paper*, which is only another alternative to sheets of cotton powder, and tip out a suitably guessed measure of powder. Rolling up the paper, form a sort of cartridge wrapped with a fuse of gun-cotton, leaving a certain length hanging down.

The cartridge is ready for use, but it would be foolhardy to light it in a saucer as one does for photography in apartments. The huge charges make a veritable small explosion, which would be able to project flaming magnesium onto the operator.

M. Brichaut suggested fixing a spring of iron wire onto a plate of zinc the size of a hand, which grips the cartridge. The plate is pierced with a hole in which one fits a sharp pointed stick; it can therefore be held vertically in the air, in a manner so as to protect you from the magnesium projections. This method of procedure also has another advantage, that you can easily place the source of lighting in the most convenient place since it is carried on the end of a stick. You only have to light the hanging thread in order for the combustion of the cartridge to take place.[10]

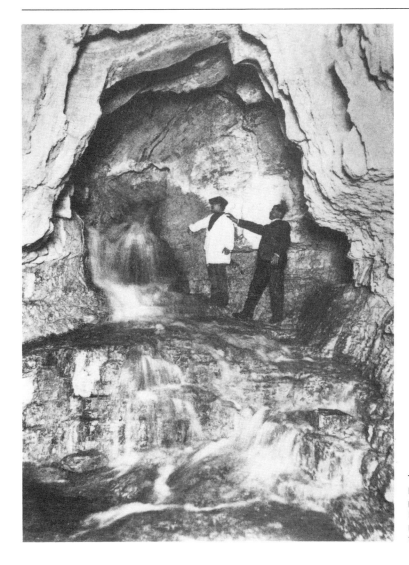

The interior of the caves at Dauphine, Sassenage, photographed by E. Guichard. Long exposure times always produced the effect of blurred, flowing water.

This, then, was the method that Vallot used. He prepared his charges of flashpowder, and ignited them with a fuse at the end of a stick. His experiments gave him enough information to be able to construct tables and formulae showing the minimum amounts of powder to use with any combination of distance, lens, diaphragm or plate; larger plates required more light to expose them correctly, as would the less sensitive emulsions. Minimum amounts of powder were recommended so as to lessen the fumes that were nevertheless produced.

By 1893, Martel had descended over 230 caves, some 120 of them being totally new ones. Most of these were in the company of

his cousin Gaupillat, or Rupin. Both were good photographers, so an excellent record of the caves was compiled. Gaupillat was still using the powder lamp he had copied from Vallot (as well as experimenting with the Nadar lamp), although he found the bellows used to puff the powder into the flame were very unwieldy.

> . . . we replaced these rather cumbersome bellows with a rubber balloon of about 10 litres capacity, supplied from a rubber tube about 1 metre long, whose end was fitted to the brass tube containing the powder. One previously inflated this balloon like a *Breton bagpipe*, then you close it with a Schloesing clip on the tube.[19]

When the simple laboratory clip was opened, air was released to blow the powder through in a controllable stream.

Martel dominated the caving scene of France as the decade continued, having a profound effect on the exploration, literature and type of photography undertaken. While he did not initially become directly involved in producing the pictures himself, he influenced the methods and materials used. For example, despite Vallot's successful experiments with flashpowder in the Paris catacombs, there was very little serious use made of the mixture. A basic distrust of the compound still remained with the explorers, and Vallot returned to his Nadar lamp. The advantages that flashpowder could bring were ignored.

Nevertheless, Martel did feel that photographs should do more than scientifically record an exploration; they should also be aesthetically pleasing. The production of this dual-purpose picture was still beset with difficulties, despite obvious improvements in lighting apparatus.

> The thousand precautions which surround the photograph are relevant, here more than ever. The operation is long and delicate. The explorer more often than not has his feet in water, has damp hands, and he is holding a candle. He needs at least two assistants to manage his equipment, which is complicated and fragile, the tripod, the camera, the screws, the lenses which get covered by a film of condensation, dark slides, lens panel, the powder which gets damp, the flasks of alcohol, tubes, funnel, spoon, rubber, lamp, wicks, scissors, clamps, matches, etc.[19]

Another problem to add to that of transporting the apparatus was the nature of the scene to be photographed. Martel was adamant that a scale should be used by all 'true' cave photographers, preferably in the form of a person, otherwise there was

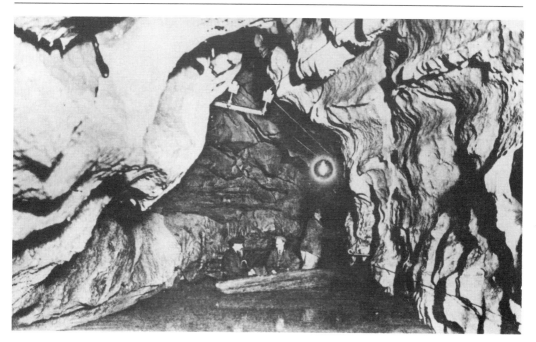

The river in the Grottes de Betharram. The tourist site was illuminated by electric light, creating difficulties for the photographer. Glass plates often suffered from halation, as seen around the bulb, caused by internal reflection of light within the plate. It was normal to extinguish all lights within the picture area to remove this problem.

nothing to show the true size of a passage or formation. Without scale, a slab of stone could appear to be a piece of gravel or a monstrous block the size of a house. Unfortunately, the use of people still presented difficulties. Both magnesium ribbon and the Nadar lamp burned for long enough to permit blurring of the image if a person moved during the exposure. There were many failures. When successful pictures were produced, these were prized.

Theoretically, with powder being burnt in a flash this difficulty would be minimized, but there were other problems. When Vallot did try using flashpowder, which ignited with a roar, it did nothing to help. Even after carefully explaining what they should expect, men posing for the picture still jumped or turned on their lanterns before the lens cap was replaced, surprised by the sudden light and sound.

Another major problem, which the Frenchmen of the last century never found a way of correcting, was that of the colour of rocks. The same trouble that Waldack had encountered still existed.

Emulsions used to make the rapid dry plates were insensitive to red colours of the spectrum, while being very sensitive to blue and green. This fact allowed the best use of burning magnesium to be made, with its rich blue actinic output. However, the photography of ochre mud or iron-stained stalagmites was impossible if any

detail had to be retained, for they only reflected light of their own colour, which did not record on the negative. Red parts of the scene appeared too dark, or black, in the final print. With no alternative, red-tinged formations were ignored by the photographer and only white calcite could be chosen as a subject.

In 1895 Martel set up a formal caving society in Paris, the Société de Spéléologie, with Martel as Secretary-General and Vallot a Vice-President.[20] This group, and the publications it produced, concentrated on many of the scientific aspects of the subject. This included photography, but not sport. Photography soon became one of Martel's most important tools in promoting speleology, both in his native France and abroad. The following year in America, for example, Hovey commented:

> . . . the time will come when what the French call the science of "speleologie" will not only have its isolated devotees, but its organized and endowed societies. Why not have an American Cavern Club as well as an Alpine Club?[21]

With the formation of the French society, the ability to pool information and resources was realized. Discussions on cave photography could more easily be undertaken and the results published. Foreign news of underground work could also be passed on. For instance, on 16 March 1895, Albert Tissandier showed his colleagues photographs taken at Jenolan in Australia.[22] Speleology was becoming an international science.

The same year that Martel instigated the French speleological society, he applied for and received grants that enabled him to visit Britain. He aimed to compare French caves with new, foreign ones. Wherever he went, throughout England, Ireland and elsewhere, he left interested audiences and almost single-handedly turned speleology into an internationally recognized discipline.

As this interest in caves developed, photographs continued to be taken to illustrate Martel's publications, reports and lectures. When he departed from England in 1895, for example, Martel left a set of lantern slides for use in lectures. At various times over the period of his campaigns he probably took occasional pictures, but he largely left the intricacies of photography to others such as Gaupillat, Vallot or other companions such as Messieurs Fourtier and Viré. Yet, necessity eventually caused him to become a serious photographer himself.

> It is necessary for me to acknowledge that, originally greatly discouraged by the difficulties and disappointments that tested my collaborators, by the disheartening abundance of *failures* and by the tiresome and too frequent proportion of two passable negatives from every twelve exposed ones, I avoided for a long

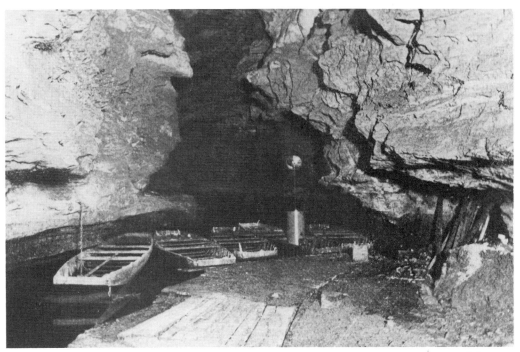

The landing stage in Padirac in May 1900, used as an illustration in Martel's book *La Photographie Souterraine*. Martel used a wide angle lens and the larger than normal plate size of 13 cm × 18 cm. This required some three to four times the amount of magnesium, compared with the more usual 8 cm × 9 cm format, to obtain a correct exposure, which took two minutes.

time giving myself up to the complex and arduous operation of cave photography.

It is only in 1899 that I decided to try the undertaking, on the occasion of the Universal Exhibition and also a little public lecture that I gave on geography underground. . . For this it became necessary to gather a great number of personal documents, particularly those suitable to my scientific objectives.

Putting to advantage the experience of others who had indirectly taught me the problems and revealed the faults of underground photography, I had only to perfect and simplify the methods in use and to correct the established imperfections. From my first attempts I was surprised to obtain much more than I expected.[1]

In fact, by 1898 Martel had begun to take occasional underground photographs, for example at the Dragon's Cave – Cueva del Drach, Majorca. Here he used a ten-minute exposure with magnesium ribbon, his preferred light source, which was either burned alone or in a clockwork lamp. By 1903 Martel had become accomplished enough to write the first book on cave photography, based on both his own and his companions' experience. Titled *La Photographie Souterraine* – 'Photography Underground' – it contains twenty-seven reproductions of underground photographs.[1]

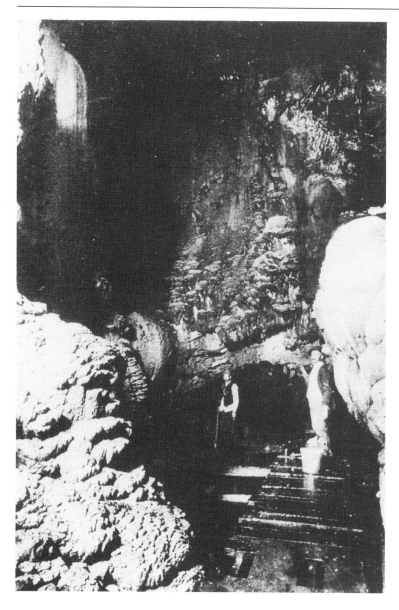

Viré's photograph in Padirac clearly shows the effects of using a single light source behind the camera, with the foreground over-exposed and the background left too dark.

Undoubtedly, the publication helped disseminate information of the French techniques. In 1903, for instance, the book was cited at the International Conference of Historical Science in Rome as being notable for the advice it contained.[23]

In his book Martel discussed the techniques and materials that had become standardized in French cave photography. Little had changed since the introduction of the Nadar lamp and its subsequent use by Vallot. Most photographers such as Vallot,

Gaupillat, Boissonnas, E. Renauld, A. Viré and others, used it, while Rupin doggedly retained his magnesium ribbon burners and tolerated the seven- to ten-minute exposures that they necessitated.[16]

Viré would sometimes burn magnesium ribbon as well as use the Nadar lamp, such as in September 1897 at the Aven Armand, when he descended the shaft in the company of Armand, Martel and the American, H.C. Hovey. The latter seemed astounded by all the apparatus the Frenchmen took with them; Martel had his usual collapsible canoe

> . . . for sailing on subterranean waters, should any be found, a coil of copper wire for our telephone, tools of all kinds needed, together with a fair supply of provisions. No wonder that the peasants took it for the outfit of a traveling [sic] circus.
>
> We took several flashlight photographs, only one of them, taken by Mr. Viré, proving very good. It represents what is called "The Virgin Forest," of mighty palmlike stalagmites rising to the lofty height of from 50 to 90 feet, and untouched as yet by the tool of the geologist or dimmed by the explorer's torch.[24]

Obviously, not all the problems of cave photography under exploratory conditions had been solved. The smoke from burning magnesium remained a major difficulty. For his own part, Martel found Padirac suitable for some of his own early experiments in photography. Access to the cave was much easier than it had been in the past. Rather than the long, dangerous descent on ladders or ropes, a metal staircase had been installed between April and November, 1898, for use by tourists. Martel's discoveries had brought about a greater interest in the caves of the Causses, and proved a spur to tourism; this giant undertaking at Padirac was performed only nine years after Martel had first descended the shaft. However, despite the benefits of easier travel underground, photography remained difficult.

> All the negatives taken in the presence of the fumes are immediately tinted grey. In the month of September 1899, after an active season of exploitation during which the visitors had been constantly illuminated by magnesium, I had lost all of a series of negatives of Padirac ([in the region of] Lot), the atmosphere of the cave having lost its transparency. It took several weeks in the off season in order that the air could recover its clarity and allow me to obtain good results (in the following December).[1]

Some experiments and research into alternative lighting continued, although none met with much success. Flashpowder was still

Due to the confined space around these Corbelled Columns in the Aven Armand, Martel was forced to take the picture in two parts. The prints were later joined to form the finished picture. Martel recorded his exposure for each 8 cm × 9 cm negative as twenty seconds; many of his exposures required more than two minutes to complete.

153

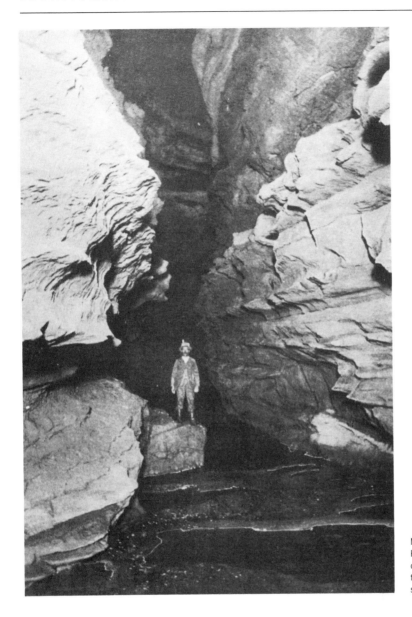

Martel's photograph of a rift in Padirac is typical of the low contrast pictures produced by his technique of using a single light source behind the camera.

frowned upon, references to 'flash light' being applied to the pure powder lamps. In other directions, attempts were made to replace magnesium powder with aluminium. This was cheaper, and gave a brighter, more intense, light, with fewer fumes when burned in oxygen. Under normal conditions, however, the flame spluttered and died, the aluminium powder clumping into small balls which would not burn.[25] Research into the use of aluminium was never seriously pursued, for the price of magnesium was still steadily

falling. From 1,000 francs per kilogramme in 1880, the price had dropped to between forty and fifty francs in 1902.[1]

Sometimes, it was necessary to burn greater quantities of magnesium than would normally be possible in a single filling of a powder lamp, thereby prolonging the flash. If too great a quantity of powder was puffed into an ordinary flame most would be wasted. One ingenious technique was to make a special candle out of beef fat:

Take: Magnesium powder 20 grammes
 Barium nitrate 30 –
 Flowers of sulphur 4 –
 Beef fat 7 –

Melt the tallow, strain it, add the *very dry* powders, pour into a zinc pot 10 centimetres high by 7 centimetres diameter. This candle burns for thirty seconds with an intensity of at least eight thousand candles.[26]

The report, from the *Moniteur de la Photographie*, was also published in America,[27] and the technique found some favour for the brilliant light it produced, which was no doubt spectacular when ignited. It was also stated that the candle was actually a 'Compound for a Twenty Thousand Candle Power' light. Yet another formula was printed in the caving society's own journal:

. . . mix some very dry sand with the magnesium and pour the mixture, by means of a funnel, onto a strip of clean cotton wool, abundantly soaked with alcohol. Then light it.[28]

The sand was used to 'dilute' the powdered metal and help spread the magnesium evenly on the cotton wool. The basic idea was an old one first suggested by White in 1865. Although the French report was not original, it did show a determination to investigate all the avenues open to underground photographers.

As not all photographers worked with Martel or his society, he was often unaware of new techniques being developed outside his immediate circle of comrades. Monsieur A. Lasson, for example, also lived in Paris and had taken pictures in both Dargilan and Padirac. Dargilan, well decorated with large chambers, had always been easily accessible, while Padirac was now a renowned show cave. Lasson, an amateur photographer, was probably interested in producing photographs either for the cave owners, or for his personal use, and does not seem to have been involved in any original explorations. Nevertheless, his pictures were of high quality. Lasson used small diaphragms rather than the accepted large ones, obtaining better depth of focus in his pictures than was

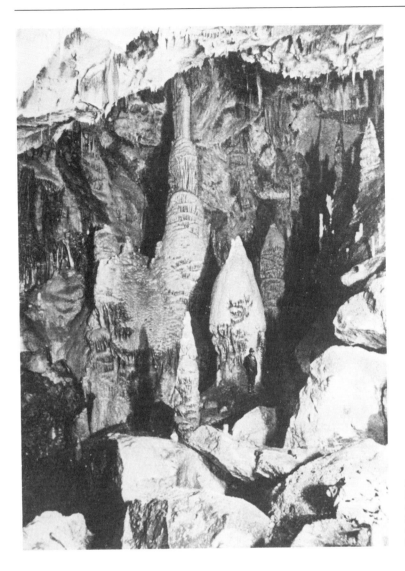

Lasson's technique differed from Martel's and produced a greater depth of field in his pictures. The high quality of his results is demonstrated by these pictures from Dargilan.

usually achieved by his contemporaries. To supply the extra light, he probably used a type of lamp which was becoming more fashionable in theatres and studios when greater amounts of light were required. Here, double or triple burners were filled with magnesium powder and fired with a single blast of air. When Martel finally learned of Lasson's work it was well advanced, Martel apparently not approving of the independent experimentation.[1]

For his own part, Martel collated the information which he gleaned from others and suggested methods of obtaining consistent results at greater distances – up to some 60 m or more – than

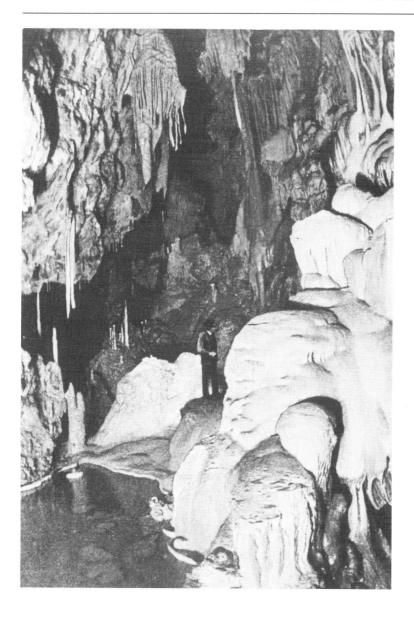

had previously been accepted as a maximum.[29] He always firmly stated the method of lighting which would give the best results, and frowned on any changes or new experiments. The angle of illumination, for example, had to always be behind, to one side of, and above the camera at about 1 m distance. If a more diffuse light was needed, for example in the case of close-up pictures, a muslin cloth held behind the light as a reflector produced a very soft evenlight. This basic angle of lighting gave a good, evenly-lit picture, but without much contrast. Shadows could not be

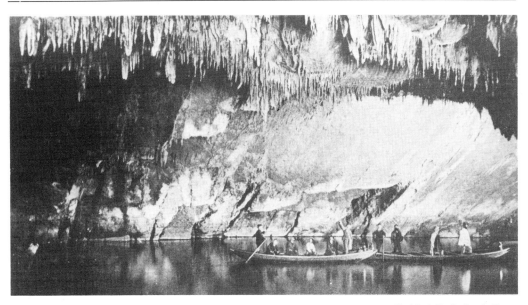

The lake in the Grottes de Han, Belgium, is used as an exit by the management of the show cave. The photograph, by Boyer, relies upon the use of magnesium powder or flashpowder to avoid the long exposure and subsequent blurring caused by magnesium ribbon.

increased without moving the flash further to the side, or introducing a second light. Neither was acceptable to Martel, who maintained a *single* light source was a necessity. Inadvertently, with his self-imposed restrictions, he created another problem.

> [The quality of the negatives] must be derived from the nature and state of the atmosphere in the caverns, for example from its percentage of water vapour, an element in which it is impossible to explain the actinic effect at the moment. . . All I can say on the subject is that, amongst my numerous successive attempts in Padirac (close to 150 negatives), the successful results were in an inverse ratio to the abundance of drips from the roof of the cavern, and that at the cave of Fées at Saint-Maurice (Valais), I was not able to obtain a single good negative of the cascade that falls from the ceiling of the final chamber, completely full of water vapour; this remains a point to be cleared up and an explanation to be provided.[1]

The explanation he sought eluded him. The problem arose from placing a single light too close to the camera. The miriad droplets of smoke and water vapour in the air reflected light back into the lens, ruining the image. One alternative would be to hide several lights within the picture area, thus lighting different parts of the scene with different flashlamps. Although this approach would have solved the problem, if the lights were placed at a sufficient angle from the camera lens, Martel's response was firm:

Without talking about the physical complications which necessitated the successive or simultaneous lighting of these multiple lights, one produced with this system only inartistic and sometimes incomprehensible pictures. This was because the multiplication and staggering of lights completely destroyed the perspective and removed all real relief. The shadows were found to be either suppressed or else intersected in an unnatural way, and the even lighting on the different levels totally destroyed the areas of obscure light inherent in the distance; on such photographs the effect of depth and of vague haziness in the distance does not exist at all. . .

As a direct consequence of the multiple light sources the picture has been falsified to a high degree in terms of the proportions and perspective. . . Nothing gives a more genuine and striking impression of underground passages . . . as the semi-darkness of the huge stalagmitic bosses or the long straws and draperies of stalactites. . .

I do not share at all, therefore, the opinion of M. Fourtier praising the use of several magnesium lamps in a manner to correct the high contrast effect of a direct and single light . . . the use of a single, powerful, prolonged and fixed source produces more satisfying results. . . The natural arrangements of the objects should be reproduced on the negative to give a true appearance of the underground such that they appear to the eye as if lit by the rays of the sun, if by chance they could penetrate into the cavern.[1]

When writing a few years later in 1906, Martel was still of the same opinion: multiple light sources were confusing to the eye. He felt that by then the theory of the subject was totally exhausted.[30] Further experimentation was pointless. No more could be added.

Martel also found at first hand the amount of hard work a photographer puts into the production of a cave picture. The hours that Gaupillat spent with his camera in Padirac in 1890 were by no means unusual. In 1899 Martel needed seven consecutive hours at the Aven Armand to take thirty-five negatives, of which seventeen were successful. At Padirac two sessions of seven and eight hours each allowed him to make sixty exposures using two cameras. This use of more than one camera became common practice with Martel, either with two plate cameras or a stereo version. He used a stereo camera to obtain a variation in his exposure; part way through the picture being taken he would cover over one lens so that one image on his plate received less light, a technique known today as 'bracketing'. This increased his chances of obtaining a single good negative from the pair. Using two or three cameras, Martel estimated that he could obtain some four to six exposures

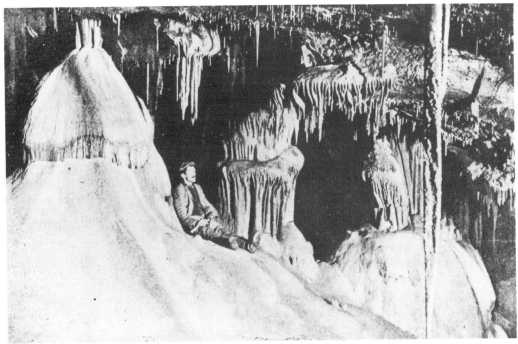

The Grottes de Lacave, photographed by Viré, whose photographs were used to make a number of postcards of this tourist site.

an hour. Smaller plate sizes were preferred because less magnesium was needed to expose them.[29]

A two-bath developer was normally used to process the plate. This consisted of a weak first developer, which made a weak negative image and allowed Martel to check his exposure before transferring the plate to a second, full strength, chemical bath. When a fully-developed negative was too weak, it could be intensified with more chemicals to make it dense enough to print.

The resulting photographs typified the pictures produced throughout this era of French exploration. Men would stand or sit in the middle distance for scale, while a single source of light illuminated the scene from the front or slightly to the side. Backgrounds were allowed to go dark. Formations could be made more prominent by playing the light of magnesium ribbon burners over them after the main exposure was finished. Save for the presence or absence of the cavers, variations from this basic technique and result were few.

Martel, even while he held photography within narrow, restrictive confines, was instrumental in causing the development of these skills and ensuring that they were adequately recorded for the benefit of others. Equally significant, the new techniques were being applied to record major cave explorations as they occurred.

For his part, Vallot gained the credit for solving many of the initial problems of photography under exploratory conditions, selflessly passing on his techniques to Martel, Gaupillat and the other explorers.

With the publication of their work, cave photographic techniques, at last, seemed to be on a firm and detailed footing.

Hand-Hewn Rock

Some of the chief difficulties may be said to exist in confined and cramped situations, or lofty chambers and gunnies, with veins or beds of high dips affording little or no foothold for camera or operator, dripping or running water, vapour, mud, grease, damp smoky air, heat, cold, draughts and darkness. The kid gloved photographer, with his delicately-made apparatus, who is afraid to soil his hands or camera, had better not attempt photography in some of our deep Cornish mines . . .

J.C. Burrow, 1894.[1]

The subject [coal mine photography] was hedged round with difficulties. . . One really flared off as much magnesium as possible, and if the result happened to be good it was good, and that was practically the gist of the whole subject. . . . [I do] not think underground photography would ever become popular.

Herbert W. Hughes, 1893.[2]

In comparison with caves, mines received relatively little attention during the nineteenth century. Archaeological studies did not apply and cases of tourism were few. Without the basic commercial incentive that tourism brought, few photographs were taken, although some travellers did record surface views.[3] There were exceptions to this rule, of course, as shown by the work of Jackson, Grant and Debenham in 1865, followed by O'Sullivan in 1867. The former three men all produced pictures that were in many ways only intended to be experimental. Jackson produced photographs of a coal-face to see if such a project was feasible; Grant used the Mill Close Mine to demonstrate his new magnesium lamp, incidentally taking the earliest metal-mining pictures. Debenham seems to have considered the Botall-ack Mine as a newsworthy venue which could be turned to commercial gain.

As has been seen, O'Sullivan was working with different motives. His pictures of the Comstock Lode mines gained, by comparison, extensive publicity, and were produced to professional standards for the government. However, since the 1860s, only sporadic attempts at mine photography had taken place. Photography of associated features above ground was common, for such pictures could be used as an aid to surveying. Photographs of American mining towns, winding gear and assay offices were standard fare for stereograph publishers. The Pennsylvanian anthracite area of the USA was particularly well covered, as were the diamond mines of South Africa.[4] Later in the century, especially in America, 'boom towns' sprang up around gold and silver strikes. These often had resident, or itinerant, photographers who captured images of the miners for a few coins – but few ventured underground. Their work was full of atmosphere, but not of the working conditions the miners faced.[5]

Those attempts that did take place underground in mines generally had very limited objectives. These might be for the purposes of litigation (for example, Brown in England in 1876), or a record of machinery for a company. When illustrations of underground scenes were required for journals or books, a drawing was more usually supplied.

As with photography in caves, the 1880s saw a general rise in the number of underground mining photographs being produced. However, far less had been accomplished in mines, compared with caves. In America, it was not until 1884 that the decision was eventually made to produce a set of photographs that would accurately show conditions in a working pit.

The project was instigated by the National Museum in Washington in order to supply pictures for the forthcoming New Orleans Exposition, an exhibition that would be attended by many thousands of people. Fred P. Dewey and J.T. Brown were placed in charge. They obtained the services of a local photographer, George M. Bretz of Pottsville. The Kohinoor Colliery at Shenandoah was chosen as the location, not only for its ease of access, but also for the 'fine exposure of the Mammoth bed, and the comparatively level character of the workings'.[6] The seam of matt-black anthracite, in some places 47 ft thick, was thought to be eminently suitable as an example of American mining.

Neither Dewey nor Bretz knew of any other work photographing mines, and were not at all sure that such a project was possible. A bright enough source of light for the photographs was the main problem. The use of magnesium in mines was not unknown: German mines used magnesium torches for general illumination,[7] and magnesium ribbon was often burned in mines for the benefit of visitors. Although they expected to encounter problems, magnesium seemed the obvious choice. On 10 August

1884, Bretz attempted to take his first experimental picture by burning half an ounce of magnesium wire;[6] his fears were well founded when the plate turned out to be totally underexposed, a complete failure.

S.B. Whiting, general manager of the Philadelphia and Reading Coal and Iron Co., was interested in the venture and suggested the use of electric lights 'in order to settle the question whether the interior of a coal-mine could be photographed or not'. His own dynamos being too large for transport into the pit, Whiting obtained the aid of R.I. Kear of the Arnoux Electric Light Co., who supplied all the necessary equipment.[6]

Finding that the only available electric wire was not long enough to reach the seam from the surface, Kear decided to take the dynamo 400 ft underground. The operation took six hours. When he had it installed, the dynamo and engine to drive it were bolted on 8 in × 6 in timbers and braced against the roof. The engine itself was powered by compressed air from the main supply pipe of the mine. The system worked well, although due to changes in air pressure as machinery operated elsewhere the engine, and therefore the dynamo, fluctuated in output.

There was sufficient power to use five arc lights, each nominally of 2,000 candle power, but effectively only delivering about 1,600 candle power due to resistance and earth leakage losses in the damp atmosphere. Some 4,000 ft of wire was needed to complete the circuit. The light would have been brilliant within the normally dimly-lit tunnels.

> Everything being in readiness, the dynamo was started late in the evening of August 28th, and a scene of surpassing beauty was revealed in Breast 39. For the first time could be seen at one glance its whole forty-two and one-half feet of alternating layers of coal, "bony," and slate. . .
>
> All the miners within sight quickly gathered to see this most unusual spectacle, and as the news of the brilliant illumination spread through the mine, a large number left their work, and came to swell the crowd. Many old miners were attracted to the spot, and were, if possible, more surprised and interested in the sight than the strangers present. Although most of them had spent the greater part of their lives in coal-mines, yet they had never before seen more than a few square feet of the coal at any one time.
>
> The scene also had its dark side, since the bright light clearly revealed the great dangers from the fall of coal and slate to which the miners are constantly exposed. The bonds which held large masses, often of many tons weight, to the roof and sides, were clearly seen to be very slender and frail, and looked as if they might give way at any time.[6]

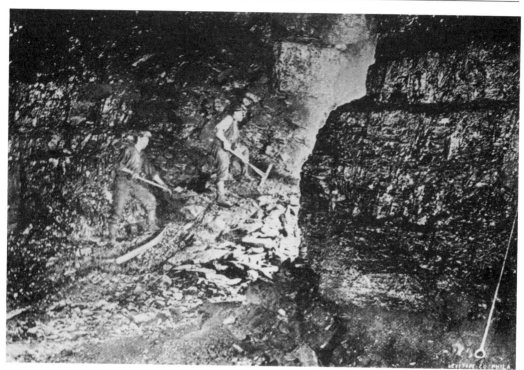

Breast 39 in the Kohinoor Colliery. Bretz's first exposure was made on 28 August 1884, using electric arc lights to show this 'scene of surpassing beauty'. This exposure was taken on the following day. The two miners are 'in characteristic positions, at work removing the pile of coal that has been thrown down by the blast... The camera was placed in the breast near the entrance on the left side, three lights were placed in the room, on the left of the camera, and two behind it in the gangway. Time of exposure, ten minutes.'

That evening a single exposure was made, but due to smoke and dust in the air it was unsuccessful. The next morning a further seven exposures were made, five of them being reasonable. Bretz used 10 in × 8 in Carbutt's Special (J.C.) Keystone dry plates, exposures varying from ten to thirty minutes each.[2] He developed the plates in a secluded mine tunnel, using the flat-bed railcar which transported the dynamo as his workbench. For his processing light, Bretz covered an ordinary glass lantern with a piece of manilla paper to give a reddish glow. The plates were insensitive to red colours, and remained unaffected. Working like this, Bretz could benefit from early mistakes and correct them as he progressed.

The exposure times Bretz was using, and the conditions he worked under, meant that there were severe restrictions on the nature of the photographs he could take. Smoke filled the air from lamps and blasting powder. Coal dust 'not only thickened the atmosphere, but deposited black particles on the plates, and in the water and reagents'.[6] Nevertheless, Bretz managed to take relatively clear photographs which included posed, only slightly blurred, miners working at the face.[8]

Further pictures were taken on 6 September 1884 at the Indian

Bretz's fifth exposure in the
Kohinoor Colliery, showing the
entrance to the breast, required
an exposure of thirty minutes.

Ridge Colliery, using the same dynamo but with a steam engine
for power. On this occasion seven lamps were run for the benefit
of a group of visitors. Bretz exposed his plate for an hour and a
half with a small diaphragm, but the angle he was forced to work at
enabled light to enter the lens, and flare spoiled the negative.
Nevertheless, he produced 30 in × 40 in enlargements of his
pictures for display and gained a great deal of credit and publicity
from the venture.[6]

Indeed, it proved difficult to improve on his results. In Britain,
the South Dyffryn Colliery Company found the same limitations of
long exposure times as Bretz had. Pictures taken for them at the
Abercanaid Colliery in South Wales by the Photophane Company
of London were also lit by electric arc lights. With exposures in
this case taking from fifteen to twenty minutes at an aperture of
f16, it was difficult to place people within the photograph without
them moving and blurring the image.[2]

A comparison was later made between exposures in limestone
and coal-mines, these taking two minutes and fifteen minutes
respectively, when each was lit by the light of two magnesium
ribbon lamps. At least double the light, and usually more, was
needed in coal-mines compared to other underground venues.[2] To
produce the massive amounts of light Bretz therefore required, he
turned once more to magnesium, this time using powder burned in
a lamp. He commonly used between four and six ounces for each

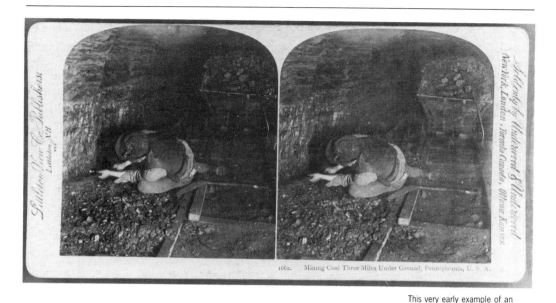

This very early example of an underground coal-mining photograph was made for the Littleton View Company in the late 1880s, although most sales were made by the distributors Underwood & Underwood in the late 1890s.

picture, becoming adept enough to use a massive camera accepting 22 in × 18 in glass plates.

One location used by Bretz was the Latimer Gangway, a mine tunnel which followed the Mammoth Bed through the Pennsylvanian coal-field. The seam was 45 ft thick, through which a massive tunnel had been excavated. Even with the difficulties in lighting such an area, Bretz produced one photograph with nine ounces of powder which showed a mine car at the end of the gallery over 100 yds away. The black anthracite 'was so very bright and lustrous' under his magnesium flashes that patches of white reflections showed in otherwise jet-black backgrounds.[2] In 1893 it was credited as being the 'largest underground photograph' in the world.[2]

The mid-1880s also witnessed the first photography of the quicksilver, or mercury, mines of New Almaden, California. Here, the underground workings were photographed by Dr S.E. Winn, the mine physician, and a Mr Bulmore, the cashier and general agent. They used electrically fired magnesium flares for lighting and the ensuing pictures were successfully used as evidence in a court enquiry in 1887.[9]

Before long other sites, such as the gold and silver mines of Central City, Colorado, were also being photographed.[9] Bretz's initial site of activity, the Kohinoor Colliery at Shenandoah, was later inspected by Frances Johnston. In 1891 *Demorest's Family Magazine* commissioned Johnston to supply pictures taken underground for possible publication. Johnston produced photographs that required exposures of only four seconds, such was the general

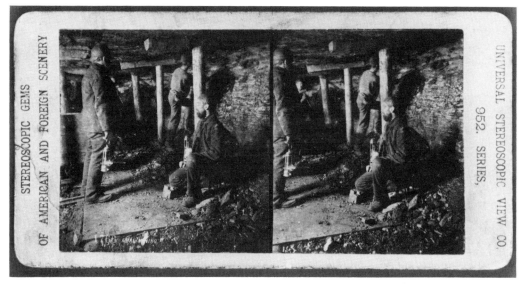

The static pose of the miners is typical of photographs that depended on long exposures. Unusually, the safety lamps have been left burning during the exposure, the one on the left leaving tracks on the negative. The picture was probably taken in the anthracite mines of Pennsylvania during the 1890s.

improvement in lighting and photographic emulsions. She probably used flashpowder for this work, indicated by the short exposure times, and is known to have later used the compound at Mammoth Cave.[10] She is believed to be the first woman to have produced photographs underground.

Meanwhile, in Britain, little or no photography had taken place in mines except for that of Frederick Brown in 1876, on which occasion he had produced a limited number of pictures for a solicitor's firm.[11] The first systematic attempts in coal-mines in this country were made by Arthur Sopwith during 1881 and 1882. He worked in the Cannock Chase collieries of the Midlands, where he eventually produced a complete set of views 'illustrating the numerous operations connected with coal mining, as carried out in the collieries under his charge'.[2] Sopwith, the pit manager, used tin parabolic reflectors in which he burned from 6 in to 10 in of magnesium ribbon. These amounts were small considering the sensitivity of the plates in use, requiring the use of the widest aperture lens that Sopwith owned. His pictures were produced with a great deal of thought, lights often being placed in the distance for initial illumination, and then removed to allow the foreground to be exposed by igniting another length of ribbon. Eventually, Sopwith gained recognition for his photographic work from the Royal Society of Arts in London.

Another contemporary photographer was a Mr Bennetts, who began his work in Beacon in Cornwall around 1880,[12] and started the production of a series of mining photographs. By 1895 he had opened a studio in Cross Street, Camborne, where the Royal

School of Mines was also situated. Over the following years, Bennetts and his son produced many fine pictures in Cornish mines such as South Crofty and Dolcoath, using first magnesium ribbon, and later, flashpowder.

Attempts by other photographers remained few and far between. There were difficulties in gaining access to commercially-operated mines by photographers not already connected with the business and there were few men in a position to do so. Equally, there were many inherent dangers in coal-mines which did not apply to photographers in other situations, such as caves.

Early in the history of coal-mining it was realized that pockets of seeping methane gas – firedamp – could spontaneously ignite, with fearful consequences. A second danger was the problem of carbon dioxide (black damp), which could build up in unventilated passages. The solution was the development of the flame 'safety' lamp, and the use of a caged canary, as warning indicators. A change in colour of the flame inside its protective gauze, or the cessation of the canary's song, indicated the presence of gas and the immediate evacuation of the mine.

A second cause of spontaneous explosion was less well understood. If atmospheric dust is present in certain proportions it can ignite without apparent cause or warning; it is for this reason that grain silos sometimes catch fire as wheat chaff dust in the air ignites. Obviously, the presence of coal-dust created extremely hazardous conditions. Newspapers throughout the last century commonly carried reports of fires and explosions in British pits, usually with tragic consequences for the men who worked in them. It was not until early this century that the results of experiments into safety with regard to coal-dust were finally accepted.[13]

The use of a naked flame, such as magnesium being burned in a reflector or a limelight burner, would seem to be little short of suicidal and would be banned in a modern coal-mine. In Britain, before 1947 and the advent of the National Coal Board and statutory laws relating to electrical and lighting equipment, it was usually left to individual managers to operate their pits and enforce whatever safety rules they thought suitable. These would vary from pit to pit and took into account the nature of the mine. Many British mines, both coal and metal, were 'naked flame', with exclusive use of candles.

Metal mines, for example those extracting lead or tin, were relatively safe from methane, which is found in coal-bearing rock. The Mill Close Mine which Alonzo Grant photographed in 1865[14] contained shale bands and, even though it was a metal mine, gas was sometimes present. By comparison, coal-mines were far more dangerous, although shallow mines were safer than deep ones. As tunnels were driven through the rock, fire damp could seep out. Coal-seams near the surface would usually have already lost their

methane, this having leached out directly into the atmosphere, leaving these tunnels relatively safe.

Deeper pits had no such advantage, as the methane had no direct escape route to the surface other than through the tunnels. Explosions could occur at any time; some coalfields were excessively dangerous in the autumn when the barometric pressure dropped, enabling gas to escape faster, although this factor was still being investigated well into the twentieth century. Whether by chance or design, all the coal-mining pictures taken by men such as Bretz were in shallow mines, where the use of an unprotected flame was relatively safe. However, it may be that the mining photographers of the last century were lucky to escape with their lives. Even in the absence of methane, dust in the air would have been an ever-present danger, with white hot magnesium flames and sparking arc lights easily able to ignite it.

Most photographers who worked underground with artificial lighting did so independently of each other. In Britain in 1891, however, Arthur Sopwith was able to give some advice concerning underground photography to Herbert W. Hughes, the manager of the Lye Cross Colliery in Staffordshire. Hughes was friendly with another photographer in Cornwall, John Charles Burrow. Together, Hughes and Burrow produced results previously considered impossible in the coalfields of the Midlands and the deep metal mines of the West Country.

Hughes considered that it was not enough merely to have technically good photographs; they should also show correct mining procedure with men at work. To this end he was not impressed with the mining pictures he had seen on the Continent. Of these, he thought that a set of photographs taken at the Clausthal and Freiberg metal mines[15] were the best. These German mines were well ventilated, which enabled the air to clear quickly following flashes or blasting. Photography was further aided by the good reflectivity of the rock, but a lack of mining knowledge on the part of the photographer effectively destroyed the pictures' usefulness. 'I may especially mention two [photographs]', Hughes said. 'In the first a miner is depicted breaking a lump of loose rock placed at the edge of the shaft, while in another a man is engaged in sawing through a piece of timber, one end of which projects over the shaft'.[2] Obviously, in both cases safety standards were being ignored.

For his early experiments, Hughes followed the advice given to him by Sopwith. He used a half plate camera with rapid dry gelatine plates, and for lighting procured two clockwork magnesium ribbon lamps, both fitted with reflectors. Even though exposures of two to four minutes were given, the results were not encouraging. Sopwith had used his magnesium ribbon in the low passages of his thin-seamed district, while at Lye Cross the seam

was 30 ft thick and the work-face correspondingly large. The two burners were totally insufficient and, with the longer exposure times he was forced to use, Hughes found difficulty in photographing miners without them moving.

As an alternative, Hughes used magnesium powder in the bare flame of an oxy-hydrogen lamp. This was essentially the remnant of a limelight burner with the calcium carbonate sphere removed, and was termed a 'Platinotype' lamp. This was marketed by the Platinotype Company and was erected on a stand with a reflector when in use. On the other side of the camera Hughes used a 1,000 candle power Optimus flashlamp to subdue the harsh lighting, with his two original ribbon burners to add detail to the shadows when required.[2]

With the large amounts of light now at Hughes' command, much of his exposure problem was solved, although smoke still created difficulties. Likewise, the working area was not always large enough to erect all the lamps:

The difficulties to be overcome are not many, but are hard to surmount. In all classes of mines, the smoke resulting from blasting, the moisture-laden and misty atmosphere, and the dripping of water from the roof are generally present, these being supplemented in coal mines by the presence of coal dust, which not only thickens the atmosphere, but deposits particles on the lens and plate. The condensation of water on the lens and plate is perhaps the most difficult matter to avoid. So far as the lenses are concerned the best preventative is to carry them in the trouser pocket, and so warm them up to the temperature of the body. Even with all precautions and after an examination has been made to see if the lens is clear immediately before exposure, the opening of some door in one of the airways may momentarily divert the regular current, and cause some cooler air to enter the place being photographed, with the result that the lens is fogged, and the plate spoiled.[2]

In comparison, Burrow had fewer difficulties in the metal mines he worked in. There were the same problems with dust in the air, which did not clear easily due to the poorer ventilation. The rock itself, though, was much lighter in tone than that of the coal-mine and the illumination did not need to be as great. Practical experiments by the two men showed that whereas about fifteen grammes of powder would illuminate a scene of two men drilling a shot hole in the basalt of the metalliferous mines, sixty grammes in the Platinotype lamp using identical plates and apparatus produced a poorer result in the coal-mines of the Midlands.

A professional photographer, Burrow lived in Cornwall near the Camborne School of Mines, and had often photographed surface

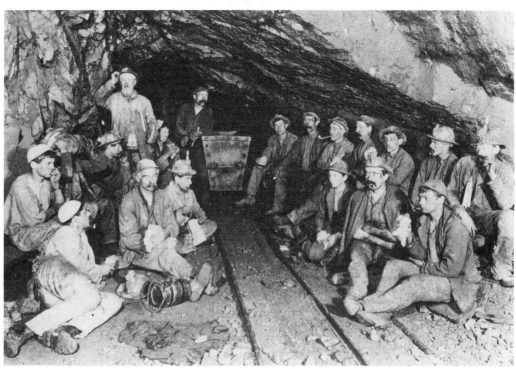

'Croust Time', East Pool Mine, Cornwall. This was one of twenty-three underground views taken by Charles Burrow which were published in *'Mongst Mines and Miners* in 1893. A rest period often coincided with the delay after blasting, waiting for smoke to clear.

views of the area. In the autumn of 1891 William Thomas, a lecturer at the school and the Secretary of the Mining Association and Institute of Cornwall, persuaded him that it could be beneficial to attempt some underground pictures, as he wanted some lantern slides to use in lectures to students. Burrow himself considered Hughes to be the most accomplished of the Midlands photographers, and gained a great deal of advice from him during Hughes' annual photographic visits to Cornwall.

Burrow, like Hughes, also chose a half plate camera in preference to larger 10 in × 8 in models, for 'its lightness, portability, and moderate size, the latter being specially important in confined situations'.[16] The wide angle lens was covered with a wide india-rubber band, for protection against light entering through the diaphragm slot, and the whole camera was fixed to a large wooden tripod with sliding legs. This could be tied to rocks or ladders when it had to be tilted or projected over drops. Burrow, though, was more concerned with the terrain he would be working in, rather than his camera, due to the

> . . . dripping or running water, vapour, mud, grease, damp smoky air, heat, cold, draughts and darkness. The kid gloved

Charles Burrow in Masonic regalia, *c.* 1900.

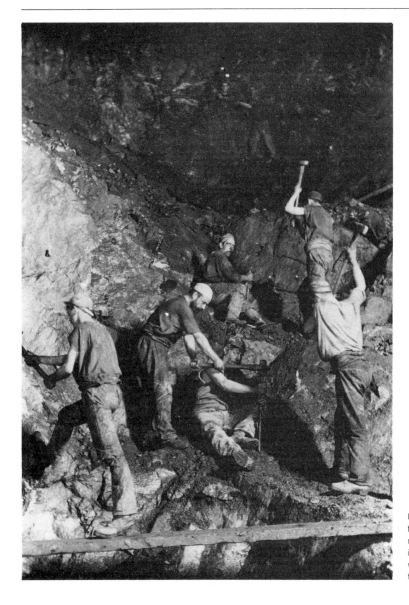

Underhand stoping at the 170 fathom level, East Pool Mine. The men are engaged in boring holes in preparation for blasting. Miners would be posed, and static, for the duration of the exposure.

photographer, with his delicately-made apparatus, who is afraid to soil his hands or camera, had better not attempt photography in some of our deep Cornish mines, unless he makes up his mind to procure a new outfit for future use at surface.[1]

Tin was a commodity in demand and activity within the mines was always great. Miners were poor and their wages had to buy all their own supplies for use underground. On their heads they wore round hats made of compressed felt impregnated with resin, a

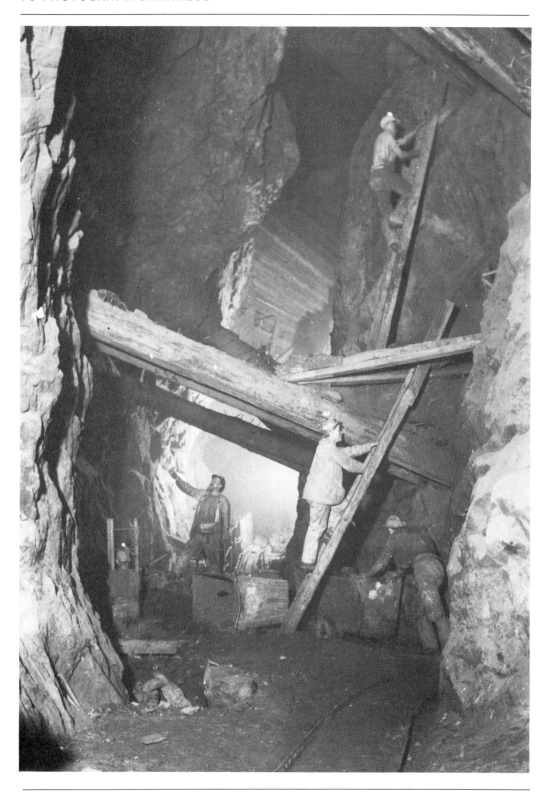

linen cap fitted underneath for comfort. Clothing consisted of any hard-wearing cloth that could be found; lighting was a candle attached to the hat. No other lamps were provided. The conditions the miners laboured under were severe. Water was the worst problem, replacing the dangers of firedamp in collieries. Eight-hour shifts were spent underground in the lower levels, which entailed working waist-deep in water and slime impregnated with arsenic.[17]

Apparently inconsequential things like the miners' candles could create major difficulties when they appeared in the picture. The flame's image was bright enough to cause reflections within the glass plate negative itself, an effect termed 'halation'. The effect on the negative was the production of a halo of light around the burning candle, a problem that also beset other photographers of the period. This halation accounts, in part, for the lack of lights within some of the early French pictures; it was far easier to place unlit candles in the photograph than to risk a ruined negative. With long exposure times any movement of a light source such as a lit candle would also leave trails across the picture, something flash lights avoided.

Burrow had no alternative to extinguishing all the candles in the picture to avoid this halation. Later, a new make of plate – the Cadett Lightning – was introduced which did not produce this fault. His earlier pictures can therefore be identified by the candle 'flames' which he scratched onto the negative, in an attempt to create a realistic effect. Hughes also found difficulties with halation and later exclusively used the new Cadett plate.

To make his pictures look genuine, Burrow posed the miners in working attitudes for the time it took to make the exposure. This was sometimes a problem. Burrow might require them to cling unprotected onto the wooden supports or appear to swing heavy hammers as shot holes were drilled. Understandably, those with a hammer held above their head wavered a little as they struggled against its weight, half blinded by flashes of magnesium light. To retain authenticity, Burrow was careful to instruct his subjects to keep their eyes open.

The one area where Burrow differed from Hughes was in his choice of lighting. Limelight was still to be found in British photographic studios, especially now that the more sensitive rapid dry plates would react with it rather more readily than the older wet collodion process. Flashpowder, on the other hand, was accepted as being a far superior light and was easily transportable, even though clouds of fumes were produced. Burrow used a combination of both: magnesium to make the main exposure, limelight to help give details in the dense shadows and to allow prior composition of the picture.

After trying commercial models, Burrow designed a pair of

LEFT, A photograph taken by Burrow in East Pool Mine at the 180 fathom level. The picture clearly shows the working conditions of the Cornish miner and the size of the main lode. The wooden supports were later replaced by reinforced concrete after accidents at the mine at Dolcoath.

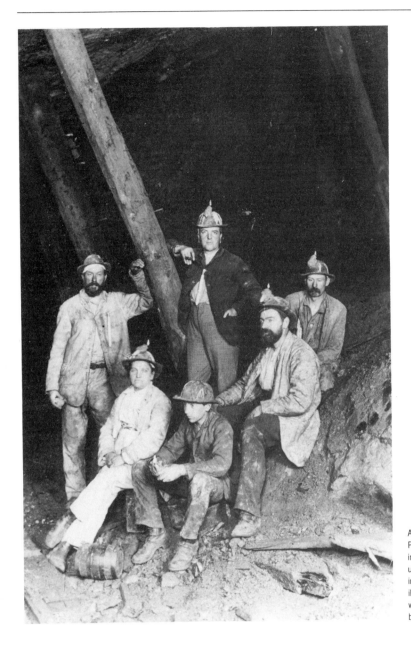

At the 70 fathom level in the East Pool Mine. The picture is unusual in that it shows a woman underground. Their employment in any British mine was made illegal in 1842; in fact, she is the wife of Charles Burrow, the boy being his son.

triple-headed flashlamps for his flashpowder compound. His limelight burners were standard designs, but utilized oxygen and hydrogen compressed-gas cylinders rather than india-rubber bags. A simple valve controlled the flow of gas and production of the light was straightforward. 'Each helper undertook a particular duty. One adjusted the lime-light burners, another attended to the oxygen and hydrogen cylinders and trappings, another prepared

the magnesium lamps, and so on', he said.[16] Several magnesium and limelight lamps might be used in some of the larger chambers, with about five or six exposures made in a working day. This rather slow rate of production was due to problems of magnesium smoke filling the air, preventing more than one photograph being taken at each location. There were also difficulties in transporting the apparatus.

Readers intending to attempt underground photography must not be discouraged when a too eager assistant, staggering through the semi-darkness with a hydrogen cylinder of 20 [cubic] feet capacity under his arm, and a pair of lime-light burners in one hand, stumbles headlong into a pool of water by the side of the level. . . Nor must they lose their self control when, after carefully selecting the driest spot available to open the magnesium powder tin for re-charging the lamps, a "flosh" of water from some unknown source falls into the tin as soon as the cover is off, instantly "dropping the curtain" most effactually upon the remainder of the day's programme.[16]

Even when everything worked as planned, Burrow still operated under trying conditions. Unlike caves and shallow collieries, these deep metal mines, penetrating over half a mile into the earth, were almost intolerably hot.

The camera was attached to the ladder and tilted at an angle of 45°. . . A state of readiness having been arrived at, the word to "light up" produced a powerful flash from the lamps and ribbons simultaneously. The lime-lights were previously at their maximum intensity. An exposure of from two to four seconds generally gave the best results. . . Water dropped everywhere and came from the foot-wall in a steady stream. Heat, water, and vapour, combined with the peculiar setting of the camera, made the work tedious and difficult.[16]

At other times, he was disturbed from his work by the miners themselves. On one occasion, after spending hours transporting his equipment into the deep levels and setting up the camera for his first picture, he was startled when the command came to fire an explosive charge. Burrow was forced to tear down his apparatus and hide beneath a main roof support.

In a few moments, bang, bang, bang, went three holes, the roar of falling stuff followed, and a few loose stones rattled down the foot-wall to the place where the camera had been fixed. This meant waiting for a long time for the atmosphere to regain a sufficient degree of clearness, and, of course, refixing the whole of the apparatus.[16]

1,000 CANDLE POWER PHOTO-EXPOSURE ILLUMINATOR.

Magnesium Powder is uninterruptedly blown **through** a spirit flame, causing not flashes— **but a** continuity of light more perfectly actinic **than** any other known.

Price, Complete with Double Inflation Blower,
15/-

Invaluable for Photographing Dark Interiors, such as Mines, Caverns, &c.

Fig. 1,635.

The ability to photograph underground was not overlooked in advertising, where magnesium powder lamps were considered 'Invaluable for Photographing Dark Interiors, such as Mines, Caverns, &c.', although the dangers of using an insufflator lamp in such situations was high.

Photography usually took a great deal of time, even when everything went as planned. Hughes considered the operation to be a quick one if it only took about an hour to get the picture, and on one occasion 'nine hours work only produced three negatives which on subsequent development were valueless'.[2]

Burrow, like Hughes, persevered. By 1892 he had amassed several hundred negatives from Cornwall, the Bristol coalfields and the slate mines of North Wales. On the basis of his work he was awarded a Fellowship of the Geological Society of London.

The following year, 1893, both Hughes and Burrow were able to exhibit their results to a wider audience. Hughes attended the 'World's Columbian Exposition', an exhibition held in Chicago. Here, there was a wealth of underground material to be seen, both mining apparatus and photographs. Charles Kerry exhibited some thirteen 'curious pictures of caves taken by flashlight', some of which were from the newly-discovered Jersey Cave at Jenolan.[18] One of the most popular pavilions was the Palace of Horticulture. This contained a cave grotto, constructed using masses of crystals and formations taken from the Mammoth Crystal Cave of South Dakota. As many as 20,000 visitors went to the Exposition daily, unconcerned with matters of conservation. Elsewhere, there was the 'Palace Of Mines', a building constructed with French-style façades. Inside, 60 ft-wide galleries were lined with displays in cabinets, the walls covered with underground photographs.[19]

Hughes was not impressed with the quality of some of the pictures he saw, although it did give him an opportunity to see Bretz's work. Additionally, with so many photographs on display, he did not like the inference that this branch of photography was an easy one:

> To instance the fact that the underground photographs are not quite so easy to obtain as may be considered by the samples shown at the 1893 Exhibition, I may state that from statistics of my own exposures, 70 per cent. of the plates exposed have been complete failures, and that out of the remaining 30 per cent., only about one-half are good.[2]

Charles Burrow's companion, William Thomas (the lecturer and mine engineer who had introduced him to the mines), estimated about 17 per cent of the early Cornish results to be successful, although by 1894 Burrow himself claimed an astounding success rate of 60 to 80 per cent for printable pictures.

Burrow differed from his fellow underground photographers in that he generally worked in much deeper mines, with greater difficulties due to heat and in transporting his cameras, compared with others elsewhere. In addition, he specialized almost solely in this type of work rather than producing underground pictures as a curious sideline to a more lucrative business. A set of Burrow's pictures was published as Woodburytype illustrations, with text written by Thomas, in '*Mongst Mines and Miners*,[16] which gained him a great deal of publicity.

Following his 1893 visit to America, Hughes presented a paper on photography in coal-mines to the Photographic Society of London[2] (which became the Royal Photographic Society of Great Britain the following year). Burrow was present and on that occasion elected a member; later, he would gain the first Fellowship of the Society to be granted for underground photography. Also at the meeting was William Debenham, who had worked in Botallack in 1865. While remaining modest about his own efforts and stating his aim of continuing with the experiments, Hughes impressed his audience. Bennett H. Brough, not a photographer himself, considered the results invaluable as teaching aids, and that 'Not only to the miner, but also to the geologist, this question of underground photography was a vital one'.[2]

The general state of underground photography at this time can be gauged by the lack of imagination shown by the Austrian government. Illustrations of underground workings were considered essential for study by both miners and geologists in trying to solve problems relating to the formation of ore deposits. To this end, Brough noted, instead of using photographs they:

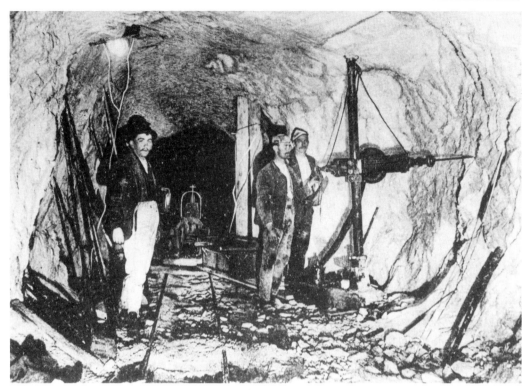

The salt mines in Salzburg were in use as a tourist attraction by the 1900s. This view, c. 1906, shows one of the compressed-air drills, used to bore holes for blasting.

. . . went to very great expense in engaging a corps of artists to make drawings illustrating the appearance of the mineral deposits which miners were working underground. These, of course, were imperfect representations, and had the Austrian Government been aware of the progress that Mr. Hughes and the other gentlemen alluded to in the paper had made no doubt a considerable amount of time and trouble would have been saved.[2]

Even with this demonstrated requirement for mining pictures, Hughes felt that underground photography would never become popular.

In the first place, few people but mining engineers had the necessary facilities; and in the second place, the work was far too costly. The subject was hedged round with difficulties, and he could do little but confess to failure after failure. One really flared off as much magnesium as possible, and if the result happened to be good it was good, and that was practically the gist of the whole subject.[2]

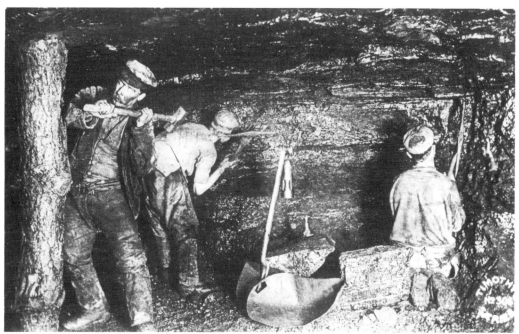

Stephen Timothy photographed the working face in the shallow Ton Pentre level *c*. 1905–10. Of interest is the mixture of lighting, both candles and flame safety lamp being present, and both shovel and curling box. The box was used to load lump coal into the trams; shovels were not in general use until after *c*.1905, as the men were not paid for small lumps of coal brought to the surface.

Thankfully, the photographers of the next century continued his work despite the difficulties. One of the more notable of these was the Revd Francis William Cobb, who photographed miners at the Brinsley Colliery at Nottingham between March 1912 and December 1913. The result of his work was a set of 115 lantern slides depicting all aspects of the collier's life.[20] William Edmund Jones of Pontypool, South Wales, produced an extensive series of lantern slides for lectures given by his father to the South Wales Miners Federation and the Independent Labour Party. Jones used flashpowder or ribbon for lighting, developing his plates in the family larder and drying them in the kitchen oven.[21] Between them, these two sets have preserved some of the most complete pictorial records of the miner's life.

However, not all photographs fared so well. When Burrow died in 1914[22] he left behind thousands of his glass plate negatives from the Cornish and Welsh mines he had visited, as well as some of the shallow Somerset coal-mines. These were inherited by a grocer, Mr Nankivell, who offered them to the Camborne School of Mines. The plates were rejected, and Nankivell returned them to his house. There, faced with stacks of these 'worthless' negatives and a scarcity of glass during the First World War, he proceeded to scrape the emulsion off each one and built a greenhouse. A few survived to be sold in a jumble sale for 6d., but even these were

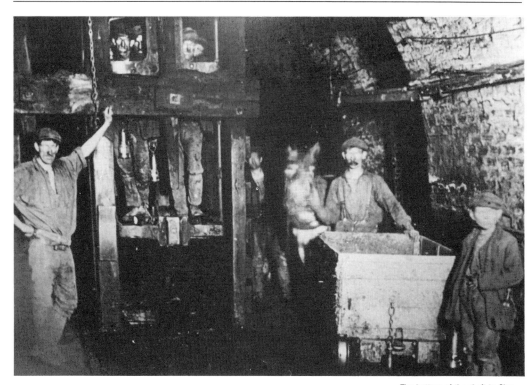

The bottom of the shaft in Clay Cross Colliery, 300 yds underground, photographed c. 1908. The picture was used as a postcard to advertise 'CxC Gold Medal Coal'. If the whole set of twenty-five cards, collected when purchases of coal were made, was presented to the company's offices in London a prize could be claimed.

unwittingly destroyed by the new owner when he stored them in a damp cellar.[12] The rest of the depleted set eventually ended their travels in the county museum at Truro.

After 1901 new commercial incentives were provided by a growing postcard industry, both for sale of the cards and for advertising. Individual mine owners had to promote their own coal; Clay Cross Colliery in Derbyshire gave away free postcards showing the coal being mined to stimulate sales.[23] Surface views of coal-mines, in particular, became common.

When safety standards in coal-mines were eventually brought to their current high standard the nature of underground photography had to change and it was no longer possible to use an unprotected flame, although naked light pits continued well into the twentieth century. Magnesium, limelight and all metallic or electrical devices that could create a spark are now banned as being too dangerous. Only 'intrinsically safe', and individually checked, flashguns or any other electrical apparatus can now be used, a far cry from the cumbersome apparatus employed by Bretz, Hughes and Burrow. But it was on the foundation of their work that modern mine photography is based, albeit safer to accomplish, and it remains difficult to match the quality of photography that these men produced.

The Gentlemen Cavers

Nor spider weaving in the dark,
Nor screech of owl, nor fox's bark,
* Nor wing of bat, nor foot of mole,*
Disturbed the hush of the haunted hole.

When suddenly just about six o'clock
The echoes were waked from their sleep by a knock,
* And there in the midst of the vaulted hole*
Two cyclops stood, with dusky hood.
* Grim and huge and ghostly tall,*
A gleam of wrath in each lone eyeball.

They formed them up in gallant ring,
Some uttered squeals, while others sing,
* And all their mingled tones unite*
To call forth from the darkness, light.

A glow, a gleam, a broader beam,
Startles those realms of ancient night,
* While bats whirl round on slanting wing,*
Astonished at this awful thing.

The rocky roof's reflected rays
Are caught up in the water ways,
* And every jewelled stalactite*
Is shining with reflected light.

One moment only, then the caves
Are plunged again in Stygian waves,
* The fairy dream has passed away,*
And night resumes her ancient sway.
* Around the wreck of one small spark,*
Deep spells are muttered in the dark.

Revd C.F. Metcalfe,
Midsummer 1897,
Wookey Hole.[1]

At the beginning of the 1890s Martel's influence on his fellow explorers was already bringing the term *spéléologie* – 'speleology' – into use in France. The caverns of the Causses were being systematically explored and there was a surge of interest in discovering the lost rivers that flowed beneath the huge limestone plateau. On the Continent, caving as a science had begun. For amateur cameramen there were new incentives to develop photographic skills under arduous conditions of exploration. In Britain, however, no such atmosphere existed; the expertise and photographic skills of the French had yet to spread across the English Channel, and there was no comparable activity.

In the sphere of mining photography, Burrow and Hughes continued their experiments in both the Cornish mines and the rich coal-fields of the Midlands, working out their own techniques without the benefit of Vallot or Gaupillat's knowledge. As for caves, these were considered to be of very little interest to all but a handful of men. While a limited number of underground pictures had been produced for tourists, any systematic exploration of the many open shafts and caverns had yet to develop. Then, in July 1895, Martel visited Britain.[2]

Edouard Martel was invited to speak at the Sixth Geographical Congress in London during the month of August, but arrived early to examine a particular cave that had been brought to his attention. By now Martel had some seven years' experience of exploring caves and he confidently set off for Yorkshire armed with lengths of rope ladder together with the firm intention of discovering the underground course of the missing river of Gaping Gill. The outcome was acclaimed a major success. Martel made the first descent of the 110 m shaft on 1 August 1895.[3]

Martel's descent of Gaping Gill was publicized in the press and has been said to have begun a new era of caving in Britain. Those men previously interested in mountaineering, rock-climbing or rambling found a new involvement: caving. The concept of exploring the caverns that lay below the mountains and moors they loved, for the sheer enjoyment of discovery, was enthralling.

In Somerset, open caves with large entrances were few, apart from Wookey Hole and the Cheddar Caves. They had been inspected over many decades in the hope of finding new extensions to tourist attractions or more archaeological remains. Stimulated by the archaeological work of William Boyd Dawkins, one man, Herbert Ernest Balch, had scoured all the known sites of the Mendip Hills many times over in his indefatigable search for remains. Indeed, Wookey Hole, with its imposing arched entrance at the head of a leafy valley, was one of the major archaeological caves of the era and yielded many important finds during successive digs. By 1895 Balch's collection of carefully catalogued bones

and prehistoric remains had grown to such proportions that he founded Wells Museum to house it.[4]

Even after news of Martel's descent of Gaping Gill reached Mendip, Balch still spent all his time in pursuit of his scientific and archaeological objectives. Unconcerned with the idea of sport or exploration for its own sake, he nevertheless became interested in the concept of photographing the caverns he so often visited. A picture could be used as a recording tool as well as a means of showing others the delights to be found underground. One of Balch's personal friends was the Revd C.F. Metcalfe of Salisbury, who had officiated at his wedding and was also an amateur cameraman. The two men teamed up, and in 1896 Balch, with his friend's aid, began to photograph the caves of Somerset and Devon. These pictures usually showed little more than the entrance, small groups of people or formations, and were not of high quality. Then, in Midsummer 1897, 'after repeated efforts which failed', the first photograph of a large chamber was made.[5] However, the circumstances surrounding the reasons for its production and the development of the techniques used, remain a matter of conjecture.

Balch lived in the small city of Wells, at the edge of the Mendip plateau, with Wookey Hole only a short distance to the west. At 27 High Street, Wells, was the photographic studio of Frank Dawkes and Harry Partridge. Balch approached the photographers with the idea of taking pictures in the vaulted Great Chamber of Wookey Hole, realizing that his own techniques and photographic equipment were not adequate for a project of this scope.[6]

When Martel visited Britain he had brought a set of lantern slides to illustrate his lectures, which he left behind for others to use. However, he left little information on how the photographs had been produced. The techniques were recorded in French journals and Martel had included a few of them in his book *Les Abîmes*.[7] However, none of this published information concerning lighting was accessible to Balch, or Dawkes and Partridge.

Nevertheless, being professional photographers, Dawkes and Partridge would have been conversant with all forms of artificial light. Limelight burners were still common and magnesium was often used when limelight was not convenient. There was no problem in transporting a calcium light into Wookey Hole, for the entrance was immense and the main chamber only a short distance within. Echoing Burrow's decision (and it is even possible that Dawkes and Partridge read details of the lighting he used), they prepared a combination of limelight and magnesium to attack the subterranean night of Wookey Hole.

Dawkes and Partridge realized that limelight would necessitate an extremely long exposure, far too great to allow a person to stay

still within the picture. The power of magnesium was well known, and it should have been the obvious choice for the main light, but instead it seems only to have been used for supplementary illumination. In the event, limelight had to be burned for two hours to obtain an image of the dark walls. A local man, Mr E. Berry, was then placed in the picture for scale and illuminated with a burst of magnesium, this providing most of the useful light. In view of Balch's prior attempts, the successful outcome was considered doubly impressive, though the relative power of the two forms of light was obvious. Balch wrote alongside a copy in his photographic album:

> This photograph is very remarkable. It is the only wide angle photograph of a great subterranean chamber which has yet been obtained. . . The exposure consisted of two hours oxyhydrogen light followed by four powerful magnesium flashes from a large lamp and about ten to fifteen feet of magnesium ribbon in a handlamp. The latter was used at the last minute to put in the figure at the far end.[5]

The Revd Metcalfe, who was also present, felt moved enough to write in praise of the two cameras and vivid lighting that illuminated the hole.

> And there in the midst of the vaulted hole
> Two cyclops stood, with dusky hood.
> Grim and huge and ghostly tall,
> A gleam of wrath in each lone eyeball.
>
> A glow, a gleam, a broader beam,
> Startles those realms of ancient night,
> While bats whirl round on slanting wing,
> Astonished at this awful thing.[1]

The cameras with their peering lenses and cloth veils, and the limelight and magnesium burners, did their job well, although the trip was abruptly brought to an end when one of the photographers fell into a pool.

Amateur photographers were increasing in numbers by 1897; the American, George Eastman, had just introduced his range of folding cameras and roll films, and cheap snapshots could easily be taken. 'You Press the Button, We Do the Rest' was Eastman's motto.[8] Photography had never been easier. The range of available cameras and specifications soon increased further; shutters had been introduced as a necessity when emulsions became too sensitive and exposures too short to retain the old method of uncapping and covering the lens, although most lacked any method of synchronizing a flash with the shutter.

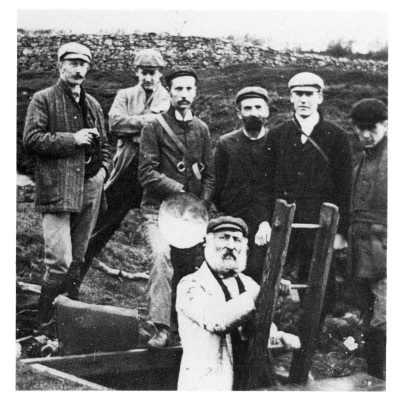

A group descending Lamb Leer Cave, Somerset, photographed by Balch in 1900. In the centre is a magnesium ribbon reflector. This might be used for general illumination, or photography.

Plate cameras had become smaller and lighter, and were also much cheaper. Commercially produced dry plates were sold ready for use; preparing your own plate was a thing of the past. Balch was evidently impressed enough by Dawkes' and Partridge's success to begin taking his own pictures in earnest, although he was often less than pleased with the results he obtained. His photographic album abounds with comments such as 'an early attempt at a photograph', or simply 'an attempt'.[5] He obviously realized his shortcomings.

While limelight could be conveniently used in Wookey's spacious chambers, it was hardly suitable for the other known Mendip sites, which were more restricted in size. Here, either flashpowder or magnesium ribbon had to be used. However, before Balch was able to experiment with more than a few pictures, the closing years of the century saw him sustain a serious accident in Lamb Leer.[9] The drop into the main chamber was normally descended by lowering on a rope being unwound from a windlass. When Balch was lowered, the rope snapped. Only chance saved his life when he became tangled in a second line alongside, cutting his hand in the process. Balch was understandably shaken but not seriously

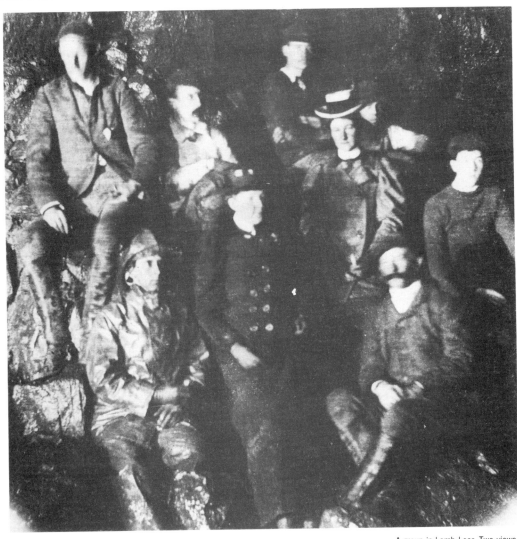

A group in Lamb Leer. Two views were taken on this occasion; this is an enlarged portion of one, excluding the surrounding cave. Reputedly taken after Balch's fall, the picture includes two women, the first to reach the bottom of the main chamber.

hurt and, although a picture was taken of the group, little more photography or other underground work on Mendip was undertaken either by Balch or his companions until the twentieth century had begun.

In Derbyshire serious exploration began in 1900 when a group of rock-climbing friends visited Eldon Hole. Their objective was to determine if techniques normally used to scale rock-faces would be useful in descents under the earth and to see if such an activity would be of any interest to them. 'Rock-climbing above ground is a fascinating sport; to enjoy it below the surface and in semi-darkness would surely be to catch a rarer thrill – at least so we

argued', wrote Ernest A. Baker, a Derby librarian.[10] The climbers certainly picked the right location to 'catch a rarer thrill'. Eldon Hole possesses a yawning entrance 100 ft long by 20 ft wide, with a drop from the surface of 220 ft. The first part of this could be scrambled down with care, but below this the rock became vertical.

The first visit was not a success, although one man was lowered part way down the pothole. It was six weeks before the men returned, in September. Then, a party of seven climbers congregated at the shaft; once again, Baker was present. He was one of those lowered past the half-way ledge to the boulder slope at the bottom. Several pictures were taken from the surface of the men descending and then F. Wightman decided to try his hand at photographing the shaft from below. He was duly tied onto the rope and lowered over the edge. Just as he swung past the ledge, Baker returned from a brief exploration of the rubble slope and chamber that led away from it, to see Wightman descending.

He hardly touched the rocks anywhere, but with camera on his back came down, slowly spinning like a joint on a roasting-jack. . . Our main object was to secure a view, but with only one man to hold the magnesium wire we spent a considerable time in the cave to little profit. There is not a flat spot in the place; in the fitful light stumbles were frequent, and once the photographer, encumbered with camera, a torch, and a bottle of paraffin, slipped and let the camera roll down the stones. But we managed to illuminate the cavern magnificently with paraffin torches, magnesium, and Bengal fire. . . Our combustibles had filled the place with smoke, the sting of which half-blinded my companion.[10]

Without experience of such work, Wightman's results were poor. Further explorations were made on Boxing Day, when Baker was joined by James W. Puttrell of Sheffield. Puttrell and Baker then began a systematic exploration of other known Derbyshire sites, beginning with Speedwell Cavern.

Speedwell largely consists of a mined tunnel, or adit, flooded throughout its length. This was driven by miners in the eighteenth century as part of their unceasing search for lead, permitting the removal of ore from natural cave passages at the far end. At the start of this century the mine was owned by J.H. Eyre, who ran tourist trips using flat-bottomed boats. At the far end of the canal visitors could disembark, to peer over the railings that protected the Bottomless Pit, a void that plunged away from the safety of the ledge.

On the evening of 4 May 1901, twenty-four men left the Peak Hotel in Castleton and entered the adit, briefly pausing for the

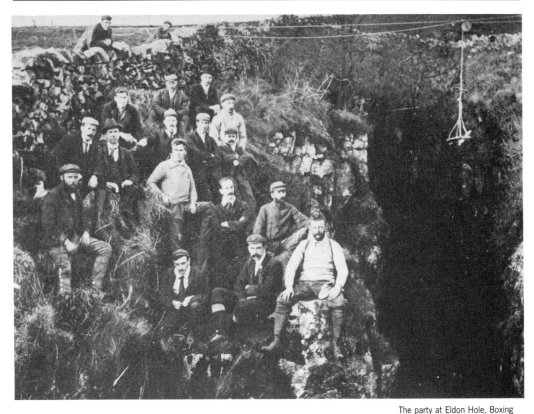

The party at Eldon Hole, Boxing Day 1900. The bosun's chair, used to lower the men into the depths, is seen hanging over the shaft. The photograph was taken by H. Eggleston.

'inevitable photograph' to be taken at the entrance.[11] As before at Eldon Hole, there was a photographer present on the exploration. On this occasion, Puttrell and Baker brought Harry Bamforth of Holmfirth as a member of the team.

Bamforth belonged to a family deeply involved in photography. His father, James, had begun a business in 1870 which supplied lantern slides for music hall entertainment. The magic lantern was a device similar to modern slide projectors, using limelight or acetylene as a light source. Typically, the slides illustrated a moralistic story, for example in support of the Temperance Movement. The lantern slides were produced in volume by Bamforth, the largest manufacturer in Britain.[12]

At the turn of the century, James Bamforth had three sons – Frank, Edwin and Harry – who were all helping in the business. All three were conversant with cameras and lighting apparatus. Limelight was used both in the music halls and in projectors. Harry Bamforth made good use of his knowledge when the chance came for him to visit Speedwell and he took along two of the firm's limelight burners.[13] Cylinders of oxygen and hydrogen gas were covered with rope for easier handling and to afford some protection.

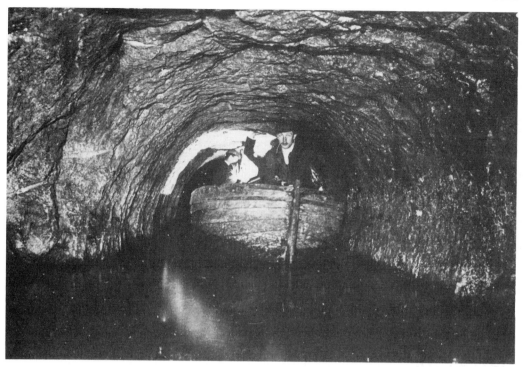

The canal in Speedwell Cavern, photographed by Harry Bamforth. The use of two light sources, one for general illumination and one within the picture, was an exciting departure from previous techniques.

The burners were made of huge wooden boxes with lenses in front. The apparatus was loaded into the boats and slowly transported along the flooded canal to the edge of the Bottomless Pit. Baker wrote:

> On the platform of the causeway the piles of ropes, planks, photographic apparatus, cylinders of gas, and the huge quantity of miscellaneous implements lying about showed that our friends had made great preparations against our coming. . . [A] powerful illuminant had been devised by the photographers, Messrs. Bamforth, of Holmfirth, and the cavern, with its black pit and the strange roof piercing the hill for hundreds of feet overhead, was lit up by such a glare of light as had never shone there before.[11]

The limelight burners were new to British cave exploration and quickly became standard equipment. With their light men could examine every detail of a large chamber with ease, though limelight remained virtually useless with regard to photography. Magnesium was still required to expose the insensitive plates, although composition was no doubt made easier with the added illumination of limelight.

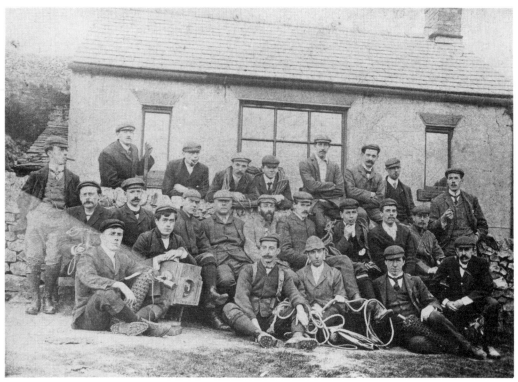

Before their exploration of the Blue John Mine at Castleton in 1902, the Kyndwr Club was photographed by Bamforth. J.W. Puttrell, the leader, is at the centre, sitting. The limelight burner with its 'bullseye' lens and the cylinders of hydrogen and oxygen are held by other explorers.

Although Bamforth was the main photographer at Speedwell, he was not the only one present. Wightman, who photographed the descent of Eldon Hole, was also part of this new exploration. With Bamforth busy operating his camera, Wightman contented himself with sketching the drop into the pit while another companion, Mr F. Smithard, took a few pictures. At least eight plates were produced that day, which was

> . . . as many photographs taken as could be secured in an atmosphere now made thick with smoke from our combustibles, we sent up the impedimenta and returned to the top of the embankment one by one. . . . Now we all gathered together in the smoky cavern for a final group, one of the most extraordinary photographs, as to conditions and surroundings, ever taken by artificial light.[11]

Many of Bamforth's pictures, both here and later at Peak Cavern, were excellent.[14] His technique and general composition proved to be very different from that of the French, for he was not afraid to place his lights within the picture itself. For recording people he used the customary light placed near to, but at the side

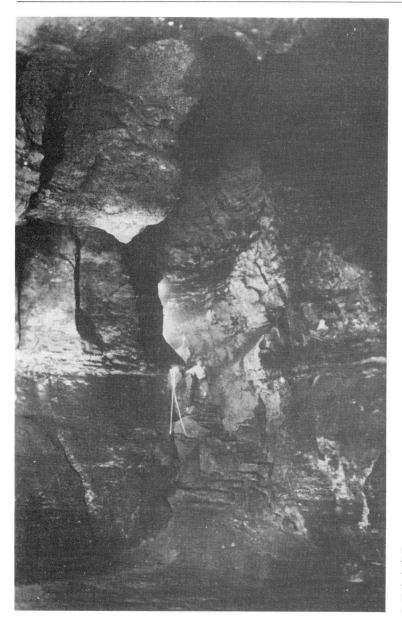

Lord Mulgrave's Dining Room in the Blue John Caverns, showing tourists descending the steps with fragments of falling magnesium leaving tracks on Bamforth's picture.

of, the camera; for more distant scenes he gave his imagination full rein and experimented, not only with side lighting, but also silhouetting people using hidden light sources. Initially, it would seem that the form of magnesium that Bamforth burned was mainly ribbon, although flashpowder was certainly used for some pictures, especially those of groups, and Bamforth was no doubt conversant with both forms of lighting.

Together, Baker and Bamforth visited all the known sites of interest in Derbyshire, the latter taking pictures and teaching Baker the basics of underground photography and lighting. On 26 April 1902 Baker and several of the other explorers, including Bamforth, Puttrell and Wightman, descended the Blue John Caverns near Castleton, where Brothers had made his original experiments into underground photography. The objective was a thorough exploration of the caverns and mine workings, which had previously been examined during the early 1890s. They soon found a new section to explore, a high rift that could only be reached with the aid of two ladders tied together. With difficulty, the men climbed the slippery rock, and Bamforth decided to attempt a photograph of the discovery. It was a dangerous proposition.

[We] stationed ourselves on the base of the cascade of stalagmite and hauled up two planks, which we fixed across the opening underneath us, and so constructed a flimsy platform for Mr. Bamforth to place his camera upon. . . . The highest point I reached was about a hundred feet up, where I stood on a rock that bridged the gulf. Upwards I saw right into the curved and twisted rift, a vision of wild beauty, and downwards I looked on a scene that was amusing in spite of the eeriness of our situation. On the two planks, eighty feet below, a full-plate camera was erected, and looked ready to topple over on the heads of the men holding lights at the bottom of the cave. The photographer dexterously got the focus and snatched his view without going behind the camera, and now proceeded to the delicate task of getting the instrument down. All the while bits of rock were falling on everybody from the climbers overhead, the various ropes were getting entangled in the fitful light, and the curious echoes of the place added to the seeming confusion.[15]

One of Bamforth's main uses of his underground photographs was in the production of postcards; it was to become an important source of income from which Bamforth increasingly earned his living. The postcard craze had a profound effect on the production of new cave photographs around the world and eventually stifled the production of stereo cards, almost banishing them to oblivion. It proved a commercial incentive that could not be ignored by owners of tourist sites.

Photographically produced British cave postcards were introduced in 1901 or 1902, although non-photographic postcards first appeared in 1869 in Austria, and Britain in 1870. Postmarked cards with cave illustrations have been found of the Bilsteinhöhle in Germany dated 1890 and earlier ones probably exist, but these are based on drawings, not photographs. In Britain postcards, by law, had one side taken up with the address, while the other bore both

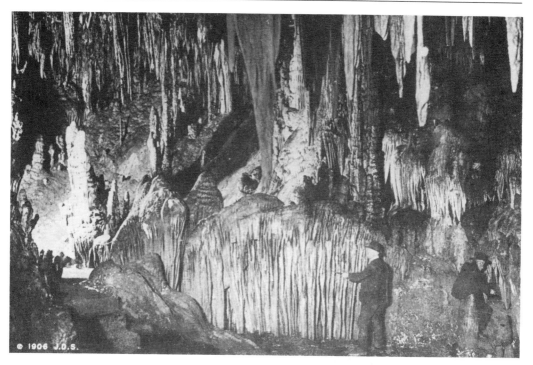

J.D. Strickler photographed Luray Caverns in 1906. The prints were used as postcards for many years. In a lack of consideration for conservation the guide is hitting the formations, called the 'Organ and Chimes', to produce different notes.

a photograph or other illustration and a space at the side or bottom for the message. In January 1902 this was amended so that the back was divided, the two halves being for address and message, which granted the publisher freedom to fill the whole of the front with the picture.[16] Australian postcards of caves, also introduced around 1901, were not permitted a divided back until 1905, one of the last countries to change their regulations.

Around the world, the commercial interest in postcards resulted in many new cave photographs being taken and existing pictures lingering in files were often resurrected. In comparison with the rest of the world Britain and her colonies were slow to realize the profit that could be gained from sales. American cave postcards had become steadily more common in the late 1890s, for example. Ben Hains permitted many of his stereo views from Mammoth Cave to be converted into postcards, some of these being published by Ganter, the manager. In Australia, Charles Kerry published postcards of his earlier Jenolan pictures.[17]

With the increasing, lucrative market of the 1900s, photographers who would not normally show any interest in the underground turned to the subject with, if not relish, at least a commercial willingness to record their nearby tourist caves. Later, British postcard photographers such as Sneath of Sheffield, Shaw

of Blackburn and S.W. Chapman of Dawlish in Devon undoubtedly fell into this category.[18] At Cheddar, local photographers such as C.H. Collard also produced their own prints for sale in the shops that lined the streets of the lower gorge. In America, one set of postcards taken in Luray Caverns by J.D. Strickler in 1906[19] provides an example of a functional photographic record that served both tourist and cave owner alike. They were unexciting, as were so many of these mass-produced pictures, yet were used for many years in both black and white and hand-coloured forms.

In Australia there were several photographers involved with cave tourism. Apart from the involvement of Charles Kerry, Harry Phillips of Katoomba bought a camera and printing press about 1908. His living was then earned taking pictures of the mountains and caves that he grew to love, selling reproductions as cards or prints, or in guide-books.[20]

Another Australian amateur photographer was John Flynn, who later founded the Flying Doctor Service. Flynn lived in Victoria and often accompanied the local prospector Frank Moon when he explored the caves of the Buchan river valley. A presbyterian minister, Flynn photographed the caves and gave lantern slide shows to his congregation, and is credited with gaining the government's interest in developing the region on the strength of the pictures he took. Other photographers such as Stephen Spurling III and John Watt Beattie (both separately working in Tasmania), and Anthony Bradley, a guide at Yarrangobilly and later Jenolan, all produced cave photographs of quality,[20] as did the landscape photographer Frank Hurley.

Many early postcards were produced as bromide paper prints, sometimes pasted onto stiff board. This allowed 'news' cards, usually taken by a local photographer, to be on sale in a matter of days. This applied not only to events such as coronations or railway crashes, but also cave explorations. Some occasions were so important they warranted the production of printed half-tone postcards. Martel's first descent of Padirac in 1889 was later depicted in this way. When a flood trapped seven cavers in the Lurloch Cave in Austria for nine days in 1894, a postcard appeared with their portraits.[21]

The new market for photographers was vast. With cheap postage for cards in Britain and deliveries both efficient and frequent with a minimum of three services a day, millions of postcards were sent each year. The boom lasted until the end of the First World War. Just as with stereo cards, cave owners welcomed the craze and used it to aid their advertising and boost revenue. The use of photographs for this purpose was exceptional in one area of Britain, at Cheddar in Somerset.

Within Cheddar Gorge in 1900 there existed two tourist 'show'

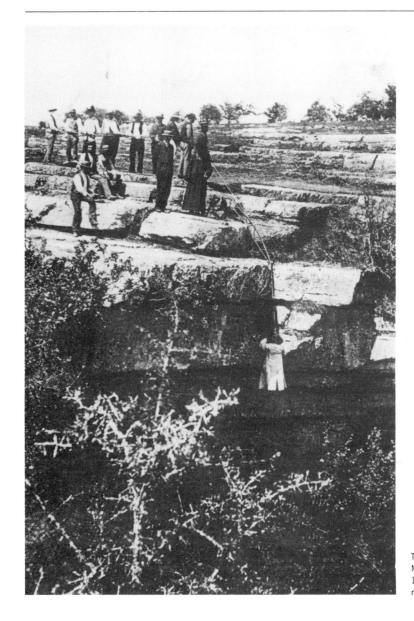

The first descent of Padirac by Martel, made on 9 and 10 July 1889. The photograph was later released as a postcard.

caves, and a developing tourist industry. On the one hand, there was Cox's Cave, operated by Edward Cox, while just a short distance away tourists were drawn to the entrance of Gough's New Cave, discovered by Edward's cousin, Richard Gough. Gough had searched for new passages for years, managing the inferior 'Old' cave until, in 1892, he opened his 'New', well-decorated cavern. When Richard Gough died in 1902 ownership of the cave passed to his widow, Frances, and two sons, Arthur and William. Arthur

was the eldest and to him fell the day-to-day management of the cave, while his mother took care of the tea-rooms at Lion Rock House, further along the gorge.[22]

Although Edward Cox and Arthur Gough were on reasonable terms outside work,[23] when it came to the business of attracting tourists to their caves they developed a publicity campaign such as Cheddar had never seen before. Any form of advertising that might increase visits to one cave rather than the other was encouraged, including sales of pictures. Photography had found a new part to play in Cheddar.

Photographs of Cheddar had been produced and sold as early as 1879, when Archibald Coke took pictures of the gorge. Around 1890 William Samuel Chapman from Dawlish in Devon produced photographs of paintings depicting the cave interiors. A photographic studio near Cox's Cave entrance[24] produced pictures of tourists arriving by charabanc, and is known to have sold photographs of Cox's Stalactite Cavern taken 'by the Best Artists, in great Variety' around 1886.[25] Unmounted photographs continued to be sold into the next century. At that time Richard Gough was unable to compete in the same way with his 'Old' cave.

Among the first postcards produced of Gough's Cave were those made by the owners in 1901 or 1902. The publisher was given as 'William Gough, Lion Rock Bazaar, Cheddar', or 'W. Gough, Tween Town' (the part of Cheddar at the mouth of the gorge). Arthur Gough, a keen amateur photographer, was the cameraman, while his brother sold the cards in their shop. Many of the pictures were later used with the imprint of established postcard manufacturers such as the Pictorial Stationery Company Ltd. or Frith's of Reigate, with Gough retaining the reproduction rights.

Frith photographs were also on sale at Cox's Cavern. These were probably taken by Frith's assistants;[26] Frith himself died in 1898. Cox, according to a handbill of about 1890, states that there were eighteen photographs credited to Frith available and on sale at the cave, this number rising to twenty-five by the end of the century.[27] Between 1902 and 1903 all twenty-five pictures were published as postcards as the craze developed; by 1910 Cox had fifty-two different views on sale, rising to seventy-two by 1932.[24] As elsewhere in the world, the sale of both original photographic prints and postcards was an important source of revenue to the cave owners.

Lighting for the underground pictures posed few problems. As tourist sites, Cox's and Gough's Caves were adequately lit so that both gentlemen and ladies could see the cascading crystal waterfalls of calcite, the stalagmite likeness of Cox's 'The Pagoda', the 'Home of the Rainbow' or Gough's reflected 'Swiss Village' of stalactites. In common with all tourist caves, every detail had to be named.

Cox's Cave relied on acetylene for lighting, while Gough used electricity. None of these lights were really bright enough for photographic purposes, but they allowed the composition to be easily determined and could be supplemented with magnesium light. Alternatively, of course, the camera could be left aimed at the formations until an image had formed, however long it took. In this case, the long exposures required would prevent the inclusion of people, but the formations themselves were considered to be of prime importance in these pictures. Indeed, the vast majority of cave photographs taken around the world were of the relatively easy subject of formations, without the use of people for scale.

The pictures that Gough and the other postcard manufacturers obtained were usually poor with boring, unimaginative lighting angles. However, for the purpose of postcard production, a changing product and quantity of production was often more important than considerations of quality. Regardless of the nature of the finished product, all further work of importance in underground photography took place in caves well removed from such tourist attractions.

The nature of the caves being explored had changed during even the few years that Bamforth and Baker had been active. Limelight burners were now considered to be too bulky and inconvenient to carry in some of the wetter, tighter locations they had begun to look at. Once the obvious sites around Derbyshire had been exhausted, the two men looked further afield. Although he now lived in Derby, Baker had been born in Somerset, and knew of the existence of caves in the Mendip Hills. They visited Cheddar in 1902 and took pictures there and at Wookey Hole, but did not hear of Balch's continuing work in exploring Mendip's caves.

During August 1901 and April 1902 the entrances to Swildon's Hole and Eastwater Cavern were dug out. Both supplied water to Wookey Hole through passages within the limestone hill.[28] Balch was interested in the sites because they might permit the exploration of the subterranean course of the River Axe from Wookey's feeder caves, Balch having failed to do so at Wookey Hole itself. This cave ended in a wide, dark pool that masked a sump. Even when, during a drought, the sump had been passed to a small air pocket, Chamber Four, further exploration was well beyond the technology of the time.

Balch, with his continuing interest in these feeder caves, influenced the whole development of Mendip caving; expeditions would be considered, reports made, and finds duly logged and noted by Balch. A visit to Swildon's Hole needed to be carefully planned in those days, both to make the best use of free time away from work (which meant that most caving was done during holidays such as Christmas or Easter) and to make the exploration

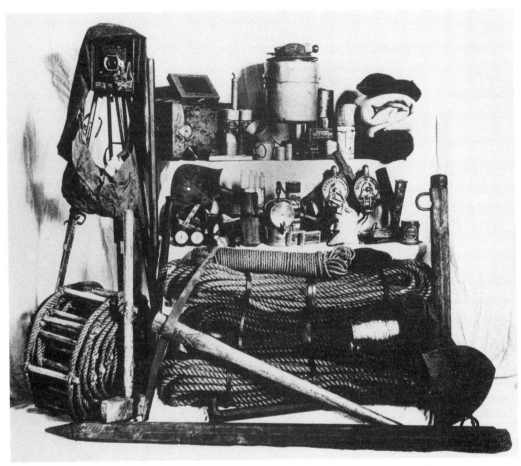

Some of the equipment considered necessary for an expedition down Eastwater Cavern early this century. Apart from pulleys, ladders and rope, there is the plate camera and tripod on the left, plus the dark slides and plates next to it on the top shelf.

as safe as possible. All the equipment and men had to be brought up onto the hills from Wells by bicycle or pony and trap, and then, having changed into old clothes, Balch and his friends could enter the course of the underground streams and follow them into the unknown.

Anything that *might* be remotely useful would be taken underground for, just like Martel, Balch felt that every eventuality should be catered for. Hemp ropes, food, stove, candles, matches and cameras would all be bundled up and passed hand-to-hand through the cave. Trips underground that might take an hour today could last more than twelve hours in these first years of the new century. The men involved had to be fit and keen to withstand their constant cold soakings.

In 1903 Baker published his book, *Moors, Crags and Caves of the High Peak*, which detailed his explorations in Derbyshire and

chronicled some of Bamforth's work.[15] That same year Baker finally met Balch, and there followed a period of co-operation between the two men that led to the joint exploration of many caves.

In the summer of 1904, Martel and his wife visited Mendip. Martel had published his small booklet on cave photography, *La Photographie Souterraine*, only the year before.[29] In the company of Balch, Baker, Bamforth and Puttrell, Martel visited the Cheddar Caves, among others, and wrote:

> I admired there a profusion of slender columns and draperies of calcite **such as I have seen nowhere else**; their incredible delicacy and rich colourings make the interior of Cox's Cave **A Veritable Jewel**. Every tone of red from tender pink to a deep brown, and even certain violet shades, decorate its sparkling crystallisations. **No other Cave presents to my knowledge such a variety of tints**.

Cox reproduced this on a new handbill,[30] and immediately had his postcards altered. These bore the message 'Cox's Cavern. Visited by H.M. King Edward VII. Martel says the best of 600', ignoring the fact that King Edward had not been near the cave since about 1857. All was fair in the feud between the cavern owners.

Martel took a few pictures of Gough's Cave and it is likely that there was an interchange of ideas and techniques between Martel, Balch, Baker and Bamforth during the visit. Baker was himself becoming quite well versed in photography but, like Balch, he never specialized in the discipline as Bamforth had. When Bamforth was present it was normal to follow his lead, everyone opening their shutters at the same time, making use of the same flash.[31]

In December 1904 it was decided to resume the exploration of Swildon's Hole. Until then only a handful of trips had been undertaken. That Christmas, Baker and Bamforth were led down the cave by R.D.R. Troup, one of the original explorers, with the hope that Balch would join them later. Since it had been raining a great deal the stream had swollen and progress was difficult. Nevertheless, Bamforth was determined to take his cameras; the previous year he had been forced by high water to leave them just inside the entrance of Eastwater Cavern, and this time he was not going to be prevented from obtaining some photographs. Baker wrote:

> We had one advantage, however: the original discoverers were with us to point the way. With luggage reduced to a minimum, two ropes, plenty of illuminants, food, and two cameras, we passed through the uninviting entrance . . .[32]

Photography was obviously considered to be a very important aspect of any exploratory work, with two cameras being taken on a 'lightweight' expedition. It was only with great difficulty that the head of an unpassed 40 ft pot was reached. The floods prevented any attempt at a descent, but photographs could be attempted at the very least. Bringing the camera the last few feet brought its own difficulties, and Baker indicated Bamforth's problems in obtaining his pictures.

It had seemed a Herculean labour to bring that much-enduring instrument down to the 300-foot level, but he [Bamforth] declared that the task was not superhuman, and, furthermore, he was determined to do it. He could not do it alone, however; that was obvious. The expedition, therefore, came down out of the stalactite gallery. Two went through the water-chute, two remained just outside it, to assist in the last and most dangerous stage of the transportation . . .

Standing in the water, with light held low under the arch, we caught sight of a hand, and then of a wading and much-crumpled-up man, lugging the camera, which he kept out of the foaming water with admirable skill. We grabbed it, and put the precious instrument in a place of safety; ten minutes later the flashlight was at work, taking our breath away with its gorgeous revelations. The photographer had his troubles even here, though not such as to be compared with those of the water caverns we had recently traversed, where at this moment two of our party, following us down, were engaged in photographing the canyons and the falls, under difficulties that few cameras have ever been confronted with. Here there was no marble pavement suitable to the splendours of the walls; nothing for the camera to stand on but an inch or two of slippery ledge, with a depth of mud in the middle that none of us cared to fathom. The only place that could be found at one spot for the flash-light was the top of my unfortunate head, which I generously put at the photographer's disposal. On it was laid a piece of stone, on which the gun-cotton was spread and sprinkled with the powder, which, when it went off, made me shut both eyes for fear of the shower of sparks . . .[32]

Bamforth remained taking pictures in the cave, soaked to the skin, for over seven hours. Obviously, in conditions such as these a limelight burner was out of the question; its bulk alone would have been too great to transport. Indeed, the large wooden plate cameras with supplies of glass plates were hard enough to bring down the water-filled passages without damage. Water could not only ruin the plates, but warp the mahogany camera panels, preventing the dark slides from operating. However, with efforts

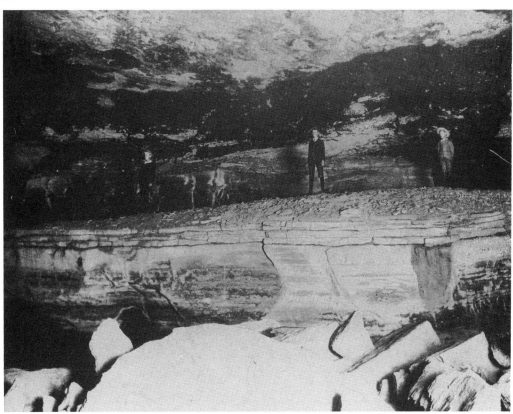

The Giant's Coffin, Mammoth Cave. The photograph was copyrighted by Ganter in 1892, the same year in which Ben Hains took the picture. In 1893 it was noted that 'Several weeks were spent in the cave testing the powerful artificial lights which he [Hains] had provided, and by dint of perseverance he was at last rewarded by the most perfect results.' The picture was used for many years in guide-books and as a postcard, and was one of the first published by Bamforth when he opened a new branch of his business in New York: one copy was posted on 14 September 1907.

such as this, Bamforth did his part in recording the scenes to be found beneath the hills of Mendip and Derbyshire, although his influence on the development of cave photography was nearing an end. In 1905, attracted by the new life he expected to find in the United States, he left the thriving postcard business he had helped found and emigrated to New York to open a new branch for the Bamforth company. He resided with his wife, daughter and son at Peekskill on the Hudson River until his death in the early 1930s.[33]

Bamforth left a changed attitude towards underground photography in Britain. The use of flashpowder as well as magnesium ribbon was now almost universal among cave photographers, despite its explosive properties. No apparatus or lamp was required to burn it, this factor suiting the confines of British caves. Only the difficulties of keeping flashpowder dry, and coping with the fumes which obscured the view, remained. Despite problems of transporting cameras, expense and general difficulties in taking the picture, flashpowder had revolutionized the photographer's ability to take pictures underground. Many cavers acquired the skill of its use.

In Yorkshire, just as in Derbyshire and Mendip, exploration of the caves was recorded with a camera whenever possible, although without the benefit of a dedicated professional photographer such as Bamforth. Surface groups were often photographed,[34] but underground pictures of sites such as Dow Cave, Douk Cave and Gaping Gill, and Dunold Mill Hole in Lancashire, were not taken for several years. The main exponents were Oliver Stringer and Samuel W. Cuttriss. Both were amateur photographers linked respectively to the Yorkshire Speleological Association (YSA) and the Yorkshire Ramblers' Club (YRC).

The YSA was inaugurated in April 1906 by Eli Simpson and Frederic Haworth, who had first caved together in 1903. Prospective members were recruited at their first meeting at the Hill Inn in Yorkshire, one of whom was Stringer, who lived in Ossett.[35] Stringer's cave photography spanned the next eight years until the outbreak of the First World War. When peace came most of the old YSA members joined the well-established Yorkshire Ramblers' Club.

The YRC was an older club, which Cuttriss became involved with around the turn of the century, photographing many of the caves the club visited. Compared with Bamforth, Cuttriss and Stringer's output was slight and the quality of the pictures they made perhaps reflected the restrictions of their cameras and the cost of materials. In addition, they often had more difficult locations to work in, fewer incentives, and usually had further to transport their bulky equipment.

In any case, exploration took first place, photography second. Pictures were taken for personal pleasure and distribution to friends by these 'gentlemen cavers'; many of those involved in Yorkshire, Derbyshire and Somerset were professional men who had the time and money to take part in such leisure activities. At Settle, in the Yorkshire Dales, professional studios such as those of Horner printed and published postcards of the tourist caves. Some photographs of Clapham Cave taken by the amateur photographer George Towler towards the end of the 1890s were published by Horner,[36] and no doubt Towler was paid for his efforts. Albeit in easy locations, some of the work produced by these pioneers was superb. For most amateurs involved in caving, it seems that incentives beyond that of producing a personal record of the expedition were necessary before a photographer would go to the expense and trouble involved in taking many pictures underground.

The professional's outlet of postcards was, of course, one of the main incentives, but there was also a growing demand for book illustrations. In Somerset, Balch and Baker were working on *The Netherworld Of Mendip*, which was published in 1907.[32] This made use of many of Bamforth's pictures, as well as their own, although

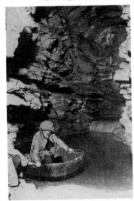

The Morgan brothers in 1912, first explorers of Dan yr Ogof in South Wales, preparing to cross a pool using a coracle. Most exploration was taking place on Mendip and in Derbyshire and Yorkshire, but a few other attempts were being made elsewhere, although few of them were photographed.

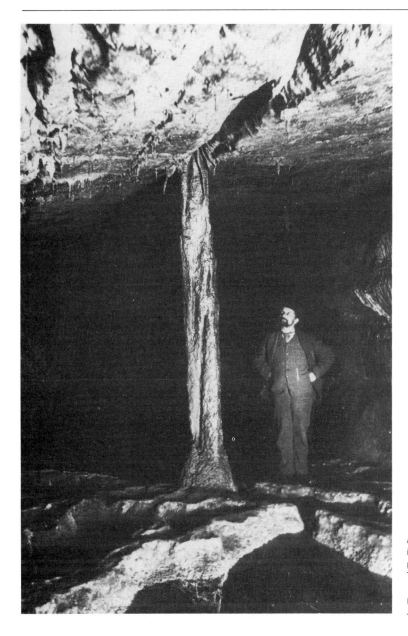

A guide, possibly Harry Harrison, in Clapham Cave, Yorkshire. The photograph was taken by George Towler towards the end of the 1890s and later published as a postcard by the firm of K. & J. Jelley of Settle.

without Bamforth's influence, new photographic work was limited in scope. However, in 1906 the Mendip Nature Research Club (soon to be renamed the Mendip Nature Research Committee) was formed, one of its main objectives being to study the Mendip hills and the caves within them. One man also interested in the locality was James Harry Savory.

Harry Savory was born in Cirencester on 28 August 1889, the

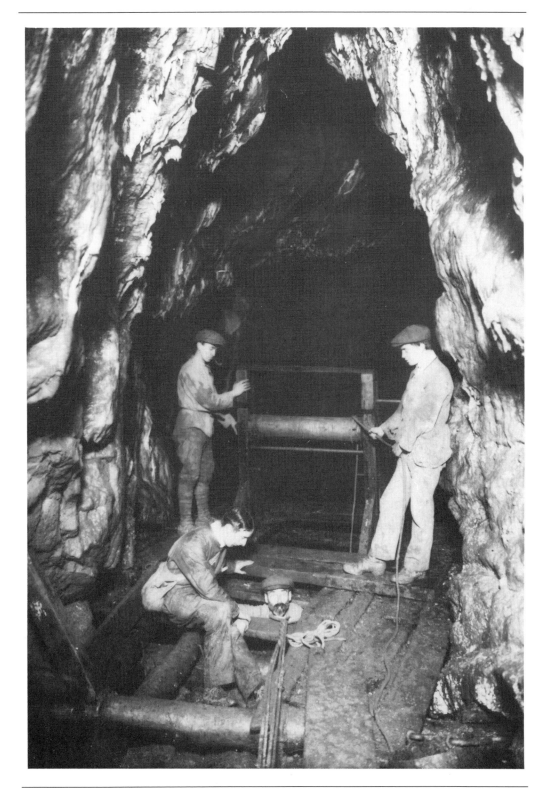

son of photographer and printer Ernest Wyman Savory.[37] He was
the eldest of four brothers and three sisters. When Savory was six,
the family moved to Bristol and set up a printing business named
the Vandyke Press, which specialized in greeting cards. Harry
Savory became a photographer and later took over that side of the
business at his Park Row studios. Then, when he joined the
MNRC, Savory came under the influence of one of its foremost
members, Balch, and was thereby introduced to caving.[38] His
initiation into Mendip's underworld began almost immediately.

Savory kept a detailed diary of his visits to Mendip.[39] His first
major caving trip was on 4 June 1910, when he helped survey in
Eastwater, although he had previously been to Wookey Hole
twice. It was not to be long before his camera was in action
underground. Balch introduced Savory to Baker, and on 28
December both men were in Wookey, lighting the subterranean
scene with magnesium. Savory first photographed Swildon's Hole
during his second visit, on 17 April 1911. For this, and most of his
underground work, he used a half plate camera. Balch also had his
camera with him and recorded some ten scenes in the upper series
and grottos of the cave, including one of Savory and the other
expedition members enjoying cups of hot soup at lunch-time. For
ease of transport and operation in the wet passages magnesium
ribbon or flashpowder was normally burned for photographic
lighting, carefully planning the order of photographs to allow air
currents to carry fumes away from the next location. A small
aperture, usually f16, was used to obtain the required depth of
field.

Savory soon gained both knowledge of the Mendip caves and
experience in his underground work. On 6 June 1911 he photo-
graphed Burrington Combe, although Savory was uncertain of the
actual caves he visited.[40] His explorations were generally detailed
and varied. Savory was involved with much of the original
exploration and spent a great deal of time digging out new
locations such as Hillgrove Swallet, the tight passages of which still
conceal the caves beyond and remain a source of interest to cavers.

By the close of 1912 Savory had already amassed an enviable
number of plates from many of the Mendip caves. The sixth of
April that year saw him underground at Swildon's once more,
where, in the company of Balch and E.E. Barnes, he photo-
graphed the Upper Water Chamber after the sluices were deliber-
ately opened in the feeder pool above. He wrote on one print,
'This picture taken after the first rush of water had passed – in full
flood photography is impossible'.[5] Not many cavers of his day
would contemplate photographing a cave passage being deliber-
ately flooded, even partially. The reality of watching the approach-
ing floodwater while protecting his flashpowder was recorded by
Savory in his diary:

LEFT, Although this picture is credited to Balch in his book *Mendip – Its Swallet Caves And Rock Shelters*, the photograph was undoubtedly taken by Savory. It is possible that two cameras were in use, sharing the same flash, leading to a mistake in identification. The picture shows the windlass in Lamb Leer, with (left to right) Barker, Chandler and Baker, with Reed holding the rope.

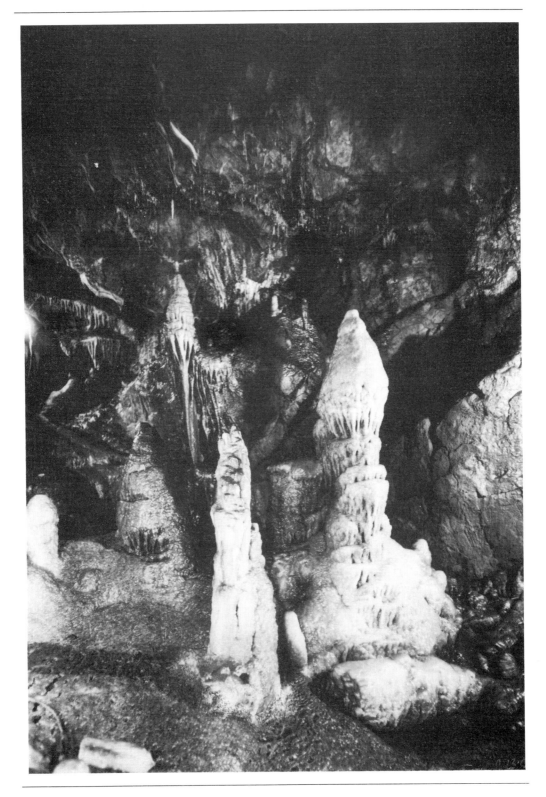

At last it came, in the distance we heard a dull vibrating roar approaching which came louder and louder until it thundered with a rush into the first water chamber, seeming to altogether envelope the stream already running there. . . . It was not just the increase of the one stream, but fresh streams broke in from everywhere practically, and a most unexpected and inconsiderate one started just behind Balch's head, making him do a dash for safety. He took his stand on my left and uncovered the flash pan and set off the touch. It seemed ages going off and in the hurry a candle was flashed across the lens. The flash went off but of course it was then no good so I hurriedly changed the plate, set another flash for Balch again, and squatted in the same place with the camera between my knees hoping for the best. . . Again wiping the lens we had another shot, the water had not abated and this time all went well, although I could see the flash had gone partly in the lens. . . This is the first time that the chamber has been seen in these conditions.

The waters now began to abate. . . . I squatted on a streaming boulder with my half-plate camera covered up in front of me. My feet extended into the stream with the camera case on my insteps and the flash on top of that. After many efforts in the damp atmosphere I got touch paper going and waited an age for the flash, in the meantime I found the mac [wrapped round the camera for protection] was smouldering and burned my hands badly. I knocked it out, shaking the camera and everything seemed to go wrong, but the flash went off in the end and I got an excellent photo.[39]

In 1913 Savory approached Gough with a view to re-photographing the entire showcave. Gough agreed, and by 13 June all the original postcards had been replaced with a new set taken on Savory's full plate camera. In addition, Balch was working on another book, *Wookey Hole, Its Caves and Cave Dwellers*,[41] in these last years before the First World War. He needed illustrations. The connection was obvious; to add to those photographs he already had, Savory began to photograph the cave and archaeological remains using a half plate camera, and both magnesium ribbon and flashpowder.

Wookey Hole was easily accessible and a popular venue for those interested in photography. On one occasion, in November 1911, Savory had found 'quite half a dozen cameras at work' when he arrived.[39] It was common in such situations to set all the cameras on tripods with their shutters open and share the flashes. Several sets of pictures exist which are therefore similar yet attributed to different photographers. Camera equipment often suffered in the upper levels of Wookey. For example, within a single expedition Savory's camera was dropped with a 'bump,

LEFT, Gough's Cave was re-photographed in 1913 by Harry Savory. Over thirty plates were exposed, with the result that twenty-one postcards were produced. The set was added to during two visits in February 1922. This scene shows a group of stalactites in Solomon's Temple, 'Pillars of Wonderful Variety and Form'.

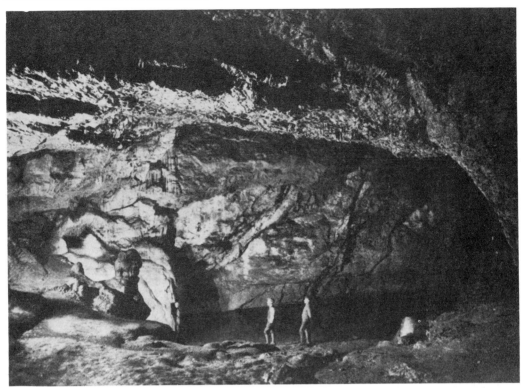

Wheeler and Barnes pose for this photograph by Savory in Wookey Hole. A photograph in an album in Wells Museum notes that this was produced using a mixture of limelight and magnesium flash.

bump, bump down the rocks till with a final leap it settled in the wet sand at the bottom', and his lens later parted from his camera to fall some 15 ft down a fissure.[39]

On 21 March 1913, during his Easter holiday, Savory repeated Dawkes' and Partridge's technique of using limelight in the First Chamber.

We struggled up with the cylinders, having to make several journeys . . . when the light burned up I saw the cave as I had never seen it before. Every detail showed in the bright light, right over to the sandbank. We used long elder wands and wired candles to them for holding up high and getting the exact field of view on screen. . . . When all was ready we exposed and made up our minds for a 2 hour exposure. . . . I had taken a 4½ inch condenser down and placed it on a little heap of sand in front of the 2 acetylene hand lamps to give a good powerful ray which we used for dispelling bad shadows where they were not wanted. . . . Time dragged slowly and we finished up with one big flash behind the Witch and another behind S shoulder by river, Barnes and Wheeler standing in for this.[39]

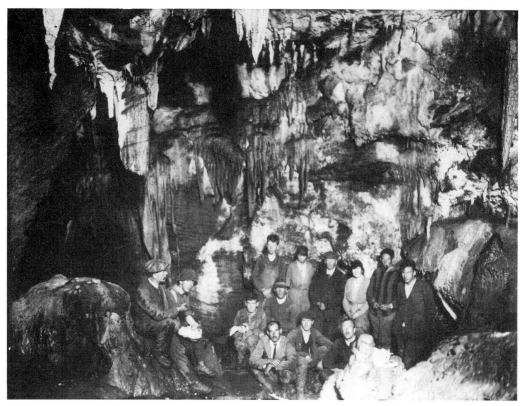

The Old Grotto in Swildon's Hole, photographed by Savory on 13 August 1921. H.E. Balch is on the left, with his brother, Reg, next to him. E.K. Tratman is on the left of the main group, which also includes the local vicar and members of his family.

Magnesium flares were also used for some of the pictures. These burned like candles for up to twenty seconds, although at a cost of five shillings each. In all, four cameras were in use, together with a limelight burner, two acetylene lamps and the condenser. Balch operated one of the cameras, photographing Savory at work, the men spending over twelve hours underground.

To supplement Savory's pictures in Balch's book on Wookey, drawings were made by both Balch and Savory to show how the caves were formed, to indicate amusing incidents underground or to illustrate sections of cave that had not been photographed. Some of these were passed for redrawing to John Hassall, a one-time cartoonist for *Punch* magazine who was sometimes taken caving by Savory. Some drawings were copyrighted by Savory and later published as postcards. Balch's volume appeared in 1914, the year war broke out, as Savory went away to fight. He had completed sixteen trips underground that year and thirty-eight the year before.[39] Balch later had the opportunity to record his gratitude for Savory's production of the drawings and delicately sepia-toned photographs.

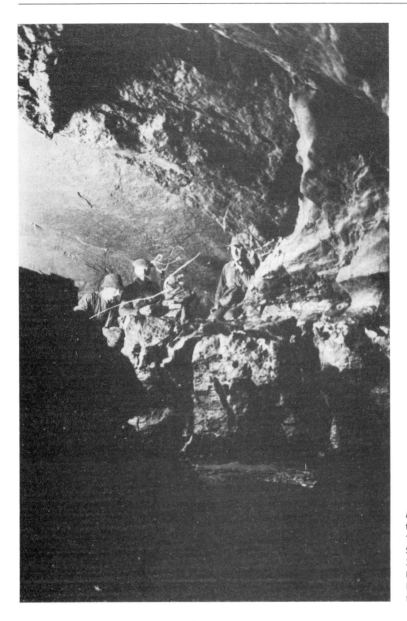

An unretouched print made from the plate Savory produced at the 'Cairn at lowest termination', Sump One in Swildon's Hole, on 3 August 1922. Savory is on the left, with Balch in the centre and Baker on the right. The candle tracks are easily seen.

I recall the years of co-operation in my cave work given by Mr. Harry Savory ... who followed the most successful cave photography ever done, by illustrating my monograph on Wookey Hole, Its Caves and Cave Dwellers, and himself took the burden of its production and publication. But for him this greatest of books on Wookey Hole would never have been published.[42]

Mendip cave exploration was interrupted by the war. Savory, invalided out of the army with a bullet wound in his neck,[43] managed to produce a few pictures in the upper series of Swildon's Hole between 1917 and 1919, but progress further into the cave was limited by the Forty, a pitch so named for its depth. This had been passed to a second smaller drop by Baker in 1914, but the dry weather that aided him was not repeated until the drought of 1921. In July that year both the Forty and the following 20 ft pitch were conquered, leaving the way open for Balch to explore the passages to Sump One (where the passage dipped underwater) during August.

The dry conditions continued and Balch took the opportunity to organize further expeditions during November 1921, then again on 2 and 3 August 1922.[44] Savory accompanied him, photographing much of the lower streamway and the dazzling purity of calcite in Barnes' Loop. At the sump, Savory even included himself in the photograph, firing his flashpowder with a fuse. This was probably made out of the chemically treated paper supplied with cans of magnesium, although it was also possible to use lengths of magnesium ribbon pushed into the powder.

The general technique for pictures of this sort was to compose the scene with the camera on a tripod, then insert the plate and open the shutter in the dark. The photographer would then grope his way back to his companions, wait until the flash had fired, then return in the dark to close the shutter before allowing the candles to be lit again. Often, it was an ill-fated sequence, for any light showing while the shutter was open could ruin the negative. When Savory photographed the group at Sump One, one hapless caver did not douse his light and moved around in front of the open lens. 'See the trouble your wretched candle tracks gave me!!', Savory noted on the resulting picture.[45] To remedy the white streaks of light, he was forced to 'spot' the print, using ink to remove the offending marks.

Perhaps the most famous of Savory's pictures was that taken in a chamber high above the Swildon's streamway. Discovered in 1921 by E.K. Tratman, it was named by Balch as the 'November 12th Grotto', although later generations have known it as 'Tratman's Temple'. Savory was photographing in Barnes' Loop when news reached Balch and himself of the discovery. Although it was suggested he immediately photograph the chamber, Savory did not visit the new galleries until 3 August 1922. As usual, there was only one chance to produce the right effects of lighting and relief before magnesium fumes destroyed the clarity of the atmosphere. The resulting sepia print has been considered by many as one of the finest pictures ever to be produced in this era, although when Savory sent Balch a copy he found fault with his own work:

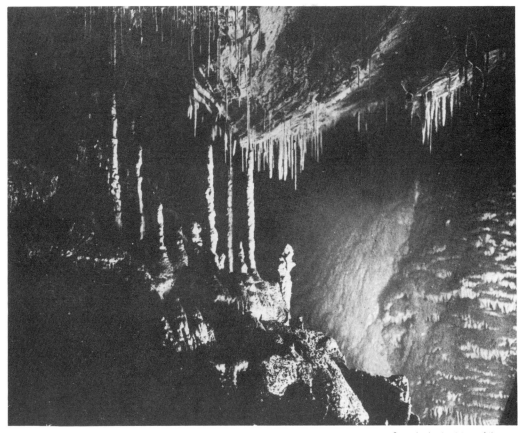

Savory's classic picture of the stalactites in Tratman's Temple in Swildon's Hole, now destroyed by vandals, photographed on 3 August 1922.

A topping instance of good *strong* light and shadow got by side lighting from concealed corner – contrasts are fine. Pity pillar on extreme right didn't come in to balance composition, but that would have brought your corner in as well [as] where light was coming from. Water evidently got into camera by its fall in pool – it pulled a square half inch of film off this subject, can you spot it? I can only attribute this to the film sticking here to the sheath in front.[45]

The mark, in a shadow area, proved to be almost invisible. Savory wrote on other prints with instructions such as 'encourage lights' (a technique which retained detail in the image by selectively masking the paper during exposure) or 'this ought to get a shade lighter to show the stream more prominently – good light and shade effect'.[46] He had high expectations of his work, and produced his pictures with meticulous care.[47] Savory has been acknowledged as one of the finest photographers ever to have taken his camera underground. His interest in cave photography

continued through the 1920s, but at the expense of his under-
ground work he turned to natural history and ornithology in the
next decade.

Apart from the level of fumes that flashpowder produced
(cavers were known to refer to the 'flashless smoke powder'), the
main disadvantage of the compound was the number of accidents
resulting from its use. Being an explosive compound, fires and
burns from blazing flashpans and detonating heaps of powder were
common, and it was inevitable that, just as the French had feared,
accidents underground occurred. The force of the explosion was
easily able to extinguish lights at great distances, even around
corners in the cave passage. One of the worst occasions was during
the photography of the bottom of the second drop in Eastwater
Cavern. A Cambridge caver named Ward was involved,[48] as Balch
recounts:

> The camera was put up and focussed. It is a great dark place
> with little of light to relieve its sombre walls. With this in mind a
> double charge of an intense illuminating powder was prepared
> and held up on, I think, a flat stone. Of course, even a single
> charge is normally fired by a touch paper and that was intended
> in this instance. He [the photographer] put his candle to the
> touch paper, as he supposed, but, perhaps due to the darkness,
> he fired the whole charge. The burst of concentrated flame
> followed and nearly the whole skin of his right hand was burned
> off. With nothing to dress his burns, he screamed in agony for
> two hours. Then, exhausted, the others set about getting him
> out. . . It took them seven hours to get him to the surface, more
> dead than alive.[49]

Balch learned of the accident the following morning when the
hapless assistant was brought into Wells 'a woebegone wretch,
almost unrecognizable . . . [with] a sickly smile'.[49] It was the end
of Ward's caving career, for the hand never healed well enough to
hold a rope again. Tratman was injured in Swildon's Hole while
using a flashpan with clockwork ignition. This produced a spark
that fired the flashpowder; Tratman was checking the mechanism
when the powder exploded in his face, luckily without any serious
effect.[50]

Despite the difficulties and dangers, Savory was by no means
alone in his work, for many cameramen had begun to record the
sights they found within the limestone areas of the country. In
particular, the 1920s saw the outstanding work of E.L. Dams and
Eric Doddrell Evens on Mendip. Evens, an accomplished photo-
grapher and microscopist as well as being a trained chemist,[51] used
a quarter plate camera between 1918 and 1937 to photograph
many of the caves and surface features, such as the Ebbor

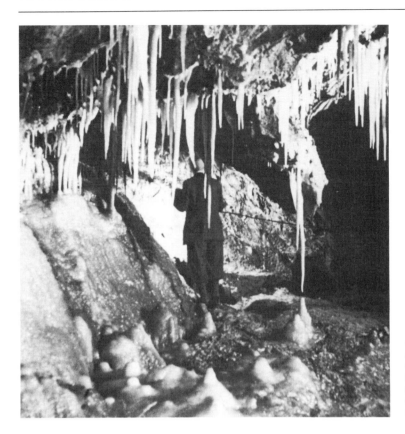

A set of photographs by May Johnson, taken after the discovery of extensions to Treak Cliff Cavern in Derbyshire, was sold as glass stereo views and postcards, the latter being published by R. Sneath of Sheffield.

Gorge.[52] Dams was active from about 1924 to 1926. Members of the University of Bristol Spelæological Society were also photographing such caves as Swildon's Hole.[53]

In Yorkshire, Eli Simpson photographed the caves he had helped to explore since the inception of the Yorkshire Speleological Association, using his camera as a recording tool. Later, he was the author of one of the few articles on cave photography to be written by a caver for cavers,[54] a further indication of rising interest. He also helped with the production of some of Stringer's pictures in the form of postcards stamped as 'Copyright, published by the Yorkshire Spelæological Association'. Possibly initiated by Stringer himself, little cash can have been raised by this venture. A fellow northerner, C.F.D. Long, was attempting to make money out of White Scar Cave, and took photographs which he used on both pamphlets and postcards. May Johnson, the first woman to reach the bottom of Gaping Gill, in 1904, used her stereo camera in the Treak Cliff Caverns of Derbyshire in the late 1920s, following the discovery in 1926 of new passages beyond the mined entrance. The list of photographs being produced is almost

endless. With new and added interest in caves for exploration and sport, more photographers rose to the challenge, and the production of underground photographs – while still not easy – could no longer be said to be unusual.

The French cave photographers had arrived at a system before the British, but much of their work had then been repeated independently. The British tailored their techniques to the wet and comparatively confined caves of England, which were being used for both sport and exploration. In France, speleology as a science provided the main impetus for both discovery and photography, but photographic techniques had changed. In every case, by the 1920s cave photographers in Britain and abroad all universally depended on the use of magnesium and flashpowder to illuminate the subterranean caverns they explored. Additionally, there was a distinct change of emphasis. Much more than ever before, cave photography now belonged to dedicated amateur or professional cameramen who had a genuine interest in the underground world they helped explore.

Lighting the Bat Cave

PROCLAMATION

WHEREAS, Pioneer Carlsbad photographer Ray V. Davis made a significant contribution to events culminating in designation of Carlsbad Caverns as a unit of the National Park System in 1923; and

WHEREAS, Outstanding photographs of the cavern's indescribable beauty taken by Davis under extremely difficult conditions . . . contributed greatly to the Cavern's international fame;

NOW, THEREFORE, I, BRUCE KING, Governor of the State of New Mexico, do hereby proclaim October 28, 1973, as:

"RAY V. DAVIS DAY"
Proclamation, State of New Mexico.[1]

My greatest satisfaction at this time is the fact that I have lived to see my vision fulfilled.
Ray V. Davis, 1976, aged eighty-two.[2]

By the close of the First World War the number of photographers had increased enormously. There was now a wide choice of cheap apparatus whose design was based on Eastman's box cameras. In addition, Hollywood was producing silent movies, changing forever the way in which man views himself. Celluloid, developed as long ago as 1889, was replacing bulky and inconvenient glass plates with roll and sheet film. It would be many years before the use of glass was completely abandoned but, gradually, photographic equipment was becoming lighter and more portable.

In 1892 Alfred Brothers wrote, 'It is difficult to imagine in what direction, except with regard to the fixing of natural colours, further discoveries may be looked for'.[3] His thoughts were only partly correct. Panchromatic emulsions, which accurately recorded all colours on black and white film, were introduced in

1906, finally enabling cave photographers to record detail in areas of reddish mud or formations. The first crude colour films were in limited use in 1920. In other directions there were many improvements also being made. Emulsions had increased in sensitivity and exposures were reduced to fractions of a second. This necessitated, in turn, the development of better shutters, for it was no longer possible to rely on removing a lens cap to control exposure.

However, the production of artificial light had not kept pace with the rest of photographic technology. While lighting had been revolutionized by flashpowder, it still depended upon chemicals that produced choking, poisonous, clouds of smoke when ignited. Flashpowder, four parts magnesium mixed with three parts each of potassium chlorate and potassium perchlorate, allowed the freedom of placing a cheaply produced light where it was required, but in most cases the fumes still restricted photography to a single picture.

The basic techniques of underground photography using flashpowder had long ago been determined by cave photographers. However, the dissemination of this information was still poor. In Europe, caving societies permitted an exchange of techniques, but elsewhere opportunities were sparse. Details could be found within the pages of the numerous photographic manuals now on sale, but these usually quoted Piazzi Smyth's original work in the Egyptian Pyramids, and suggested emulating his techniques with magnesium ribbon. Although it was often stated that cave photography was easy to accomplish using flashpowder, no useful details were given.

Most cave photographs still depicted the interiors of tourist caves and were reproduced as postcards. For these, simple techniques were adequate; magnesium could be used to aid the electric lighting installed by the owners and, while the pictures were rarely exciting, they sufficed. Difficulties still arose when non-specialists attempted to photograph large chambers, such as those at the Grottes de Han in Belgium. Postcards from the first decades of the century show people drawn onto the picture with a stylus prior to printing.[4] Restricted by exposure times, photographers were sometimes still unable to include people in the pictures, and such solutions were common. In the case of the Han cards the management took the opportunity to alter the scale of some pictures, making small passages appear like large chambers in comparison with the small figure with his blazing torch. Obviously, although the French had successfully lit large chambers, their techniques were still not being practised elsewhere.

After the First World War there was a general increase in interest in caves and cave photography around the world, for example in Yugoslavia, where Franci Bar photographed the local caverns.[5] In France in 1922 Norbert Casteret established

Postcards of the Grottes de Han, c. 1906, had people drawn on them, although not always to the correct scale. These formations are only a few feet high.

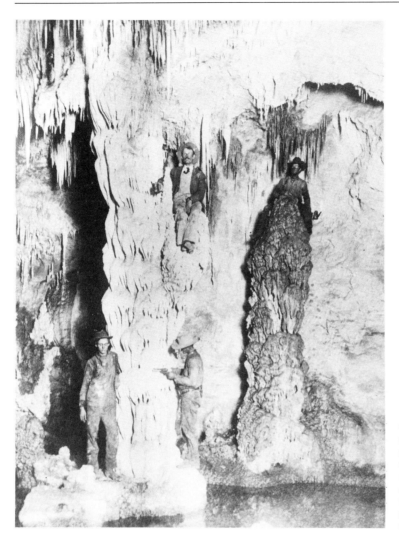

Taken for Charles Doss *c.* 1907, this picture shows guano miners beside the 'Stalactite Spring', Carlsbad Caverns (then called the Bat Cave). Doss may be the man at the top centre. Note the oil lamp held on the right and the gun held by the man at the centre bottom.

himself in the forefront of speleology when he held his breath and dived the water-filled passage at Montespan, leading to important discoveries of cave art. He became an accomplished photographer as well as author, earning his living from speleology.[6] Casteret had an enormous impact on caving, thrilling his readers and causing many of them to become involved in the sport themselves.

Cave photography was becoming more common as more people began to venture underground, encouraged by the publicity produced by Casteret and others like him. However, there were still challenges to overcome. In particular, the problems of photographing one American cave, and the spectacular outcome, can serve as a demonstration of work around the world.

By 1900 one region of New Mexican desert was known to contain several caves with large bat colonies, which meant there were good supplies of guano to be found. Guano was in demand as a fertilizer and several caves in the area were eventually mined. One large opening, known as the Bat Cave, was first investigated in 1901 by Jim White, a cowhand from the local town of Carlsbad.[7] From about 1907 he worked for a succession of mining companies, exploring further into the cavern as he did so. He found enormous caverns filled with glittering calcite formations. Few people believed his tales: 'Batty as his Bat Cave', the saying went.

By the time the miners withdrew from the area, around 1917, White lived with his wife in an old wooden shack close to the cave entrance. He was determined to prove his reports and attract visitors. He began constructing crude trails for the tourists he hoped would come. The area was rugged and remote, and visitors to the shack were few. A rude trail led up from the Carlsbad road, but it was a long day's journey to reach the Bat Cave from the town. Before people were going to make any effort to see the caves they would have to be convinced that there was something worth seeing. The only way was to get some pictures taken.

Photographs had been taken at the Bat Cave before. Around 1907 several underground pictures of the guano miners had been taken by a Carlsbad photographer for Charles Doss, the owner of the El Paso Transfer & Mining Company.[8] In 1914 Ira Stockwell, a Carlsbad resident, took pictures of a group of visitors with his Kodak camera.[9] In neither case did the pictures indicate the wealth of beauty to be found further within the caverns.

The first photographer that White approached wanted $100 to go into the cave and produce the pictures. With only just enough money for himself and his wife to live on, White had to refuse. He continued with his tentative forays into the caverns, until one day between 1918 and 1922 two men drove by in an old, beat-up jalopy, and asked if they could visit the cave. They had with them an early Kodak snapshot box camera, and even asked if they could take pictures.[10] This was just what White had wished for and he welcomed the request.

Before they could make any attempt to take their pictures they had to get some flashpowder. In 1913 a Kansas man, Ray V. Davis, had moved to Carlsbad as a farmer.[11] He was an amateur photographer and opened a modest photographic studio in the town in 1916, which he ran until about 1930.[12] White sent the two strangers to Davis to get their powder; the next day they brought back not only the flashpowder, but the photographer as well. Arrangements were made for Davis to take some pictures the following day, helped by White and the two men. Davis wrote:

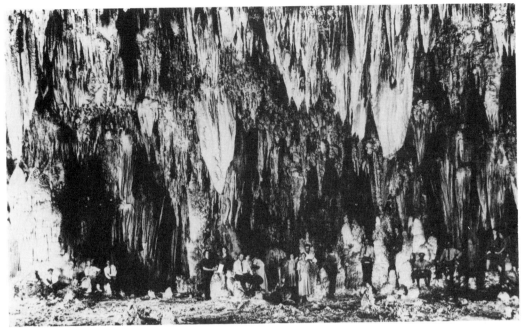

This Davis photograph was taken *c.* 1925 in the King's Palace, Carlsbad Caverns, with eighteen visitors posing among the formations.

My first trip . . . into the Bat Cave . . . was extremely arduous, strenuous, tiresome and time-consuming, but above all exciting. . . In this part of [the cave] there was very little formation, but Jim told me of big and beautiful stalagmites (upright) and stalactites (hanging), so I made arrangements with him for a trip to go first to the King's Palace. This trip alone would take about four or more hours to get there and the same to get out. . . In the early years of Jim White's exploration of the Cavern, I was with him on most of these trips and in many places we made the very first footprints . . .

My first view of the formations was close up as the only light we had was kerosene lamps . . . but even so, with that small amount of light, I immediately saw that here was something the whole world should see and later when I saw the Big Room, the Giant Column, the Totem Poles, and more and more, I decided I would try to show it in pictures so that the whole world would know about it.[13]

Davis used all of his twenty-four plates within the first section of the cave.[10] The results were encouraging. He planned to take more, but needed to find a better method of lighting the large chambers. Having no experience with using flashpowder on this scale, Davis obtained some magnesium flares from local railroad workers for his first trial exposures. The results were poor. The

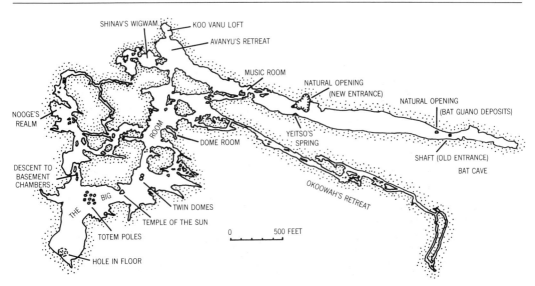

SHINAV'S WIGWAM
KOO VANU LOFT
AVANYU'S RETREAT
MUSIC ROOM
NATURAL OPENING
(NEW ENTRANCE)
NATURAL OPENING
(BAT GUANO DEPOSITS)
NOOGE'S
REALM
ROOM
DOME ROOM
YEITSO'S
SPRING
SHAFT (OLD ENTRANCE)
BAT CAVE
DESCENT TO
BASEMENT
CHAMBERS
OKOOWAH'S RETREAT
THE
BIG
TWIN DOMES
TEMPLE OF THE SUN
TOTEM POLES
0 500 FEET
HOLE IN FLOOR

A plan of Carlsbad Caverns, based on Willis T. Lee's 1924 survey.

black voids that surrounded him soaked up the seemingly puny lights. Something far superior to the hand-held flares was needed. Davis soon resorted to a combination of magnesium ribbon and flashpowder and, by increasing the amounts used, he began to meet with success. Many of his underground forays took a great deal of time and there were a lot of separate visits.

> I never kept track of the number of trips I made, but many! My equipment was very heavy as I used a 5–7 or 10–8 inch camera and a special handbuilt tripod, which alone was very heavy and awkward to carry and then I always had to keep one hand free of equipment to hang on as there were places I could easily slide a hundred feet or more.[13]

With both the tripod (which itself weighed 50 lb) and his cameras to manhandle, Davis found some difficulty in entering the cave. The miners had left behind a winch and petrol engine, used to bring up guano in a barrel. This proved the easiest way into the cave, riding in the bucket rather than using the unsteady ladders.

> The old Bucket or Barrel . . . was an interesting experience because the gasoline engine would sometimes stop, leaving you hanging in midair or slip back a few feet as the braking system was just a plank against the flywheel – and it could have failed. I always felt relieved when my feet were on solid ground. My camera equipment filled the bucket and I had to stand on the edge of it and hang onto the cable. I was never anxious to do this, but it beat climbing two or three ladders, nearly two hundred feet.[13]

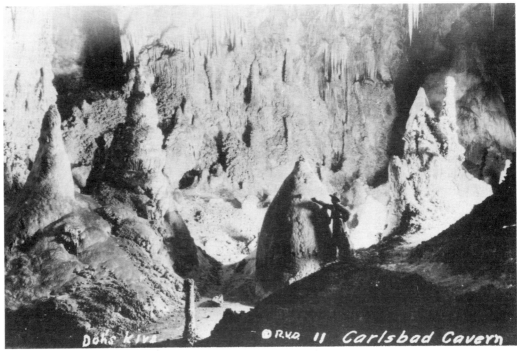

Doh's Kiva ⊕ R.V.Q. II Carlsbad Cavern

Davis photographed Doh's Kiva in The Big Room, Carlsbad Caverns, on one of the earliest expeditions. The picture was used in the January 1924 edition of *National Geographic*. Doh, in Apache mythology, was a fly that built a kiva, or dwelling, for the sun. As can be seen, Davis was already producing a feeling of depth in his photographs by using separate light sources.

Once installed in the cave, Davis fired his flashpowder and flares among the formations, using groups of his companions for scale. White usually acted as guide for these trips, and often appeared in the photographs. Davis normally worked from the most distant part of the cave back towards the entrance, to avoid the intrusion of clouds of smoke. He found the King's Palace one of the easier areas to work in, because it was level and close-up pictures were possible, and it became one of the first chambers to be photographed.[14]

However, taking pictures proved a lengthy business, and Davis soon found he needed a brighter flash to illuminate the larger stalagmites, several of which are over 60 ft tall. Massive amounts of flashpowder were needed for pictures of areas like the Big Room. Faced with problems from the huge amounts of flashpowder required and difficulties in setting it off in quantity, Davis decided to manufacture a new flashlamp.

My secret was centred around a mortar-carrying device which I made to burn magnesium powder in. This device was attached to a hollow pole, from which I ran a rubber tube into a jar of magnesium. I would then put a small amount of magnesium in the V-shaped device and light it with a match, then blow

through the tube to force the powder into the flame. . . . It was necessary to hurry from place to place to keep ahead of the smoke from the burning magnesium. . . . It was only possible to take one picture a day because of the smoke generated.[15]

The home-made flashlamp, similar in principle to the Nadar lamp, worked perfectly. A reflector was fashioned from an old pie dish. The tube was an old water pipe, while the tray at the top was later modified to accept an alcohol-soaked sponge. This would fire any powder blown into it and permitted numerous flashes to be triggered without recharging the gun. The flash apparatus was also potentially lethal. Often, people warned Davis that he would 'blow his head off someday', and indeed on one occasion he coughed while blowing through the magnesium tube, causing the powder to spill over and burn one hand. However, with the new flashgun, Davis was able to produce increasing numbers of high-quality prints, processing them in his Carlsbad studio.

Davis put the prints up for display and sale in his shop. His agreement with White was that there would be no charge for producing the pictures, but money could be recovered by selling copies.[16] Once the prints were seen, White's faith in the caverns was justified. Suddenly, townsfolk were willing to make an effort to see the cave. Davis helped, and organized a visit for Carlsbad dignitaries, businessmen and a newspaper reporter on 11 September 1922. His choice of visitors was deliberate. If he could show respected people the sights, the rest of the town would then believe both White and himself.[14] Thirteen people travelled with Davis to the cave and helped him take further photographs.[17] The visit proved the foundation of a new industry.

Davis began to send his photographs to newspapers and magazines in order to promote the caves. One of these, dubbed 'The Largest Black and White Photo Ever Made', was a picture of the Big Room. Davis sent this and others to the *The National Geographic Magazine* as part of his publicity campaign, but they were rejected.[15] This was a reaction that Davis became used to, for many people thought the pictures must be fakes. 'I will never know how many thousands of pictures I donated to publicize the Caverns', he later wrote.[13]

One of the few concerns that did show an interest in Davis' suggestions was the Paramount Picture Corporation. In 1922 the company seriously considered using the caves in a film, although without an electricity supply they could not proceed, and withdrew from the project.[18]

Nevertheless, Davis continued with his photography, helped by White, who acted as a guide. Davis normally used 5 in × 7 in plate cameras for underground work, sometimes operating three at once to make the best use of the expensive flashes. The cameras were

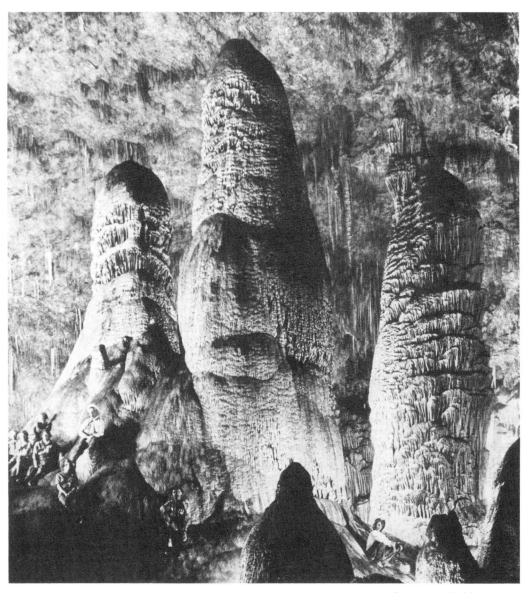

Davis photographed these stalagmites in The Big Room, with Jim White seated on the right. When it was made into a postcard (opposite) the figures were removed by retouching the negative, although their outlines can still be determined. As fashions changed, such practices were common in the postcard industry.

sometimes left in the cave between trips, until Davis returned on one occasion to find one lying on the ground in pieces, the wood glue used to make it having dissolved in the high humidity.[19] This was not his only problem. Magnesium, in the quantities he was consuming, was expensive. Each picture could cost up to $15 in materials.[20]

Davis was friends with a local rancher, Carl B. Livingston,[21] who in turn knew people in the New Mexico State Land Office.[14]

The office was contacted by the two men, sending some of Davis'
pictures with the suggestion that the caves ought to be investi-
gated. As a result, the Land Office despatched Robert Holley, a
member of its department and a close friend of Livingston's.
Holley was to prepare a report, though he remained rather
sceptical. The general feeling was that the pictures could be fakes.
Holley said of the area, 'We didn't feel as though this cave was of
much importance, but the Department thought I'd better run

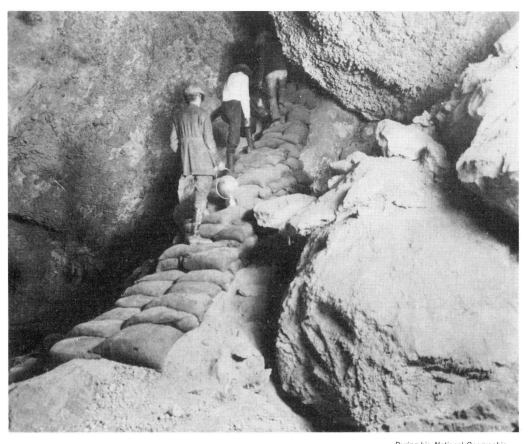

During his *National Geographic* expedition on 14 April 1924 Willis T. Lee photographed Jim White, Elizabeth Lee and Dana Lee ascending the 'Golden Stairs', made from guano sacks filled with cave soil.

down and measure it up so's they'd know if it was big enough for them to consider'.[10] In the spring of 1923 Holley sent in his document, over a month in preparation, by now overwhelmed by the sights he had seen. He freely confessed:

> I am wholly conscious of the feebleness of my efforts to convey in words the deep conflicting emotions, the feeling of fear and awe, and a desire for an inspired understanding of the Divine Creator's work which presents to the human eye such a complex aggregate of natural wonders in such a space.[10]

To help justify his words, Holley included more of Davis' pictures and recommended that the site be preserved for the nation as an everlasting national monument.[22]

Another early visitor to the caves was an El Paso attorney, Maj. Richard F. Burgess. Like Davis, he wrote to the National Geographic Society on 5 September 1923, suggesting that it should

investigate the area.[23] In response, the society forwarded the letter to the United States Geological Survey.

There was due to be a visit to the Carlsbad area by Dr Willis T. Lee on behalf of the Geological Survey[23] to inspect the site of a proposed storage reservoir; instead of doing this work, Lee was detailed to look at the Bat Cave and was taken there by White.[24] An accomplished photographer, Lee was able to produce some of his own pictures, helped by Davis.[25] The results, and those taken by Davis which had previously been rejected, were then submitted to *The National Geographic Magazine*.

With all the publicity now being attracted, and with the involvement of government offices as well as the interest of *The National Geographic Magazine*, it is not surprising that the caves were renamed and a national park was planned. On 25 October 1923, primarily due to Holley's report and the visual effect added by Davis' pictures, President Coolidge instigated 'Carlsbad Caverns National Monument', a part of the nation's heritage. A few months later, in January 1924, Lee's illustrated account was published in *The National Geographic Magazine*.[26]

The legislation was just in time to arrest the growing traffic in crystals and stalactites which were being removed by souvenir hunters for sale at roadside shops. Davis' pictures had become perhaps some of the most important cave conservation photographs ever produced, for without the publicity they gained and the subsequent inauguration of the park, the cave formations would have been decimated. His initial aim of documenting and promoting the cave was accomplished and Davis was made the official caverns photographer.

The publicity that the cave had gained enabled Davis to finally sell copies of his pictures to newspapers. Many appeared locally,[27] but his major 'break' came when the *New York Times* published a full page of his photographs,[28] although he was uncredited and only paid $100 for the complete syndication rights.[29] The Carlsbad citizens were in full support of Davis' actions in gaining publicity:

> Mr. Davis is to be complimented on his work in connection with this project, for his efforts have been untiring. He has given freely of his time and labor to say nothing of expense in order to get the Carlsbad Cave before the public, and had he not journeyed into the interior of this mighty cavern, equipped with camera and other paraphernalia to obtain the wonderful views that he did finally get, no doubt the cave would have remained in . . . obscurity.[29]

While Davis continued with his photography, Lee made a proposal to his office to grant him leave for a second, extended,

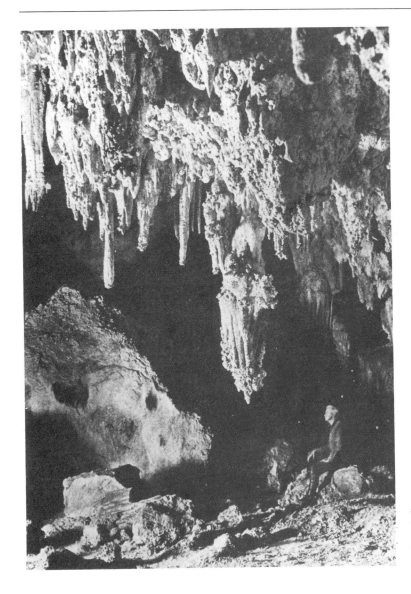

The Armory near Shinav's Wigwam, so named for the club-like appearance of the stalactites. Taken during his 1924 expedition, the picture features Willis T. Lee.

expedition to the cave. At the same time he approached the president of the National Geographic Society for funding, who set aside $16,000 for him.[30] The stated aim was to document, survey and fully explore the caverns, as well as take more pictures.

Lee and his family arrived on 20 March 1924, and within a week began taking photographs using flashpowder and a magnesium powder blowlamp. Jacob Gayer, staff photographer for *National Geographic*, enlisted the aid of Carl Livingston to help him in his work. They used a dynamite blasting machine to fire charges of flashpowder; up to 1,000 ft of magnesium wire and four bottles of

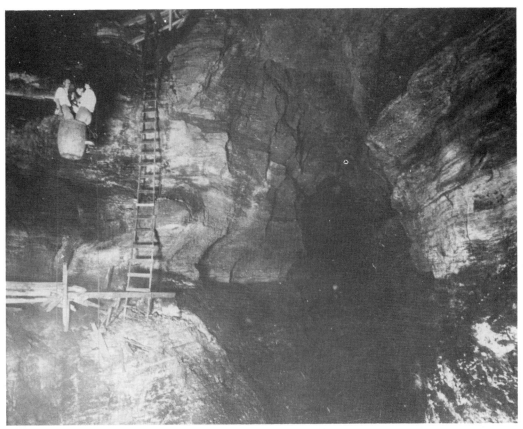

Taken during the 1924 Lee expedition, the guano bucket is seen lowering people down the 170 ft shaft. The ladders were used when the engine was not working.

powder were used for each shot. Over three hundred photographs were taken by Lee and his companions during the expedition.

Ciné films began to be produced, both by Lee and by professional newsreel companies.[24] Clearly, both the expedition and the caverns were considered prime material for the public. The majority of pictures were taken by Lee, supplemented by Gayer's and Davis'. Gayer produced some in colour, among the earliest attempted underground. One, of Elizabeth Lee and her father in the Dome Room, appeared in 1925 in *The National Geographic Magazine*,[31] the year before Lee died at the age of sixty-two.

By now, Davis was not only photographing in Carlsbad Caverns, but also in other caves as they were discovered.[32] He had become the outstanding American cave photographer of the era. However, the use of large powder lamps and huge amounts of flashpowder by Davis and Lee was unusual. Even with normal volumes of flashpowder, accidents still continued. One magazine editor was forced to ban his staff from using flashpowder after one of them lost an

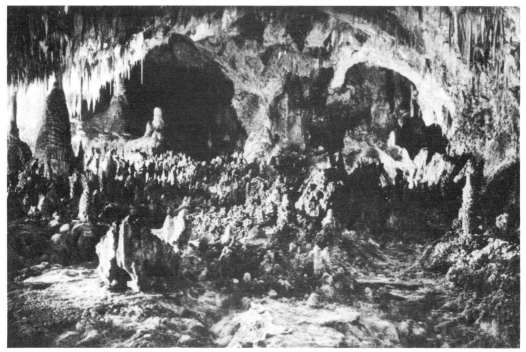

Jacob Gayer photographed a portion of The Big Room during Lee's 1924 expedition. In the distance on the left a group of tourists can be made out, dwarfed by the stalactites.

arm in a premature explosion. Davis himself knew the awesome power of the compound. As the official caverns photographer he was to photograph a group of over a hundred dignitaries inside the cave, and decided to use flashpowder with its short duration flash to ensure a crisp image, even if somebody moved.

> I made a special trip out to the Cavern a day or so before to test the experiment – as it was just that. I was to use the old plunger used to set off dynamite and it worked fine so I had nothing to worry about; however, when the time came to take the picture, there was a delay long enough to cause the powder to get damp and the plunger did not work. . . .
>
> Naturally, I was frustrated and embarrassed in front of these VIP's. I had to think fast and did, – one or two people had a newspaper in their pockets, so I asked them for the newspapers to make a fuse long enough so I could get away without getting burned. This idea was all right except for one thing – I had piled the powder in a heap instead of stringing it out and that made an explosive out of it . . . it went off with a tremendous explosion and in that second I could visualize tons of formation falling on this group of people. Well, everyone was probably as scared as I was for that short second or so but I want you to know that was one of the longest second or so in our lives.[13]

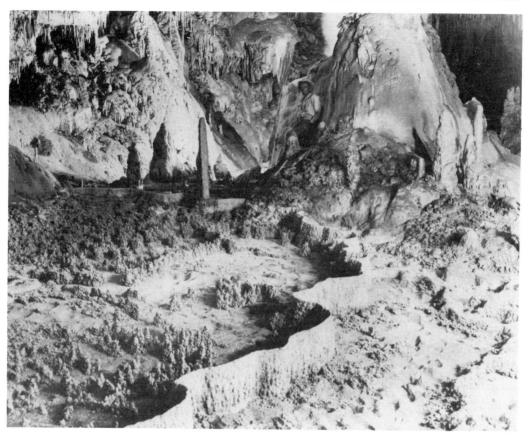

The Chinese Wall in Hidden Cave, with Carl Livingston as a model, taken *c.* 1926 by Ray Davis. Within the space of a few years most of the formations seen here were destroyed by vandals.

The picture was a success, but flashpowder in this quantity was an ever-present danger. Understandably, other photographers did not have any experience of using such large amounts of powder and for many years Davis' photographs were the only ones available for sale. Other photographers commonly underestimated the amount of powder they needed. When the Santa Fe Railroad sent a man to take some advertising photographs, he brought half a pound of powder, not enough to take a single Big Room picture.

Davis maintained a very high standard. By 1930 he estimated he had taken about 1,000 exposures in the cavern, with only seventy-five of these being of good commercial standard.[20] Many more might have been acceptable if it had not been for the problems of using magnesium. In general, a replacement for flashpowder was sorely needed to keep pace with the increasing sophistication of cameras, for safety, and to remove the inconvenience of smoke-filled rooms.

The most obvious method was to find a reliable means of containing the fumes while allowing light to escape, but previous attempts in that direction had all required inconvenient or expensive

apparatus. However, the basic solution of enclosing the light and fumes, for example in muslin bags or lanterns, was sound. The first such suggestion had been made for the purpose of underground photography in 1859, when William Crookes suggested burning pieces of phosphorus in jars of oxygen. He thought several of these could be dotted about Mammoth Cave, or else:

> A still more brilliant light, but a terribly expensive one, can be obtained by burning the new metal, magnesium, in oxygen. . . A piece of magnesium wire, held by one end in the hand, may be lighted. . . It then burns away of its own accord, evolving a light insupportably brilliant to the unprotected eye.[33]

To prevent the incursion of magnesium smoke, one solution was to ignite the flashpowder electronically (using the battery at the bottom), enclosing the fumes in a muslin bag hung on the frame.

In theory, it would be easy to contain fumes within the oxygen container. Oxygen itself was readily available for use in limelight production, but magnesium was ruinously expensive in 1859 and was still an experimental material. J.H. Jones lamented the fact when he considered photographing the entrance to Porth yr Ogof in South Wales in 1860, which needed to be 'well lighted up'.[34] Photographers of that period, for example Adolphe Braun at the Grotte de l'Arveiron,[35] were forced to confine their interests to cave entrances.

While Crookes' underground experiment with enclosed magnesium never took place, his basic suggestion was correct. However, before a viable method of encapsulating the light was found, other avenues in the search for a smokeless enclosed light were explored.

In 1888, a Prof. Bolton collected carbon disulphide in a jar of nitric acid, lighting the gas with a match. The explosion was described as being highly actinic, with no smoke or debris, and more powerful than magnesium.[36] Only the difficulties of production prevented it being adopted.

Glass globes were hard to produce, even after 1879 when Thomas Edison invented the electric light bulb. Nevertheless, in September 1882 the Englishman John McClellan was granted a provisional patent for the idea of sealing magnesium in a glass globe filled with oxygen. It was never manufactured. However, magnesium is not the only metal that can be induced to burn; aluminium can be ignited if there is sufficient oxygen present, a fact well known to photographers of the last century. In 1893 the Englishman Thomas Bolas suggested burning aluminium leaf in oxygen, electronically igniting a number of jars at the same time to photograph a coal-mine.[37] The ideas were ahead of their time, and did not attain commercial viability until well into the twentieth century, although the Frenchman, Chauffour, had designed a system using a sealed light source for Louis Boutan, who used it to produce the first successful underwater flash pictures in 1893.[38]

Boutan's early apparatus for taking flash pictures underwater used a barrel of air to keep an alcohol lamp alight, underneath the glass dome (C). The camera was contained in a waterproof wooden box (M). Squeezing the india-rubber bulb (P) ejected magnesium powder into the flame, after which all the equipment had to be hauled to the surface for reloading.

The design was expensive to produce and limited in practical application.

The first real commercial developments were not made until 1925. In Germany, Dr Paul Vierkötter used a magnesium-coated wire inside an evacuated globe, firing it electronically. Low-pressure oxygen was soon added to the sphere as an obvious refinement. Further experiments in 1927 showed that aluminium foil in pure oxygen burned even better than magnesium and was also cheaper. Bolas' ideas finally came to fruition. In 1929 the first true flashbulb, the 'Vacublitz', was finally put into commercial production by Johannes B. Ostermeier in Germany and was quickly followed by a similar version, the 'Sashalite', from the General Electric Company in America the next year.[39]

These bulbs were typical of those available in the 1930s. Two wires led from the terminals in the base to a tungsten filament, this being coated with a primer explosive paste made of zirconium and lead peroxide. Heat from the wire burned the paste, which ignited the aluminium foil. The one danger was from explosion, but this could only occur if the bulb had a cracked glass. To detect this, in 1933 the Phillips Company introduced a blue spot of cobalt chloride into their bulbs which would turn pink if moisture reached it, indicating a faulty bulb.[40] Bulbs were also coated with cellophane to prevent the thin glass shattering; this was later given a blue coating to match the sensitivity of colour films.

Both the Vacublitz and the Sashalite were massive by modern standards, the size of 100 watt light bulbs. Placed in a normal household light socket they could be fired by switching on the current, or they could be used in special battery-powered flashguns. They removed the problems of smoke being released into the air, were safe and permitted synchronization with a camera shutter so that they fired automatically, using dry batteries for power.

However, despite these obvious advantages, bulbs met with little favour among cave photographers; apart from increased cost, eight to ten of the most powerful bulbs were needed to supply the same light as one ounce of flashpowder. One cave photographer, Robert Nymeyer, felt that they were cumbersome and easily shattered, and that a single medicine bottle of powder would provide the same light as twenty-four bulbs.[41]

In 1927 Ray Davis employed Nymeyer as a darkroom assistant. As such, Nymeyer had to produce up to 2,000 postcards of the caverns a night. On one occasion, he also helped Davis produce a massive 40 in × 60 in enlargement of one of his early pictures in the Big Room, washing it in the waters of the nearby Pecos River.[15] Nymeyer learned a great deal from the arrangement, also helping take some of the underground pictures. In 1931 he purchased the studio and set up his own photographic business, after Davis left the area.[42]

The Sashalite bulb, left, used aluminium foil in an oxygen atmosphere. It was later replaced by GEC's 'Type 22' bulb (centre), which used aluminium wire. Bulbs such as these were very sensitive to radar and strong radiation; every Type 22 packet carried a warning to this effect, and the bulbs were packed in lead containers for transport near any radar sources. Bulbs replaced flashpowder, such as Geka Fumosin (right), which claimed to be 'Absolutely Smokeless' in an attempt to retain a share of the market. Such claims were nonsense.

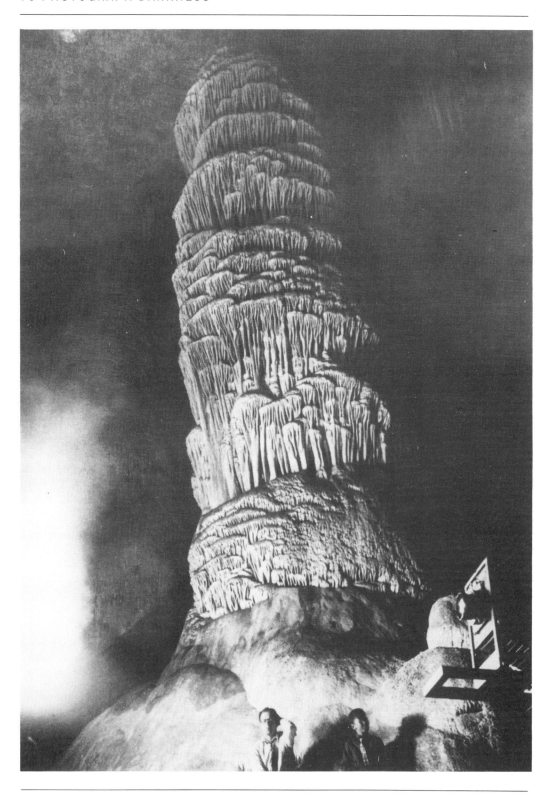

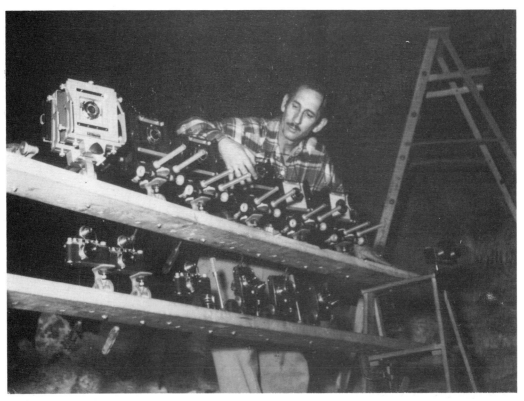

'Tex' Helm setting up some of his cameras for 'The Big Shot' in Carlsbad Caverns in 1952.

By 1933 Nymeyer began to develop his own interest in caving for sport and exploration, and of course photography.[43] Large plate cameras would not have allowed much freedom of movement, so Nymeyer used small, light, easily-transportable materials, his camera held in a specially-made leather holster. No tripod was needed, Nymeyer relying on propping up his camera on convenient stones, firing flashpowder in rolled up pages of his favourite paper, *Western Story*. It was the time of the Depression. To save expense his flashpowder sometimes consisted of magnesium powder mixed with gunpowder obtained from twelve-bore shotgun cartridges. Despite these restrictions, during the 1930s Nymeyer produced a classic set of pictures in the caves of New Mexico.

Nymeyer was not the only cave photographer to shun the use of flashbulbs. In 1937, in Wyandotte Cave, Indiana, George F. Jackson and Charles J. Rothrock held the same view, noting that when using flashpowder *'There is some danger of explosion . . . [and] a lot of smoke, but if one exposure is all that is required, this is of little consequence'.*[44] The use of bulbs was never seriously considered. Russell T. Neville was also a keen cave photographer.

LEFT, Ray V. Davis often used several cameras for his pictures, making the best use of his lighting. A second camera is seen in this picture in Carlsbad Caverns. His assistant, Robert Nymeyer, is on the left, and Davis' son Eugene on the right. The photograph was taken on 15 January 1928.

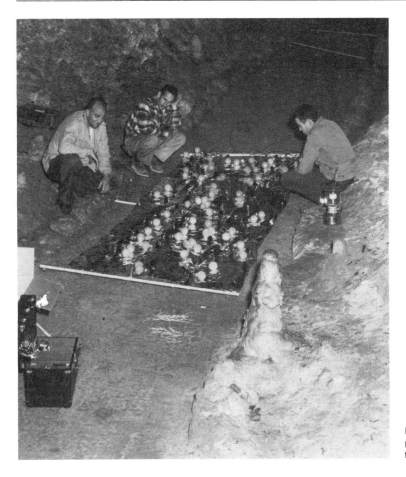

Helm (centre) with two engineers prepare a single bank of flashbulbs on a foil reflector.

By May 1937 he had amassed some 5,000 cave scenes using his Eastman 5 in × 7 in box camera, as well as many feet of ciné film. He relied totally on flashpowder at the rate of 'one heaping teaspoonful for every 12 feet of distance'.[45]

But the tide was slowly turning against magnesium. Despite prejudice based on cost and size, bulbs were a distinct improvement on the dangerous flashpowder and their eventual acceptance was inevitable. Following the Second World War, faced with public reluctance to use their product, American manufacturers began an advertising campaign to raise sales of their bulbs. This suggested an idea to professional photographer Ennis Creed Helm – 'Tex' to those who knew him. Helm had worked on the Fort Worth *Star-Telegram*, and later for newsreels,[46] and therefore had experience with the media and advertising. He owned a camera shop in Carlsbad, and approached the bulb manufacturer Sylvania Electric Products with the idea for an even more ambitious

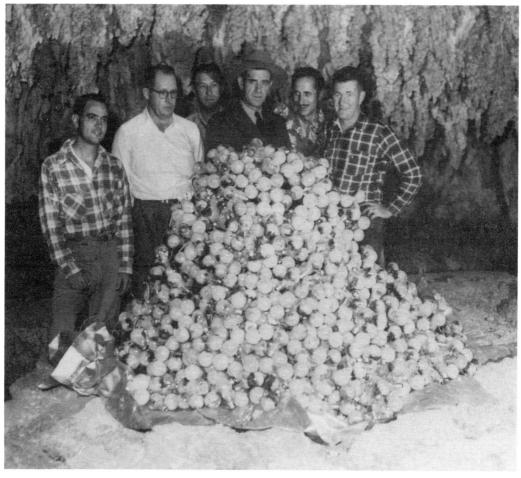

An immense pile of used Sylvania flashbulbs in Carlsbad Caverns, 1952. The photographer, 'Tex' Helm, is second from right.

project. Helm had explored and photographed Carlsbad Caverns since 1924,[47] when he was working for the *Star-Telegram*, and had considered taking a picture of the Big Room in colour since 1947. Now, in 1950, he thought he could see his chance.

As the chamber was a massive 180 ft high, 600 ft wide and over half a mile long, Helm would need massive amounts of light, not least because colour film was insensitive by modern standards. Sylvania realized the importance of the project and the boost to sales that a successful conclusion could bring. Carlsbad Caverns were already drawing some 530,000 visitors a year, the subject was a popular one and what better way existed of demonstrating the mighty power of the Sylvanian product? Early in 1951 the company committed 2,400 of its Superflash bulbs to the project.

The Texan began to make his plans, but was not ready to proceed until the following year. Two Sylvania electrical engineers

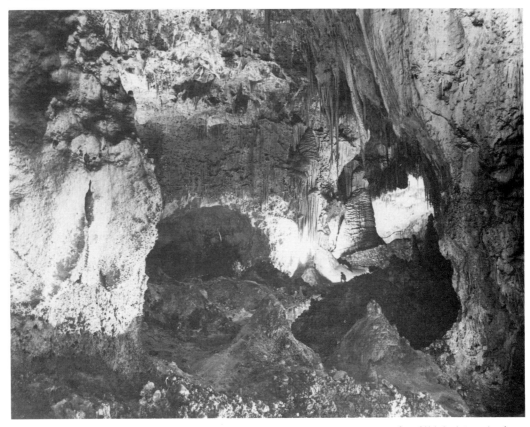

One of Helm's photographs of
The Big Room, 1952.

brought two truck-loads of bulbs and helped lay three miles of
copper wire to synchronize the flash. A.C. Wright, a foreman of
the Southwestern Public Service Co., helped design the system
and supervised the installation. On the night of 18 August 1952,
after the tourists had left, Helm and his helpers set up eighteen
cameras, each one with a different aperture, on a plank of wood
balanced across two step-ladders. Bulbs were wired together in
banks and placed around the Big Room, ready to be fired by mains
electricity. Fifty aluminium reflectors and 'scores' of flexible foil
reflectors were placed to direct light into every corner. To act as
scale, 150 Carlsbad residents were brought in, to stand in darkness
near the centre of the chamber. Delay followed delay as problems
were discovered and solved. Midnight passed, helpers stood about
cold and tired. Then, at 1.30 in the morning of 19 August, all his
camera shutters locked open, Helm exploded all 2,400 bulbs in a
single violent burst of light.[48] As the *National Geographic* said:

Carlsbad Caverns, which are usually as dark and quiet as the

tomb, have stirred with nocturnal fire of late. For photography's sake, their limestone chandeliers and draperies have been bombarded with light four times as intense as sunshine. The caverns have seen New Mexico's most vivid flash since the firing of the world's first atomic bomb near Alamogordo in 1945.[49]

Helm wrote of his own delight,

The tears blurred my eyes. It was too much . . . if you understand . . . a dream absolutely coming true. The picture is beautiful beyond all words.[50]

Sylvania Electric Products in New York were also delighted with the result and, with a strange penchant for figures, computed the light as being equivalent to three million sixty-watt light bulbs. The company's advertising used not only Helm's picture, but also one of Long Island by night, lit with a further 1,400 bulbs.[49] Sales rose, and Sylvania sent a further 14,000 bulbs to Helm so that he could continue his project.

Helm gained a great deal of publicity for both Sylvania and himself due to his use of flashbulbs. As a testimony to his results, and those of Davis, both sets of pictures are still being published today as some of the best photographs ever produced in Carlsbad.

Nevertheless, the high cost and bulky nature of flashbulbs meant that it was many years before they were fully accepted for amateur use underground, and publications on cave photography appearing in the 1950s still recommended the use of powder in all but a few situations. Not until the late 1950s and early 1960s did flashbulbs gain in popularity as they became smaller and their full advantages were realized. They were safer and did not obscure caverns with fumes, enabling several pictures to be attempted at one location; a massive boon. Ultimately, bulbs enabled the production of underground photographs with a greater ease and reliability than had ever previously been possible and, as their use spread, flashpowder and magnesium finally vanished from the market place.

CHAPTER TEN

Moving Pictures

. . . due to the comparatively little air space . . . the oxidised-magnesium flares sending forth a great volume of smoke, it was hardly thirty seconds before the choking dense fumes descended but the operator was enabled to obtain some 10 to 15 feet of film of this wonderful sight.

Oudtshoorn Courant, *South Africa, concerning ciné filming at Cango Caves, 1919.*[1]

These caves are wonderful. They want to film 'King Solomon's Mines' in them. American Co. did take films 3 years ago but film got burnt and Co. killed in Great Transkei Railway accident – Hard luck. Love from Doris.

Tourist at Cango Caves, writing on a postcard, 1923.[2]

Photographic materials and techniques had steadily improved during the course of the nineteenth century, enabling underground photographs to be produced with increasing ease. However, there was one obvious and major challenge left for photography to conquer, both above and below ground: the capture of movement on film.

Since the end of the nineteenth century crude ciné cameras had been available,[3] but using them underground posed different problems to those of the 'still' photographer. Ciné cameras operate by moving film past the lens, each frame being exposed as a separate picture. The mechanics of the operation dictate that each section of film can only be exposed in front of the open shutter for a short time; the film then moves on ready for the next frame. Since the shutter speed is therefore pre-determined, extremely bright lights are required to obtain a correct exposure. This presented colossal problems in finding a suitable artificial light source for use underground. The production of continuously burning bright lights, rather than a short duration flash, was difficult to arrange. It was this factor, rather than the cameras and

associated equipment, that prevented early film-makers venturing underground.

The earliest ciné film to show detail of a cave was made in 1896. The Kinetograph, or camera, recorded the scene on film while a Kinetoscope, or viewer, was used to see the result. These were invented by an Englishman, Dickson, employed in America as part of Thomas Edison's team of inventors. Edison patented the invention, and controlled sales of both camera and viewer around the world. The film stock was very similar to the modern 35 mm format.

However, the apparatus had not been patented in England and when it was released in October 1894 it was copied by Robert W. 'Daddy' Paul. Edison's viewers were in short supply and Paul stood to make a good living from his Kinetoscope copies. There was no shortage of prospective purchasers; his work was good and demand was high. However, finished films ready for viewing were few. Edison restricted his own films to those concerns that had purchased his own Kinetoscopes; without a film to show Paul would not be able to sell his version of the viewer. In March 1895 Paul therefore joined forces with a professional photographer, Birt Acres, and the two men invented the first British ciné camera to make their own films, thereby assisting sales of Paul's viewer.[4] Soon, the French Lumière brothers produced the first 'true' projector, and within months Paul and Acres had invented another of their own. The same problem remained, however: to sell the projector, there had to be available films.

During 1895 the men made a series of films, first together, then separately. Paul introduced the world's first colour films (hand colouring the black and white version) and completed around seventy different titles in 1896. One of the most popular was *A Sea Cave Near Lisbon*, an 80 ft film which was twice the length normally shown to early cinema audiences, and which would have run for between one and two minutes. It was one of a set of fourteen taken by the photographer Harry Short on Paul's behalf, making up *A Tour In Spain and Portugal*.[4]

The films were first shown on 22 October 1896. *The Era* newspaper reported that they included:

> . . . a cave on the Coast of Galicia . . . one of the most beautiful realisations of the sea that we have witnessed. The foam-crested waves rush into the recesses of the rocks, clouds of spray are hurled into space, and the grandeur and beauty of the scene are unmistakable. The new pictures are received night after night with much favour . . .[5]

The location given by the reporter, Galicia, was in fact more accurate than that of Lisbon named in the title. The film remained

popular in Paul's catalogues for many years and became one of his most successful films. In 1903 his brochure said:

> This famous film has never been equalled as a portrayal of fine wave effects. It is taken from the interior of a great cave, looking over the ocean. Big waves break into the mouth of the cave and rush toward the spectator with the finest and most enthralling effect.[6]

The film was lit by daylight, however, and while it is the earliest known film to feature a cave it can hardly be classed as a true underground attempt using artificial light. The first trials of this nature were made in America as early as 1915 in White's Cave,[7] Kentucky, but little is known of the outcome or the techniques used, save that the quality was exceedingly poor. Even before this, in 1913, the South African Cango Caves were the subject of a suggestion for ciné filming, but the scheme came to nothing.[8] R.C.E. Nissen, a cameraman with African Films, was filming ostrich farms in the area and suggested using footage taken in the caves as part of a general film. His proposed charge, £50, caused some discussion, but eventually the idea was dropped.[9]

Then, in 1916, the *Oudtshoorn Courant* newspaper suggested improvements to Cango Caves that might draw more visitors to the area and hence increase revenue. An American film company was also rumoured to be interested in the idea of dramatizing Rider Haggard's novel *King Solomon's Mines*, which was set in East Africa and contained underground scenes.[10] If the cinema company's interest could be confirmed and the film made, publicity could be gained when it was shown around the world.

To support both schemes, it was necessary to install electric lights in the cave, but funds were lacking and a long series of arguments about who should provide the facilities began. The town council and local businessmen remained hopeful that their one great tourist attraction could be utilized to their benefit. The First World War prevented any progress, but Rider Haggard's story and film was still raised as an occasional subject for discussion by the *Courant*. However, despite repeated attempts to improve the caves, nothing was accomplished until after the war.

Having seen some of the newspaper reports, in 1918 African Film Productions Ltd. of Johannesburg, which was interested in filming *King Solomon's Mines*, stated that it would consider using Cango Caves – but a source of light would be essential:

> It would be absolutely impossible to take any pictures in [the caves] unless some means of lighting were devised – either electrical, or magnesium of sufficient strength and uniformity, or arc lights.[11]

A further suggestion was that the authorities should purchase Delco Plants (a type of generator) for a power supply, but finance was once again the stumbling block and the film company pulled out of the project.[11]

The following year, 1919, the Universal Film Manufacturing Company arrived at Oudtshoorn with twenty tons of baggage.[8] The company was part of an overland expedition from the Cape to Cairo, on behalf of the Smithsonian Institute of Washington, DC, filming the local tribesmen and conditions it found on the way. As part of the film the director, Mr Stowell, and the cameraman, Mr Horne, decided to include Cango Caves. Their lighting was to be magnesium flares. The local paper stated that:

> It required some four or five male adults to convey the necessary accoutrements to the chambers to be filmed, and the three dozen or so magnesia [sic] flares took some little strength to convey up and down the winding path which leads into the bowels of the hill. . . The placing of the flares in their correct positions on reaching the first chamber in order to get the picture, was a work of art and required much patience and thought, but eventually the willing volunteers had each got their stations marked out by the two flares they were to hold on the return journey, the idea being to cinema the further chambers first. The next chamber was similarly dealt with . . .[12]

Having planned the filming positions within the large chamber, the third of the three chambers was approached and filming started. The *Oudtshoorn Courant* reporter expected a spectacular sight, but perhaps experienced rather more than he bargained for. This third chamber was much smaller than the earlier ones, and:

> . . . due to the comparatively little air space in the chamber for the oxidised-magnesium flares sending forth a great volume of smoke, it was hardly thirty seconds before the choking dense fumes descended but the operator was enabled to obtain some 10 to 15 feet of film of this wonderful sight. The smoke descended in clouds. The volunteers sent their flares flying and the party ran for it through the narrow going, the cameras and paraphernalia were snatched up and helter skelter close on the heels of each other men, women and children ran for their lives, the smoke wafted by the slight draught which percolates through the caves overtaking some of the back markers. One of the party missed his footing as he negotiated a hole, fell heavily into it and there was little time to think of his hat which was left in the hole. The choking cloud had not yet been beaten. At last where the narrow opening leads on to a ladder and the next big chamber the smoke had been outdistanced and 30 persons, some of them

The postcard sent by Doris from Oudtshoorn, postmarked 24 January 1923.

coughing violently, gathered after their unique experience. It gave them some little idea of what the ordeal had been for the first gas attack launched by a vile enemy against the Canadians on the Western front.[1]

In the largest of the chambers some seven flares were used, but the light was not bright enough to allow a good exposure so a second attempt was made using fourteen flares. Each gave out 4,000 candle-power of light, making 56,000 candle-power altogether. They burned down in two minutes, allowing the director, Mr Stowell, to bring his total footage up to some 25 ft of film. Experiments such as this were expensive: this film had cost 'almost a sovereign a second, or foot of film,' and further work was impossible, not only for cost reasons but also because of the opaque fumes which filled the cave.[1]

The town council, newspaper and local inhabitants all thought that the film would bring a great deal of publicity to the area, but their hopes were destroyed when Cango was entirely missing from the cinema version.[13] The fate of the exposed reels is now unknown. One clue may lie with a postcard sent in January 1923 by a tourist staying in the Queen's Hotel, Oudtshoorn.

These caves are wonderful. They want to film "King Solomon's Mines" in them. American Co did take Films 3 years ago but film got burnt and Co killed in Great Transkei Railway accident – Hard luck. Love from Doris.[2]

Was Doris correct? The American Company she mentioned could be that of Universal Films, the time-scale being approximately correct. However, no records of any such train crash have been traced. Possibly, the answer will never be known.

In 1925 the British Empire Exhibition was due to be held in London. Advance warning of the event was given to enable participants to prepare their entries, and in 1923 further suggestions to produce a film of Cango's interior were made by African Film Productions Ltd. The company was also experimenting with underground photography in the Transvaal Gold Mines, shooting a film titled *The Dust That Kills*.[14]

Once again, problems with lighting and finance held up the attempt until it was too late, although plans were laid for the photographer Joseph Albrecht and his electrician, Holt, to film during April 1924.[15] Electric cables had not yet been laid to the caves and the contract was eventually cancelled. The locals were furious. The *Courant* suggested using flares instead of arc lights, but the film company quashed the idea:

We have had probably more experience in underground photography than the vast majority of moving picture companies, and one of the best actually photographed films so far made is the film we made for the Chamber of Mines entitled 'The Dust That Kills'. . . . The biggest area photographed in this film was one of roughly 30 feet by 20 feet. The candle power used was 200,000 . . .[16]

The conclusion was that flares were not suitable for use at Cango, the fumes occluding the subject far too easily when used in the quantities required. Despite this decision, when the British Empire Exhibition was extended for a further year, the opportunity to make a film arose again and a test length of film was made on 17 February 1925. The company, this time, reversed its earlier statement.

By means of six big flares, in which were magnesium powder, Mr. Noble was able to light up the Caves very brilliantly, and took several scenes of the interior, and also of the entrance. . . The film does justice to the interior of the Caves. . . The lighting is good, and it can easily be imagined what a fine film will be able to be taken, if 12 flares are used for each scene, which will be the case if and when the Town Council agree to have a 500 ft. film taken.[16]

The test was obviously a success, but due to rising costs the final production was apparently never made.[17]

With this test reel it had been shown that underground filming was possible, if there was an incentive to cover the cost of materials and lights. The 1920s was an era of experimentation in this field, and many such films were attempted, all aimed at some form of commercial return.[18]

One format was the newsreel. In 1924 several short films were made in Carlsbad Caverns when the caves were recognized as part of America's national heritage. The first of these was by the International News Reel Company, under the control of a Mr Brockhurst,[19] who arrived during Willis T. Lee's second expedition on 29 March. A second film was made by the Fox Motion Picture Company, which began filming on 15 May. Various others, including Lee's party, also took ciné films.[20]

Henry Otto was the director of the Fox newsreel, with Joe August the cameraman and Eli Dunn as a helper. Lee was in control of the caverns and at first refused the Hollywood company access as it would 'smoke up my caves'.[21] However, an idea of using the film for educational purposes appeared to change the situation and the project began.

Lee and his daughter, Elizabeth, were used as actors, while Lee's son, Dana, helped carry the equipment. The camera alone weighed 110 lb. Paths were being constructed at the time, in preparation for the many tourists that were expected, the workmen helping make the film by holding the magnesium flares. Each flare burned for a minute, two to five being needed for each normal 'take'. At that time, magnesium flares cost $4 each; as the large chambers required some $60 worth of light, film-making was clearly expensive.

One finished newsreel of Lee's expedition was shown in Carlsbad on 10 May 1924, and although it was of reasonable quality his son noted that, in the best tradition of the news industry, most of the captions were wrong. Two more films were shown on 19 June, the International News version being better than that of Fox.[20]

From that time Carlsbad, with its impressive formations and a national interest, was often used for Hollywood films and newsreels. These helped advertise the caverns, which benefited both the town and the national park immensely. For example, one two-reel film made in 1928 by World Wonder Productions was based on Indian lore and was shown commercially throughout the country. Directed by Edward Ferguson, it starred Guy Linton and Ferguson's daughter Elsie, and was taken 'solely for its dramatic and travelogue interest'. The Santa Fe Railroad used portions of it for 'travel education'.[22]

At least eight more films, or parts thereof, were shot in the

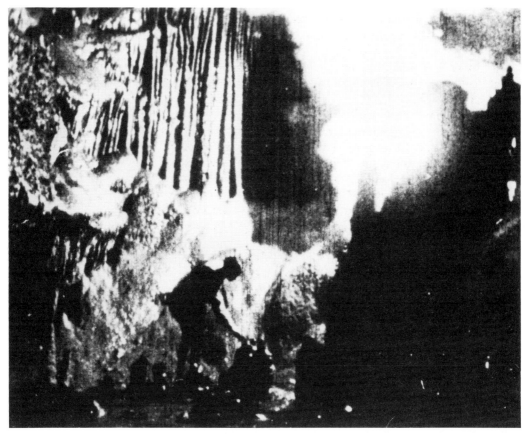

This frame from Neville's 1927 film shows smoke rising from a magnesium flare. The original nitrate film is now in poor condition.

caverns before the Second World War,[23] with many more newsreel attempts being made. However, it seems that while the quality of some was reasonable, the local townsfolk became less than impressed with the majority of the results. The publicity was useful, but the attendant disruption to Carlsbad daily life must have worn thin. By 1930 so many films had been produced that when 'yet another' was proposed by Al Smith of Hollywood, the comment came that 'unless less rotten than those who have gone before the idea doesn't click very much with Carlsbad people'.[24]

While many of the newsreels being produced were of Carlsbad, several were made elsewhere. When Endless Caverns in Virginia were opened to the public on 14 August 1920, a systematic exploration was begun by the American Museum and Explorer's Club, in several expeditions spread over the next few years. Photography was encouraged and many photographs were produced using magnesium ribbon or flashpowder, which showed carefully posed men being enveloped by clouds of fumes. The firms of Pacific & Atlantic and Underwood & Underwood released

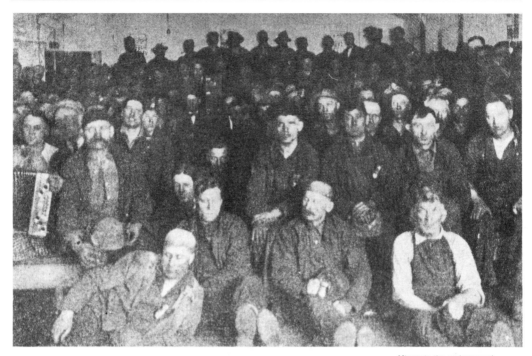

Miners in the underground
theatre in the Spruce Iron Mine.

pictures for magazine use and the cinema newsreel companies
Pathé and International gave the expeditions ciné coverage.[25]
Once again, publicity was the lure that brought the production of
photographs in its wake.

During the period from 1925 to 1927 Russell Trall Neville, with
the help of his family and friends, made the 16 mm film *In The
Cellars of the World*.[26] This was the first film of any quality or
length that included footage showing caves being explored for fun.
Neville used various locations in Kentucky caves such as Colossal
Caverns and Mammoth Cave, and Wyandotte and Marengo
Caves in Indiana, as well as minor caves in the north-east of the
country. One portion was shot during two weeks of July 1927 in
Carlsbad Caverns.[27] The final part of the finished film was taken
between 11 and 13 July 1927, when Neville organized a single
fifty-one hour thirty-five minute photographic expedition into Old
Salts Cave. Eleven men camped underground in sparse conditions,
sleeping on the sand covered with a single blanket. The occasion
was notable for the use of a 'wild' cave; Old Salts was not, nor has
been since, a tourist attraction. Neville captioned this portion of
his film with the comment that, as far as he knew, 'this is the first
attempt to present actual cave interior scenes with a movie
camera'.

Neville used magnesium flares for lighting, each of which

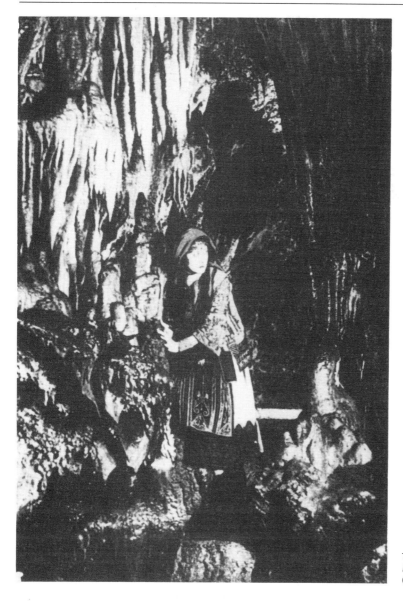

The Fairy's Door, from the film *Phroso* made by Mercanton in the Grottes de St-Cézaire.

burned for thirty seconds. Many sequences were extremely well lit, though scenes showing large chambers sometimes suffered with smoke collecting in the roof and descending on the cavers. The film was a remarkable production for its day, given the technology available for Neville's use.

As Ray V. Davis noted when he helped produce a Hollywood film in Carlsbad Caverns, using flares was highly exciting.

The movie industry had on occasion used magnesium flares for a

few short outdoor night scenes, so we decided for a shot of the Big Room it would take twenty-two flares of two-minute duration. On account of the smoke a longer time would be useless. Well, when all those flares were going, it was like sunlight and such a beautiful underground sight had never before been seen by man.[28]

The use of motion pictures to depict underground scenes was increasing. By 1926 films concerning mine safety were not only being made, but were being shown in an underground theatre at the Spruce Iron Mine in Minnesota.[29] In 1928, the film *Demanovske Jeskyne* was made in Czechoslovakia.[30] At about the same time a film, *Phroso*, was made by Mercanton at the Grottes de St-Cézaire in France.[31]

Apart from Neville's film, these all attempted to show parts of tourist caves that were easily accessible, and contained stalactites and stalagmites, which would appeal to an audience. Hollywood used subterranean locations as backgrounds for its stories when the script called for them. Neville had in part shown what real caving was like in relatively easy locations, although some in the north-east had been confined. Now it was the turn of the British. Prof. Edgar Kingsley Tratman of the University of Bristol Spelæological Society decided to attempt to place the caves of Mendip on film.[32]

Tratman, who had discovered the November 12th Grotto in Swildon's Hole, was a keen amateur cameraman throughout the 1930s. He knew that some commercial cinema film had been taken in the comfort of the Cheddar Caves,[33] but this was an easy location to film in. Knowing nothing of Neville's film, Tratman conceived the idea of making an underground caving film using real cavers. Ciné film was very insensitive and lighting was obviously a problem for an amateur in terms of expense, availability and convenience. Because of the expense, magnesium flares were ruled out: Neville evidently had more capital to spend on his project than was available to Tratman. Arc lights were too cumbersome and unavailable; they might be suitable for Hollywood but for Tratman another solution had to be found. His answer was the purchase of three paraffin lamps made by the Tilley Lamp Company for use on building sites.

The lamps used about a gallon of paraffin pressurized in a tank then released past a valve to burn inside a mantle. A reflector threw out an incandescent beam of light through armoured glass doors at the front, the resulting intense heat being vented through radiator fins at the back. There were serious drawbacks to the system; the mantles kept breaking and it was not unusual for twelve spares to be used on a single trip. Burns were common from the radiator fins, which unfortunately were shaped and treated like

The 1937 film of Lamb Leer showed Bertie Crooke lowering one of the paraffin lamps into the entrance of Lamb Leer, in preparation for filming underground.

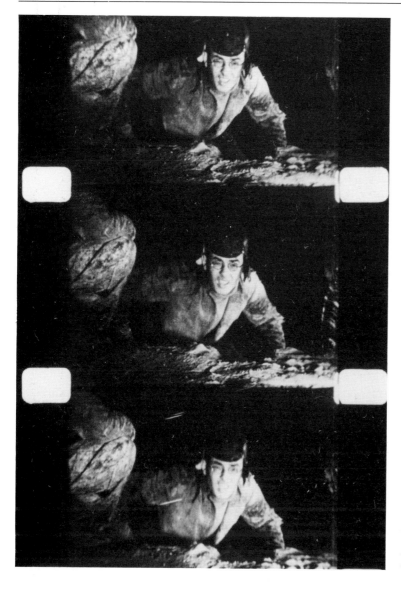

Most shots taken by Tratman were close-ups. The paraffin burners were not bright enough to permit ciné film to be made of the larger chambers.

a handle by unwary cavers. Nevertheless, the lamps sufficed, and about 800 ft of film was taken in some of the easily accessible Mendip caves, such as Goatchurch Cavern, Read's Cavern, Aveline's Hole and Swildon's Hole, during the summer of 1933. The resulting experimental footage was assembled into a film and shown to members of the society, although it was never fully titled.[7]

Pleased with the results of his experiment, Tratman resolved to continue filming, beginning in the summer of 1937. There were not

many cavers available to help with an extended project such as this, so the University of Bristol Spelæological Society linked up with another Mendip group, the Wessex Cave Club. Lamb Leer Cave was chosen as the subject, the objective being a full-length film. The location was topical for, following a collapse, the entrance had just been reopened and a new concrete shaft installed by Wessex members the previous year.

Tratman knew that the lights he had, two large Tilley lamps plus one smaller one, were insufficient, so he purchased two more, one of them a huge three-burner lamp that was so cumbersome it was nicknamed 'Big Bertha'.[34] It was worth every ounce of its weight, for light was always at a premium. Even with all five lamps burning, a correct exposure on the 16 mm black and white film was almost impossible to achieve, so Tratman slowed the film down to half speed,[32] thereby allowing more light to fall on each frame. However, projectors ran at a standard speed, so when the finished version was shown on screen this would cause the cavers to apparently move too quickly. Tratman counteracted this effect by instructing every person to walk at half speed. Examination of the completed film indicates this technique was applied to much of it, as well as the earlier experimental work, although with the additional lights some close-up views in Lamb Leer appear to have been shot normally.

The operation was fraught with difficulty. Cavers attempted to walk at half speed over uneven terrain, stumbling in the glare of the lamps while trying to maintain an uncertain balance. When one fell over, the finished film showed the caver apparently collapsing at double speed. Getting the same people to act as models two weekends running became impossible. Nevertheless, the project was found to be fun by all those involved. One sequence involved the use of the aerial ropeway which spanned the main chamber, recently installed for the annual conference of the British Speleological Association. A wooden box, made from a sugar crate, was slung from a pulley on cables which crossed the cavern, allowing access to passages on the far side. Tratman intended filming a ladder descent into the main chamber from the only vantage point, half-way across the ropeway. The box was just big enough for him to fit into, as the cradle free-wheeled over the drop to be drawn back in by a hand-operated winch. It was one of Tratman's most uncomfortable shots.

In order to film the first part of the rope ladder descent the photographer had to be out in the cradle at the appropriate distance from the stage. Rocking the photographer was considered a good sport by all – except of course the photographer. Several attempts were made to get this shot. Finally two lamps were hung on the front of the cradle and one below. Then I

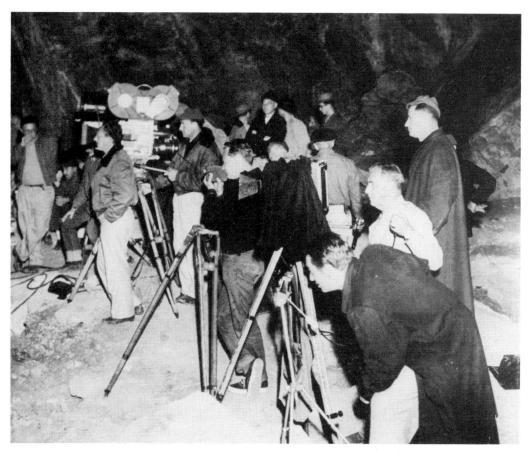

After the Second World War it was not unusual to find caves used freely as ready-made 'sets' for Hollywood movies. Carlsbad Caverns remained popular: *Cave of the Outlaws* was shot in the caves between 11 and 22 April 1951.

climbed in and was passed Big Bertha who had to be settled somehow between my legs. Then came the camera and stand. Somehow I had to half stand over Big Bertha with my head almost touching the pulley and work the camera. It was about the hottest piece of filming that I have ever had to do. Still the shot was worth it.[34]

Around 5,000 ft of film was shot in about twenty visits, producing some 2,300 ft that was correctly exposed, of which only 500 ft went to make the final eleven-minute film.[35] The surface footage was shot on an early version of Kodachrome colour film. The results were edited by Tratman's colleagues, the bulk of the work falling to S.B. Adams.[32] Tratman himself did not see the finished version until 1945 – 'A bit of trouble in the Far East prevented me', he later wrote.[36]

In the space of less than twenty years, technology had progressed to the extent that ciné filming underground had become

perfectly feasible, even for amateurs with limited resources but lots of ingenuity. Both Neville's and Tratman's films proved that 'wild' caves could be portrayed in moving pictures, but it was Hollywood newsreels and movies that had the greatest effect in educating the public. Certainly, long before the Second World War, ciné films had shown the theatre-going public what conditions were like underground and had begun to encourage more people to take an interest in what lay beneath their feet.

Post-War Underground

Advancement in any particular branch of science is often slow and laborious, and, if examined in detail, the progress is not very apparent. When, however, the distant Past is contrasted with the Present, it is evident that great strides have been made and important revolutions effected. . . . One is apt to be satisfied with the attainment of any special object, regarding it as the acme *of human effort. But there is no standing still, and what seems perfect to-day will be superseded tomorrow.*

Charles Burrow, 1893, concerning his photography in Cornish tin mines.[1]

Following the Second World War many pre-war clubs and societies dedicated to the exploration and study of caves re-formed, while others sprang up. With many of the basic photographic techniques now well established a few examples of the major trends, and details of the changing technology being used, will suffice to indicate the nature of the colossal upsurge of work being undertaken.

With more people visiting caves and mines for recreation or scientific work, and easier, more reliable, techniques for producing photographs, it is understandable that many more pictures began to be produced around the world. Apart from any other reason, there was an increase in the number of magazines and books printed, all of which required illustrations. As societies grew in size and stature their own publications improved,[2] and by the early 1950s detailed instructions on how to take underground photographs were being published. In France a booklet devoted totally to cave photography was released in 1952,[3] while in 1953 the major book *British Caving* carried a chapter on the subject.[4]

In general, the use of flashbulbs gradually replaced flashpowder, which, for most work, was abandoned by the end of the 1950s. However, for cave photography, bulbs were not only considered 'bulky, fragile, and expensive, but also add the burden of the firing

device and reflector'.[4] It was not until the early 1960s, as the price of bulbs dropped still further, that flashpowder virtually disappeared from the cave photographer's repertoire.

The best lighting angles to use, as worked out by earlier photographers, still applied to the modern 'new' techniques. All the prior hard-won information concerning techniques of lighting and composition was still valid, although better publicized. One noticeable difference was in the quality of the lighting, which became more directional with harsher shadows, compared to those pictures produced by flashpowder.

Bulbs may have been slow to replace magnesium ribbon and flashpowder, but they did enable photographs to be taken with more speed and in wetter situations. Where flashpowder would become soaked near a streamway, a bulb could be fired with relative ease. Furthermore, repeat pictures could be made without the problem of clouds of fumes obscuring the scene. Despite this, there was no real change in the *type* of photograph produced, except that it was easier to include water. However, cave exploration was also being extended into new areas, and here bulbs had a crucial part to play.

Underwater photography in the sea or other open areas of water was already established,[5] although successful pictures using artificial light were few. In mines, remote waterproof cameras equipped with lights were in use following the Second World War. These were lowered down flooded shafts in the Lens region of France, checking for bombs and booby traps.[6] But, in speleology, the challenge of finding new passages had led to a totally new sphere of operation which needed recording: cave diving.

Caves such as Swildon's Hole in England had been explored to the limits of 'dry' passage but, as the caverns penetrated deeper into the limestone, they dipped underwater to become a 'sump' or 'siphon'. To follow cave passages further into the unknown was the prime aim of the Cave Diving Group, formed in England in 1946.

Diving equipment was crude; oxygen rebreathing sets were standard issue. These were, essentially, a bag of oxygen filled from a cylinder which was breathed until empty. Cracking open a valve on the cylinder then refilled the bag. These sets, utilizing cartridges of soda lime to absorb the carbon dioxide gas formed by breathing, could easily fail. Heavy lead boots were used for 'bottom walking', with a line laid to follow on the way out. If the line was lost, or a diver stumbled and fell over in the murky water, the situation became serious. In the first few years following the inception of the group, several lives were lost.[7]

To help lay the line, divers constructed their own personal 'Apparatus For Laying Out Line And Underwater Navigation', 'AFLOLAUN' or 'AFLO' for short. Line was laid from a reel at

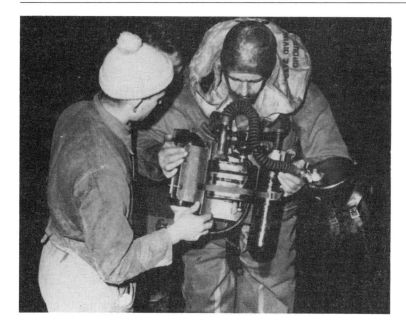

Rebreather apparatus used by the Cave Diving Group at Wookey Hole, 1948. The bag around the diver's neck was inflated from the cylinder on the right and breathed until empty, carbon dioxide being removed by soda lime in the central canister. The left-hand cylinder was a reserve.

the back, while at the front a compass showed direction and a car headlamp, powered by a car battery, illuminated the water. For many years, it was enough just to survive under these conditions, but CDG members soon wanted to record their work on film.[8] In March 1955 Luke Devenish added a camera in an underwater housing to his AFLO, the year after he first developed an interest in photography.[9]

Fixed behind the camera was a rack of flashbulbs, held by clips to stop them floating away. For underwater use they were ideal, because they were totally sealed. Devenish fired them in a reflector at the end of an 18 in-long arm that projected to one side of his AFLO, which was considered to be one of the best in existence. As well as his Photowac (the underwater camera) and bulb carrier there was also an 'Aflohonk', a horn used for signalling. Despite these features, Devenish obtained poor results when he began work at Wookey Hole. Light was reflected back from silt particles in the water, obscuring the image; the flash was too close to the lens. Devenish had to find a means of firing the bulb away from the camera, well to one side.

This presented a major problem, for a bottom-walking diver could not move about without stirring up sediment from the bottom of the sump, making photography impossible. Devenish showed his determination and patience by placing the flash on a tripod about 12 ft away, before returning to the camera position and his AFLO. He then settled down to a wait of 'ten or twenty minutes' while the silt settled,[9] breathing quietly from his bag of

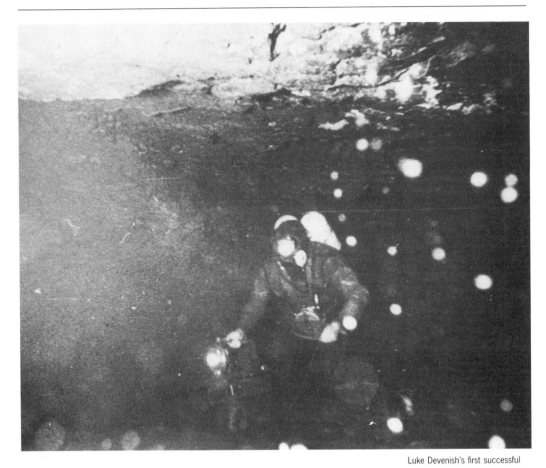

Luke Devenish's first successful underwater photograph, taken in Wookey Hole *c.* 1956. Bob Davies, the diver, is wearing an aqualung, the first to do so for cave diving in Britain. The white marks are out-of-focus lumps of dirt, dislodged from the roof by the diver's bubbles.

oxygen, and then signalled with his Aflohonk that he was ready. His subject moved in from the bank, the flash fired and the two divers could finally leave the muddy environment they had created. Although the results were described as 'encouraging',[10] Devenish lost interest and gave up in 1956, only one year after he had begun.[9] It was a humble beginning for what was to become a specialized field of cave photography.

Ciné filming underwater in caves also began in the same period in the clearer waters of Europe at the Fontaine de Vaucluse.[11] Such attempts became more common over the succeeding years as commercial interests such as television and the cinema created new outlets.

The use of flashbulbs and underwater cameras were not the only technological developments that affected photography underground. Colour work, for example, steadily increased as film became more sensitive and the cost dropped. Electronic flashguns were also under development; the first units were commercially

introduced by Kodak in 1940 as large studio strobes called Kodatrons,[12] based on Harold Edgerton's research.[13] After the invention of the transistor in 1948 they became smaller and lighter, and by the 1960s photographers increasingly used electronic flash, rather than pay for consumable flashbulbs. The electronic flashgun eventually replaced flashbulbs, in the same way that bulbs superseded flashpowder.

Electronic flash differs from bulbs, not only in running costs but also has different lighting characteristics. For example, the angle of illumination is narrower than that from a bulb, and the duration of flash is much shorter (commonly around 1/20,000th of a second, compared to 1/30th of a second). These differences produce very different effects in the final picture; bulbs can produce blurred effects with flowing water, while electronic flash will freeze all movement.

Soon after the new flashguns were first made 'portable' (they still weighed some 15 lb) they were in use in a British cave. In Devon, John Hooper had begun studying the behaviour of bats in 1947. The following year, in the autumn of 1948, he attempted to photograph them in flight and succeeded in producing pictures that would have been impossible with flashbulbs.[14] The flash was connected to a device which fired it automatically when a bat flew through a beam of light, casting a shadow on a sensor.

With the production of slave units, electronic components are further revolutionizing cave photography. Slave units detect the visible light or infra-red output of an electronic flash and then trigger another flashgun. No cable or physical connection is required in this system, with obvious advantages for cave photographers. High sensitivity is obviously required and many cavers use custom-built slaves. Some of these are sensitive enough to operate at distances of over half a mile.[15]

Slave units were the key to easier, faster production of underground photographs and enabled advances to be made underwater. In Britain, a variety of attempts had been made in sumps since Devenish completed his experiments; however, despite the availability of specialist underwater cameras, the success rate was low. In 1975 Martyn Farr conceived the idea of writing a book on the history of cave diving.[7] This would require photographs, so the following year he began to experiment using a flashgun at the end of a cable. It soon became evident that, in the confined underwater spaces, a cable was potentially lethal since it could easily entangle a diver. Replacement of this physical connection with a specially-designed slave unit solved the problem, although it left other difficulties to overcome. The techniques since developed by Farr and others have pointed the way forward in this three-dimensional alien environment.

Cavers have always had the ability to attack a problem and

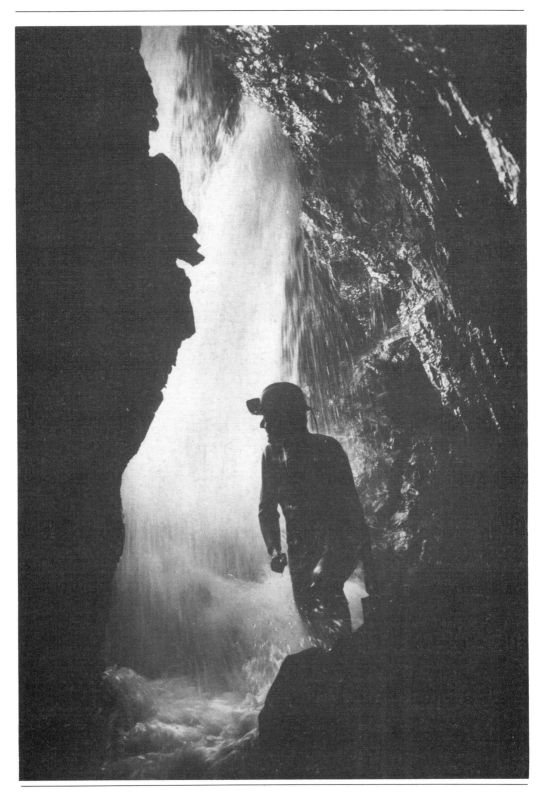

Electronic flash, with its very short duration burst of light, enables the photographer to freeze all movement, as in this photograph of a caver in Ogof Ffynnon Ddu in South Wales, taken by the author.

devise a means of surmounting it. Their ingenuity has helped make caving and cave exploration what it is today. Many of the solutions arrived at, even in modern times, can be somewhat surprising. Take, for example, the 'diprotodon', a form of magnesium powder lamp which used liquid propane as a propellant to form a 4 ft × 3 ft × 1 ft incandescent flame. A diprotodon was an extinct genus of giant wombat, a fitting name for a light developed for the giant caverns of Australia's Nullarbor Plain.[16] It might appear to be a radical lighting development, yet in essence it is the same system used by Vallot and Gaupillat during Martel's French campaigns of the 1890s.

LEFT, The use of flashbulbs and slave units enable action pictures to be taken while retaining the effect of movement in the water, as shown by this photograph in Bridge Cave, South Wales, taken by the author.

Truly new technical developments are few, although history has shown that every new item of equipment has in turn been replaced

by another, better one as technological improvements are made. Electronic images are bound one day to leave the realm of pure video and replace conventional film. Electronic devices are helping in the photography of huge chambers, such as those in Mulu, Borneo. Sarawak Chamber, 700 m long and up to 430 m wide, is the world's largest cave chamber,[17] and required radio instructions to co-ordinate the activities of six cavers firing flashguns.[18]

Holography is a process which generates a three-dimensional image, but remains expensive and requires cumbersome apparatus. A single cave hologram is known to have been produced, when, in 1978, Ian Davinson and Jerry Wooldridge, in conjunction with Holographic Developments Ltd, produced a picture of straw stalactites in Ogof Ffynnon Ddu in Wales.[19] A ciné camera on a gantry was swung round the formations at a predetermined rate, the individual frames later being converted into a hologram. Perhaps the future will see more of this work, though hopefully not involving such a painstaking method.

Thus, during the years since Nadar and Brothers began their subterranean work in the early 1860s, techniques and materials have altered enormously. Books detailing the techniques of cave photography are now available in many major languages,[20] with numerous articles appearing in virtually every country. Lighting has changed from arc lamps to magnesium ribbon, magnesium powder to flashpowder, bulbs to electronic flash. To predict future developments in the field of artificial lighting would be difficult.

In 1892 Alfred Brothers wrote 'the quick plates now in use make such [underground] subjects comparatively easy'.[21] Indeed, compared to his cave pictures in 1865, he was right: subterranean photography had become easier and would continue to do so. Burrow, in 1893, felt that 'there is no standing still, and what seems perfect to-day will be superseded tomorrow'.[1] Perhaps only one thing is certain, and that is man's ability to adapt, modify, innovate and solve the successive problems of photography in a subterranean world. As Ray Davis said of his work in Carlsbad Caverns:

> Exploration and promotion always has been and always will be one of the burning desires of man. . . Man changes – The world changes. The old Bat Cave changed little.[22]

At all levels of their interest in the underground, photographers enjoy the challenge of producing pictures in limitless underground night, attempting to better their previous efforts. The cave possesses a subtle, dramatic, ruthless, beautiful, awe-

inspiring environment, which, when properly cared for, changes little from generation to generation. Capturing its atmosphere and vitality has proved difficult in every age, success bringing its own rewards. With this challenge lies part of the fun, magic and satisfaction involved when man attempts To Photograph Darkness.

A Chronology of Important Dates

1808 Humphry Davy, who later invented a mining safety lamp, experiments with Bunsen batteries, decomposing earths and alkalis to extract metals, one of which is magnesium.

1812 Earliest references to Bengal light.

1825 Thomas Drummond develops the Drummond light, later to be known as limelight, from Guerney's earlier invention of a method for producing light.

1839 The daguerreotype and calotype methods of photography are announced in France and England by Daguerre and Fox Talbot.

1840 Ibbetson, at the Royal Polytechnic Institute of London, experiments with and improves limelight, replacing the alcohol burner with a hydrogen flame. He daguerreotypes a piece of coral under a microscope in under five minutes, compared with the more usual twenty-five minutes using sunlight.
Both Godard and Antoine Claudet experiment with limelight, finding it produces shorter exposures than their chemical acceleration techniques.

1841 Claudet patents his methods of portraiture using limelight.
Attempts made, unsuccessfully, to use oil lamps in photography.
Surface view of Burra Burra copper mine, Australia, taken.

1849 David Brewster invents the stereoscopic viewer.

1850 L.D. Blanquart-Evrard of Lille, France, introduces commercial albumen paper, used for making positive prints.

1851 Fox Talbot produces the earliest electronic flash photograph, using a spark, of a spinning copy of the newspaper, *The Times*.
Frederick Scott Archer invents the collodion wet plate process.
Beginnings of the stereo craze following the Great Exhibition in London.
First suggestions for using electric light for portraiture.

1852 J.D. Llewelyn photographs sea cave entrances on Gower, Wales.
Disdéri, in France, introduces the carte-de-visite.

1853 Formation of the Photographic Society of Great Britain, later to become the Royal Photographic Society.

1854 27 September. Wedding ceremony takes place in Howe's Cave, New York. A photograph has been ascribed to this event, but it was taken much later.
Foundation of the London Stereoscopic Company, which became one of the largest publishers in the world. In 1858 it was advertising 100,000 views for sale.
Gaudin and Delamarre patent Bengal light for use in portraiture.

1855 Formation of the Manchester Photographic Society.

1856 Prof. Bunsen separates magnesium from the ore by electrolysis.

1857 February. John Moule patents his pyrotechnic compound, photogen.
The carte-de-visite comes into general use.
Caron and Deville publish their account of magnesium preparation in France.

1858 Moule exhibits ambrotypes in London taken 'by artificial light' using photogen.
In Germany, Bunsen produces small quantities of magnesium by electrolysis.
Nadar installs arc lights powered by fifty Bunsen cells in his new studio.

1859 Bunsen and Roscoe suggest the use of magnesium for photography.
Henry Crookes attempts pictures using magnesium light, but these fail due to insufficient supplies.
J.H. Jones wishes to photograph Porth yr Ogof in South Wales, if a suitable artificial light were available.
October. 'V.C.' contacts William Crookes concerning underground photography in Mammoth Cave. Crookes advises burning magnesium or phosphorus in oxygen, and (rightly) considers that photogen would be unsuitable.
Establishment of the E. & H.T. Anthony Co., stereo view publishers in New York.
Entrance to the Swiss ice cave, the Grotte d'Arveiron, photographed by Adolphe Braun either this year or 1858.

1860 By now virtually all homes have a stereo viewer.

1861 4 February. Felix Nadar patents the use of arc lighting for portraiture.
April. Outbreak of American Civil War.
About the middle of December, Nadar begins his photography in the Paris catacombs using arc lights powered by fifty Bunsen batteries.

1862 Nadar finishes his underground work in the Paris catacombs and sewers around the middle of March. It has taken him three

months to produce about 100 pictures. Later, he photographs canal construction in Marseilles' sewers using magnesium.

First patent on commercial preparation of magnesium granted to Edward Sonstadt.

Entrances to the Caves of the Mosquito Plains (Naracoorte), Australia, photographed.

1863 First commercial production of magnesium at the Magnesium Metal Company in Manchester.

Mather and Platt invent the first magnesium lamp.

1864 22 February. Alfred Brothers produces first portraits using magnesium light. He discovers the advantages of using ribbon rather than wire.

Solomon and Grant patent a clockwork magnesium lamp.

Charles Piazzi Smyth prepares for his Egyptian expedition. He invents a miniature wet plate camera.

May. End of American Civil War.

1865 27 January. Brothers produces the first cave photograph at the Blue John Caverns, Derbyshire, using magnesium tapers.

March. Henry Jackson of Oldham takes first mining pictures in Bradford colliery using magnesium tapers.

18 April. Smyth begins first exposure tests for his pyramid pictures using magnesium tapers. The first use of flashpowder; magnesium powder mixed with gunpowder.

26 May. J. N. Hearder of Plymouth experiments with bars of magnesium, accidentally igniting them using electricity.

August. Capt. Bamber RN publicly demonstrates magnesium in a special lamp.

August. Alonzo G. Grant produces pictures in the Mill Close Lead Mine in Derbyshire using his clockwork double-burner magnesium lamp; the first metal mine photographs.

6–18 September. William White lectures on magnesium at the British Association meeting in Birmingham.

November. J. Traill Taylor demonstrates a flashpowder compound in London.

November. William E. Debenham of London photographs in the Botallack Mine in Cornwall using magnesium tapers.

Leth photographs inside the Imperial Vaults at Vienna using magnesium wire.

The American Magnesium Company in Boston begins production.

1866 Charles Waldack, during two expeditions, takes stereo photographs in Mammoth Cave. The first expedition ends by 8 July, the second by October. These are the first high quality photographs produced underground which are intended to illustrate the cave rather than test magnesium. He also attempts use of a crude flashpowder mixture.

Price of magnesium in Britain falling rapidly.

1 December. Fr. von Treisinger of the polytechnic of Lemberg, now the city of Lvov in the USSR but then part of the

Austro-Hungarian Empire, photographs the stone reliefs and sarcophagi in the catacombs using magnesium.

Bazin takes underwater photograph while sealed in a metal box.

1867 January–February. Timothy O'Sullivan produces underground pictures using magnesium at the Comstock mines, Nevada, for the Government Survey of the 40th Parallel. These are the first American mining photographs.

Photographic attempt in Cathedral Cave, Wellington, fails.

1868 14 March. Emil Mariot writes to Cave Commission, Adelsberg (Postojna), for permission to take pictures. Pictures are taken by magnesium and printed by 24 May.

December. George Proctor, Mass., patents studio for use with magnesium; the idea is never used successfully.

1871 Richard Leach Maddox invents the photographic dry plate. This is insensitive: the slow change-over from collodion wet plates takes the rest of the decade.

1873 Joseph Martini takes over from Mariot as photographer at Adelsberg.

1874 Association Belge de Photographie founded, with Dandoy and Waldack as members.

1876 23 October. Armand Dandoy granted permission to photograph in the Caves of Han, Belgium.

November. Frederick Brown uses mixture of limelight and magnesium in Bradford Colliery, near Walsall, over a two-day period.

1877 Mandeville Thum produces poor quality photographs of Mammoth Cave.

Howe's Cave near New York photographed by A. Veeder, producing about twenty stereo views, using limelight as the sole light source.

Henry Van der Weyde uses the first electrically-lit photographic studio, built for the purpose, in London. This uses a 4 ft reflector and lens with exposure times of two to ten seconds.

1878 March. William Brooks photographs the artificial 'caves' at Reigate using limelight and paraffin lamps.

Eadweard Muybridge demonstrates photography of motion.

H.D. Udall produces forty-four underground views of Pluto Cave, Ohio.

Commercial dry plates available.

Discovery of Luray Caverns.

1879 Hart produces first known successful underground photographs in the Fish River (Jenolan) Caves, Australia, using magnesium.

First cave society formed in Vienna.

Thomas Edison invents the light bulb.

1880 Publication by Philip Frey & Co. of twelve prints taken in Mammoth Cave.

Invention of the half-tone block printing process permits the cheap reproduction of photographs using ink on paper.

Bennetts begins photographic work in Cornish mines, producing much of his work later in the decade.

1881 Martin Kříž photographs the Eliscina caves, Czechoslovakia, using an arc lamp.

Cango Caves, South Africa, photographed by C. Mason.

Arthur Sopwith photographs at the Cannock Chase Colliery, Britain, this year and 1882, using magnesium ribbon.

1882 20 September. John McClellan patents the idea of using magnesium wire enclosed in a glass globe of oxygen.

C.H. James begins production of some seventy stereo views in Luray Caverns using the caves' arc lights.

1883 January. G.A. Kenyon burns magnesium in oxygen for the first time, then experiments with flashpowder compounds. The suggestion was first made in 1859.

1884 Jenolan photographed by Caney of Mount Victoria by May.

10 August. George Bretz experiments with magnesium in the Kohinoor colliery, Shenandoah.

28 August. Bretz uses five arc lights to take seven 10 in × 8 in negatives. He later uses magnesium powder.

Name 'Jenolan' officially replaces 'Fish River' as name of caves.

Bromide papers are produced commercially, eventually replacing albumen paper.

1885 Between 1885 and 1890 W.E. Hook photographs Manitou Grand Caverns, Colorado, and produces as stereo views and cabinet cards. These caves are also photographed by Jackson, Thurlow and many others. Photography of tourist caves becomes more common.

The change-over from wet to dry plates has begun.

Photograph of a Spanish cave entrance published as a half-tone.

Invention of the gas mantle.

1886 7 March. Società Alpina delle Giulie discusses use of magnesium ribbon lamp for underground photography; the experiment is never performed.

September and October. W.F. Sesser photographs interior of Mammoth Cave.

1887 Gaedicke & Miethe, Germany, produce reliable flashpowder compound.

Price of magnesium continues to fall rapidly.

T.N. Armstrong notes that pure magnesium powder will burn readily when blown into a flame, a principle sometimes attributed to him but well known and in use much earlier in the decade.

Dyer takes pictures in Jenolan.

Károly Divald photographs in Szepesbéla Cave, Hungary.

December. W.F. Donkin suggests firing magnesium using electricity, heating platinum wire to ignite it.

1888 January. P. Swanson suggests using guncotton with magnesium powder, firing it by electricity in oxygen gas – a crude version of what would later become the flashbulb.

February. Jacob Riis uses flashpowder in the slums of New York. A journalist, he demonstrates and publicizes its use.

June. E.A. Martel begins first of his annual campaigns in the Causses. Gaupillat decides to produce underground photographs the following summer.

Max Müller, Germany, photographs the Hermannshöhle using flashpowder triggered in a device of his own making.

First flashpowder trays introduced.

George Eastman introduces his first popular camera, the Kodak, which uses rolls of paper negatives.

Celluloid introduced as sheet film. It eventually replaces glass plates.

H.C. Hovey introduces Ben Hains of Indiana to caving to produce underground pictures for use as lantern slides. Hains later dubs himself a 'Cave Photographer'.

Charles Kerry photographs Jenolan.

1889 Kerry's photographs of Jenolan published in book form.

By June, Hovey has taken Harry A. House to Jewell Cave, Virginia, and attempted photography of the caverns, with poor results.

1–3 June. Hanna takes a set of twenty-two pictures using magnesium tapers in Waitomo Glow Worm caves, New Zealand, aided by Thomas Humphries and a Mr Bain.

Martel's second campaign explores Padirac. First attempts at photography by G. Gaupillat using a magnesium ribbon lamp. Results are poor. Joseph Vallot begins underground experiments using a modified Regnard magnesium powder lamp.

Max Müller publishes sixteen of his underground Hermannshöhle pictures with the first tables showing amounts of powder and apertures to use underground.

Eastman begins use of celluloid roll film in his cameras. The material is flexible and later enables inventors to use it in ciné cameras.

1890 Flashpowder explosions have caused at least five fatalities over the past three years, and the inherent dangers of the compound are realized; however, it is too useful to be abandoned.

6 June. Károly Divald produces photograph of the sculptor László Szent in the Baradla Cave at Aggtelek.

Vallot announces details of his photography. Henceforth, the Regnard lamp is used as a standard flashlamp by most French cave photographers.

The rise in cave tourism has led to increasing sales of items such as guide-books and photographs. Illustrated postcards of the Bilsteinhöhle, with postmarks, date from now. Earlier ones may be discovered.

Jersey Cave, Jenolan, discovered by Charles Kerry.

1891 Frances Benjamin Johnston takes pictures in the Kohinoor
Colliery, Shenandoah, using magnesium.
Paul Nadar introduces his pure powder lamp. Vallot finds it
superior to the Regnard lamp. Photographs of large chambers
enabled with greater ease.
Herbert Hughes of Dudley photographs the collieries of Staf-
fordshire using magnesium powder in a platinotype lamp.
Autumn. Charles Burrow begins underground photography
using limelight and magnesium flash in Cornish tin mines, aided
by advice from Hughes.

1892 Vallot begins experiments with flashpowder in the Paris cata-
combs. These are successful, but flashpowder remains un-
popular, largely due to Martel's influence.
Johnston uses flashpowder to photograph Mammoth Cave.
Burrow photographs interiors of North Wales slate mines.
6 October. First formal meeting and formation of the Yorkshire
Ramblers' Club, based in Leeds. Amateur photographer Samuel
W. Cuttriss is one of the early members.
Prof. C.V. Boys experiments with spark photography and uses
short duration flashes to photograph shadows of bullets.
Martini is succeeded by R. Hammel as photographer at Pos-
tojna.

1893 C.E. DeGroff photographs the Marble Cave of Missouri in the
company of Hovey.
Improvements in the gas mantle bring it into general use: it
enables safer, brighter lights using coal gas.
Charles Burrow publishes his Cornish tin mine pictures and
details of their production.
Publication of twenty-five views of Mammoth Cave by the
Louisville & Nashville Railroad, using pictures by Johnston,
Hains and Darnell.
First ciné work using celluloid film begins above ground.
Thomas Bolas suggests burning aluminium leaf in jars of oxygen,
firing them electronically.
Louis Boutan uses magnesium powder to produce flashes under-
water in a crude 'flashbulb' apparatus operated by blowing the
powder into the flame of an alcohol lamp, maintained by
supplies of air from a barrel.

1895 Martel forms the French Speleological Society.
1 August. Martel descends Gaping Gill, England, beginning a
new era of speleology.
M. Schäber photographs in Postojna.

1896 Herbert Balch begins photography at Wookey Hole, with
limited success.
Harry Short photographs a sea cave near Lisbon, the first ciné
film to feature a cave.

1897 Dawkes and Partridge produce first photographs of a large
cavern in Wookey Hole using limelight and magnesium ribbon.
The exposure lasts two hours.

Between 1897 and 1902, Albert J. Perier, an employee of the photographic firm of Baker & Rouse, photographs Jenolan caves.

Photographs by Winn and Bulmore, taken in the New Almaden quicksilver mines, California, used in litigation.

1898 F. Pfühl makes a set of twelve stereo views in Cango Caves, South Africa.

The first double exposure technique to be used in a ciné film is incorporated into *La Caverne Maudite* (The Cave of the Demons), in which a cave is used for the background.

1899 Martel begins underground photography in his own right in France.

J.H. Harvey photographs the Buchan Caves, Australia.

1900 January. Yorkshire Ramblers' Club publishes its journal, which contains photographs of formations in Gaping Gill by Cuttriss.

September. Eldon Hole, Derbyshire, descended; photographs taken by F. Wightman using paraffin torches, magnesium tapers and Bengal light.

Introduction of the photographic picture postcard in Britain.

Chillagoe Caves (probably Royal Arch Cave), Australia, photographed. The pictures are taken wholly or partly with the aid of sunlight, which shone down shafts onto the formations.

1901 Harry Bamforth accompanies Puttrell and photographs, with F. Smithard, the Bottomless Pit in the Speedwell Mine, Derbyshire, using magnesium tapers and flashpowder.

Earliest known British and Australian cave postcards postmarked.

About this time Arthur Gough begins to take pictures in his cave.

A. Bolé and Kotal photograph in Postojna.

16 August. First explorations of Swildon's Hole, Mendip.

1902 Bamforth and Ernest Baker visit Mendip; photograph Gough's Cave.

April. First explorations of Eastwater Cavern, Mendip.

British law allows a divided back on picture postcards, permitting the whole of the front to be taken up with the illustration.

1903 Martel publishes *La Photographie Souterraine*, the first book on underground photography. He visits Britain and meets with Balch, Baker and Bamforth, and photographs Gough's Cave.

1904 December. Bamforth photographs Swildon's Hole using magnesium on guncotton.

1905 Bamforth emigrates to America.

Australia permits a divided back on its postcards.

W.E. Jones, South Wales, begins photographing local collieries.

1906 Formation of the Yorkshire Speleological Association, under the leadership of Eli Simpson. Photographer Oliver Stringer introduced to caving, remaining active until *c.* 1910.

Harry C. Cook produces photographs of Howe's Cave and other north-eastern USA caverns.

J.D. Strickler photographs Luray Caverns.

1907 N.A. Forsyth takes at least twenty-seven stereo views in Morrison Cave – now Lewis and Clark Caverns, Montana – and markets these as a set.

1910 A.E. Shaw of Blackburn photographs in Yorkshire caves and produces postcards of them. Many other professional photographers are by now taking pictures in tourist caves.

4 June. J. Harry Savory begins caving. Photographs in Wookey Hole at end of year.

1911 17 April. Savory photographs Swildon's Hole for the first time.

1912 March. Revd Francis William Cobb begins photography in the Brinsley Colliery, Nottingham.

1913 Earliest known suggestion for underground ciné photography in Cango Caves, South Africa. Experiment not carried out.

1914 August. Outbreak of First World War.

Swildon's Hole's 'Forty' pitch passed by Baker.

1915 Production of earliest known underground ciné film, undertaken in White's Cave, Kentucky.

1916 Serious suggestions made for ciné filming in Cango Caves. These films were not taken due to lack of funds and lighting.

1918 November. End of First World War.

Davis reputedly photographing in Carlsbad.

1919 Universal Film Manufacturing Company shoots 25 ft of ciné film in Cango Caves using magnesium flares. The film is never shown.

1920 R. Sneath of Sheffield produces underground photographic postcards of Yorkshire and Derbyshire caves.

14 August. Endless Caverns, Virginia, opened to the public. Motion picture newsreels of the ensuing explorations released by Pathé and International News services.

Mines are being inspected for German bombs using an underwater remote camera built by Siebe Gorman & Co.

1922 11 September. First formal visit by tourists to Carlsbad Caverns, stimulated by Davis' photographs.

1923 25 October. Ray V. Davis' photographs instrumental in formation of Carlsbad Caverns National Monument. Lee photographs in Carlsbad.

1925 Paul Vierkötter experiments with enclosed magnesium in oxygen atmospheres; the first 'modern' flashbulb.

17 February. Successful test ciné films taken in Cango Caves by the African Film Company. It had previously successfully shot underground film in Transvaal mines for *The Dust That Kills*.

Russell Trall Neville begins making the ciné film *In the Cellars of the World*.

February. Floyd Collins dies in Sand Cave. Underground photograph taken of the trapped body by John W. Steger of the *Chicago Tribune*.

20 March–15 September. Willis T. Lee photographs in Carlsbad. Three newsreels made of the caves. Jacob Gayer takes underground colour photographs.

1926 Safety films concerned with mining are being shown at an underground theatre in the Spruce Iron Mine, Minnesota.

1927 11–13 July. Neville finishes his film *In the Cellars of the World* with a fifty-one hour thirty-five minute expedition into Old Salts Cave.

Robert Nymeyer begins work with Ray Davis at Carlsbad.

1928 Production of the film *Demanovske Jeskyne* in Czechoslovakia using tourist caves; Mercanton produces a ciné film in, or partly in, the Grottes de St-Cézaire in France.

1929 Johannes Ostermeier produces the first commercial flashbulb: aluminium foil in oxygen enclosed in a glass capsule.

1930 General Electric Company, America, produce the Sashalite flashbulb; the company becomes one of the world's largest bulb producers.

1931 Harold Edgerton, Kenneth Germeshausen and Herbert Grier develop the electronic strobe flashgun at the Massachussetts Institute of Technology, Boston.

1932 H.G. Watson, Australia, builds magnesium powder blow lamp to supply large flashes for cave photography. His pictures are now in the Mortlock Library in South Australia.

1933 The Phillips Co. improves the safety of flashbulbs with the introduction of a blue safety spot in its photoflux bulbs.

Robert Nymeyer begins cave photography.

E.K. Tratman begins ciné filming in Mendip caves using paraffin burners for lights.

1935 Commercial synchronization devices, linking the flashbulb to the shutter, are introduced.

27 July. Formation of the British Speleological Association.

1936 Lamb Leer Cavern permanently reopened after many years of closure.

Introduction of 35 mm format Kodachrome colour film.

1937 Tratman films Lamb Leer Cavern.

1939 Falcon Press Flash Camera introduced, the first camera to have a built in flash synchronizer.

May. Formation of the Speleological Society of the District of Columbia, later to become the NSS.

September. Outbreak of Second World War.

1940 First electronic flash units commercially available, marketed by George Eastman, and intended for studio use. They are not portable without extreme difficulty.

1941 Clay Perry (real name Clair Perry) publishes an article on Howe's Cave in *The Saturday Evening Post* with pictures taken by Arthur Palme. The pictures were taken on Kodachrome using the cave's electric lights, increased from 20,000 to 40,000 watts for the purpose.

1945 August. End of Second World War.

1946 Formation of the Cave Diving Group in Britain.
9 November. Formation of the Cave Research Group of Great Britain.

1947 Colour ciné film of Jenolan made by Ralph Symonds.
National Coal Board formed.

1948 Cave Diving Group in Britain obtains some old landing lights for use for underwater photography.
Invention of the transistor, enabling the production of smaller, lighter electronic flashguns. John Hooper, in Britain, makes good use of the new 'portable' units and begins specializing in bat photography.
Flash of a nuclear explosion at Bikini used to make 'first successful photo made by flash of an atomic bomb'; US Government publication.

1950 Autumn. Hooper, having found success with his electronic flash units, begins experimenting with electronic beam-relays to trigger the lights as bats fly through them.

1952 19 August. Tex Helm takes his 'Big Shot' of the Big Room, Carlsbad Caverns, in colour using 2,400 flashbulbs.
Déribére publishes the photographic manual *La Photographie Spéléologique*.

1955 March. Luke Devenish experiments with underwater sump photography at Wookey Hole.

1959 The Calypsophot underwater camera produced; the forerunner of the Nikonos.

1966 Hill develops 'Diprotodon Hillii' from Watson's original design, a magnesium rocket-fuel burning lamp for underground work in large chambers in Australia.
Introduction of the flashcube by Kodak, using four bulbs in their own reflectors, for use with Instamatic cameras.

1970 Introduction of the magicube: flashbulbs which can be fired without a battery, using a percussion explosive.

1972 Introduction of the flashbar, a set of flashbulbs which will fire in order without reloading and intended for use on 'instant' cameras.

1975 Introduction of the flipflash, a similar device to the flashbar.

1977 Norman Poulter improves Diprotodon (see **1966**) by adding liquid propane as a propellant.

1978 First underground hologram produced in Ogof Ffynnon Ddu, Wales.
Electronic slave units using both visible light and infra-red light to trigger them have been developed by cavers. They are refined over the next ten years to be sensitive enough to operate in large chambers under caving conditions.

1981 First of a series of photographic manuals published:
Italy, 1981. A. Baptizet publishes *Cinéaste des Cavernes*;
Italy, 1982. E. Prando publishes *Fotografia Speleologica*;
France, 1984. F.M. & Y. Callot publish *Photographier Sous Terre*;
Britain, 1987. C.J. Howes publishes *Cave Photography. A practical guide*.

1984 Photograph taken of Sarawak Chamber in Mulu, then the world's largest, using radio for communication.

Glossary

Cross-references are indicated in **bold**.

Actinic Light

The blue component of light to which **emulsions** of the last century were especially sensitive.

Adit

Horizontal mine tunnel entering a hillside, also known as a level.

Albumen Print

Thin **paper**, coated with albumen (egg white) in which potassium iodide has been dissolved. After drying, the paper could be stored and was available commercially. To prepare it for use and to sensitize it, it was immersed in a solution of silver nitrate. It was used for making a positive print from a negative glass **plate**, and became the standard paper in photography throughout the nineteenth century. If the coating was thick enough, the print had a glossy finish; thinner coatings, as well as the type of paper base used, affected the clarity and finish obtained.

Ambrotype

From the Greek term 'imperishable' or 'immortal', the ambrotype was a portrait made on glass which was deliberately underexposed to give a very weak image. This negative was backed with black card or velvet and enclosed in a case. The clear areas of the negative therefore appeared black, while the other parts reflected light when viewed at the right angle, appearing light; the negative, under these conditions, appeared as a positive. The **emulsion** used was **collodion**; these prints are sometimes called 'collodion positives'.

Aperture

The size of the hole which admits light through the camera lens. Early cameras used an interchangeable metal ring, termed a diaphragm, to alter the aperture.

Arc Light

A continuous spark formed by the passing of a large current of electricity

across the tips of two carbon electrodes. The production of the spark was controlled by the gap between the electrodes, clockwork motors moving the rods closer as they burned down.

Aven

An ascending vertical shaft in a cave; in France, generally reaching the surface. See also **Pothole**.

Bengal Light

A pyrotechnic compound of ten parts nitre (potassium nitrate), four parts sulphur and one part antimony sulphide, patented under the name of 'photogen' by John Moule in 1857 for use in photography. Bengal light was also known as Bengal fire, and was in fact known from 1812. Used for studio photography with limited success; the dense fumes that resulted from burning the compound were a problem and it was not popular outside Britain. It was also used underground as a general illuminant by cave guides and explorers. Its use in cave photography was limited, and few pictures were successfully made with its light. Martel, on one occasion finding himself without alternatives, used Bengal light to photograph ice caves.

Coloured versions were produced, matching the light to the effect required in the picture, e.g. lightening skin tones:

Blue.	Chlorate of potash	10 parts by weight.
	Nitrate of potash	10 parts
	Protochloride of copper	5 parts
	Sulphur	4 parts
	Shellac solution	6 parts
Green.	Chlorate of potash	10 parts
	Chlorate of barium	6 parts
	Shellac solution	5 parts
Red.	Chlorate of potash	10 parts
	Nitrate of potash	10 parts
	Strontium nitrate	5 parts
	Shellac solution	5 parts

(See Anon. 'Bengal Fires.' *Scientific American Supp.* **63**, (1641), 15 June 1907. p. 26300.)

Pyrotechnic compounds such as these have reappeared many times under different names, e.g., the mixture aloxin, based on potassium chlorate and aluminium bronze (10 per cent aluminium mixed with 90 per cent copper).

(See Pavličević, Drago-Pavlek. 'Metode Osvetljavanja Kemijskm Sredstvima.' *Simpozij O Fotodokumentaciji Krasa In Jam.* Postojna, 1979. pp. 43–5.)

Boudoir Card

An 8¼ in × 5 in card, used for display, on which was mounted an **albumen print**. Popular from the 1870s.

Bracketing

The production of the same picture at different exposures, ensuring that one will be correct.

Bromide Print

A print made on bromide **paper**, introduced in 1873 by Peter Mawdsley. The **emulsion** contains silver bromide, with a small silver iodide content. Modern prints are made on bromide paper, although the 'paper' base is normally made of plastic, coated with resin.

Cabinet Card

Albumen print made by the wet **collodion** process and mounted on stiff card, 6½ in × 4½ in in size. First thought of in England in about 1863 and used for improved portraits, as it was larger then the **carte-de-visite**. It remained in use until about the time of the First World War.

Calcite

A cave mineral formed of calcium carbonate.

Calotype

The first negative-positive process invented by Fox Talbot and announced in 1839. Prints were first called talbotypes, later calotypes. It allowed many reproductions from a single original negative, made on **paper**, an improvement over the **daguerreotype** although the overall quality was poorer.

Carte-de-Visite

Patented by André Adolphe-Eugène Disdéri in 1854, a carte was produced using a special camera to make eight portraits on a single **plate**. The 3½ in × 2¼ in prints were then mounted on stiff 4 in × 2½ in card. This was usually titled with the sitter's name on the front, and studio advertising on the back. Its popularity spanned the period between about 1860 and 1895.

Cellulose

Cellulose acetate (celluloid) is a material used as a transparent, flexible **film** base, replacing the earlier **nitrate** base (nitro-cellulose) for ciné and roll films as it is non-flammable and more stable.

Collodion

Used as a carrier for photographic chemicals on a glass **plate**, forming the **emulsion**, because it would adhere to the glass and was transparent. Collodion was prepared by dissolving guncotton in alcohol and ether, then adding sulphuric acid. It was previously used as a wound dressing. It enabled **wet plate photography** to take place, the major disadvantage being the hardening of the emulsion that occurred soon after coating the plate, due to the solvent evaporating.

Contact Print

A print produced by placing ('contacting') a negative onto sensitive **paper** before exposing it to light. The print is the same size as the negative.

Daguerreotype

Photographic print produced by Daguerre's process. An image was produced on silvered copper plates. Sensitivity was conferred by iodine vapour, then the plate was developed in mercury vapour. In general use between 1840 and 1860. American daguerreotypes were often superior to European ones since their copper plates were commercially polished.

Dark Slide

Container used for **plates** (or **film**) that enables them to be handled in daylight. A double dark slide carries two plates, back to back.

Depth of Field

The distance between the nearest and furthest point in the picture which will be in focus; small **apertures** produce greatest depth of field.

Diaphragm

See **Aperture**.

Dry Plate

The dry plate replaced the use of the **wet plate** process during the 1870s, enabling greater convenience for the photographer because the plate could be prepared prior to use and developed later, cutting down on the amount of chemicals that had to be carried. There was also an improvement in **sensitivity**. Invented by Richard Leach Maddox in 1871, the process went through various stages of improvement by other photographers before it was sensitive enough to be usable. Generally in use after 1878.

Electronic Flash

The first electronic flash picture was taken by Fox Talbot in 1851 using a spark; later, this was repeated by Ernst Mach between 1885 and 1886 and C. V. Boys in 1892. The modern flash system was developed in the 1930s by Harold Edgerton, who used a high voltage charge from a capacitor, which was discharged through a tube filled with xenon gas, giving a flash of light. The first commercial units were made in 1940. This principal design has been retained, with the use of batteries to charge the unit rather than mains electricity. Electronic flash allows repeatable flashes at low cost together with a very short duration high-intensity light. Additional circuits now ensure correct exposure control using sensors. For modern underground work their main failing is bulk and sensitivity to water. Electronic flash units are sometimes termed strobes, especially in the USA.

Emulsion

The sensitized coating on the surface of a glass **plate**, **film** or **paper** which reacts to light.

Feeder Cave

A cave known to supply water to another cave at lower altitude.

Film

A transparent, flexible base material coated with a sensitized **emulsion**. Film replaced glass **plates**. The development of a flexible base material enabled roll film to be developed. See also **Cellulose**.

Flashbulb

The flashbulb, developed in 1925 and first produced commercially in 1929, uses aluminium foil or wire in an oxygen atmosphere (at about half atmospheric pressure). Flashbulbs solved the problem of smoke generated by the burning of **magnesium**, by containing the fumes. A flashbulb is fired by passing an electric current through the terminals, which heats a filament. This fires an explosive paste made of zirconium, which in turn ignites the aluminium. Early bulbs were large and expensive, and it was not until the late 1950s that improved smaller versions became generally accepted for cave photography, for which they proved ideal. Although now little used by photographers in favour of **electronic flash**, for underground work they are still invaluable with their wide angle of illumination, waterproofing and high power.

Flashpowder

Flashpowder first came into general use in 1887 when mixtures of **magnesium** powder and an oxidizing agent were refined and developed by the Germans, Gaedicke and Miethe. It became almost immediately accepted by photographers, despite the dangers of its explosive nature. Its use enabled a flash of instantaneous light to be produced without complex equipment, at low cost. There were various formulae developed, each giving slightly different properties:

1. For general use and rapid burning:
Potassium perchlorate	3 parts
Potassium chlorate	3 parts
Magnesium powder	4 parts

2. For a large, long duration flash:
Magnesium	2 parts
Sulphur	1 part
Barium nitrate	3 parts
Tallow or beef suet	1 part

 Knead the ingredients together before use.

3. For a large flash source, use a 'flash sheet':
Collodion	180 grammes

Magnesium	70 grammes
Potassium chlorate	1 gramme
Alcohol	35 cm^3

Dissolve the potassium chlorate in the alcohol, add to the **collodion**, mix in magnesium powder, pour onto glass and allow to set. Peel off when dry, hang up and light one corner.

Format

See **Plate**.

Formation

The deposition of calcium carbonate in one of several forms in caves to produce, e.g. a stalagmite (a formation growing from the floor of the cave) or stalactite (a formation growing from the roof of the cave).

Halation

A problem due to the internal reflection of light within glass **plates**, creating a halo effect around bright light sources. Halation could not be avoided until the introduction of the Cadett Lightning plate in the early 1890s.

Half-tone

A process whereby a photograph is reduced to small dots, which can be printed using ink rather than by a photographic process.

Holography

A technique, using lasers, of producing a three-dimensional image which can be viewed from various angles to obtain different perspectives. A range of versions can be produced; the first cave hologram was taken using a ciné camera mounted on a boom which could swing past the subject in an arc. The camera was moved at a predetermined speed to take a series of frames which were then converted into the hologram. The image is produced by viewing through the holographic sheet, and appears behind it.

Karst

An international term for a limestone terrain, typified by underground drainage and caves. Originally the German name for the Slavic word 'kras', meaning a bleak or waterless place, specifically an area east of Trieste.

Lantern Slides

Magic lantern slides were introduced with photographic images on glass (rather than drawn or painted ones) around 1849. Most, however, date from the 1890s and later. Cave scenes on lantern slides date predominantly from the 1900s, when cameras and projectors became more common

as well as there being more interest in caves. British lantern slides were 3¼ in square, while others were 3¼ in × 4 in.

Level

See **Adit**.

Limelight

Limelight was popularized in 1825 by Thomas Drummond. Produced by heating a sphere of lime (calcium carbonate) using a hydrogen flame in oxygen until the lime turns incandescent. Later, coal gas was used to replace the dangerous hydrogen. The burner was usually equipped with a clockwork motor to turn the lime to prevent uneven heating. The light was very bright to the eye but contained very little of the **actinic light** required for photography and so necessitated relatively long exposures. Used for cave photography, primarily in easily accessible caves during the 1890s and 1900s in Britain.

Magnesium

First commercially available in 1863, although it took several years until supplies were good·enough and cheap enough for photographers to obtain it easily. Magnesium could be used as either wire or ribbon, forming tapers when bundled together, and permitted the beginning of underground photography without the need for cumbersome equipment such as **arc lights**. Later, in the 1880s, magnesium powder was used to give instantaneous flashes. It is the main consituent of **flashpowder**.

Nitrate Film

A flexible, transparent **film** base made of nitro-cellulose that replaced the use of glass as a medium for carrying photographic **emulsions**. It was inflammable and unstable, irreversibly degenerating with time, becoming an explosive. Early ciné and roll films were produced on nitrate stock, in the former case causing many current problems in conservation. See also **Cellulose**.

Orthochromatic

Film or **paper** only sensitive to blue and green light (early plates were less sensitive to green than blue). Red colours appear darker than they should on black and white prints. This caused a problem for cave photographers because reddish mud or formations appeared black on prints. See also Panchromatic.

Panchromatic

Film or **paper** sensitive to all colours of light, so that they are correctly tonally reproduced on black and white paper. See also **Orthochromatic**.

Paper

Prints made directly onto photographic paper are named for the characteristics or manufacture of the paper:

PAPER TYPE	DATE OF GENERAL USE
Albumen print	1850 – *c*. 1895
Bromide print	1880 – present
Calotype print	1841 – *c*. 1857
Platinotype print	1880 – *c*. 1914

There were many other papers and processes, which are not mentioned in this volume. See also **Half-tone, Photogravure, Woodburytype**.

Photogen

John Moule patented the name 'photogen' in February 1857. See also **Bengal light**.

Photogravure

Method of reproducing a photograph in ink with a full range of tones, without the use of dots as in **half-tone**. Commercially introduced in 1880. The print is of high quality and it may be difficult to tell that it is not a photograph. High quality copies of photographs were made by this method and often tipped (attached to the page) into books. Usually the process is stamped or written on the **paper** or mount of such a print.

Plate

A 6½ in × 8½ in glass plate was used as a standard size by early camera manufacturers and as this was **contact printed** it controlled the finished print size. Later sizes were subdivisions of this, giving the following formats:

Full or Whole plate	6½ in × 8½ in
Half plate	4¼ in × 6½ in
Quarter plate	3¼ in × 4¼ in
Postcard size	3¼ in × 5½ in (cameras with this format appeared around 1902)

Platinotype

Paper printing process patented in England in 1873. It was commercially introduced in 1880 as a ready sensitized paper which gave a sepia- and black-toned print. It was in use for fine printing until the mid-1890s, then decreasingly until 1914. Platinotype paper is identified as such on the reverse.

Pothole

British term for a cave with a vertical entrance shaft (as opposed to a horizontal cave system); in USA, a pit; France, abyss, abîme or gouffre. See also **Aven**.

Printing Out Paper

Used for proofing prints, as the thin **paper** produces a low quality image in sunlight, without the use of developer.

Reversal Process

The production of a positive image in a single step, e.g. a colour transparency.

Sensitivity

As an example of the sensitivities that could be attained under ideal conditions and bright sunlight, the following exposure times were possible:

Daguerreotype	*c.* 1840	30 minutes
Wet plate	*c.* 1860	15 seconds
Gelatin **dry plate**	1878	1/200 second
Improved gelatin dry plate	*c.* 1900	1/1000 second

Show Cave

A cave developed for tourism, usually with prepared paths and permanent lighting. Compare with **Wild Cave**.

Slave Unit

An electronic device which picks up the impulse of light from a flashgun and triggers another flash. This enables cave photographers to fire multiple flashes in synchronization without the need for cables connecting the guns. Before sensitive slave units were developed pictures using more than one flash had to be produced by using a tripod, opening the camera shutter, then firing the flashes manually before closing the shutter. Slave units were first produced when early **electronic flashguns** were introduced in the 1950s, but only towards the end of the 1970s and early 1980s were sensitive units utilizing infra-red sensors made specially for underground use.

SLR

Single Lens Reflex camera system, where the photographer views the image he is about to take through the lens rather than via a separate viewfinder.

Speleology

The scientific study of caves; a speleologist is a scientist involved in this study, whereas a caver (USA, spelunker) is primarily involved with sport.

Stalactite

A cave **formation** growing from the roof, hanging down.

Stalagmite

A cave **formation** growing upwards from the ground, often beneath a **stalactite**.

Stereograph

A pair of photographs mounted on stiff card, usually 3½ in × 7 in or 4 in × 7 in in size. Each photograph is slightly different, having been taken from viewpoints a few inches apart to simulate the stereo vision of human eyes. This gives the illusion of depth when placed in a special viewer. Early cards sold individually for about 25 cents in America, later dropping to about 50 cents for sets of twenty. Popular between about 1855 and 1920, there were peaks to the collecting craze in America in the 1860s and 1890s. Early in that period stereo cards accounted for most of the photographs taken outside studios.

 Glass stereo slides were also produced, which were more popular in Europe than America. Glass stereographs of caves usually date from the 1890s, as sets of views for sale to tourists, e.g. those originally taken by Martel at Drach. Amateur cave stereos on glass as negatives were still in general production in Britain well into the 1930s and several modern cave photographers now specialize in the production of stereo photographs, mainly using colour transparency film.

Stope

A mining term for a worked-out mineral vein, left open rather than being filled with 'deads' (worthless stone).

Strobe

An American term for **Electronic Flash**.

Sump

A water-filled cave passage, also known as a trap, water trap or siphon (the latter particularly in France).

Talbotype

See **Calotype**.

Wet Plate Process

This basic system of photography was invented by Frederick Scott Archer in 1851. **Collodion** was used to coat a clean glass **plate**, then dipped in silver nitrate to sensitize it. It had to be used within a few minutes while wet, before the collodion hardened. Development was in pyrogallic acid – 'pyro' – (which reacted with oxygen easily so had preserving agents added), then fixed in 'hypo' (sodium hyposulphite, now termed sodium thiosulphate). The process totally replaced the **daguerreotype** and **calotype** by the end of the 1860s, with almost universal use soon after its introduction. Recognizing wet plate negatives is relatively easy, although due to their age these are incredibly rare in any underground context. They have uneven edges where the collodion did not flow to the sides and may show cracks in the **emulsion**, formed as it dried.

Wild Cave

A cave used for sport and exploration, not developed for tourism. Compare with **Show Cave**.

Woodburytype

A technique of producing copies of photographs on **paper** using ink. The result was of very high quality. The process was patented: Woodburytype copies had to be credited to the process as part of permission of use. Brooks' and Burrow's underground photographs were produced as Woodburytypes.

Dating Cave Photographs

To be useful in research, as well as being of general interest, it is important to attempt to date a cave photograph – at least to within narrow limits. Stereographs, in particular, are an important source of visual and historical information. Although such a project is sometimes near-impossible, the following pointers may help:

1. Early-issue 3½ in × 7 in stereo cards were flat, while after a few years they were mounted onto curved card to aid the illusion of depth when viewed. Slightly larger cards, 4 in × 7 in ('artistic' or 'cabinet' cards) or even 4½ in × 7 in ('imperial' cards), were introduced alongside the smaller format from about 1873 in America (slightly earlier in Britain), giving an indication of an earliest date. From *c.* 1874 to 1877 a 4¾ in × 7 in format was also in use. The original square corners on stereo cards petered out *c.* 1870; rounded corners were introduced *c.* 1868 and eventually replaced the square corners. Glass stereographs were introduced in the 1890s.

2. In the case of American stereo cards the date of 'entry' (i.e. registration) according to an Act of Congress may appear on the mount, e.g. Waldack's 1866 stereographs of Mammoth Cave. This gives an indication of the year of photography (although not the year of manufacture of the copy). Registration normally took place very quickly after the photograph was produced, typically within a few weeks, although not all photographs were registered as a fee had to be paid. For example, Hains only registered his underground photographs of Mammoth Cave; his surface pictures were not protected.

3. Cards which have printed pictures using half-tones, rather than stuck-on prints, are most common during the period 1898–1930, peaking towards the end of that period. Photogravures are usually identifiable by the printer's mark, and date from the same period.

4. Consulting suppliers' catalogues, e.g. Underwood & Underwood or E. & H.T. Anthony, can give valuable clues. These list the cards for sale at any one time. Some lists give details of photographic supplies, and the type of card mount in use that year can limit the date of production, e.g. by colour, embossing, thickness, size or curl.

5. Comparison with known datable pictures or information (such as when railings were put in the cave, or the fashions and dress of the people in the scene, etc.) can limit the date.

6. Illicit copying of the more lucrative photographs was perhaps more common than generally recognized, at least in America; printed (or handwritten) information may not always be accurate, being designed to mislead a prospective client into buying the illegal copy. These pictures are, of course, of interest in their own right even if such a fraud has been detected. Many of Waldack's stereos were thus copied.

7. Particularly in the case of unmounted pictures, the reverse of the paper may give a clue to its date. Some papers from the 1880s, and increasingly by the end of the century, had manufacturer's imprints – especially in the case of amateur photographs. For example, Velox printing out paper was introduced in 1898, providing an earliest date. The name of the studio that printed the picture may appear, which can be traced in trade directories to find the period in which it operated.

8. Many stereo cards and prints carry the name of either a publisher or photographer, together with an address where more copies could be purchased. Check trade directories for dates of the business/photographer/distributor/publisher, to determine when the photograph could have been produced at any given address.

9. Do not study the single picture in isolation; is it one of a series, where one of the other views might hold a clue to dating the whole set? For example, a building shown on one photograph may be traceable, with regard to date of construction, extension or modification, leading to inferences concerning the production of other pictures.

Chemical Names

Chemical nomenclature has changed several times during the period of history covered by this study. The names given in quotations may not, therefore, still be in common use. The modern equivalent terms are as follows:

PAST	PRESENT
Acetic acid	Ethanoic acid
Acetylene	Acetylene (ethyne)
Aluminium bronze	1 part aluminium, 9 parts copper
Barium nitrate	Barium nitrate
Bromide of cadmium	Cadmium bromide
Chlorate of barium	Barium chlorate (V)
Chlorate of potash	Potassium chlorate (V)
Collodion	Alcohol, ether and guncotton
Guncotton	Pyroxyline
Hyposulphite/hypo (fixing agent)	Sodium thiosulphate (then termed sodium hyposulphite)
Iodide of ammonium	Ammonium iodide
Lime	Calcium carbonate (in the context of limelight production, although lime is technically calcium oxide)
Nitrate of potash	Potassium nitrate (V)
Nitrate of silver	Silver nitrate
Nitre	A group of nitrate chemicals, including potassium and sodium nitrate
Potassium chlorate	Potassium chlorate (V)
Potassium iodide	Potassium iodide
Potassium perchlorate	Potassium chlorate (VII)
Protochloride of copper	Copper (I) chloride
Pyro (developer)	Pyrogallic acid (pyrogallol)
Saltpetre	A group of nitrate chemicals, including potassium and sodium nitrate
Soda lime	Sodium hydroxide (caustic soda) mixed with calcium oxide (quicklime)

Strontium nitrate	Strontium nitrate
Sulphate of iron and ammonia	Ammonium ferrous sulphate

Typical formulae:

Collodion	Alcohol (70 cm^3), ether (140 cm^3), guncotton (3.5 g)
Sensitizing solution	Silver nitrate (14 g), potassium iodide (1 g), distilled water to make 250 cm^3
Developer	Equal amounts of two solutions were mixed just before use: Solution A: pyrogallol (30 g), sodium sulphite (30 g), distilled water to make 250 cm^3 Solution B: potassium carbonate (30 g), sodium sulphite (30 g), water to make 250 cm^3
Fixer	Sodium thiosulphate (120 g), water to make up to 500 cm^3. Fixer used with dry plates had alum added, to harden the gelatine.

Notes:

1. The spelling 'sulphur' is generally retained in Britain, although the International Union of Pure and Applied Chemists (IUPAC) favours 'sulfur'.
2. For a discussion on the name change of the photographically-important chemical 'hypo', see Newhall, B. *Latent Image.* Garden City, Doubleday, 1967.
3. Other formulae for sensitizing, developing and fixing solutions were in common use, and most photographers had their preferred mixtures which they matched to the specific results they wished to obtain.

Units of Measurement

Throughout this book units of measurement are given as those in use at the time for the country under discussion, and often appear in quotations. The following conversions may therefore prove useful to any reader who is not conversant with any specific value.

Money

Britain: Prior to 1971 the monetary system was based on twelve pence (12d.) to a shilling (1s.), twelve shillings to the pound (£1). This was superseded by a decimal system, one hundred 'new' pence (100p) to the pound (£1). One shilling equals five new pence.

America: One hundred cents (100c) equals one dollar ($1).

France: One hundred centimes (100c) equals one franc (FF1).

Conversion: Conversion rates between currencies continuously fluctuate (especially following the American Civil War, when the dollar varied from $4 to $9 to the £). As a guide for pounds sterling, US dollars and French francs, the average conversion rate for the following key dates is:
 1865: £1.00 = $7.50 = FF25.00
 1888: £1.00 = $4.75 = FF25.00

Weight

British: Avoirdupois weight (used for chemicals, but not precious metals; magnesium was not considered a precious metal): 437.5 grains (437.5 gr) equals one ounce (1 oz); sixteen ounces (16 oz) equals one pound (1 lb).

Metric: One thousand grammes (1,000 g) equals one kilogramme (1 kg).

Rough conversion:	Grains to grammes:	divide by 15.5
	Ounces to grammes:	multiply by 28
	Pounds to kilogrammes:	divide by 2.25
	Grammes to grains:	multiply by 15.5
	Grammes to ounces:	divide by 28
	Kilogrammes to pounds:	multiply by 2.25

Length

British:	Twelve inches (12 in) equals one foot (1 ft), three feet equals one yard (1 yd).
Metric:	One hundred centimetres (100 cm) equals one metre (1 m).

Rough conversion:	Inches to centimetres:	multiply by 2.5
	Feet to metres:	divide by 3.3
	Centimetres to inches:	divide by 2.5
	Metres to feet:	multiply by 3.3

Light

Light was measured in candle power, this being the luminous energy emitted per second from a British Standard Candle, which was made to certain specifications. The candle power unit was superseded by the candela in 1948. Within 2 per cent, the light output from one Standard Candle (1 cp) is equal to one candela (1 cd).

It is not easy to compare light output in candelas with common light sources such as electric light bulbs, which are designated in watts (a measure of the power consumed, not light emitted). Light emission from any source depends not only on power (or the efficiency of its conversion), but also the reflector in use. It should also be remembered that the brightness of a given light to the human eye may not match the sensitivity of photographic emulsions. However, for rough comparisons with photographic light sources:

Candle power to watts: multiply by 0.75.

Burning a single magnesium ribbon is roughly equivalent to a 250 watt photoflood electric light.

Notes and References

Figures in **bold** refer to the volume number of the appropriate journal.
Figures in parentheses () refer to the issue number.

INTRODUCTION.

1. Leigh, E. *England Described: Or the several counties & shires thereof briefly handled, &c.* London, Marsh, 1659.
2. Hobbes, Thomas. *De Mirabilibus Pecci. Being the wonders of the Peak in Darby-shire . . .* London, Crook, 5th edn., 1683.
3. Howes, C.J. 'The Secrets Of Porth Yr Ogof.' *Country Quest*, **23**, (4), Sept. 1982. pp. 5–8. Some early visits by travellers to the cave are mentioned.
4. Russell, Ronald. *Guide To British Topographical Prints*. Newton Abbot, David & Charles, 1979.
5. Quoted, for example, in Gernsheim, H. *The Origins Of Photography*. London, Thames & Hudson, 1982.
6. The quotation is taken from the *Leipziger Stadtanzeiger* newspaper, reprinted in Gernsheim, H. and A. *A Concise History Of Photography*. London, Thames & Hudson, 1965.
7. Painting, David. *Swansea's Place In The History Of Photography*. Swansea, Royal Institution Of South Wales, 1982.
8. Davies, J.D. *Historical Notices Of The Parishes Of Llanmadoc And Cheriton, In The Rural Deanery Of West Gower Glamorganshire. Part 2*. Swansea, 1879. pp. 55–7.
9. Howes, C.J. 'Cave Photography In South Wales Prior To 1860.' *Cave Science*, **15**, (3), Dec. 1988. pp. 149–55. The cave-related photography of both Gutch and Llewelyn is discussed. See also an associated paper, 'The Dillwyn Diaries, 1817–1852, Buckland, And Caves Of Gower (South Wales).' *Proceedings University Bristol Spelæological Society*, **18**, (2), 1988. pp. 298–305.
10. Archer, F.S. 'On The Use Of Collodion In Photography.' *The Chemist*, March 1851.
11. Fox Talbot, W.H. *The Pencil Of Nature*. Lacock, Talbot, 1844. The book was illustrated with twenty-four calotypes, and published in six parts from 1844 to 1846.
12. Buckland, Gail. *First Photographs. People, places, and phenomena as captured for the first time by the camera*. New York, Macmillan, 1980.

CHAPTER 1. LET THERE BE LIGHT.

1. Nadar, F. *Quand J'étais Photographe*. Paris, Flammarion, 1900. pp. 99–129. The parts relative to Nadar's work in the catacombs were reprinted in *Le Paris Souterrain de Félix Nadar. 1861*. Paris, Caisse Nationale des Monuments Historiques et des Sites, 1982.

2. Browne, T. and Partnow, E. *Macmillan Biographical Encyclopedia Of Photographic Artists & Innovators*. Canada, Macmillan, 1983. pp. 442–3. An excellent account of Nadar's life, one of the few in detail in English, is given by Gosling, Nigel. *Nadar*. New York, Alfred A. Knopf, 1976. Additional references are found in its review by Hauptman, William. 'Homme Phototypique.' *History of Photography*, **1**, (4), Oct. 1977. pp. 349–51.

3. Newhall, Beaumont. *The History Of Photography*. London, Secker & Warburg, 1982.

4. A lithograph by H. Daumier entitled *Nadar élevant la Photographie à la hauteur de l'Art* appeared in *Le Boulevard*, 25 May 1862.

5. Pyke, Magnus. *The Science Century*. London, Murray, 1967. The mantle was patented in 1885, but not perfected or commonly used until *c*. 1893.

6. Eder, Josef Maria. Translated by Epstean, Edward. *History Of Photography*. New York, Columbia University Press, 1945.

7. Burke, James. *Connections*. London, Macmillan, 1978. Burke's discussions cover both the invention and use of limelight as well as its replacement of gas burners.

8. Gernsheim, H. and A. *The History Of Photography. From the earliest use of the camera obscura in the eleventh century up to 1914*. Oxford, Oxford University Press, 1955.

9. Adam, William. *The Gem Of The Peak; or Matlock Bath and its vicinity*. Derby, John and Charles Mozley, 5th edn., 1851. Reprinted, Buxton, Moorland, 1973.

10. Stevenson, F.J. 'Adventures Underground. The Mammoth Cave of Kentucky in 1863.' *Blackwood's Magazine*, **231**, (1400), June 1932. pp. 721–56. Stevenson's text, originally written for his mother in the form of a letter, mentions the use of Bengal fire on several occasions. Stevenson also used a 'blue light paper'. This was paper impregnated with the chemicals, normally burned and thrown into shafts to illuminate them as it fell.

11. Throughout this book prices are based on monetary units in use at the time. In Britain the monetary system was based on 12 pence (12d.) to a shilling (1s.), 12 shillings to the pound (£1). This was superseded in 1971 by a decimal system, 100 'new' pence (100p) to the pound (£1). One shilling equals five new pence.

12. Prinet, Jean and Dilasser, Antoinette. *Nadar*. Paris, Armand Colin, 1966.

13. Anon. 'The International Exhibition.' *The British Journal Of Photography*, **9**, (166), 15 May 1862. pp. 183–5. Gernsheim (ref. 8) suggests that Nadar's catacomb pictures were displayed in the 1862 exhibition in London, but no record of any such entries has been located.

14. Anon. 'Jurors' Awards In The Photographic Department Of The International Exhibition.' *The British Journal Of Photography*, **9**, (171), 1 Aug. 1862. pp. 290–2.

15. Willesme, Jean-Pierre. *Les Catacombes*. Paris, Les Musées de la ville de Paris, 1986.

16. Anon. 'Photography In The Catacombs Of Paris.' *Scientific American*, **7**, (1), 5 July 1862. p. 5.

17. Nadar's underground work has been inaccurately dated in various references and given as early as 1858 to as late as *c*. 1865. The datings given throughout this chapter are based on contemporary Paris newspaper reports. The exact date of Nadar's first photographs in the catacombs is not known and must be deduced from later reports. December is the most likely month for his first experiments underground. The year of 1861 is certain.

18. Anon. 'Les Catacombes De Paris.' *Le Moniteur Universel*, (67), 8 March 1862. p. 328, col. 3.

19. Anon. 'Exhibition Of The French Photographic Society, considered from an English point of view.' *The British Journal Of Photography*, **10**, (190), 15 May 1863. pp. 212–13.

20. Use of the wood engravings was widespread. For example, see Tissandier, G. *A History And Handbook Of Photography*. London, Sampson, Low, Marston, Searle & Rivington, 1876. Newspapers such as *Le Monde Illustré* were early publishers of the underground views.

CHAPTER 2. MAGNESIUM: THE START OF AN ERA.

1. This extract from *The Standard* was reprin-

ted in *The British Journal Of Photography*, **11**, (240), 9 Dec. 1864. pp. 493–4.

2. Hallett, Michael. 'Alfred Brothers, Photographer of Manchester.' Supplement to Feb. *Historical Group Newsletter*. Royal Photographic Society, 1975. pp. 1–6.

3. Anon. 'Death Of A Pioneer Photographer.' *Daily Mail*, 27 Aug. 1912.

4. Hallett, Michael. 'John Benjamin Dancer 1812–1887: A Perspective.' *The British Journal Of Photography*, 3 Dec. 1987. pp. 1474–7. This paper, originally published in a slightly different form in *History of Photography*, **10**, (3), July–Sept. 1986, discusses the relationships between many of the members of the Photographic Society.

5. Bunsen, R. and Roscoe, H.E. 'Professor Bunsen and Dr. H.E. Roscoe's Photo-Chemical Researches. IV. The photochemical action of the sun compared with that of a terrestrial source of light.' *Phil. Trans. Roy. Soc.*, **149**, (2), 1859. pp. 879–926. See also Roscoe, H.E. 'On The Chemical Properties Of Light.' *The British Journal Of Photography*, **11**, (229), 23 Sept. 1864. pp. 367–9.

6. Frankland, E. 'On Magnesium As A Source Of Light.' *Journal of Gas Lighting &c.* 21 Feb. 1865. Reprinted in *Experimental Researches On Pure, Applied & Physical Chemistry*. London, John Van Voorst, 1877. pp. 542–8.

7. For further information on Crookes (1832–1919) see Brettell, Richard R. *et al. Paper And Light. The calotype in France and Great Britain.* Boston, David Godine, 1984. p. 114.

8. Crookes, William. 'Artificial Light For Photographic Purposes.' *The Photographic News*, **3**, (58), 14 Oct. 1859. p. 71. The letter is signed 'V.C.' and is included with Crookes' reply.

9. Anon. 'Magnesium.' *The British Journal Of Photography*, **12**, (265), 2 June 1865. p. 290. The report quotes from a pamphlet published by F. Pitman of London.

10. Brothers, Alfred. 'Magnesium.' *The British Journal Of Photography*, **35**, (1451), 24 Feb. 1888. p. 126.

11. Brothers, Alfred. *Photography; Its History, Processes, Apparatus, and Materials.* London, Charles Griffin & Co., 2nd edn.,

1899. The stereo photograph of the Blue John Cavern is not present in the 1st edition of 1892. Brothers was working on a 3rd edition at the time of his death; this was never published.

12. Anon. 'Magnesium: The True Method Of Using It.' *The British Journal of Photography*, **23**, (818), 7 Jan. 1876. pp. 2–3.

13. Sainte-Claire Deville, H. and Caron. 'Chimie Minérale – du magnésium, de sa préparation et de sa volatilisation.' *Comptes Rendus. Hebdomadaires des séances de l' Académie des Sciences,* **44** for Jan.–June, 23 Feb. 1857. pp. 394–6.

14. Anon. 'The Magnesium Light – Patents For Methods Of Procuring The Metal.' *The Photographic News*, **8**, (253), 10 July 1863. pp. 327–8.

15. Reynolds, Emerson J. 'Magnesium: It's Preparation And Properties.' *The British Journal Of Photography*, **12**, (247), 27 Jan. 1865. pp. 38–40.

16. Anon. 'Report of Ordinary Meeting, Feb 9.' *Proceedings*, Manchester Literary and Philosophical Society, 1864. pp. 233–5.

17. Details of the disagreements leading to the move are contained in part in the minutes of the Manchester Photographic Society, November 1863 to April 1864, held at Manchester Central Library.

18. Brothers, Alfred. 'Communication To The Ordinary Meeting, Manchester Literary and Philosophical Society.' *Proceedings*, 9 Feb. 1864. p. 235.

19. William Mather later became Sir William. He died in 1920. Although credited with innovations concerning magnesium, Mather does not appear in any of Sonstadt's patents or later patent improvements as these were taken out before his involvement. Patents 3021, 1862 and 1278, 1863 are the principal documents concerned with the production of magnesium. The conversion from wire into ribbon does not seem to have been patented.

20. Anon. 'On The Use Of The Light Of Magnesium Wire In Combustion As A Photographic Agent. Communication to the Photographic Society Of Scotland Ordinary Meeting.' *The Photographic Journal*, 15 Mar. 1864. pp. 5–6.

21. Anon. 'Literary & Philosophical Society Of Manchester – Photographic Section. Inaugural Address.' *The British Journal of Photography*, **11**, (237), 18 Nov. 1864. pp. 464–5.

22. Brothers, Alfred. *A Short Record Of My Life, being an autobiography of Alfred Brothers FRAS of Manchester (January 2 1826 –).* 1908. Typescript of unpublished manuscript.

23. Brothers, Alfred. 'Hints On Portraiture By The Magnesium Light.' *The British Journal Of Photography*, **11**, (239), 2 Dec. 1864. p. 483.

24. Schaaf, Larry. 'Charles Piazzi Smyth's 1865 Conquest Of The Great Pyramid.' *History of Photography*, **3**, (4), Oct. 1979. pp. 331–54. Schaaf discusses Smyth's work at the pyramid in detail and includes many references of relevance to his photographic life and work. Smyth's astronomical work is fully covered in Brück, H.A. and Brück, M.T. *The Peripatetic Astronomer. The life of Charles Piazzi Smyth.* Bristol, Adam Hilger, 1988. A full discussion of Smyth's disagreements with the Royal Society and others is included, but little is mentioned of his photography. The volume also includes a bibliography of Smyth's publications.

25. Taylor, John. *The Great Pyramid. Why Was It Built? & Who Built It?* London, Longman, Green, Longman & Roberts, 1859. Taylor died in 1864: although he and Smyth corresponded by letter, the two men never met and Taylor never knew of the pyramidology cult that his work spawned.

26. Wilson, Derek. *Francis Frith's Travels. A photographic journey through Victorian Britain.* London, J.M. Dent, 1985.

27. Smyth, Charles Piazzi. *A Poor Man's Photography At The Great Pyramid In The Year 1865; compared with that of the Ordnance Survey establishment, subsidized by London wealth, and under the orders of Col. Sir Henry James . . . at the same place four years afterwards; a discourse delivered before the Edinburgh Photographic Society on December 1st, 1869.* London, Greenwood, 1870.

28. Anon. 'Photographic Society Of Scotland.' *The Photographic News*, **8**, (299), 27 May 1864. p. 260.

29. For further information on Sidebotham see Milligan, H. 'Joseph Sidebotham: a Victorian amateur photographer.' *The Photographic Journal*, March–April 1978. pp. 83–7.

30. White, William. 'Recent Applications Of Magnesium.' *The Photographic Journal*, 15 Sept. 1865. pp. 145–8. Also published in *The Photographic News*, **9**, (367), 15 Sept. 1865. pp. 437–8. As well as White's comments, the lecture included a prepared statement by Smyth concerning his photographs in the pyramid.

31. Gaudin, Mc.A. 'The Magnesium Light.' *The British Journal Of Photography*, **11**, (224), 19 Aug. 1864. pp. 307–8.

32. Nicol, John. 'Photography In And About The Pyramids. How it was accomplished by Prof. C. Piazzi Smyth.' *The British Journal of Photography*, **13**, (318), 8 June 1866. pp. 268–70. The construction and operation of Smyth's camera is discussed in detail. Nicol was a friend of Smyth's and a member of Edinburgh Photographic Society.

33. Anon. 'Talk In The Studio.' *The Photographic News*, **8**, (328), 16 Dec. 1864. pp. 611–12. Reprinted in ref. 24.

34. Baker, Ernest A. and Balch, Herbert E. *The Netherworld Of Mendip. Explorations in the great caverns of Somerset, Yorkshire Derbyshire and elsewhere.* London, Simpkin, Marshall, Hamilton, Kent & Co., 1907.

35. Hughes, W. *Map Of Derbyshire. 1/5 inch to 1 mile.* London, J.S. Virtue & Co., 1868.

36. Howes, C.J. 'The World's Earliest Underground Cave Photograph By Alfred Brothers F.R.A.S.' *Cave Science*, **12**, (1), March 1985. pp. 25–9. A revised reference list appears in **12**, (2), June 1985, p. 66.

37. Ford, Trevor D. 'Blue John Fluorspar.' *Proc. Yorks. Geol. Soc.*, **30**, pt 1, (4), 1955. pp. 35–6.

38. Royse, John. *Ancient Castleton Caves.* Sheffield, Chas. Swinburn & Co. Ltd., 1943.

39. Anon. 'Report of the Ordinary Meeting, Manchester Literary and Philosophical Society Photographic Section, Feb 2.' *The British Journal of Photography*, **12**, (249), 10 Feb. 1865. pp. 76–7.

40. Brothers, Alfred. 'Photography Underground.' *Birmingham Daily Post*, Wed. 15 Nov. 1876. p. 5, col. 1.

41. Adam, William. *The Gem Of The Peak; or Matlock Bath and its vicinity*. Derby, John & Charles Mozley, 5th edn., 1851. Reprinted, Buxton, Moorland, 1973.

42. Anon. 'Members List & Monthly Meeting, Tue 28 March.' *Transactions, Manchester Geological Society*, 1865.

43. Jackson, Vernon L. 'Photography Under Ground.' *The British Journal Of Photography*, **23**, (868), 22 Dec. 1876. p. 611.

44. Chapman, J.G. *Manchester And Photography*. Manchester, Palantine Press, 1934. Smyth's letter, reproduced by Chapman, is dated 2 Feb., at which time Smyth had been at Giza for 'about three weeks'.

45. Smyth, Charles Piazzi. 'Magnesium Light At The Pyramids.' *The Photographic News*, **9**, (339), 3 March 1865. p. 107.

46. Buckland, Gail. *First Photographs. People, places, and phenomena as captured for the first time by the camera*. New York, Macmillan, 1980.

47. Smyth, Charles Piazzi. *Descriptive Album of Photographs of The Great Pyramid taken by Professor C. Piazzi Smyth, F.R.S.E., &c., &c., in 1865, and published in their present form in 1879 by J.S. Pollitt*. Manchester, Pollitt, 1879. The portfolio contained fifty annotated photographs, of which four were underground scenes. A single copy is known to exist in Manchester Central Library.

48. Smyth, Charles Piazzi. 'Photographing The Pyramids.' *The British Journal Of Photography*, **12**, (265), 2 June 1865. p. 294.

49. Smyth, Charles Piazzi. 'Photographs Of The Pyramids By The Magnesium Light.' *The Photographic News*, **9**, (352), 2 June 1865. p. 258.

50. Letter dated 30 Sept. 1866, held by Royal Observatory, Edinburgh.

51. Anon. 'Edinburgh Photographic Society.' *The British Journal Of Photography*, **13**, (317), 1 June 1866. pp. 263–4.

52. Smyth, Charles Piazzi. *Life And Work At The Great Pyramid during the months of January, February, March, and April, A.D. 1865; with a discussion of the facts ascertained*. **2**. Edinburgh, Edmonston & Douglas, 1867.

53. White, William. 'Employment Of The Magnesium Light In Photography.' *Proceedings*, British Association 35th Annual Meeting, 1865. pp. 102–4.

54. Grant was involved in arguments with Henry Larkin, inventor of a magnesium lamp, who accused Grant of copying his design. Letters were exchanged in *The British Journal of Photography* which showed Larkin had some justification in his claims, indicating that Grant had bought a Larkin lamp before inventing his own. Larkin's patent was number 2786, 1865, dated 28.10.65 although not granted until 27.4.66.

55. Anon. 'Magnesium Lamps.' *The British Journal Of Photography*, **12**, (250), 17 Feb. 1865. pp. 86–7.

56. Crookes, William. 'The Magnesium Light.' *The Photographic News*, **9**, (333), 20 Jan. 1865. p. 26.

57. Grant, Alonzo G. 'Notes On Magnesium.' *The British Journal of Photography*, **12**, (281), 22 Sept. 1865. pp. 487–8.

58. Grant, Alonzo G. 'Photography In A Lead Mine.' *The British Journal Of Photography*, **12**, (277), 25 Aug. 1865. p. 442.

59. Grant, Alonzo G. 'The Magnesium Light In A Lead Mine.' *The Photographic News*, **9**, (364), 25 Aug. 1865. p. 407.

60. Grant knew of Brothers' work with magnesium, although he may not have known of the photography in the Blue John Caverns (then termed the 'Blue John Mines'). Both men had been at the 1864 British Association Meeting. They also exchanged letters concerning the design of magnesium lamps in the press, Grant attacking Brothers. See Grant, A.G. 'The Magnesium Light.' *The British Journal Of Photography*, **11**, (240), 9 Dec. 1864. p. 507 and Brothers' reply in the next issue on 16 Dec. p. 523.

61. Anon. 'Magnesium.' *British Journal Of Photography*, **12**, (264), 26 May 1865. p. 281. Reprinted from a report from the *Mining Journal*.

62. Anon. 'New Artificial Light.' *The British Journal Of Photography*, **12**, (283), 6 Oct. 1865. p. 514.

63. Anon. 'Visit Of The Prince And Princess Of Wales To Plymouth And Cornwall.' *Illustrated London News*, **47**, (1327), 5 Aug. 1865. p. 111, cols. 2–3.

64. Anon. 'Photographs Of A Mine By Magnesium Light.' *The British Journal Of Photography*, **12**, (291), 1 Dec. 1865. p. 608.

65. Pritchard, Michael. *A Directory Of London Photographers 1841–1908.* Bushey, ALLM Books, 1986.

66. Hughes, Herbert W. 'Photography In Coal Mines.' *The Photographic Journal*, **18**, New Series, 25 Nov. 1893. pp. 93–101. Debenham was present at the meeting and gave his personal comments.

67. The full inscription on Smyth's gravestone reads;

'Beside the Earthly Remains of his Lamented Wife, here lies interred the Body of CHARLES PIAZZI SMYTH. Born 3rd January 1819 died February 21st 1900. Astronomer Royal for Scotland from 1845 to 1888, who earned unperishing renown by his Journeys to distant lands for scientific objects, and by his eminent Astronomical and other Scientific Writings and Researches. As Bold in enterprise as he was Resolute in demanding a proper measure of public sympathy and support for Astronomy in Scotland, he was not less a living emblem of pious patience under Troubles and Afflictions, and he has sunk to rest, laden with well-earned Scientific Honours, a Bright Star in the Firmament of Ardent Explorers of the Works of their Creator.

Still achieving, still pursuing, Learn to Labour and to Wait.

He prayeth best, who loveth best All things both great and small;

For the dear God who loveth us, He made and loveth all.'

68. Throughout this book prices are based on monetary units in use at the time. In Britain the monetary system was based on 12 pence (12d.) to a shilling (1s.), 12 shillings to the pound (£1). This was superseded in 1971 by a decimal system, 100 'new' pence (100p) to the pound (£1). One shilling equals five new pence.

69. Anon. 'Magnesium Light.' *Scientific American*, **12**, (18), 29 April 1865. p. 276, col. 3.

CHAPTER 3. MAMMOTH CAVE.

1. Waldack, Charles. 'Photographing In The Mammoth Cave.' *The Photographic News*, **10**, (430), 30 Nov. 1866. pp. 567–9. This account of the second expedition was reprinted in both the *British Journal Of Photography* (in an abbreviated form) and the *Philadelphia Photographer* (the journal which Waldack had originally sent it to). There were some minor differences in wording in the versions, presumably due to editing or typesetting faults. The above reference is used as the basis for quotes in this volume.

Waldack, Charles. 'Photography In The Mammoth Cave.' *The British Journal of Photography*, **13**, (344), 7 Dec. 1866. pp. 584–5.

Waldack, Charles. 'Photography In Mammoth Cave – 1866.' *Philadelphia Photographer*, **3**, Dec. 1866. pp. 359–63. Reprinted *NSS News*, **27**, (1), Jan. 1969. pp. 7–9.

2. White, William. 'Recent Applications Of Magnesium.' *The Photographic Journal*, 15 Sept. 1865. pp. 145–8. Also published in *The Photographic News*, **9**, (367), 15 Sept. 1865. pp. 437–8.

3. Anon. 'An American Magnesium Lamp.' *The British Journal Of Photography*, **12**, (293), 15 Dec. 1865. p. 638.

4. Anon. 'Magnesium.' *The British Journal of Photography*, **12**, (291), 1 Dec. 1865. p. 608.

5. Parish, Peter. *The American Civil War.* London, Methuen, 1975.

6. Anon. 'Magnesium Light.' *Scientific American*, **12**, (18), 29 April 1865. p. 276, col. 3. The Navy was ordering supplies of the metal from England, where the Magnesium Metal Company was increasing its production. For the report of blockade runners, see ref. 2.

7. Quinlan, James F. 'Photographic Entrepreneurs At Mammoth Cave, 1866: Preliminary Report.' *Journal of Spelean History*, **6**, (2), April–June 1973. pp. 38–9.

8. Silliman, Benjamin. 'On The Mammoth Cave Of Kentucky.' *Edinburgh New Philosophical Journal*, **51**, April–Oct. 1851.

pp. 227–33. The text is taken from a letter to Prof. Guyot, Cambridge, dated Louisville, 8 Nov. 1850.

9. Crookes, William. 'Artificial Light For Photographic Purposes.' *The Photographic News*, **3**, (58), 14 Oct. 1859. p. 71. The letter from 'V.C.' concerning suitable light sources to use for photography in Mammoth Cave is included with Crookes' reply.

10. Perry, Clay. *Underground Empire*. 1948. Reprinted, Port Washington, Friedman, 1966. It is supposed to represent the wedding of Lester Howe's daughter Elgiva to H.S. Dewey on 27 September 1854, a date too early to be believable concerning the lighting and sensitivity of photographic emulsion at that time. Presumably, Howe produced the picture at a later date (certainly after those at Mammoth had been taken) for publicity purposes. Subsequent publications have accepted the photograph's authenticity without question, as did Perry. During the Depression of the 1930s Clay (real name 'Clair') Perry wrote many cave stories which were specially illustrated by a photographer, Arthur Palme.

11. The correct spelling of John R. Proctor's name is 'Procter'. His father was George Procter and John was nephew to Larkin J. Procter (again, correctly spelt), manager of Mammoth Cave. However, contemporary references use the 'Proctor' spelling (e.g., when the railroad reached the cave the halt was named 'Proctor's Station') and this spelling has been retained throughout this volume. Quinlan (ref. 7) discusses these spelling differences further.

12. Waldack's age is deduced from the 1870 Ohio census, when he is stated as being 39. His age in 1866 is therefore *c.* 35. The census also confirms his Belgian origins; he emigrated before 1857, when he published a book (see ref. 28), and set up shop as a 'photographic chemist' at 31½ W. 3rd St, Cincinnati, according to *Williams' Cincinnati Directory*. There were then several changes of address; in 1866 his studio was at 28 W. 4th St., with his home on the corner of 9th and Vine.

13. Waldack, Charles. 'Photography In The Mammoth Cave By Magnesium Wire – 1866.' *Philadelphia Photographer,* **3**, July 1866. pp. 241–4. Reprinted *NSS News,* **26**, (12), Dec. 1968. pp. 200–2, with introductory notes by Jackson, G.F. This account of the first expedition was reprinted, complete with the *Philadelphia Photographer* editor's comments, in;
Waldack, Charles. 'Photography In The Mammoth Cave By Magnesium Light.' *The British Journal of Photography,* **13**, (328), 17 Aug. 1866. p. 394. There were some minor differences in individual words, presumably due to editing or typesetting faults. There was only a brief report in the *Photographic News* (see ref. 18). The report in *The British Journal Of Photography* was used as the basis for quotes in this volume.

14. Anon. 'Mat Bransford.' *Louisville Journal,* 20 Aug. 1863. Reprinted in *Journal of Spelean History,* **18**, (2), April–June 1984. p. 60.

15. Meloy, Harold. 'The Bransfords Show Mammoth Cave.' *Journal Of Spelean History,* **19**, (1), Jan.–Mar. 1985. pp. 4–8. Waldack only refers to his guide as 'Man Friday', and could be either Mat or Nick Bransford. Meloy suggests the former is more likely.

16. Forwood, W. Stump. *An Historical And Descriptive Narrative Of The Mammoth Cave Of Kentucky. Including explanations of the causes concerned in its formation, its atmospheric conditions, its chemistry, geology, zoology, etc. with full scientific details of the eyeless fishes.* Philadelphia, J.B. Lippincott, 1870.

17. Wilson, Edward L., in Waldack, Charles. 'Photography In The Mammoth Cave.' *Philadelphia Photographer,* **3**, July 1866. p. 244; **3**, Dec. 1866. p. 363. Reprinted *NSS News*: [Part 1] 'Photography In The Mammoth Cave By Magnesium Wire – 1866.' **26**, (12), Dec. 1968. p. 202; [Part 2] 'Photography In Mammoth Cave – 1866.' **27**, (1), Jan. 1969. p. 9. Wilson's comments are made at the end of each of Waldack's articles.

18. Crookes, William. 'Photographing The Mammoth Cave.' *The Photographic News,* **10**, (419), 14 Sept. 1866. p. 443.

19. Sherston, Robert. 'In The Mammoth Cave Of Kentucky.' *Wide World Magazine,* **5**, (27), June 1900. pp. 256–65. Sherston attributes the statement that $500 of magnesium had been consumed to 'the late Charles Waldack'.

20. All Waldack's cards published by E. & H.T. Anthony were identified on the front with the notice of copyright registration. A label was glued to the back with details of the actual view. In this way a standard stock of card could be used.

21. Anon. 'Pictures By The Magnesium Light.' *The British Journal Of Photography,* **13**, (343), 30 Nov. 1866. p. 574.

22. Crookes, William. 'Photography In The Mammoth Cave At Kentucky.' *The Photographic News,* **10**, (430), 30 Nov. 1866. pp. 565–6.

23. Anon. 'New Applications Of Photography.' *The British Journal Of Photography,* **13**, (347), 28 Dec. 1866. p. 616.

24. For further details of the influential Anthony Company and the effects they had on stereo photograph sales see Anon. 'Photography In America. A gigantic photographic establishment.' *The British Journal Of Photography,* **13**, (314), 11 May 1866. p. 225. and Darrah, William C. *The World Of Stereographs.* Gettysburg, Darrah, 1977.

25. For example, see Crookes, William. 'Mammoth Cave Views.' *The Photographic News,* **11**, (460), 28 June 1867. p. 304.

26. Reprinted in Anon. 'Photography In The Mammoth Cave.' *The Photographic News,* **11**, (453), 10 May 1867. p. 228.

27. Quinlan, James F. *Early Photographic Expedition At Mammoth Cave, 1866.* Private Publication, 1966, revised 1970.

28. Waldack, Charles and Neff, Peter. *Treatise Of Photography On Collodion* . . . Cincinnati, 1857. A second edition was published in 1858 and reprinted in 1860. *The American Almanac of Photography* was edited by Waldack in 1864.

29. Waldack left Cincinnati in 1874 and returned to Belgium. He was listed as a professional photographer at 187 Boulevard du Chateau, Ghent in the 1878 edition of the trade directory *Wegwijzer van Gent.*

Surviving membership cards of the Association Belge de Photographie show that he was a founder member in 1874. None of his photographs were exhibited in the 1875 International Photographic Exhibition in Ghent, when he instead displayed American photographic equipment. This may indicate he was acting as a representative. The ABP published a yearbook, the *Bulletin Association Belge de Photographie sous le Protectorat du Roi,* in which Waldack published technical papers with a co-author, D. Rottier: see 'Recherches Sur Les Révélateurs Aux Sels Ferreux.' Part 1, **1**, (5), 1874. pp. 128–33; Part 2, **2**, (3), 1874. pp. 93–5. He returned to Cincinnati in 1878, when he also left the society's membership list. His studio was re-established at 160 W. 4th St., later changing address several times. His wife, Mary, took over the business in 1881 and continued until 1893. Waldack died in 1882.

CHAPTER 4. SUBTERRANEAN LIGHT.

1. Anon. 'Photography Underground.' *Walsall Observer,* 11 Nov. 1876.

2. Eder, Josef Maria. Translated by Epstean, Edward. *History Of Photography.* New York, Columbia University Press, 1945.

3. Anon. 'Magnesium Light in The Tombs.' *The Photographic News,* **11**, (441), 15 Feb. 1867. p. 84. Von Treisinger worked in the city of Lemberg, now Lvov in the USSR, in December 1866.

4. Wilson, Edward L. 'Magnesium Light, And How To Photograph With It.' *The Photographic News,* **11**, (447), 5 April 1867. pp. 161–2. Wilson notes a fall of 50 per cent in the price of magnesium and cites Waldack's pictures in Mammoth Cave as an example of the metal's uses.

5. Anon. 'Illustrations Of The Meeting Of The British Association At Birmingham.' *Illustrated London News,* **47**, (1334), 16 Sept. 1866. pp. 256–7. This meeting serves as an example of the many which demonstrated the power of magnesium.

6. Gernsheim, H. and A. *The History Of Photography. From the earliest use of the camera obscura in the eleventh century up to*

1914. London, Oxford University Press, 1955.

7. Witkin, L.D. and London, B. *The Photograph Collector's Guide.* London, Secker & Warburg, 1979.

8. Lloyd, Valerie, in Martin, Rupert (ed.). *Floods Of Light: Flash Photography 1851–1981.* London, The Photographers' Gallery, 1982. pp. 11–13. The booklet covers the work of several photographers such as Brothers and Smyth, but some information is based on Gernsheim or Eder and perpetuates mistakes in these volumes.

9. Several of O'Sullivan's negatives and prints form part of the George Eastman House Collection, New York.

10. Buckland, Gail. *First Photographs. People, places, and phenomena as captured for the first time by the camera.* New York, Macmillan, 1980.

11. Krefft, [J.L.] Gerard. 'Fossil Remains Of Mammals, Birds, And Reptiles, From The Caves Of Wellington Valley,' in Anon, *Catalogue Of The Natural And Industrial Products Of New South Wales, forwarded to the Paris Universal Exhibition of 1867.* Sydney, Govt. Printer, 1867. pp. 111–24. Quoted in Lane, E.A. and Richards, A.M. 'The Discovery, Exploration And Scientific Investigation Of The Wellington Caves . . .' *Helictite,* 2, (1), 1963. pp. 1–53.

12. Kranjc, Andrej. 'O Prvih Fotografijah Iz Postojnske Jame.' *Naše Jame,* 25, 1983. pp. 23–8. There is an English summary. Additional information about Mariot has been received as pers. comm. from Kranjc, 1984 and 1987. J.M. Eder, in his *Handbuch,* wrongly records Mariot's pictures as taken during 1868.

13. Kranjc, Andrej. 'O Starejših Fotografijah Iz Postojnske Jame.' *Naše Jame,* 28, 1986. pp. 19–25.

14. Kraus, Franz. *Höhlenkunde.* Vienna, Gerold, 1894.

15. Putick, W. [pseud. Von Alben, W.P.] *Führer In Die Grotten Und Höhlen Sowie In Die Umgebung Von Adelsberg, Lueg, Planina, St. Canzian Und Zirknitz In Krain.* Adelsberg, R. Šeber, 1897. This guide-book contains an advertisement for Schäber's photographs, sold in a variety of formats including stereo cards. Schäber later wrote an illustrated guide-books and by the close of the century was also producing postcards. Maks Séber (1862–1944), the publisher, is depicted in Savnik, Roman. *Stopetdeset Let Turistične Postojnske Jame.* Ljubljana, 1968.

16. Dandoy's photographs were sold with a notation on the mount stating his exclusive concession at the caves. The existing plate negatives are held by the Archeological Society of Namur in the Museum of Archeology. For Dandoy's biography see Dupont, Pierre-Paul. *Un Demi-Siecle De Photographie A Namur Des Origines A 1900.* Namur, Credit Communal, 1986.

17. Shaw, T.R. *History Of Cave Science.* Crymych, Oldham, 1979.

18. Anon. *Views In Mammoth Cave.* Frankfurt-am-Main, Philip Frey & Co., 1880. The publication is mentioned in Hovey, H.C. and Call, R.E., translated by Martel, E.A. 'Bibliographie Chronologique et Analytique de Mammoth Cave, Kentucky (états-unis d'Amérique) 1815–1914.' *Spelunca, Bull. et Mémoires de la Société de Spéléologie,* 9, (73), 1914 for Sept. 1913. Hovey and Call state that the publication contains '12 bad photographs' (p. 211).

19. Brown, Frederick. Advertisement. *Kelly's Directory, Walsall.* 1882. p. xviii.

20. Anon. 'Photography Underground.' *Birmingham Daily Post,* 9 Nov. 1876. p. 5, col. 6.

21. Greenwood, Henry. 'Photography Underground.' *The British Journal of Photography,* 23, (864), 24 Nov. 1876. p. 563.

22. Brothers, Alfred. 'Photography Underground.' *Birmingham Daily Post,* 15 Nov. 1876. p. 5, col. 1.

23. Greenwood, Henry. 'On Things In General.' *The British Journal of Photography,* 23, (868), 22 Dec. 1876. p. 604.

24. Darrah, William C. *The World Of Stereographs.* Gettysburg, Darrah, 1977. The date of Veeder's photograph is given as 1877 by Darrah, while Shaw (see ref. 17) gives 1878.

25. Hovey, H.C. 'Howe's Cave.' *Scientific American,* 44, (3), 15 Jan. 1881. pp. 35–6.

26. Brooks, William. 'Subterranean Photography. The caves at Reigate, and how I photographed them.' *The British Journal of Photography,* **26**: Part 1, 28 March 1879. pp. 146–7; Part 2, 4 April 1879. pp. 158–9.

27. Gurnee, Russell H. *Discovery Of Luray Caverns, Virginia.* New Jersey, Gurnee, 1978. The circumstances surrounding the discovery are covered in detail.

28. Quinlan, James F. 'Notes On The Stebbins Paintings Of Luray Caverns.' *Journal Of Spelean History,* **9**, (2–4), April–Dec. 1976. pp. 33–5.

29. Hovey, H.C. 'The Luray Caverns By Electric Light.' *Scientific American,* **46**, (11), 18 March 1882. p. 164, cols. 1–3.

30. Hovey, H.C. *Celebrated American Caverns.* Cincinnati, Robert Clarke & Co., 1882. pp. 166–7.

31. Anon. 'A Magnesium Torch.' *Scientific American,* **55**, (4), 24 July 1886. p. 58. Magnesium flares were used for tourism in Austrian ice caves such as the Eisriesenwelt, which still utilized their light in 1986.

32. Anon. 'Our Illustrations.' *Cape Times Weekly,* 1 May 1901. p. 4. Also in Craven, S.A. 'Early Cine-Photography At The Cango Caves.' *Bull. South African Spel. Assoc.,* **26**, 1985. pp. 17–27.

33. Székely, Kinga. *First Famous Hungarian Cave Photographer: Károly Divald.* Text of poster displayed at the International Symposium on Cave Tourism, 10–12 Nov. 1988, at Postojna, Yugoslavia. Divald died in 1897, his sons taking over the business. Many early Hungarian postcards from these cave locations are Divald's photographs, although few are credited. The date of his visit to Baradla Cave comes from an entry in the visitor's book.

34. Sprague, Stuart S. 'Luray Caverns In The 1890's: A Study In Speleo-Economics.' *Journal Of Spelean History,* **6**, (2), April–June 1973. pp. 30–2.

35. Dunkley, John R. *Jenolan Caves. As they were in the nineteenth century.* Published by the Speleological Research Council Ltd. for Jenolan Caves Historical & Preservation Society, 1986.

36. Wilkinson, C.S. 'The Fish River Or Binda Caves', in *The Railway Guide Of New South Wales.* Sydney, Govt. Printer, 1879. p. 142.

37. Caney & Co. possessed a studio in Mount Victoria, New South Wales, from 1883–5, this address appearing on his photographs of Jenolan. Some prints in a private collection are consistent with having originally been part of a bound set. These have 'May the 2nd and 5th 1884' marked on the mount, presumably by the purchaser indicating the date of his visit. Caney gives the name of the cave as Fish River, this name being replaced in 1884. Therefore, the pictures were probably taken in 1883.

38. Richter, J.E. 'The Fish River Caves, Near Sydney, Australia.' *Scientific American,* **51**, (15), 11 Oct. 1884. pp. 223 and 229. The article was repeated in *Scientific American Supplement,* **50**, (1291), 29 Sept. 1900. pp. 20687–8.

39. Wilkinson, C.S. *Photographs Of The Jenolan Caves, New South Wales. (Interior views photographed by means of the electric and magnesium lights.)* Sydney, Charles Potter, Govt. Printer, 1887. The text is limited to a single page.

40. Stirling, James. 'Preliminary Report On The Buchan Caves. Appendix B.' *Reports Of The Mining Registrars For The Quarter Ending 31st December 1889.* Govt. pub. 1889. Four prints are included in the report, all apparently gold toned. Three of the full plate glass negatives survive in a private collection. Harvey is described by Stirling as being 'of the Public Works Department', which, as a government employee as well as a keen amateur photographer, is possibly the reason he was approached to produce the pictures. Three of the prints are interiors, lit with either magnesium ribbon or flashpowder. One picture was produced with the aid of daylight in the entrance.

41. Humphries, Thomas. 'Waitomo Glow-Worm Cave,' 1889. Reprinted in *New Zealand Spel. Bull.,* (7), Oct. 1953. pp. 1–10. This report is a transcription of the original handwritten report, part of which was published in *Appendices To Parliamentary Journals.* (H18, 1889). The report does not make it clear what form of magnesium was

burned, although the implication is that it was ribbon. Flashpowder may have been used; it was known in New Zealand at that date.

42. Richards, J.H. *Waitomo Caves*. Reed, Wellington, 1954. An excellent account of the discovery and development of the cave is given in Arrell, Robert. *Waitomo Caves. A Century Of Tourism*. Waitomo, Waitomo Caves Museum Soc., 1984.

43. America was not the only country where railways attempted to involve themselves in tourism and caves. The South Africa Railways and Harbours Co. made approaches to take over control of Cango Caves in the 1920s, following their electrification and the railway reaching Oudtshoorn in 1904. Although rejected, the railway used photographs of Cango as advertising to increase its sales of tickets into the area.

44. Cards and album pages were both inscribed 'Photographed by W.F. Sesser, with a Collins Camera', suggesting the possibility that Sesser was being sponsored by this company as well as the railroad.

45. Anon. *Photographic Views Of Some Of The Important Parts Of Mammoth Cave Situated In Edmondson Co., Kentucky, USA*. Louisville & Nashville and Mammoth Cave Railroads. The volume has no author or date attributed to it, but it is thought to have been published in 1887, the year after the photographs were copyrighted, or at the latest, 1888. It measures approximately 17¾ in × 14¼ in) with twenty-one 10¼ in × 7½ in prints. The railroad also published *Subterranean Wonders. Mammoth Cave And Colossal Cavern, Kentucky*, as further promotion for its services. It ran to at least twenty-one editions.

46. E.g., in Binkard, Adam D. *Pictorial Guide To The Mammoth Cave, Kentucky*. Cincinnati, G.P. Houston, 1888.

47. Hook's pictures were generally poor quality. The statement concerning the number of views available is printed on the reverse of some cards.

48. Without commercial outlets it is unlikely that many cave photographs would be taken by these commercial photographers. Therefore, the pictures probably date from after the opening of the caves for tourism. Manitou Grand Cavern was opened earlier than Cave of the Winds but was not a financial success for several years. It is possible that the photographs from both sites date from after the latter cave was opened in 1885.

CHAPTER 5. EXPLOSIVE POWDERS.

1. Wilson, Edward L., in Waldack, Charles. 'Photography In The Mammoth Cave.' *Philadelphia Photographer*, 3, Dec. 1866. pp. 359–63. Reprinted *NSS News*: [Part 2], 'Photography In Mammoth Cave – 1866.' 27, (1), Jan. 1969. p. 9. Wilson's comments are made at the end of Waldack's article.

2. Gilbert, Geoffrey. *Photo-Flash In Practice*. London, Focal Press, 1947.

3. Gernsheim, H. and A. *The History Of Photography. From the earliest use of the camera obscura in the eleventh century up to 1914*. Oxford, Oxford University Press, 1955.

4. White, William. 'Recent Applications Of Magnesium.' *The Photographic Journal*, 15 Sept. 1865. pp. 145–8. Also published in *The Photographic News*, 9, (367), 15 Sept. 1865. pp. 437–8.

5. Larkin, Henry. 'On A New Magnesium Lamp.' *The British Journal Of Photography*, 31 Aug. 1866. pp. 417–18.

6. Larkin, Henry & White, William. 'Preparing Magnesium And Its Chloride.' *The Photographic News*, 14, (599), 25 Feb. 1870. p. 91.

7. Anon. 'Taking A Photograph By The Magnesium Light.' *Scientific American*, 50, (18), 3 May 1884. p. 275.

8. Anon. 'Magnesium Flash Lamps.' *Scientific American*, 58, 31 March 1888. p. 199. And Anon. 'Improved Method Of Burning Magnesium Powder.' *Scientific American*, 58, 28 June 1888. p. 49, col. 2.

9. H., G.M. 'A Magnesium Torch.' *Scientific American*, 72, 6 April 1895. p. 218, cols. 2–3.

10. Anon. 'Manchester Photographic Society.' *The British Journal Of Photography*, 35,

(1460), 27 April 1888. p. 270. A society trip underground was planned for 28 April 1888, although one member had already been to Poole's Cavern (spelt 'Pool's') to try out his flash apparatus. There is no evidence that earlier underground photographers, detailed in chapter four, used magnesium powder rather than the more common ribbon.

11. Kerry's first use of magnesium is mentioned in the *Australasian Photographic Review*, May 1898. p. 29; June 1898. pp. 28–9; July 1898. p. 26.

12. Burke, Quentin. 'Charles Kerry.' *Australasian Photo-Review*, March 1952. pp. 142–58. Burke includes a footnote of a personal communication from Van der Velden, one of Kerry's staff, that the lamps were built specially by his friend H.J. Quodling, inspecting engineer for the NSW Railways. A note concerning Quodling implies that Kerry used these for his cave photography. The use of flashpowder or ribbon is more likely. The *Australian Photographic Journal* of Oct. 1903, pp. 224–6 also contains an article by Kerry on cave photography.

13. Anon. 'A Cheap Flash Lamp.' *Scientific American*, **62**, 22 Feb. 1890. p. 123, col. 2.

14. Anon. 'Manchester Photographic Society.' *The British Journal Of Photography*, **35**, (1451), 24 Feb. 1888. p. 125.

15. Anon. 'The Magnesium Light.' *Scientific American*, 21 Jan 1893. p. 38. The magazine reported on an earlier comment by the *British Journal of Photography*.

16. Schaaf, Larry. 'Charles Piazzi Smyth's 1865 Conquest Of The Great Pyramid.' *History Of Photography*, **3**, (4), Oct. 1979. pp. 331–54. Schaaf indicates the details concerning gunpowder mixed with magnesium filings come from Smyth's personal diary.

17. Further information about Taylor can be found in Anon. 'J. Traill Taylor.' *Scientific American*, **73**, (21), 23 Nov. 1895. p. 322. Eder, in his *Handbuch* (see ref. 29) notes that Taylor was the first to use 'flashpowder' compounds, a mistake perpetuated by other volumes.

18. Kenyon, G.A. 'On The Oxymagnesium Light.' *The British Journal Of Photography*, 2 Feb. 1883. p. 61.

19. Anon. 'Magnesium Light For Photographic Purposes.' *Scientific American*, 24 Sept. 1887. p. 199.

20. Details of the invention are reported in detail by both Eder 1945 and Gernsheim 1955. The photographic press was filled with enthusiastic reports and speculations on the use of 'instant light' at the time of its invention.

21. Information on Riis is found in MacDonald, Gus. *Camera. A Victorian Eyewitness*. London, Batsford, 1979, and in Alland, Alexander. *Jacob A. Riis. Photographer & Citizen*. New York, Aperture, 1974.

22. Anthony, E. and H.T. *Illustrated Catalogue of Photographic Equipments and Materials for Amateurs*. 1891. The pistols sold at $4, with cartridges $1 for a box of fifteen. This compared to complete basic camera and developing systems from $7.50, to the top range plate stereo cameras which sold at $100. Flash lamps for powdered magnesium cost between $3 and $6. Magnesium, in any form, was $0.50 an ounce.

23. Bullock, John G. & Mitchell, Charles L. 'On The Dangers Of Flash-Light Compounds.' *The British Journal Of Photography*, 21 Feb. 1890. pp. 117–19. The results of experiments concerning the safety of magnesium flashpowder are given in Anon. 'Practical Experience As To Magnesium Lighting.' *Scientific American*, **62**, 8 March 1890. p. 154.

24. Ideas for remote triggering of the powder are included in Harrison, W.H. 'The Future Of The Magnesium Light In Photography.' *The British Journal Of Photography*, **35**, (1451), 24 Feb. 1888. pp. 120–1. See also ref. 23.

25. Anon. 'A Photographic Flash Light Apparatus.' *Scientific American*, **69**, 12 Aug. 1893. p. 101, cols. 1–2.

26. Anon. 'Photographing By Artificial Light.' *Scientific American*, **52**, (20), 16 May 1885. p. 312, col. 1.

27. Kloos, J.H. and Müller, M. *Die Hermannshöhle Bei Rübeland*. Weimar, Schwier, 2 vols., 1889. The photographs are mounted on card, each printed with details of the location. The first volume contains the text, the second consists of the prints in a portfolio.

28. For example, in Kraus, Franz. *Höhlenkunde*. Vienna, Gerold, 1894. Also see Eder, Josef Maria. *Aufürliches Handbuch Der Photographie*. 1912.

29. Eder, Josef Maria. *Aufürliches Handbuch Der Photographie*. 3rd edn., **1**, (3), 1912.

30. Shaw, T.R. *History Of Cave Science*. Crymych, Oldham, 1979.

31. The *Daily Graphic* published this half-tone picture on 4 March 1880. However, there had been a prior instance in the *Graphic* on 2 Dec. 1873, when a picture was presented 'as being the first photograph ever printed in a newspaper directly from a photograph'. Papers did not begin general use of half-tones until the 1880s and then only occasionally. For a full discussion of the development of photographs on the printed page see Gernsheim, ref. 3.

32. Daubiton, M.A. *et al*. *The Hades Of Ardenne. A visit to the caves of Han*. London, Sampson Low, Marston, Searle & Rivington, 1883.

33. For example, in Forwood's 1870 guide to the *Mammoth Cave Of Kentucky*. Philadelphia, J.B. Lippincott. The guide reproduced twelve of Waldack's photographs, printed by 'The Duval Steam Lith. Co. Phila.'

34. Ross, M. and Stonehewer-Cooper, H. *The Highlands Of Cantabria, or, three days from England*. London, Sampson Low, Marston, Searle & Rivington, 1885. The photograph faces p. 136.

35. Panton, J. Hoyes. *The Mammoth Cave Of Kentucky*. Louisville, Darnall, 1890. The booklet was 'Published and Copyrighted, 1890, by C.G. Darnall, Commercial Photographer'. Many of the pictures, if not all, were taken by Ben Hains.

36. Witkin, L.D. and London, B. *The Photograph Collector's Guide*. London, Secker & Warburg, 1979. pp. 170–1.

37. Doherty, Amy S. 'Frances Benjamin Johnston 1864 – 1952.' *History Of Photography*, **4**, (2), April 1980. pp. 97–111. See also: *Mammoth Cave By Flash-light*. Washington, Gibson, 1893. [The book contains twenty-five of Johnston's photographs]; Daniel, P. & Smock, R. *A Talent For Detail: the photographs of Miss Frances Benjamin Johnston 1889–1910*. New York, Harmony, 1974; Sherston, R. 'In The Mammoth Cave Of Kentucky.' *Wide World Magazine*, **5**, (27), June 1900. pp. 256–65. The article is illustrated with photographs by Hains and Johnston, the pictures being credited to *Demorest's Magazine*, but supplied by the Louisville and Nashville Railroad Co.

38. C.E. DeGroff of Warrensburg, Montana, was taken to the Marble Cave of Missouri by E.O. Hovey, son of H.C. Hovey. His pictures are reproduced as drawings taken from the photographs. Four of them are included in Hovey, E.O. 'The Marble Cave Of Missouri.' *Scientific American*, **68**, (5), 4 Feb. 1893. pp. 63, 70–1. The countries listed are those with major numbers of photographs or stereo cards being produced, as attested by publishers' catalogues.

39. Nymeyer, Robert. *Carlsbad, Caves, And A Camera*. Teaneck, Zephyrus Press, 1978. Several photographs attributed to Bert Leck show social gatherings at and in caves. The Leck family were involved with later cave photographers in the area, and in particular with the commerical concern of Carlsbad Caverns when it officially opened to the public. Fiona Leck Collins was Nymeyer's aunt: she gave Leck's prints, from her album, to Nymeyer. They are now part of the collection of the Carlsbad Caverns Natural History Association.

40. Howes, C.J. *Cave References In Scientific American*. Crymych, Oldham, 1987.

41. Hovey gives the location of Jewell Cavern as West Virginia, 'five miles east of Alderson and a mile and a half west of Fort Spring'. However, the only modern record of a 'Jewell Cave' is over the border in Tennessee.

42. Hovey, H.C. 'The Jewell Cavern.' *Scientific American*, **60**, (22), 1 June 1889. pp. 339–40, cols. 3; 1–3.

43. Anon. 'Wyandot Cave And Its Wonders.' *Scientific American*, **60**, (10), 9 March 1889. p. 149, col. 3. Part of the report reads; 'Dr. Hovey was the first writer to bring the Indiana caverns into general notice. . . A few years ago he took with him a skillful artist, who made a large number of

sketches, some of which were afterward published. But during the last year a young artist, Mr. Ben Hains, has taken for Dr. Hovey's use a series of admirable photographs, which were exhibited for the first time in connection with this lecture. Besides the series from Wyandot Cave, there were some lovely scenes from Marengo and Sibert's Caves. These are pronounced the very best specimens of subterranean photography yet produced.' Several such reports of Hovey's lectures appear in *Scientific American* (see ref. 40).

44. Hains used both the *Scientific American* reference and this additional title on his stereo cards.

45. Hovey, H.C. 'The Pits And Domes Of Mammoth Cave.' *Scientific American, 61*, (16), 19 Oct. 1889. p. 247, cols. 1–3. Also, Hovey, H.C. 'The Pits And Domes Of Mammoth Cave.' *Proc. American Assoc. For The Advancement Of Science 38th Meeting*, Aug. 1889. pp. 253–5.

46. Hovey, H.C. 'The Colossal Cavern Of Kentucky.' *Scientific American, 75*, (9), 29 Aug. 1896. p. 183, cols. 1–2.

47. Many postcards from Mammoth Cave are imprinted with Ganter's name; there is no evidence that Ganter himself ever produced his own photographs.

48. Cato, Jack. *The Story Of The Camera In Australia*. Sydney, Inst. Australian Photography, 3rd edn., 1979.

49. Davies, Alan and Stanbury, Peter. *The Mechanical Eye In Australia*. Melbourne, Oxford University Press, 1985.

50. Millar, David P. *Charles Kerry's Federation Australia*. Sydney, David Ell Press, 1981.

51. See *The Australian Photographic Journal*, Dec. 1892. p. 19; Oct. 1893. p. 83.

52. Kerry, Charles. 'Cave Photography.' *Australian Photographic Journal*, Oct. 1903. pp. 224–6. Extracts reprinted in Burke, Quentin. 'Charles Kerry.' *Australasian Photo-Review*, March 1952. pp. 142–58.

53. Cooke, Samuel. *The Jenolan Caves: An Excursion In Australian Wonderland*. London, Eyre & Spottiswoode, 1889.

54. Ellis, R. and Hamilton-Smith, E. and Shaw, T.R. *Australian Caves On Postcards*.

1900–1939. An Annotated Catalogue. In preparation.

55. Trickett, O. *Guide To The Jenolan Caves New South Wales*. 2nd edn. [1st edn., 1899] Sydney, Govt. Printer, 1905.

56. Hall's photographs are not earlier than 1889, as one of his series shows pipes used for the hydro-electric scheme and wood stacked for the boiler installed in the cave. The hydro scheme first came into use in 1889. The photographs also show shadows consistent with their production by flashpowder.

57. Rowe's address at Jenolan is only recorded as 1896–1897 by Davies and Stanbury (ref. 49). However, Shaw, T.R. 1989 (pers. comm.) states that one of Rowe's pictures indicates the presence of the boiler installed in 1884, but not the pipes of the 1889 hydro-electric scheme. The picture was therefore taken before the pipes were installed in 1889, and presumably other photographs from this series may date to the same period. Rowe was not the only resident photographer at Jenolan: a permanent photographer's kiosk was built in 1898. See Trickett, O. *Annual Report Of The Department Of Mines & Agriculture, New South Wales, For The Year 1898*. Sydney, Govt. Printer, 1899.

58. Lane, E.A. 'Jenolan Obituaries. A.J. Perier.' *Helictite*, **4**, (3), April 1966. pp. 62–3. Perier worked for Baker & Rouse, later to become Kodak (Australasia) Pty. Ltd., both being photographic firms.

59. E.g., in Gibbs, Philip. *Wonders Of The World*. London, Hutchinson, nd. *c.* 1920.

CHAPTER 6. BENEATH THE DESERTS OF FRANCE.

1. Martel, E.A. *La Photographie Souterraine*. Paris, Gauthier-Villars, 1903.

2. Vallot, Joseph. 'Photographie Instantanée Des Grottes Et Cavernes.' *Bulletin de la Société Française de Photographie*, 1890. pp. 239–43. Paper presented at the annual conference, 2 May 1890.

3. Shaw, T.R. *History Of Cave Science*. Crymych, Oldham, 1979.

4. Panos, Vladimir, in Burkhardt, R. *et al.* Martin Kříž. *Pantheon Of Czech Speleo-*

logists. Olomouc, 6th Int. Congress of Speleology, 1973. 17 pp, pp. 3–4. This reference indicates that Kříž used only ten Bunsen batteries; that of sixty (Kraus, Franz. *Höhlenkunde.* Vienna, Gerold, 1894.) is more likely to be correct as ten would not provide the power required by an arc light. See also *Mittheilungen der section für Höhlenkunde,* (2), Vienna, 1883, p. 3 for details of his first visit.

5. Boegan, Eugenio. 'Cinquantaquattro Anni Di Vita Speleologia – l' attività speleologica della Sezione di Trieste del C[lub] A[lpino] I[taliano] 1883–1936.' *Le Grotte d' Italia,* **2**, Series 2, (16), 1938 for 1937. p. 114 and Morpurgo, Emil. 'La Grotta Di Trebiciano.' *Società Alpina Delle Giulie Atti E Memorie, Anno 1886 E Primavera 1887.* Trieste, 1887. p. 139. There are no entries in later reports to indicate that the planned photography was ever carried out.

6. Baring-Gould, S. *The Deserts Of Southern France.* **1**. London, Methuen, 1894. Baring-Gould used Martel's published works and engravings from his text as the basis for the chapters on underground exploration. The quotes are his translations from the French.

7. Casteret, Norbert. *E.A. Martel. Explorateur du monde souterrain.* Paris, Gallimard, 1943. Casteret records Martel's campaigns in table form. See also Shaw, T.R. (ref. 3), 1979, for an account of Martel's discoveries.

8. Martel, E.A. 'Sous Terre.' *Annuaire Du Club Alpin Français,* **15**, 1889 for 1888. pp. 238–94.

9. Martel, E.A. 'Cave Exploring.' *Wide World Magazine,* **1**, (3), June 1898. pp. 271–82.

10. Vallot, Joseph. 'Photographie Souterraine. Grottes, carrièrs et catacombes.' *Annuaire Général De Photographie,* 1893. pp. 513–22. Vallot was an acknowledged expert in the field of photography. He was a member of honour in the Société Française de Photographie in 1892 at the 1st International Photographic Exhibition at Paris. See *Figaro Photographie,* a supplement in parts to *Le Figaro,* August to Sept. 1892.

11. Further details concerning the prints in the Paris exhibition have been scarce. No specific mention of them is made in the French newspapers of the time (e.g., *Figaro-Exposition,* a supplement in parts with the newspaper), official reports of the exhibition, or the official catalogue (either the French or English version). The French catalogue (*Catalogue Officiel De L'Exposition De La République Mexicaine,* 1889) lists the prints in the photographic section. However, there are no details, entries in the catalogue only giving the number of prints in each section without further explanation.

12. Kranjc, Andrej. 'O Starejših Fotografijah Iz Postojnske Jame.' *Naše Jame,* **28**, 1986. pp. 19–25.

13. Martel, E.A. 'Joseph Vallot (1854–1925).' *La Nature,* (2670), 6 June 1925. pp. 367–8. Interestingly, Martel does not mention any of Vallot's caving achievements in the obituary.

14. Vallot, Gabrielle. 'Grottes Et Abimes.' *Annuaire Du Club Alpin Français,* **16**, 1890 for 1889. pp. 145–69. A drawing based on Joseph Vallot's picture fp.160.

15. Philippe, Michel. *Le Gouffre De La Fage. À Noailles (Corrèze) et son gisement paléontologique.* La Fage, Cave Management, 1975. 32pp.

16. Rupin, Ernest. 'La Photographie Des Cavernes.' *Spelunca, Bulletin de la Société de Spéléologie,* **1**, (4), Oct.–Dec. 1895. pp. 154–5. Rupin notes that there were two main methods in use; flashpowder and ribbon. The former was preferred by Vallot and Gaupillat but Rupin thought the results were always grey and without detail, at least for distant objects. He advocated the use of ribbon, making sure a scale such as a hat or walking stick was always in the picture.

17. Browne, T. and Partnow, E. *Macmillan Biographical Encyclopedia Of Photographic Artists & Innovators.* Canada, Macmillan, 1983. pp. 442–3.

18. Anon. 'New Designs For Flash-Lamps.' *The Year-Book Of Photography And Photographic News Almanac.* 1892. pp. 180–1.

19. Martel, E.A. *Les Abimes.* Paris, Delagrave, 1894. Martel added a footnote on p. 28 that all photographic information was written using notes supplied by Gaupillat.

20. The officials of the *Société* are detailed in *Spelunca. Bulletin de la Société de Spéléologie,* **1**, 1895. p. 20.

21. Hovey, H.C. 'The Colossal Cavern Of Kentucky.' *Scientific American,* **75**, (9), 29 Aug. 1896. p. 183, cols. 1–2.

22. Anon. 'Meeting of 16th March.' *Spelunca, Bulletin de la Société de Spéléologie,* **1**, (2), April–June 1895. p. 49. On his voyage round the world, Tissandier wrote 'Les Grottes de Jenolan (Australia) dans les Montagnes Bleues.' *Spelunca. Bulletin de la Société de Spéléologie,* **1**, (2), April–June 1895, p. 50–6. There was no mention of photography, but two drawings are found on pp. 53 and 55. The detail indicates that these were probably drawn from photographs.

23. Feruglio, G. 'Application De La Photographie Au Magnésium A L' Archéologie. Atti dil congreso internaz. di scienze storiche in Roma. 1903.' *Mondo Sotterraneo,* **1**, (4), 1905. p. 86. Feruglio cites Martel's 1903 book on cave photography as being of use in the archaeological field.

24. Hovey, H.C. 'The Aven Armand, Lozere, France.' *Scientific American,* **78**, (15), 9 April 1898. pp. 228–9.

25. Anon. 'Éclairage à L' Aluminium.' *Spelunca. Bulletin De La Société De Spéléologie,* **3**, (9–10), Jan.–June 1897. p. 83.

26. Anon. 'Photographie Des Cavernes.' *Spelunca. Bulletin De La Société De Spéléologie,* **3**, (9–10), Jan.–June 1897. pp. 83–4.

27. For example, Anon. 'Compound For A Twenty Thousand Candle Power Magnesium Light.' *Scientific American,* 15 Feb. 1890. p. 103. Another technique, for large diffuse flashes, was to glue magnesium powder between two sheets of paper, then cover the outside in potassium chlorate and seal this in with more paper. After drying, the 'sandwich' was hung up and lit. See *Le Petite Temps,* 1 March 1896.

28. Anon. 'Flambeaux Au Magnésium.' *Spelunca, Bulletin de la Société de Spéléologie,* **1**, (4), Oct.–Dec. 1895. pp. 153–4.

29. Anon. 'La Spéléologie Aux Congrès Des Sociétés Savantes. 1901–1904. M. Martel.' *Bulletin Et Mémoires De La Société De Spéléologie,* **5**, (37), June 1904. pp. 30–2.

30. Martel, E.A. 'Photographie Au Magnésium. La Photographie Souterraine.' *Bulletin Et Mémoires De La Société De Spéléologie,* **6**, 1906. pp. 752–3.

CHAPTER 7. HAND-HEWN ROCK.

1. Burrow, J.C. 'Photography In Mines.' *Trans. Royal Geol. Soc. of Cornwall,* **11**, 1895. pp. 621–33. The paper was read at a 'Joint Meeting of the Scientific Societies of Cornwall, at Penzance, 15th June, 1894'.

2. Hughes, Herbert W. 'Photography In Coal Mines.' *The Photographic Journal,* **18**, New Series, 25 Nov. 1893. pp. 93–101.

3. One of the earliest surface views is a calotype of the Burra Burra Copper Mine in Australia, taken about 1849–1850. See Davies, A. and Stanbury, P. *The Mechanical Eye In Australia. Photography 1841–1900.* Melbourne, Oxford University Press, 1985. Other such surface views taken throughout the formative years of photography almost certainly exist.

4. Darrah, W.C. *The World Of Stereographs.* Gettysburg, Darrah, 1977. The Pennsylvanian anthracite basin was particularly well covered by A.M. Allen, Josiah Brown, Johnson, Langenheim, and Schurch, all publishing stereo views from the 1860s onwards. Placer mining in California was photographed in 1865. The diamond mines of South Africa also attracted a great deal of attention. No underground views were taken for stereo views until much later in the century.

5. Two examples of general surface photography in these transient towns are given in Berton, Pierre. *The Klondike Quest. A photographic essay 1897–1899.* Boston, Little Brown & Co., 1983. and Hart, P. and Nelson, I. *Mining Town. The photographic record of T.N. Barnard & Nellie Stockbridge from the Coer d'Alenes.* Washington, University of Washington Press, 1984. In both cases the variety of photographs is immense but deals predominantly with surface views. A single underground picture is in each volume. See also Sloane, H.N. and Lucille, L. *A Picture History Of American Mining From Pre-Columbian Times To The*

Present Era. New York, Crown Publishers, 1970.

6. Dewey, F.P. 'Photographing The Interior Of A Coal-Mine.' *Trans. American Inst. of Mining Engineers,* **16**, 1888. pp. 307–12 & 4 figs.

7. Anon. 'A Magnesium Torch.' *Scientific American,* **55**, (4), 24 July 1886. p. 58. The price of magnesium in 1886 was $7.50 a pound.

8. Some of Bretz's albumen prints of the Kohinoor colliery are held in the George Eastman House Collection, New York, where they are wrongly dated *c.* 1875.

9. Todd, Arthur Cecil. *The Cornish Miner In America.* Truro, Bradford Barton, 1967.

10. Doherty, Amy S. 'Frances Benjamin Johnston 1864–1952.' *History Of Photography,* **4**, (2), April 1980. pp. 97–111.

11. Anon. 'Photography Underground.' *Birmingham Daily Post,* 9 Nov. 1876. p. 5, col. 6.

12. Watton, W.J. 'The History Of Underground Photography In Cornish Mines.' *Camborne School Of Mines Journal,* **77**, 1977. pp. 30–4. The work of some modern photographers in Cornish mines is also mentioned.

13. McTrusty, J.W. *Mine Gases And Gas Testing. [for underground officials and workmen] including an account of colliery explosions, coal dust, and breathing apparatus.* Wigan, Thomas Wall & Sons, 2nd edn., 1919.

14. Grant, Alonzo G. 'Photography In A Lead Mine.' *The British Journal Of Photography,* **12**, (277), 25 Aug. 1865. p. 442; 'The Magnesium Light In A Lead Mine.' *The Photographic News,* **9**, (364), 25 Aug. 1865. p. 407.

15. Börner, H. *Der Bergmann In Seinem Berufe.* Freiberg, 1891.

16. Burrow, J.C. and Thomas, W. *'Mongst Mines And Miners.* 1893. Reprinted, Truro, Bradford Barton, 1965. For other reproductions of Burrow's photographs, see Barton, D.B. *Historic Cornish Mining Scenes Underground.* Truro, Bradford Barton, *c.* 1965.

17. Anon. 'The Tin Mining Industry Of Cornwall.' *Scientific American Supplement,* **63**, (1635), 4 May 1907. pp. 26189–91. The article is illustrated with Burrow's pictures.

18. See *The Australian Photographic Journal,* Dec. 1892, p. 19; Oct. 1893, p. 83, referenced in Millar, David P. *Charles Kerry's Federation Australia.* Sydney, David Ell Press, 1981.

19. Anon. 'The World's Columbian Exposition.' *Scientific American Supplement,* **35**, (910), 10 June 1893. pp. 14536–44. With his visit, Hughes was able to talk to Bretz and learn of all other work being done at the time. These are recorded in his talk to the Photographic Society of London (ref. 2). See also Hovey, H.C. 'Notes From The World's Columbian Exposition, Chicago 1893. The marvelous cavern of the Black Hills.' *Scientific American,* **69**, (12), 16 Sept. 1893. p. 179, cols. 2–3.

20. Englander, D. and Osman, C. *The British Worker. Photographs of working life 1839–1939.* London, Arts Council of G.B., 1981. Cobb was rector of Eastwood until the First World War.

21. Keen, Richard. *Coalface.* Cardiff, National Museum of Wales, 1982. Jones began photographing the pits from about 1905 using a Thornton Pickard half plate camera. South Wales colliery owners and miners were involved in a series of strikes and confrontations between 1893 and 1926; the rise of the unions was perhaps aided in part by the photographs taken by Jones that demonstrated to all the conditions the men toiled under.

22. Anon. 'News And Notes. Death of Mr. J.C. Burrow.' *The British Journal Of Photography,* **61**, (2844), 6 Nov. 1914. p. 830.

23. The Clay Cross photographs were taken *c.* 1908–1910, and advertised the company's 'Gold Medal Coal'. By collecting a set of some twenty-five cards and presenting them to the company's office in London an unspecified free gift could be claimed. Perhaps for this reason few of the cards were ever posted.

CHAPTER 8. THE GENTLEMEN CAVERS.

1. Balch re-wrote this verse from memory into his photographic album in Wells Museum,

where it is clear that Metcalfe (who was also an amateur photographer) was talking about illumination by magnesium during the first photographic attempts in Wookey Hole. In *The Netherworld of Mendip* (see ref. 32), and *Mendip – The Great Cave Of Wookey Hole* (1929) the verse is repeated, although the link to the first photographic attempt is not made clear. In neither case is the poem repeated in full; the reference to cameras is missing. There are variations between the various versions.

2. Shaw, T.R. *History Of Cave Science.* Crymych, Oldham, 1979.

3. Martel, E.A. *Irlande Et Cavernes Anglaises.* Paris, Delagrave, 1897. One of the earliest English accounts of Martel's descent is found in Martel, E.A. 'Descent Of The Abyss Of Gaping Ghyll, England.' *Scientific American Supplement,* **41**, (1054), 14 March 1896. pp. 16852–4. This was translated from *La Nature.*

4. Stanton, W.I. *Pioneer Under The Mendips. Herbert Ernest Balch of Wells.* Wells, Wessex Cave Club. Occ. Pub. Series 1, (1), 1969.

5. Photograph album, Wells Museum.

6. Some early photographs attributed to Balch may have been taken prior to the attempt by Dawkes & Partridge, but they are of poor quality and of formations rather than the whole chamber.

7. Martel, E.A. *Les Abimes.* Paris, Delagrave, 1894. Notes on photography were by Gaupillat (see footnote on p. 28).

8. Newhall, Beaumont. *The History Of Photography. From 1839 to the present.* London, Secker & Warburg, 1982. See also Ford, Colin (ed.). *The Story Of Popular Photography.* London, Century, 1989; Mees, C.E. Kenneth. 'George Eastman And His Place In The History Of Photography.' *PSA Journal,* **16**, (12), Dec. 1950. pp. 711–14.

9. Balch himself wrote little about the incident, the date of which is uncertain. At least two photographs were taken of the party, which included the first two ladies to make the descent. One print appears in Barrington, N. and Stanton, W. *Mendip. The complete caves and a view of the hills.* Cheddar, Barton, 1977. The plate of the other version is in Wells Museum (see ref. 47).

10. Baker, E.A. 'The Explorers Of Elden Hole.' *Wide World Magazine,* **7**, (40), July 1901. pp. 354–60.

11. Baker, E.A. 'The Descent Of The "Bottomless Pit."' *Wide World Magazine,* **8**, (43), Oct. 1901 [wrongly dated 1900]. pp. 49–55.

12. Alderson, Frederick. *The Comic Postcard In English Life.* Newton Abbot, David & Charles, 1970. Magic lanterns had been popular since the time of Samuel Pepys who referred to them as 'a lanthorne with pictures in glasse to make strange things appear on a wall'.

13. Bamforth made some of the earliest Kinematograph films in Britain, using his expertise in story construction. His sons helped. Harry's brother, Frank, was usually cameraman and director, and Edwin was one of the actors. Harry would take the finished films to be shown in nearby village halls. Limelight would have been used for the projector.

14. Puttrell, J.W. 'The Secret Of The Peak Cavern.' *Wide World Magazine,* **9**, (54), Sept. 1902. pp. 544–51. The article includes photographs by Bamforth.

15. Baker, E.A. *Moors, Crags & Caves of the High Peak and the Neighbourhood.* Manchester, Heywood, 1903. 207pp.

16. Holt, T. and V. *Stanley Gibbons Postcard Catalogue.* London, Gibbons, 1981. 210pp.

17. For details of Kerry's postcard production see: Millar, David P. *Charles Kerry's Federation Australia.* Sydney, David Ell Press, 1981. For details of Kerry's cave postcards see ref. 20.

18. Details concerning Chapman are included in Worden, Raymond. *Chapman's Devon In Camera.* Buckingham, Quotes Ltd., 1987. Chapman published many postcards from the West Country, and supplied pictures to other publishers such as Frith. Sneath and Shaw worked in Derbyshire and Yorkshire respectively, mainly between *c.* 1905–10.

19. Strickler's name has appeared with at least three different spellings (e.g., Stickler and Stricker) in publications; Strickler is the correct spelling.

20. Ellis, R. and Hamilton-Smith, E. and Shaw, T.R. *Australian Caves On Postcards. 1900–1939. An Annotated Catalogue.* In preparation.

21. Shaw, T.R. 'Postcards Of Caves.' *Long Island Post Card Club Bulletin,* Fall issue, 1985. pp. 4–6. An account of the rescue is given in Anon. 'Cave Explorers Buried For Eight Days.' *Scientific American Supplement,* **38**, (972), 18 Aug. 1894. p. 15539, cols. 1–2; this reference states eight days rather than nine for their time underground.

22. The early history of the Cheddar Caves is covered by Irwin, D.J. in *Proceedings University Bristol Spelæological Society*: 'The Exploration Of Gough's Cave And Its Development As A Show Cave.' **17**, (2), 1985. pp. 95–101; 'Gough's Old Cave – Its History.' **17**, (3), 1986. pp. 250–66; also see ref. 24.

23. Howell, Chris. *Memories Of Cheddar.* Bath, Howell, 1984.

24. Irwin, D.J. 'Cox's Cave, Cheddar. A History.' *Proceedings University Bristol Spelæological Society,* **18**, (1), 1987. pp. 20–42.

25. Cox, C. & J.S. *Cox's Stalactite Cavern, (brilliantly lighted with gas,) Cheddar Cliffs, Somersetshire.* Axbridge, Oliver, *c.* 1886. Handbill, Longleat House Library, West Muniment Room, Box 24, 2.XVIII. (Discussed in ref. 24).

26. Frith used other photographers to supplement his own work for his photographic coverage of Britain, following the opening of his Reigate studios in 1860. The postcard photographs of Cheddar are unlikely to have been taken by Frith himself. Commissioned photographers include Anson, Bartlett, H. Barton, Bedford, Bell, Brown, Fair, Griffiths and Leavor, the Hartnoll brothers, Lewis, Mitchell, O'Evans, A. Pettit, Preston, Tims, Ward, Washington Wilson (who is known to have photographed Peak Cavern), Wood and Yallop.

27. Cox, E. *Cox's Stalactite Cavern, lighted with Welsbach incandescent, a brilliant white light. c.* 1899. Handbill, containing details of twenty-five photographs by Frith available at 4d., 1 shilling, or 2 shillings each. (The first page is reproduced in ref. 24, p. 28).

28. Johnson, Peter. *The History Of Mendip Caving.* Newton Abbot, David & Charles, 1967.

29. Martel, E.A. *La Photographie Souterraine.* Paris, Gauthier-Villars, 1903.

30. Martel wrote an article on his 1904 visit to Mendip in 1905. 'La Désobstruction Des Abimes Les Cavernes Des Mendip-Hills (Angleterre).' *Nature,* Paris, **34**, (1698). pp. 23–6. The front of Cox's handbill, *c.* 1907, is reproduced in ref. 24, p. 29.

31. This has led to difficulty in identifying the photographer of some pictures. Photographs taken in this way are almost identical. Three different copies of a scene in Chamber One in Wookey Hole are known, and on one later occasion some ten cameras were in use at once in Chamber Three. A plate negative in Wells Museum attributed to Balch is almost identical to that by Savory which was used in Balch's 1914 Wookey Hole book (see ref. 41).

32. Baker, E.A. and Balch, H.E. *The Netherworld Of Mendip.* Bristol, J. Baker & Son, 1907.

33. Bamforth, J.D. Pers. Comm. Letter dated 4 April 1986.

34. Several surface pictures of this period are known from such locations as Gaping Gill, and Alum Pot. T.C. Bridges of Bradford is known to have produced at least one surface view of the YRC at Long Churn. Some photographs are discussed in Craven, S.A. 'Messrs. Dawson, Townend & Co. – Pioneer Potholers.' *The Yorkshire Ramblers' Club Journal,* **11**, (37), 1976. pp. 170–2.

35. Craven, S.A. 'The Yorkshire Speleological Association.' *British Caver,* **64**, Aug. 1976. pp. 27–35.

36. Howes, C.J. 'A Few "Unknown" Cave Photographers.' *Historical Group Quarterly,* Royal Photographic Society, (78), 1987. pp. 7–9. Several of the lesser-known British photographers are discussed. Michael Horner of Settle ran his studio from 1867 to 1927, with his son Anthony. K. & J. Jelley took over the Horner firm when Anthony retired. They still hold the plate negatives taken by George Towler, who was probably a local amateur photographer.

37. General biographical details on Savory are found in his obituaries; *Proceedings Bristol Naturalists Society,* **30**, (4), 1963. pp. 299–300; *The Falconer,* **4**, (2), 1962. pp. 42–3.

38. Savory first appears in the annual report of the society in the list of members for 1911. His meeting with Balch, joining the MNRC and subsequent initiation into caving, would therefore have taken place within a very short period of time, probably during 1910, when he first went caving. Savory's diaries do not indicate any further details concerning the dates of these events.

39. *A Man Deep In Mendip. The caving diaries of Harry Savory 1910–1922.* Extracts from the diary are published by Alan Sutton Ltd., Gloucester, edited by John Savory, 1989. Quotations are taken from his typescript. Many entries covered walks in the Mendip Hills, while others concerned caving. A few later entries showed he retained an interest in caves after 1922, and photographed in Wookey Hole in 1928, but with the conclusion of Balch's major work in Swildon's Hole, Savory's attention turned elsewhere.

40. Savory annotated a print of Aveline's Hole taken on 5 June 1911 with his intention to return and photograph six other named caves and locations, and indicates that he did not know with certainty the name of the cave in his picture.

41. Balch, H.E. *Wookey Hole Its Caves And Cave Dwellers.* London, Oxford University Press, 1914.

42. Balch records these thanks in his photograph albums, held by Wells Museum. They form part of his reply when granted the Honorary Freedom of the City of Wells on 15 April 1944.

43. Savory, J. Pers. comm. Letter dated 15 February 1984.

44. Details of the exploration of Swildon's Hole are to be found in Balch, H.E. 'Mendip Nature Research Committee Report For 1922.' *Mendip Nature Res. Comm.,* 1923. pp. 21–2; Anon. 'Mendip Nature Research Committee Report For 1921.' *Mendip Nature Res. Comm.,* 1922. pp. 26–31. These reports are illustrated with Savory's photographs. The subject is investigated further in refs. 28 and 48, and Savory's diaries show there was a visit made on 10 August which was associated with the expeditions that led to the discoveries of 1921.

45. Print in Balch's photograph album, Wells Museum. The comment is also recorded in Davies, P. *Pictorial History Of Swildon's Hole.* Wells, Wessex Cave Club, 1975.

46. Handwritten detail on a set of prints in Balch's photograph albums in Wells Museum. The former comment is part of a 'before and after' set where the modified picture is also included.

47. A list of plate negatives by Savory held in Wells Museum has been produced by Baines, A. and Hill, D. *J.H. Savory Plates.* 1984. Savory's plates held by the University of Bristol Spelæological Society have been documented by Howes, C.J. *The Savory Plates In The UBSS Collection.* 1988. Other plate negatives by Balch and others are included in Howes, C.J. *Cave Plates And Photographs In Wells Museum.* 1988. All lists are available at Wells Museum.

48. Wells, O.C. *A History Of The Exploration Of Swildon's Hole.* Private pub., 1960. Ward is not identified as the caver in Balch's writings: Wells cites a pers. comm. as the source of his identification.

49. Balch, H.E. *Mendip – Its Swallet Caves And Rock Shelters.* Bristol, John Wright & Sons, 1937.

50. Tratman, E.K. 'Caving In The Mendips, Somerset, In The Early 1920s.' Unpub. ms of the University of Bristol Spelæological Society Presidential Address, 1969. Typescript in the UBSS library.

51. Hatherly, H.M. 'Eric Doddrell Evens.' *Microscopy,* **32**, (10), July–Dec. 1974. p. 437.

52. A list of photographs taken by E.D. Evens held by Bristol Museum and notes concerning his postcards (probably printed by Chapman of Dawlish) has been produced by Irwin, D.J. Unpub. ms, 1988. Also see Irwin, D.J. 'Early Cave Photographers And Their Work.' *Belfry Bulletin,* (406/407), Feb.–Mar. 1982. pp. 10–21.

53. For example, details of these explorations are included in *Proceedings University Bris-*

tol Spelæological Society. See Prowse, D.C.
'Field Work.' **2**, (1), 1923 for 1922–3. p. 88;
Adams, S.B. 'Field Work.' **2**, (2), 1924. p.
176; Adams, S.B. 'Swildon's Hole.' **4**, (3),
1935 for 1932–5. p. 223.

54. Simpson, E. 'Cave Photography.' *Caves And Caving,* **1**, (5), Nov. 1938. pp. 191–3.

CHAPTER 9. LIGHTING THE BAT CAVE.

1. A copy of the proclamation is held by the New Mexico State Office. A bronze plaque signed by the State Governor, Bruce King, was presented to Davis on 28 Oct. 1973 which read 'To Ray V. Davis, whose many superlative photographs of Carlsbad Cavern's indescribable beauty were a most significant factor in the creation of Carlsbad Caverns National Monument October 25th, 1923.' The proclamation as quoted has been shortened.

2. An exhibition of Davis' photographs was held at the Bassett Centre, Carlsbad, during April 1976 (later extended until November). Each set had comments by the photographer. This quotation comes from a panel entitled 'Satisfaction'. The exhibition was reported on and advertised widely in *The El Paso Times*, e.g., 21 April 1976. Photographs of the displays and comments are held by the Carlsbad Caverns National Park Service.

3. Brothers, A. *Photography; Its History, Processes, Apparatus, and Materials.* London, Charles Griffin & Co., 2nd edn., 1899.

4. Details of the cards, the common ones of which were published between 1906 and 1914, are given in Schuurmans, T.J.C. *Postcards Of The Caves Of Han Printed By Nels Of Brussels Between 1905 And 1940.* Rotterdam, Schuurmans, 1988. [2nd edn. 1989].

5. Kranjc, Andrej A. 'Raziskovalec Franci Bar.' *Življenje In Technika,* **33**, (9), 1982. pp. 33–40.

6. Johnson, Peter. 'Norbert Casteret.' *Descent,* (78), Oct.–Nov. 1987. p. 22.

7. Although often reported as such, White was not the first person to 'discover' the caves, whose entrance was large enough to have been known locally. Rolth Sublett was 'reportedly lowered into the cave by his father in 1883'. White was the first to conduct extensive explorations of the cave, although there were many others who later claimed the honour of having begun this work. See: Anon. 'Davis Part Of Cave History.' *Carlsbad Current-Argus Supplement*, 16 May 1980, for Davis' account. For a compilation of references to all early claims for discovery see Bullington, Neal R. *Who Discovered Carlsbad Cavern?* Unpublished ms, 1968. [Carlsbad Caverns archives].

8. Doss left the area in 1907, according to the *New Mexico Sun*, 31 May 1907. The Park archives state the photographer was from Carlsbad; if he was a professional only three studios were open at that time. See: Rudisill, Richard. *Photographers Of The New Mexico Territory 1854–1912.* Santa Fe, Museum of New Mexico, 1973. Possible photographers are R.J. Boatman (1905–6), G.W. Overman (1905–6), and Robb & Co. (1907–8). Rudisill's sources of information are the New Mexico business directories. However, an incompletely referenced newspaper clipping in the Park archives dated 10 January 1928 states that one Samuel Hughes had a contract for removal of guano from the caves in 1905, at which time photographs were taken for him. The three photographs mentioned in this report were taken in the Bat Cave and placed on display in the Chamber of Commerce in Carlsbad. No such photographs are now known, unless they are the ones reported to have been taken for Doss.

9. Information concerning the prominent Carlsbad resident, Ira Stockwell, is to be found on record cards in the photographic archives of Carlsbad Caverns National Park Office. Further details are to be found in the Carlsbad City Museum.

10. White, J. and Nicholson, F.E. *The Discovery And History Of Carlsbad Caverns New Mexico.* Carlsbad, C.L. White, 2nd edn., 1937. Later editions dropped the credit for Nicholson's involvement with the booklet. He was in fact the primary author, writing after interviewing White.

11. Anon. *Ray V. Davis*. Biographical notes written by Carlsbad Caverns National Park staff for the fiftieth anniversary celebrations, 1973. The proclamation to Davis was presented at the anniversary ceremony.

12. Ref. 11 states that Davis bought his photographic studio in 1914. However, according to the New Mexico business directory the F.G. Hodsoll studio was sold to Davis in 1916. In 1925 Davis purchased land (see *The Carlsbad Current*, **33**, (15), 9 April 1925. p. 1, col. 5) in Carlsbad and opened a new studio, built in 1927. This had a half interest owned by J.B. Leck (see *The Carlsbad Argus*, **39**, (55), 17 May 1927. p. 1, col. 5). When Davis promoted the Palo Duro Canyon State Park he moved to Canyon, in Texas, operating a studio there (see *The Daily Current-Argus*, **40**, (256), 3 Jan. 1930. p. 3, col. 5; also Davis, Ray V. *My Three Years Promoting The Palo Duro Canyon In The Texas Panhandle*. Unpublished ms notes made for Carlsbad Caverns National Park archives, 1970). Davis returned to reopen a photographic shop in Carlsbad in 1932 (see *The Daily Current-Argus*, **43**, (102), 5 Sept. 1932. p. 1, cols. 3–4). Also see ref. 42. Clippings of the above newspaper references are held by the National Park archives.

13. Davis, Ray V. *The Old Bat Cave, The Carlsbad Cavern And Me*. Unpublished ms, held by Carlsbad Caverns National Park library, 1970. 6pp. These notes were later used as the basis for Davis, R.V. 'Lens Of The Labyrinth.' *New Mexico Magazine*, **48**, (9–10), Sept.–Oct. 1970. pp. 24–7. The date of the earliest visit by Davis is difficult to determine. Davis later remembered this as being 'about 1915', a date often quoted in articles but not accurate; this date was prior to the opening of his shop (see ref. 12). A date nearer to that given for a visit in 1922, and almost certainly not before 1920, (see ref. 17) is more likely to be when Davis first began producing photographs. These can be tentatively placed in order of production using information written on them. Early copies are handwritten, and titled as 'Bat Cave'. Davis later added a copyright symbol, and finally a number. More recent prints have the title typeset on them.

14. Interview notes made by W.R. Halliday with Davis in 1968, held as part of the Mellor collection in the Carlsbad Caverns Natural History Association library.

15. Moore, Art. *Discovery Of "World's Largest Black And White Photo" Made 50 Years Ago Uncovers Early History Of Carlsbad Caverns*. Unpublished ms and interview notes, held by Carlsbad Caverns National Park, 1969. 8pp.

16. Caiar, Ruth. *One Man's Dream. The Story Of Jim White Discoverer And Explorer Of The Carlsbad Caverns*. New York, Pageant Press, 1957.

17. [Perry, S.L.] 'Beautiful Sights In Bat Caves West Of Carlsbad 1,800 Feet Underground.' *The Carlsbad Current*, (40), 15 Sept. 1922. p. 1, cols. 1–3. Perry was the editor of the newspaper and made a fourteenth person on the expedition, travelling on his own from outside the town. This reference is the first published mention of Davis' photography, and the first formal visit by tourists to the cave.

18. Anon. 'New Use For Bat Guano Caves.' *The Carlsbad Argus*, **34**, (2), 27 Oct. 1922. p. 1, col. 3. Letters between the Paramount Corporation and Davis are included in this report.

19. Interview notes made by Tom Mellor with Davis in 1973, held as part of the Mellor collection in the Carlsbad Caverns Natural History Association library.

20. Nunn, Annie Dyer. 'Ray Davis; Camera Explorer.' *The Chronicle, Carlsbad*, 17 July 1930.

21. Livingston often worked with both Davis, and later Lee, in producing pictures in the caves. He wrote several articles about cave exploration. See Bursey, Joseph A. 'Carl B. Livingston.' *New Mexico Magazine*, May 1932. pp. 9–10 and 40.

22. Holley, Robert A. *Report On The Feasibility Of Securing The Carlsbad Cave As A National Monument, To The Commissioner, General Land Office, May 14 1923*. Govt. pub, 1923.

23. Grosvenor, Gilbert. 'Carlsbad Caves Interests National Geographic Society.' *The Carlsbad Argus*, **35**, (9), 14 Dec. 1923. p. 1.

Grosvenor was the president of the society. His reply by letter to Burgess is published in this report.

24. Lee, Dana W. 'The National Geographic Society's Expedition To Carlsbad Cavern, New Mexico, March 20, to September 15, 1924: a diary and record of the expedition.' *Journal of Spelean History*, **1**, (3), Summer, 1968. pp. 59–80.

25. Alden, William C. 'Memorial Of Willis Thomas Lee.' *Bull. Geol. Soc. America*, **38**, 30 March 1927. pp. 70–93.

26. Lee, Willis T. 'A Visit To Carlsbad Cavern.' *The National Geographic Magazine*, **45**, (1), Jan. 1924. pp. 1–32. Lee's original ms was longer than that published. A copy is held in the Mellor collection in the Carlsbad Caverns Natural History Association archives. A short section on photography indicates that in addition to flashpowder and Davis' blow-lamp, magnesium flares used for ciné photography were also burned. These flares could give light for up to twenty seconds, producing large volumes of smoke.

27. Wells, John. 'Carlsbad Cave Designated As A National Park.' *The Carlsbad Argus*, **35**, (4), 9 Nov. 1923. p. 6. Four photographs by Lee and Davis are reproduced.

28. This was published on 18 November 1923.

29. Anon. 'Carlsbad Cave Pictures To Be Syndicated Over World.' *The Carlsbad Argus*, **35**, (4), 9 Nov. 1923. p. 1.

30. Gale, Bennett T. *Historical Sketch Carlsbad Caverns National Park*. Unpub. ms by Park naturalist, 1952.

31. Lee, Willis T. 'New Discoveries In Carlsbad Cavern.' *The National Geographic Magazine*, **48**, (3), Sept. 1925. pp. 301–20. The colour photograph appears on p. 290 as plate XVI.

32. [Anderson, A.W.] 'Make [sic] First Pictures Of The Hidden Cave.' *The Carlsbad Current*, **33**, (31), 30 July 1925. pp. 1; 7. This expedition lasted three days. Davis had the pictures on display within a few days. Other caves he photographed included Cottonwood and Giant Cave.

33. Crookes, William. 'Artificial Light For Photographic Purposes.' *The Photographic News*, **3**, (58), 14 Oct. 1859. p. 71.

34. Jones, J.H. 'A Photographic Trip Up The Vale Of Neath. Part 3.' *The Photographic News*, **4**, (89), 18 May 1860. pp. 28–9.

35. Shaw, T.R. 'Martel's First Cave.' *Proceedings University Bristol Spelæological Society*, **17**, (3), 1986. pp. 246–9. Adolphe Braun (1811–1877), official photographer to the Court of Napoleon III, published a stereo view of the glacier cave *c*. 1859. He is known to have produced a number of photographs of ice caves in the area.

36. Dayton, R. 'A New Flash Light.' *The British Journal Of Photography*, **35**, (1464), 25 May 1888. p. 327.

37. Hughes, Herbert W. 'Photography In Coal Mines.' *The Photographic Journal*, **18**, New Series, 25 Nov. 1893. p. 93–101.

38. Boutan, L. *La Photographie Sous-Marine Et Les Progrés De La Photographie*. 1900. Earlier attempts at underwater photography using flash had been made, but Boutan is acknowledged as being the first successful photographer. He used magnesium powder blown into a flame, sealed within a large glass dome, for his early flashes. Chauffour used magnesium in oxygen sealed in a glass globe, ignited using a platinum filament which was electrically heated. See also Cappon, M. and Zannier, I. *Photographing Sports*. Chicago, Rand McNally, 1981. p. 169.

39. For details of flashbulb design see Forsythe, W.E. and Easley, M.A. 'Characteristics Of The General Electric Photoflash Lamp.' *Journal Optical Soc. America*, **21**, 1931. pp. 685–9; Dalladay, A.J. *The British Journal Photographic Almanac*. London, Greenwood, 1959; Gilbert, G. *Photo-Flash In Practice*. London, Focal Press, 1947.

40. Coe, Brian. *Cameras. From daguerreotypes to instant pictures*. London, Marshall Cavendish, 1978.

41. Nymeyer, Robert. *Carlsbad, Caves, And A Camera*. Teaneck, Zephyrus Press, 1978. The original annotated photographs used for the production of this book are of very high quality. They were donated to the Carlsbad Caverns Natural History Association after use in production of the book.

42. Anon. 'Leck Studio In New Hands.' *The Daily Current-Argus*, **41**, (228), 27 Jan.

1931. Leck took over the studio when Davis left in 1930. See also ref. 12.

43. Nymeyer, Robert. 'Wonders Below.' *New Mexico Magazine,* Dec. 1938. pp. 9–11; 38–40.

44. Jackson, George F. 'Photographing The Cellars Of The World.' *The Camera,* **55**, (3), Sept. 1937. pp. 163–7.

45. Neville, Russell T. 'How To Take Cave Pictures.' *Popular Photography,* May 1937. pp. 51; 63.

46. Adams, M. and Parker, J. 'Carlsbad's Tex Helm: Walking Photographic Legend.' *Carlsbad Current-Argus,* **99**, (125), 12 March 1978. For further details of Helm (6 Feb. 1903–22 Aug. 1982) see 'Caverns Chronicler Dead At 79.' *The El Paso Times,* 24 Aug. 1982. pp. 1b–2b.

47. News release prepared by Gwyn R. Snelson, 1980. Snelson, of Carlsbad, inherited Helm's photographs upon his death.

48. Details of the timing and statistics of the production of the picture are included in Helm's *Carlsbad Caverns Collector Album* and a postcard of the shot published by Helm. He sold 350,000 slide copies and 1,000 posters of the picture in the six years after its production.

49. Sutherland, Mason. 'Carlsbad Caverns In Color.' *The National Geographic Magazine,* **104**, (4), Oct. 1953. pp. 433–68.

50. Anon. 'Wow, What A Photo Helms' 'Big Shot' Was.' *Carlsbad Current-Argus,* 24 Feb. 1980.

CHAPTER 10. MOVING PICTURES.

1. Anon. *Oudtshoorn Courant,* 24 Sept. 1919. p. 2, col. 4.

2. Postcard depicting Cango Caves, private collection. Enquiries with South African agencies have been unable to positively confirm any such railway accident.

3. Coe, Brian. *The History Of Movie Photography.* London, Ash & Grant, 1981.

4. Barnes, John. *The Beginnings Of The Cinema In England.* Newton Abbot, David & Charles, 1976. 240pp. This volume is an excellent discussion of the development of the British film industry.

5. Anon. 'Mr R.W. Paul's Animatographe

6. Catalogue of Paul's films, June 1903. Copy held by the Barnes Museum of Cinematography. His early catalogues are discussed in ref. 4, pp. 206–7. A copy of the film exists in the Kodak collection, Bradford, England.

7. Brison, David. Letter dated 29 Oct. 1973 to E.K. Tratman concerning ciné photography. Tratman replied on 2 Jan. 1974, giving details of his film in Lamb Leer. Copies of both letters are held by the Univeristy of Bristol Spelæological Society.

8. Craven, S.A. 'Early Cine-Photography At The Cango Caves.' *Bull. South African Spel. Assoc.,* **26**, 1985. pp. 17–27. The paper covers all the early filming at Cango in detail, as well as carrying notes by Howes, C.J. on contemporary films made elsewhere in the world.

9. Anon. *Oudtshoorn Courant,* 11 March 1913. p. 2, cols. 2–3; p. 4, col. 8; 12 April 1913. p. 4, col. 2.

10. Anon. *Oudtshoorn Courant,* 9 Nov. 1916. p. 4, col. 2.

11. Correspondence in Oudtshoorn Municipal Archives. A.5/31.

12. Anon. *Oudtshoorn Courant,* 22 Sept. 1919. p. 4, col. 4.

13. Smithsonian Inst. Archives 1919 – African Exhibition Film No. 71327, Record Unit 192 (in South African Library Manuscripts Dept).

14. Anon. *Oudtshoorn Courant,* 24 Aug. 1923. p. 3, col. 4. The film *The Dust That Kills* is preserved in the South Africa Film Video And Sound Archives, Pretoria. A second film about gold mining made during the 1930s is also preserved, titled the *Golden Harvest Of The Witwatersrand.*

15. Transvaal Archives SAS 581 G4/4/33.

16. Anon. *Oudtshoorn Courant,* 30 April 1924. p. 5, col. 3; 20 Feb. 1925. p. 2, cols. 7–8; 23 Feb. p. 4, col. 7; 25 Feb. p. 2, cols. 7–8; p. 3, col. 1.

17. A section of film entitled 'Cango Caves' has been restored by the South African National Film Video And Sound Archives, Pretoria. It is attributed to the African Film Production Co., made in the 'early 1920s' (pers. comm.); it is not clear if this is the footage produced for the exhibition.

18. Many fictional films, often 'one reelers', included the topic of caves and had been made earlier than this. For example, the Vitagraph Company produced nine films based around caves between 1912 and 1914. These had such titles as *The Cave Dwellers' Romance* or *A Cave Man Wooing*, and did not use real locations. For further examples, see Lauritzen & Lundquist. *American Film Index 1908–1915.* 1976. pp. 91–2.

19. Alden, William C. 'Memorial Of Willis Thomas Lee.' *Bull. Geol. Soc. America,* **38**, 30 March 1927. pp. 70–93.

20. Lee, Dana W. 'The National Geographic Society's Expedition To Carlsbad Cavern, New Mexico, March 20 to September 15, 1924: a diary and record of the expedition.' *Journal of Spelean History,* **1**, (3), Summer 1968. pp. 59–80.

21. Livingston, Carl B. 'The Balloon Blunder.' *New Mexico Magazine,* April 1934. pp. 12–14; 48–50. Livingston helped Lee during the expedition.

22. Several newspaper references cover the WWP films:

 a. Anon. 'Movie Drama In Cavern Setting.' *The Carlsbad Argus, c.* 3 Feb. 1928. [Clipping in National Park archives].

 b. Anon. 'Finish Movie Work At The Cavern.' *The Carlsbad Argus,* 10 Feb. 1928. 'Edward Ferguson and party, of the World Wonder Productions, motion picture corporation of Holywood, left yesterday afternoon for Hollywood, after having spent a week in making motion pictures in Carlsbad Caverns . . .'

 c. Anon. 'Boles Is Home From N.P.S. Meet.' *The Carlsbad Argus,* 6 March 1928. Thomas Boles, Park Superintendent, was given a copy of the film while in California.

 d. Anon. 'Cavern Movies Here Next Week.' *The Carlsbad Argus,* 6 March 1928. The forthcoming showing of the film was advertised.

 e. Anon. 'Cavern Placed High In Parks.' *The Carlsbad Argus,* 9 March 1928. The film was reported to be shown 'at the Crawford Theatre on Tues & Wed nights, next week. . .' This was an advance showing, for 'the picture will not be titled and released for a few weeks yet'.

23. Details of some films shot in the caverns are given in a document in the caverns' archives: 'Historical Resume of Commercial Filming at Carlsbad Caverns 1924–1983.' (Acc. No. 978.91). In addition to those films already mentioned, this states that early films were made on the following occasions:

 a. 2 Oct. 1927: Metro-Goldwyn-Mayer: news film of caverns and bat flight.

 b. 13 May and 21 Oct. 1928: Metro-Goldwyn-Mayer, Kinograms, and International Newsreel took newsreel footage.

 c. Parts of feature films were made in the 'late 20s' (a cowboy film) and on 10 July 1929 (Haunted World, by Norman Dawn of Hollywood).

 As well as the above, Movietone, Kinograms, and Paramount were reported to be interested in filming in Anon. 'Another Movie To Be Made In Cave.' *The Carlsbad Argus,* 25 March 1928. Filming took place in May: Anon. 'More Movies In Carlsbad Cavern.' *The Carlsbad Argus,* 11 May 1928. According to the *New York Times,* the Nicholson expedition of 1930 also produced ciné film: Nicholson, F. 'Explorers Start To Carlsbad Cave,' 26 Feb. 1930. 'Nicholson Finds Bed of Lost River,' 15 March 1930.

24. Anon. 'Another Cavern Picture.' *The Daily Current-Argus,* 21 Nov. 1930.

25. Ashton, H. *et al. Exploring The Endless Caverns Of New Market, Virginia. In the heart of the Shenandoah Valley.* New York, Nomad, 1926. The booklet reprints articles from journals and papers. Pictures are credited to Pacific & Atlantic, Underwood & Underwood, Harris & Ewing, and Crawford & Carter of Washington.

26. The film *In The Cellars of the World* was made on nitrate film stock, which decomposes over a period of time. Most has been rescued and transferred to both a negative and video copy. Information used to write this section has been gained from captions within the film stating the locations and subjects, and notes in Halliday, W.R. *Depths Of The Earth. Caves and cavers of the United States.* New York, Harper & Row, 2nd edn., 1976. One picture from Old

Salts shows a cloth with the names of the eleven cavers written on it. This includes George F. Jackson, Julia Neville (who appeared in many of the other caves filmed) and Homer Collins, brother of the fated Floyd Collins who lost his life in Sand Cave in 1925, during the period of shooting the film. Andy Lee Collins appears in earlier parts of the film. As well as being an expert ciné photographer, Neville was also adept at producing black and white photographs. He was nicknamed 'The Cave Man'. The film is now in the care of the National Speleological Society, USA. An abstract concerning the film appears in *NSS Bulletin,* **32**, (4), Oct. 1970. p. 122, and it was shown during the NSS Cave Photo/Cinematography Session at the 1970 annual convention.

27. An unreferenced newspaper clipping is held by the Carlsbad Caverns National Park archives, *c.* February 1928. It states that Neville gave a lecture in New York on 'Caves of the World', and that 'Mr Neville spent two weeks in the Carlsbad cavern last July studying and photographing the varied formations . . .' during which time he added footage to his film *In the Cellars of the World.* This is also mentioned in ref. 23.

28. Davis, Ray V. *The Old Bat Cave, The Carlsbad Cavern And Me.* Unpublished ms, held by Carlsbad Caverns National Park library, 1970. 6pp. Davis helped with the production of Fox's newsreel footage and was technical advisor for *The Medicine Man,* filmed in the caverns in June 1929 by Irvin Productions, Hollywood. The quote refers to the latter film.

29. Collins, James H. 'An Underground Moving Picture Theatre.' *Scientific American,* **134**, (5), May 1926. p. 320.

30. The Czech film is mentioned in notes by Howes, C.J. appended to ref. 8 and by Brison, D.N. in ref. 7.

31. Details come from a postcard made from a scene in the film.

32. Tratman, E.K. 'Making A Film In Lamb Leer.' *Mendip Nature Research Committee Journal,* **2**, (2), Aug. 1966. pp. 65–7. For a detailed account of the production of Tratman's films see Howes, C.J. 'E.K.

Tratman's Underground Ciné Films, 1933–1937.' In preparation.

33. Tratman, E.K. 'Ciné Photography.' *Proceedings University Bristol Spelæological Society,* **4**, (3), 1935. p. 261.

34. Tratman, E.K. 'Early Ciné Photography In Caves In Mendip, Somerset.' *Transactions Cave Research Group,* **11**, (4), Dec. 1969. pp. 255–7.

35. Tratman gave various lengths and a running time of eight minutes for his finished film. The film runs for eleven minutes, including the surface photographs at each end, and is about 500 ft long.

36. Shaw, T.R. 'History Of The University Of Bristol Spelæological Society.' *Proceedings University Bristol Spelæological Society,* **12**, (1), 1969. pp. 9–30. Tratman's notes were lost in Singapore; UBSS records were destroyed during the Second World War during enemy action.

CHAPTER 11. POST-WAR UNDERGROUND.

1. Burrow, J.C. and Thomas, W. *'Mongst Mines And Miners.* 1893. Reprinted, Truro, Bradford Barton, 1965.

2. For example, the *NSS News.* This publication grew both in number of pages and photographs. This increase is analysed in Soule, Gary K. 'Photo History Of The "NSS News".' *Wisconsin Speleologist,* **19**, (2), April 1985. Reprinted 1988 by the NSS.

3. Déribéré, M. *La Photographie Spéléologique.* Paris, Prisma, 1952.

4. Detailed instructions in English were given by Donald A. Coase in Cullingford, C.H.D. (ed.). *British Caving. An introduction to speleology.* London, Routledge and Kegan Paul, 1953. A second (revised) edition was published in 1962. Coase, an expert cave photographer, had died in 1958 so the section was updated with additional notes on stereo and colour photography by C. Lewis Railton, and on ciné photography by John H.D. Hooper. Details on the use of flashpowder were retained in the second edition, but its use underground was waning.

5. Flash underwater was not solved until Boutan's attempts in the early 1890s. There

were many prior attempts to produce photographs without the use of flash. One of the earliest was in 1866 when the Frenchman Bazin was sealed into an iron box and lowered to the ocean bed. He took his pictures through a glass panel using electric lights, before being winched up and released before he suffocated. Anon. 'Submarine Photograph.' *Scientific American*, **15**, (14), 29 Sept. 1866. p. 215. See also *Scientific American*: 'Photography At The Bottom Of The Sea.' **30**, (23), 6 June 1874. p. 353, col. 3; 'Submarine Photography.' **77**, (4), 31 July 1897. p. 74, col. 3.

6. Anon. 'Exploring With A Camera.' *Scientific American Monthly*, **2**, (2), 1920. p. 172.

7. Farr, M.J. *The Darkness Beckons*. London, Diadem, 1980. Farr's slave units were designed by Rod Beaumont.

8. In November 1946 the Admiralty offered the CDG the use of an underwater camera to record details of relics by The Witch in Wookey Hole. A number of ex-RAF landing lights were aquired in 1948, with the intention of using them for underwater lighting. Despite these attempts there are no records of successful photography. See *Cave Diving Group Letter To Members*: (3), 2 Sept. 1946. p. 2; (4), 3 Nov. 1946. p. 4; (6), 29 Mar. 1947. p. 3; (11), 27 June 1948. p. 3.

9. Devenish, Luke. Pers. comm. 1984.

10. The *Cave Diving Group Letter To Members*, (25), Dec. 1956. p. 10. states that, 'Devenish has been getting some encouraging underwater photographs at Wookey. We hope to give details in the next issue.' No such details were subsequently recorded.

11. *The Sunday Times* (27 January 1957) reported an expedition to the Fontaine de Vaucluse: 'During the second week Louis Malle, co-director of Cousteau's film, "The Silent World", covered the dives with a ciné-camera.'

12. Details on the development of electronic flash are given in Coe, Brian. *Cameras. From daguerreotypes to instant pictures.* London, Marshall Cavendish, 1978. Early information is in Snow, P. *Electronic Flashlight Photography*. London, Fountain Press, 1961. Their electronic design is covered by Towers, T.D. *Electronics And The Photographer*. London, Focal Press, 1980.

13. Edgerton, Harold E. *Electronic Flash, Strobe*. Cambridge Mass., MIT Press, 1979. [2nd edn. 1984]: Edgerton, Harold E. 'Strobe Photography: A Brief History.' *Optical Engineering*, **23**, (4), July–Aug. 1984. pp. 100; 102–5.

14. Hooper, John. 'Photographing Bats In Flight.' *Country Life*, 15 March 1956. pp. 462–4. Further information, pers. comm.

15. In excess of twenty different slave flash circuits have been published in the caving press during the 1980s. Examples may be found in: France, S. 'Flashgun Slave Units.' *Caves & Caving*, (42), Winter 1988. pp. 2–4; Howes, C.J. 'Making Slaves For Cavers.' *Descent*, (85), Dec.–Jan. 1988. pp. 34–5.

16. Diprotodon was developed over a long period of time. The first version was produced by H.G. Watson in 1932. This was a powder-burning blow lamp, made from an old fire extinguisher cylinder, with a pump, gauge and tap welded on to make a powered version by J. Maitland Thomson. In 1966 it was revised by C.A. Hill of South Australia, using high-density magnesium powder stored in a brass polish tin. This was an early rocket fuel, made by melting magnesium in a nitrogen atmosphere and pouring it through a fine mesh into liquid nitrogen. In use, a modified automobile petrol valve controlled the flow: when the petrol valve was opened, powder flowed into a tube to be expelled by a blast of air from an inflated child's balloon. Later, fellow Australian Norman Poulter replaced the balloon with a liquid propane propellant to aid ignition of the powder. Burning took place in a 6 in car headlamp reflector. Diprotodon allowed huge areas to be lit with its 4 ft × 3 ft × 1 ft incandescent flame, consuming an ounce of powder every thirty seconds. The unintentional similarity of the final result to Larkin's magnesium lamp of 1865 is noticeable. Powder lamps had been in general use for many years during the

previous century and had been extensively used for cave photography in France in 1889 and after by Vallot. By comparison, his Regnard lamp produced a two metre flame. For further details see pp. 29–31 of 'Mulla-mullang Cave Expedition Report 1966' by the Cave Exploration Group of South Australia; also see: 'Symposium On Cave Photography,' *Transactions Cave Research Group*, **11**, (4), 1969. p. 232; Hamilton-Smith, E. and Lewis, I. 'Farewell Captain J. Maitland Thomson – Some Recollections of a Determined Individual.' *Australian Caver*, (113), 1987. pp. 21–2.

17. Middleton, J. and Waltham, T. *The Underground Atlas. A gazetteer of the world's cave regions*. London, Hale, 1986.

18. Eavis, A.J. *et al. Caves Of Mulu '84*. Bridgwater, British Cave Research Association, 1985. The slave units used were designed by Ian Davinson.

19. Davinson, Ían. 'Cave Holography.' *Caves And Caving*, (3), Feb. 1979. pp. 9–13.

20. For example, in French: Baptizet, A. *Cineaste Des Cavernes*. Colmar, SAEP Ingersheim, 1981; Callot, F. and Y. *Photographier Sous Terre*. Paris, V.M., 1984. Baptizet's book concerns ciné photography in caves. Ciné photography in Italian is covered by Prando, E. *Fotografia Speleologica*. Milan, Il Castello, 1982. In English there is Howes, C.J. *Cave Photography. A practical guide*. Buxton, Caving Supplies, 1987. Suggestions for taking pictures on caving expeditions, both 'still' and ciné, are given by Wooldridge, J. and Perou, S. in Willis, D. (ed.). *Caving Expeditions*. London, Expedition Advisory Centre/BCRA, 1986.

21. Brothers, A. *Photography; Its History, Processes, Apparatus, and Materials*. London, Charles Griffin & Co., 1892. [2nd edn. 1899].

22. Davis, Ray V. *The Old Bat Cave, The Carlsbad Cavern And Me*. Unpublished ms, 1970. Held by Carlsbad Caverns National Park library. 6pp.

Picture Credits

All illustrations are from the author's collection, with the exception of:

Bibliothèque Nationale, Paris, 1, 11, 13, 14
Carlsbad Caverns Natural History Association, 233, 236
Mr Chamberlaine-Brothers, 19
L. Devenish, 259, 260
Institution of Mining and Metallurgy, London, 165, 166
Karst Institute, Postojna, 76
Manchester Public Libraries, 39
R. Mansfield, 156, 157
National Archives, Washington, 74
National Parks Service, 220, 228, 231, 237, 238, 239, 240, 255
National Speleological Society, 249
Royal Institution of Cornwall, 172a, 172b, 173, 176
Royal Observatory, Edinburgh, 25, 28
T.R. Shaw, 61, 63, 85, 90, 92, 96, 97, 98a, 98b, 99, 110, 111, 113,
 114b, 115, 117, 118, 120, 121, 122, 125, 129, 130, 131, 144, 151,
 153, 160, 191, 192, 197, 205, 246, 251
University of Bristol Spelæological Society, 206, 208, 211, 212,
 252, 253
Wells Museum, 188, 200, 214

Index

Figures in italics refer to illustrations

Accident, 231–3; burns, 107, 140, 215; falling, 187–8; fatal, 84, 106
Acetylene, *102*, 190, 199; lamp, 210, 211; projector, 41
Acid, 73, 111; acetic, 53; carbonic, 38; nitric, 2, 53, 234; sulphuric, 2
Acres, Birt, 243
Actinic light, 5, 66, 82, 83, 149, 158, 234
Adams, S.B., 255
Adelsberg, 75–6, 77, 78, 87; *see also* Postojna Jama
Advertising, 94, 99, 116, 136, 196, 198; coal-mine, 182; Luray Caverns, 86; magnesium, 22, 35, 41, 45; magnesium powder lamps, *178*; Mammoth Cave, 50, 95–6; Postojna, 76–7; railroad, 95–7, 99
Aerial photography, 2
AFLO, 258
Aflohonk, 259
African Film Productions Ltd., 244, 247
Aggtelek Cave, 91
Air, John, 29
Albrecht, Joseph, 247
Albumen, 27, 80; on glass, 81; paper, 80, 266; print, 81, 96, 108, 127
Alcohol, 53, 63, 65, 103, 148, 155, 225; flame, 3, 140; lamp, 4, 23, 37, 101, 103, 108, *136*
Aldis, 42
Allom, of New Zealand, 93
Aloxin, 279
Alpine Club, 150
Aluminium, foil, 235; leaf, 234; powder, 154
Amateur Photographic Assoc. of Victoria, 92
Ambrotype, 6
American Cavern Club, 150
American Civil War, 36, 49, 50, 68, 74; blockade runners, 49; end of, 49, 268; outbreak, 49, 267
American Magnesium Co., 48, 50, 52, 55, 60, 73
American Museum and Explorer's Club, 249
Ammonia, 24, 53
Ammonium iodide, 53
Anchor Insurance Co., 19

Angle of illumination, 157
Anthony, E. & H.T., 70, 71, 78, 94, 105, 267
Anthracite, 163, 167
Antimony sulphide, 4, 104
Aperture, 207; *see also* diaphragm
Aqualung, first cave use, 260
Arabs, in Smyth's pictures, 38, *39*
Arc light, 6–8, 9, 18, 87, 101, 109, 133, 164–6, 170, 244, 252
Archer, Frederick Scott, xx, 27
Armand, Louis, 137, 142, 153
Armenian paper, 134
Armstrong, T.N., 270
Arnoux Electric Light Co., 164
Arsenic, 175
Association Belge de Photographie, 71, 78
Atomic bomb, 241; light used for photography, 276
August, Joe, 248
Aveline's Hole, 253
Aven Armand, 153, 159

Bain, of New Zealand, 93
Baker & Rouse Ltd., 273
Baker, Ernest A., 189–91, 194, 200–2, 204, *206*, 207, 212–13
Balagny, 135
Balch, Herbert Ernest, 184, 186–8, 199–201, 204, 206–7, 209, 211–13, 215
Balch, Reg., *211*
Ballooning, 1, 17
Balzac, Honoré de, 8
Bamber, Capt., 46
Bamforth, Harry, 190–4, 201–5
Bamforth, James, 190
Bar, Franci, 219
Baradla Cave, 91
Barium, 106; nitrate, 155
Barker, G., *206*
Barnes, E E., 207, 210; Loop, 213
Barometer, 134; barometric pressure, 170
Barons' cave, Reigate, 85
Bat Cave, 221, 229, 264; *see also* Carlsbad Caverns
Bats, 261

Battery, 235; Bunsen, 7, 9, 11, 12, 18, 133; Daniell, 7; electro-magnetic, 67
Baumes-Chaudes, 134
Bazin, photography underwater, 269
Beattie, John Watt, 196
Beef fat, use in flash compounds, 155
Belgrand, of Paris, 12, 15
Bellows, 105, 136, 141, 143, 145, 148
Bengal fire, 4, 6, 18; formula, 4, 279; light, 4–6, 18, 31–2, 50, 67, 107, 108–9, 115, 119, 140, 189; paper, 146; *see also* photogen *and* green fire
Bennetts, of Cornwall, 168
Berry, E., 186
Betharram, Grottes de, *149*
Bilsteinhöhle, 194, 271
Binda Caves, *see* Jenolan
Bishop, Stephen, 54
Black damp, 169; *see also* carbon dioxide
Blanc, 143
Blanquart-Evrard, L.D., 266
Blitz, János, 91
Blitzlicht, 105, 108
Blockade runners, 49
Blue John Caverns, 4, 32–4, *192, 193*, 194; Crystallised Cavern, *34*; survey (1860s), *31*
Blue light, 4, 5; *see also* Bengal light *and* glass, blue
Boissonnas, 153
Bolas, Thomas, 234
Bolé, A., 273
Bolton, Capt., 47
Bolton, Prof., 234
Boom towns, America, 163
Boston Magnesium Co., *see* American Magnesium Co.
Botallack tin mine, 44, 52, 162, 179
Boudoir card, 97
Boutan, Louis, 234
Boyer, 135, *158*
Boys, C.V., 281
Bradley, Anthony, 196
Bradley, George, xv
Bransford, Mat, 54–5
Bransford, Nick, 4, 54
Bransford, Thomas L., 54
Braun, Adolphe, *xx*, 234

Bretz, George M., 163, 165–6, 170, 179, 182
Brewster, David, 266
Brichaut, 146
Bridge Cave, *262*
British, Assoc. for the Advancement of Science, 41, *42*, 43; Empire Exhibition, 247; Speleological Assoc., 254, 275
Brockhurst, 248
Brooks, William, 84–5
Brothers, Alfred, 19–20, 22–4, 27, 31–6, 37, 41, 47, 50, 77, 83, 136, 194, 218, 264; lamp, 42; portrait of, *19*
Brough, Bennett H., 179
Brown, Frederick, 82–3, 84, 163, 168
Brown, J.T., 163
Buchan, caves at, 92; river valley, 196
Bulb, *see* flashbulb
Bulmore, of California, 167
Bunsen, Prof., 20, 21; batteries, 7, 9, 11, 12, 18, 133; burner, 3, 7
Burge, J.G., 97
Burgess, Richard F., 228
Burial, crypt, 41; grounds, 9; vault, 72, 75
Burra Burra copper mine, 266
Burrington Combe, 207
Burrow, John Charles, 162, 170–8, 179, 181–2, 184–5, 257, 264; portrait of, *172*

C., V., 20–1
Cabinet cards, 94, 97
Cadett Lightning plate, 175
Cadmium bromide, 53
Calcium, carbonate, 82, *83*, 84; light, *85*, 87, 119, 185; oxide, 83; *see also* limelight
Calico, bag, 103; tubes of, 73
Calotype, xviii–xx, 19
Camborne School of Mines, 171, 181
Camera, 100; box, 115, 186; Calypsophot, 276; ciné, 242–3, 264; Collins, 96; Falcon Press flash, 275; Nikonos, 276; plate, 159, 187, 194, 209, 223; problems with, 62, 202, 209–10, 214, 225–6; Smyth's miniature, *26, 28*, 29–30; stereo, 33, 159; waterproof, 258, 276; Instamatic, 276
Canal, Suez, 36
Canary Islands, 24
Candle, 17, 22, 109, 123, 200, 209, 213, 215; in caves, 33–4, 87, *115*, 118, 134, 210; flash, 155; in mines, 43, 72, *74*, 82; power, 164, 171, 246; in pyramids, 36; tracks, 175, *212*, 213
Caney & Co., *90*, 91, *92*
Cango Caves, 87, *114*, 242, 244–7
Carbon, in batteries, 7; carbonic acid, 38; dioxide, 169, 258; disulphide, 234; rod, 6, 7
Carbutt's Special (J.C.) Keystone Co., 165
Carlsbad Caverns, 218, *220*, 221–33, *236*, 238–41, 248–51, 264; ciné films, 248–9, *255*; guano bucket, 223, *231*; survey, *223*; The Big Shot, *237*, 238–41
Caron & Deville, 21, 267
Carte-de-visite, 19–20, 52, 97
Casteret, Norbert, 219
Catacombs, 18, 41; in Paris, 8–9, *10, 11*, 12, *13*, 15, *16*, 145, 148; in Rome, 41

Cathedral Cave, 75
Causses, the, 133–4, 143, 153, 184
Cave, art, 220; costume, Mammoth Cave, 55, *56*; diving, 258–60, 261; Diving Group, 258–9, 276; of Fées, 158; of Fountains, *see* Fountain Cave; of the Outlaws, 255; painting in, 86; photograph, first, 35; Research Group of Great Britain, 276; of the Winds, 97, 99; *see also under individual cave names*
Caves, of Bellamar, *112*; of Dauphine, *147*; of Mosquito Plains, 268; of Naracoorte, 268; *see also under* goufre *and* grottes *and under individual cave names*
Celluloid, 218, 272
Chalk, 8
Chamber of Mines, 247
Chandler, *206*
Chapman, S.W., 196
Chauffour, 234
Cheddar, Caves, 184, 201, 252; Gorge, 196, 198–9
Chemicals, 291–2; *see also under individual names*
Chidley, of Walsall, 82
Chillagoe Caves, *130*, 273
Cholera epidemic, 68
Civil war, *see* American Civil War
Clapham Cave, *see* Ingleborough Cave
Claudet, Antoine, 4, 266
Clausthal and Freiberg metal mines, 170
Clay Cross Colliery, 182
Clockwork, arc lamps, 8; ignition, 215; limelight burners, *83*, 84; magnesium lamps, 42–3, 46–7, 48, 60, 72, 101, 123, 139, 143, 151, 170
Coal, dust, 165, 169; gas, 3, 84, 85; mines, 72, 75, 162–71, 179, 181–2; *see also* anthracite *and* colliery
Cobalt chloride, 235
Cobb, Francis William, 181
Coffee Cave, 97
Coke, Archibald, 198
Colby, Col. Thomas, 3
Collard, C.H., 196
Colliery, Abercanaid, 166; Bradford, 35, 82–3; Brinsley, 181; Cannock Chase, 168; Clay Cross, 182; Indian Ridge, 165–6; Kohinoor, 163, *165, 166*, 167; Lye Cross, 170–1; South Dyffryn, 166; Ton Pentre, *181*; *see also* mine, coal
Collins, Floyd, 275
Collodion, 65, 79–81; in heat, 27; keeping moist, 29–30; paper, 19; dry plate, 77, 79–80; wet plate, *xix*, xx, 5, 18, 27, 33, 80–1, 82, 84, 175; preparation of, 2, 52–3; printing negatives, 24; sensitivity of, 50, 60, 79–80; speed of drying, 2, 10–11, 65–6, 82
Colomb, Capt., 47
Colossal Caverns, 121, 250
Colour, 231; of Bengal light, 279; correct rendering of, 66–7, 149–50, 218–19; earliest, 231; film, 219, 235, 239, 243, 255; flashes, 105, 106; photography, 218–9, 239; sensitivity of plates, 149, 165
Compressed air, 42, 164; drills, *180*; *see also* hydrogen *and* oxygen
Comstock Lode mines, 74–5, 163
Condensation, 34, 148, 171

Confectionery, 81
Contact print, 40, 68
Contrast, 64, 154, 157
Cook, Harry C., 274
Cooke, Samuel, 125
Coolidge, President, 229
Copper, mine, *113*, 266; plate, xix
Copyright, 59, 67, 70
Coracles, use underground, *204*
Cornell, Frederick K., 92
Cotton, fireproofed, 111; wool, 2, 155
Cox, Edward, 197
Cox's Cave, 197–8, 201
Cromwell, Oliver, 127
Crooke, Bertie, *252*
Crookes, William, 20–1, 50, 234
Cross, W.R., 96, *97*
Crypt, *see* burial crypt
Crystal Cave, 96–7
Cueva del Drach, *69*, 151
Curling box, 181
Cuttriss, Samuel W., 204
Cwm Porth Cavern, *see* Porth yr Ogof

Daguerre, Louis, xviii, xix, 59
Daguerreotype, xviii–xx, 2, 4, 6, 18, 19, 27; aerial, 2; artist's use of, 1; studio, 54
Dams, E.L., 215–16
Dan yr Ogof, *204*
Dancer, John Benjamin, 20
Dandoy, Armand, 78, *79*, 112
Daniell cell, 7
Dargilan, 134, 155, *156, 157*
Darnall, C.G., 113, 115
Daumier, Honoré, 2
Davinson, Ian, 264
Davis, Bob, *260*
Davis, Eugene, *236*
Davis, Ray V., 218, 221–9, 231–3, 235, *236*, 241, 251, 264
Davy, Humphry, 266
Dawkes, Frank, 185, 187–8, 210
Dawkins, William Boyd, 184
De Jaubert, 142
Debenham, William Elliot, 44–5, 52, 75, 162, 179
DeGroff, C.E., 115
Delamarre, *see* Gaudin & Delamarre
Delaroche, Paul, xviii
Delco Plant, 245
Depth of field, 145, 155–6, 207
Developer, 52, 60, 65; two bath, 160
Devenish, Luke, 259, 260
Devil, the, xv, 72, 82
Deville, *see* Caron & Deville
Dewey, Fred P., 163
Dewey, H.S., *51*
Diamond Cave, 70
Diamond mines, 163
Diaphragm, 52, 145, 155, 166, 172
Dickson, 243
Diprotodon, 263
Disdéri, A.E.E., 266, 280
Divald, Károly, 87, 91
Division of focus, 67
Dolcoath Mine, 169, *174*
Donkin, W.F., 270
Doss, Charles, *220*, 221
Double exposure, first use in ciné film, 273
Douk Cave, 204
Dow Cave, 204

Dr Hill Norris Co., 36
Drach, Cueva del, 69, 151
Dragon's Cave, 151
Drawing on plates, *124*, 175, 219, *226, 227*
Drummond, Thomas, 3–4; light, 3; *see also* limelight
Dudley, Robert, xv
Duignan & Co., 82
Dunn, Eli, 248
Dunold Mill Hole, 204
Duval Steam Lithograph Co., *70*
Dyer, of Jenolan, 92
Dynamite, 134, 232
Dynamo, 67, 164–5; *see also* generator

East Pool Mine, *172, 173, 174, 176*
Eastman, George, 115, 186, 218
Eastwater Cavern, 199–201, 207, 215
Ebbor Gorge, 215
Ebonite, 29, 37
Edgerton, Harold, 275, 281
Edison, Thomas, 7, 234, 243
Eggleston, H., *190*
Eggs, in emulsions, 27, 80–1
El Paso Transfer & Mining Co., 221
Eldon Hole, xv, 188–9, *190*, 192
Electricity, 6–7, 41, 67, 100, 199; arc light, 6–8, 87, 139, 164, 219, 244; in caves, 87; firing flashbulbs, 234–5, 239–40; first use in portraiture, 266; first studio use, 269; increased wattage, 276; lamp, 141; light bulb, 149, 234; *see also* battery *and* dynamo *and* generator
Electrolysis, 6, 84
Electronic flash, 261, 264; development of, 275; earliest, 266; first commercial units, 276; use in freezing motion, *263*
Eliščina Caves, 133
Empress Maria Theresa, sarcophagus of, 72
Endless Caverns, 249
Engravings, xvi–xvii; wood, 15, 91, 113
Equipment, in Mammoth Cave, *61*, 62–4; Martel's, 134, 141, 153; on Mendip, 200; early photographic, *xix*; in Speedwell Caverns, 191; weight of, 53
Ether, 2, 10, 27, 38, 53
Evens, Eric Doddrell, 215
Exhibitions, *see under individual names*
Explosions, 84, 106, 170, 215, 237; spontaneous, 169
Exposure, bracketing, 159–60; difficulties with, 66–7, 81, 153, 165; double, 273; duration, xix, 10–11, 82, 84, 85, 87, 107, 145–6, 151, 165–6, 167; tables, 108, 116, 147
Eyre, J.H., 189

Faraday, Michael, 21
Farr, Martyn, 261
Fées, cave of, 158
Ferguson, Edward, 248
Film, ciné, 242–56, 260, 272, 273; colour, 218–19; infra-red, xxi; Kodachrome, 275; newsreel, 94, 248–50, 256; nitrate, *249*; roll and sheet, 218; *see also* plate
Firedamp, 83, 169, 175; *see also* methane
Fireworks, 47, 111, 140, 146
Fish River Caves, *see* Jenolan

Flame safety lamp, 169
Flash, bags, 111; bar, 276; coloured, 105, 106; cube, 276; enclosed in muslin, *234*; gun, electronic, 260, 264; instantaneous, 105, 141; light, 105; pan, 100, 107, 215; synchronizing with shutter, 107, 186; *see also* electricity
Flashbulb, 234–5, 237–41, 257–8, 259, 260–1, 264; safety spot, 275; Sashalite, 235; Vacublitz, 235
Flashpowder, 103–8, 113, 123, 175, 193, 203, 209, 230, 231–4; accidents, 106–7, 140, 215; coloured, 105, 106; explosion, 106–7, 231, 237–8; exposure, 108; first use of, 103–4; formula, 109, 219, 282; Geka Fumosin, *235*; grinding, 106; lamps, 76, 107, 224–5; and moisture, 106–7, 108; production of, 140; replacement by bulbs, 241, 257–8, 261; safety of, 106–7, 140, 141; smokeless, 107, 235; use, 146–7, 237; *see also* magnesium
Flatt's Cave, 49
Flint Ridge, 55
Flipflash, 277
Flying Doctor Service, 196
Flynn, John, 196
Fontaine de Vaucluse, 260
Forsyth, N.A., *113*, 274
Forwood, W. Stump, 70
Foulquier, Émile, 137, 142
Fountain Cave, *86*, 117, 121
Fourtier, 150, 159
Fox Motion Picture Co., 248
Fox Talbot, William Henry, xviii, xxi, 19, 28; portrait of, *xix*
French International Exhibition (1878), 78; (1889), 135
Frey & Co., Philip, 78
Frith, Francis, 27, 29, 198
Fuse, 147, 213; platinum wire, 107

Gaedicke, Johannes, 105, 108
Ganter, H.C., *116, 119, 203*
Gaping Gill, 184–5, 204, 216
Gas, 3, 101; coal, 3, 84, 85; compressed, 42, 164, *180*; in explosions, 106; light, 3, 17; mantle, 3, 252, 270, 272; in mines, 83, 169–70, 175; poisonous, 7, 12, 25, 84, 106, 140; town, 84; *see also under individual gases*
Gastineau, Henry, *xvi*, xvii
Gaudin & Delamarre, 4; patent of Bengal light, 267
Gaupillat, Gabriel, 134–39, 140, 141, 142–3, 148, 150, 152, 159, 161, 184, 263
Gayer, Jacob, 230–1, *232*
Gelatine, 24, 81
General Electric Co., 235
Generator, 9, 87, 245; development of, 6; *see also* dynamo
Geographical Society Congress (1895), 184
Geological, Society of London, 178; survey of America (1923), 229; survey of America, (1867), 73; survey of Australia (1887), 91–2; Survey & Bureau, Kentucky, 70
George H. Brown's Daguerrean Saloon, 14
Germeshausen, Kenneth, 275
Giza, *see* pyramids of

Glass, blue, 3, 5–6; scarcity of, 181; screen of, 5, 7; screen, frosted, 8
Goatchurch Cavern, 253
Godard, 266
Gold, chloride, 24; mines, 74–5, 167; toning, 81
Gouffre, de Bramabiau, 134; de la Fage, 143; de Padirac, 137–9, 141–4, 151–5, 158–9, 196, *197*; *see also under* grottes
Gough, Arthur, 198, 199, 209
Gough, Richard, 197–8
Gough, William, 198
Gough's Cave, 197–8, 201, *208*; Old Cave, 197
Gould and Curry Mine, 75
Government control of caves, 91–4
Gower sea caves, xix
Grand Caverns, *see* Weyer Cave
Grant, Alonzo G., 42–3, 45, 72–3, 75, 139, 162, 169
Great Oregon Caves, *114*
Green fire, 119
Greenwood, Henry, 82–3
Grier, Herbert, 275
Grotta di Trebiciano, 133
Grotte de l'Arveiron, 234
Grottenfest, 77
Grottenkomission, 76–7
Grottes, de Betharram, *149*; de Han, 78, *79*, 112, 134, *158*, 219; de Lacave, *160*; de St-Cézaire, *251, 252*; *see also under* gouffre
Guano, 221, 223
Guernsey, Galsworthy, 3, 4
Guichard, E., *147*
Guide-book, 91, 94, 112–13, 115, 196; Grottes de Han, *79*, 112; Mammoth Cave, 70, 97, 112–13, 115; Paris, 17; Postojna Jama, 78
Guncotton, 2, 27, 53, 107–8, 111
Gunpowder, 4, 49, 103–4, 106, 140, 237
Gutch, J.W.G., xix, xxi

Haggard, Rider, 244
Hains, Ben, 115–21, 123, 129, 131, 132, 137, 195, *203*; stereo views, *117*, 121
Halation, *149*, 175
Half-tone, 68, 112–13, 115
Hall, W.F., 127, 131
Halley's Comet, 19
Hammel, R., 78
Han, *see* Grottes de Han
Hanna, J.R., 93–4
Harold Edgerton, 261
Harrison, Harry, *205*
Hart, of Jenolan, 91
Hart, F.W., 42, 73
Harvey, J.H., 92
Hassall, John, 211
Haworth, Frederic, 204
Hearder, J.N., 43
Heat, ripening plates, 81; shields, 3, 5–6
Helm, Ennis Creed, *237*, 238–41
Hermannshöhle, 108, *110, 111*, 136
Herschel, John, 25
Hidden Cave, *233*
Hill Inn, 204
Hillgrove Swallet, 207
Holley, Robert, 227
Hollywood, 218, 248–9, 252, 255–6
Holographic Developments Ltd., 264
Holography, 264
Holt, Mr, 247

Holzt, Adolf, *103*
Hook, William E., 97, *98*
Hooper, John, 261
Horne, Mr, 245
Horner, Michael, 204
House, Harry A., 117–20
Hovey, Horace C., 54, 87, 117–21, 150, 153
Howe, Elgiva, *51*
Howe's Cave, 50, *51*, 84–5, 87, 274, 276
Howes, Chris, *262, 263*
Hughes, Herbert W., 162, 170–1, 172, 175, 178–9, 182, 184
Humidity underground, 66, 158
Humphries, Thomas, 92–4
Hurley, Frank, 196
Hydro-electric power, 93, 308
Hydrogen, 4, 6, 22, 42, *83*, 84, 176–7; cylinder, 176, 190, 192
Hypo, *see* sodium hyposulphite

Ibbetson, 266
Ice cave, Grindelwald, *xx*
Immigration, USA, 48
Independent Labour Party, 181
India-rubber, 172; bags, 64, 67, 83, 84, 176
Indian attacks, 54
Ingleborough Cave, 204, *205*
Insufflator lamp, 102; *see also* lamp, powder
Intensified negatives, 160
International, Conference of Historical Science (1903), 152; Exhibition of France (1889), 135; Exhibition of London (1862), 8; Exhibition of Paris (1878), 78; News Reel Co., 248, 250
Intrinsically safe apparatus, 182
Iodine, 281
Ireland, survey of, 3
Iron wire, 48, 55, 62; melting of, 56

Jackson, George F., 237
Jackson, Henry, 35–6, 75, 83, 162
Jackson, William Henry, 99
James, C.H., 87, *88*, 91; list of views, *89*
James, Jesse, 95
Jaur Cave, 145
Jelley, K. & J., *205*
Jenolan, 91–2, 112, 123, 125, 127, 150, 178, 195–6; Arch Cave, *92*; former names, *122*, 270, 304; Coral Grotto, *120*; Devil's Coach House, *90*; Exhibition Cave, *125, 126, 131*; Imperial Cave, *128*; Lucas Cave, *129*; map of area (1889), *122*; Nettle Cave, *121, 124*; Jersey Cave, 125, 178
Jewell, Capt., 118
Jewell Cavern, 118
Johnson, Matthey and Co., 22
Johnson, May, 216
Johnston, Frances Benjamin, 113, 115, 167
Jones, C.D., 125, 127
Jones, J.H., 234
Jones, William Edmund, 181

Karst, 133
Kear, R.I., 164
Kenyon, G.A., 104, 270
Kerry, Charles Henry, 102, 123–9, 131, 132, 178, 195–6
Keystone View Co., *114*
Kinetograph, 243

Kinetoscope, 243
King, Bruce, 218
King, Clarence, 73
King Edward VII, 201
King, Henry, *120, 121*, 123
King Solomon's Mines, 242, 244, 247
Kodachrome, 255
Kodak, 221, 261
Kodatrons, 261
Kotal, of Postojna, 273
Kříž, Martin, 133
Kyndwr Club, *192*

Lacave, Grottes de, *160*
Lacey, S., *xvi*, xvii
Lacroix, 17
Ladder, rope, 134, 137, 142
Lamb Leer, 187, *188, 206, 253,* 254; paraffin lamps in, 252
Lamp, advertisement for, *178*; acetylene, 210–11; alcohol, 4, 23, 37, *136*; Aldis, 42; arc, 9, 24, 72, 87, 133, 164–6, 264; Brothers, 42; bulls eye, 46; clockwork, 42–3, 46–7, 48, 60, 72, 101, 123, 139, 143, 151, 170; Diprotodon, 263, 321; flame safety, 169; flashpowder, 107–9, 176, 224–5; Grant's, 42–3, 45, 72–3; kerosene, 222; lard-oil, 55, *56*, 65; limelight, *83*, 84, 176–7, 185; Mather & Platt, 23, 42; Müller, 108–9; multiple use of, 159; Nadar, 145–6, 148–9, 153, 225; oil, 3, 9, 17, *220*; Optimus, 171, *178*; paraffin, 85, 251–4; petrol, 140, 145; petrol/magnesium, 103; Platinotype, 171; powder, 101–2, 107, 108, *136*, 140–1, 143, 145–6, 148, 149, 153, 155, 224–5, 234, 263; Regnard, 140–1; ribbon, 42–3, 45, 72, 125, 133, 139, 141, 151, 153, 160, 166, 170, 171, 186–7; safety, 47, *168*, 169; signalling, 47; spirit, 23, 101, 103; thumb-wheel, 23, *42*; *see also* limelight burner
Land Office, the, 227
Lantern, 5, 72, 103, 108, 149, 165, 234; magic, 190; slide, 41, 45, 120, 121, 150, 172, 181, 185, 190, 196
Larkin, Henry, 101, 299
Lasson, A., 155–6, *157*
Launay, *137*
Lead, 43
Leck, Bert, 115
Lee, Dana, *228*, 248
Lee, Elizabeth, *228*, 248
Lee, Willis T., *228*, 229–31, 248; survey made by, *223*
Legends, xv
Lens, cap, 143, 145, 149; Dallmeyer stereo, 60; defects, 52, 166; division of focus, 67; Lerebour portrait, 43; Ross stereo, 60; Voigtlander, 60; wide angle, 151, 172; *see also* diaphragm
Leth, of Vienna, 72
Lewis & Clark Caverns, 274
Light, bulb, 269; calcium, 3, 85, 87, 119, 185; house, 3, 47; multiple sources, 159, *224*; positioning of, 64, 157–9; types of, 3, 109; *see also* actinic light *and* lamp
Lime, *see* calcium carbonate
Limelight, 72, 85, 185, 210–11, 234; burner, *83*, 84, 171, 177, 185, 190–1, *192*, 199, 202; exposure with, 84,

85, 186; invention of, 3–4; in mines, 82–3, 169, 182; projector, 41; sensitivity of plates, 50, 83; signalling device, 47; in studios, 175; in theatres, 4, 48; *see also* lamps *and* oxyhydrogen light
Limewater, 140
Linseed oil, 140
Linton, Guy, 248
Lithium, 106
Litigation, photographs used in, 82, 163
Littleton View Co., *167*
Liverpool Amateur Photographic Assoc., 104
Livesey, Thomas, 35
Livesey, W.C., 35
Livingston, Carl, 226, 230, *233*
Llewelyn, John Dillwyn, xix, xxi
Londe, Albert, 135
London Stereoscopic Co., 267
Long, C.F.D., 216
Long Island, 241
Luray Caverns, 86–7, *88, 89*, 91, *195*, 196
Lurloch Cave, 196
Lycopodium, 109

Mach, Ernst, 281
Maddox, Richard Leach, 81
Magicube, 276
Magna Carta, 85
Magnesium, advertising of, 22, 35; bars, 44; causing blurred image, 96, 118, 149; cartridges, 105, 119; in civil war, 49; chloride, 22; coloured, 47, 101, 105, 106; cost, 43, 45–6, 47, 48, 68, 100, 103, 155, 226, 248; demonstration of, 22–3, *42*; and electricity, 44; enclosing, 233–5; failure with, 75; fireworks, 47; flares, 163, 167, 211, 222, 245–8, 250–2; in jewellery, 43; lamp, *see under* lamp; Light Views, 123; Metal Co., 22, 23, 24, 31, 33, 35, 39, 41, 45; in mines, 87, 162, 163–4, 166; oxide, 56, 61, 73, 103, 140; powder, 47, 101–4, 109, 119, *136*, 140, 141, 143, 145, 156, 171, 224–5; preparation of, 20–2; production of ribbon, 23–4; production of wire, 22–3; public's reaction to, 30–1; quantity required, 37, 233; rate of burning, 55–6, 61–2; replacement by aluminium, 154; ribbon, 43, 55–6, 72, 82, 85, *96*, 100, 102, 104, *115*, 119, 123, 127–8, 134, 140, 151, 163, 168, 186, 207, 213, 223, 249; safety rockets, 47; sales of, 86; with sand, 101, *102*, 155; smoke, 34–5, 37–8, 44, 57–8, 60–2, 68, 73, 93, 100, 102, 103, 104–5, 125, 139, 141, 143, 153, 177, 192, 234, 249; tapers, 23, 33, 48, 55–7, 62, 64, 65, 67, 68, 85, 100; in theatres, 48, 73, *136*; use underwater, 234; wire, 22–3, 36, 37, 44, 46–7, 56, 72, 101, 164, 230; *see also* flashpowder
Mair, Judge, 93
Mammoth Cave, xvii, 4, *5*, 20, 49–52, *53*, 57–71, 73, *80*, 94, *98*, 104, 112–13, *116, 118, 119*, 123, 168, 234; advertising, 50, 95–6; Bengal light used in, 4; in ciné film, 250; costume, 55, *56*; exploration by Hains, 120–1; guidebooks, 70, 97, 112–13; guides, 54, 61; map (1882), *54*; Photographic Co.,

59; sales of cards, 78, 195; stage-coach, 95; surveying, 55
Mammoth Crystal Cave, 178
Manchester, Geological Soc., 35; Literary and Philosophical Soc., 23–4, 28, 35, 40; Photographic Soc., 20, 22, 32, 267
Manitou Grand Caverns, *98, 99*
Mannequins, used underground, *10, 11, 12, 14*
Marble Cave, 115
Marengo Cave, *117*, 120, 121, 250
Mariot, Emil, 75–8
Martel, Edouard Alfred, 132, *133–7*, 139, 141–3, 145, 147–8, 150–3, 154, 155–61, 196–7, 201; in Britain, 150, 184–5; portrait of, *137*
Martini, Joseph, 77–8, 87, 139
Mas de Rouquet, 141
Mason, C., 87
Massachussetts Inst. of Technology, 275
Mather, William, 23, 24, 33, 39–40, 42; and Platt lamp, 23, 42
Mawdsley, Peter, 280
McClellan, John, 234, 270
McKittrick Cave, 115
McLachlan, Lachlan, 19
Mead, Charles, 85
Measurement, standardizing, 25; units of, 293–4
Measuring rods, 29, 3*7*, 38, *39*
Mellor, Mr, 22, 24, 32, 33, 41
Mendip, Nature Research Club, 205; Nature Research Committee, 205
Mercantile Marine Association of Liverpool, 47
Mercanton, *251*, 252
Mercury, 24, 167, 281
Meredith, Abe, 61
Metals, *see under individual metals*
Metcalfe, Revd C.F., 183, 185, 186
Methane, 169–70; *see also* firedamp
Metric system, 25
Miethe, Adolf, 105, 108
Mill Close Mine, 43, 162, 169
Mine, 75, 162–3, 178, 180; anthracite, 163; Chamber of, 247; coal, 35, 72, 75, 82–3, 162, 164–9, 170–1, 179, 181–2; copper, *113*, 266; diamond, 163; first pictures in, 36–7, 75, 162; gases in, 83, 169–70, 175; gold, 74–5, 163, 247; guano, 221, 223; iron, *250*, 252, 275; lead, 43, 162, 169; lime-stone, 166; mercury, 167; metal, 75, 87, 169, 170, 171, 177; naked flame, 169, 182; piping gas into, 83; safety in, 170; salt, *180*; saltpetre, 49; silver, 163, 167; slate, 178; tin, 44, 162, 169, 173, *174*, 184; *see also* quarrying *and under individual names*
Mining Assoc. and Inst. of Cornwall, 172
Mirror, 8; as heat shield, 7
Mont Blanc Observatory, 139
Montespan, 220
Moon, Frank, 196
Morgan brothers, *204*
Morgan, Johnny, 49
Morrison Cave, *113*, 274
Mortlock Library, 275
Mosquito Plains, Caves of the, 268
Moule, John, 4–6, 18, 21, 31, 44, 104
Mudd, James, 20
Müller, Max, 108–11, 116, 131, 136;

Müller's powder, 109; Müller's lamp, *109*
Mulu, 264
Muslin, 6, 157; bags, 73, 234
Muybridge, Eadweard, 269

Nadar, Félix, 1–2, 6–17, 18, 72, 145; portrait of, *1*
Nadar, Paul, 145; lamp, 145–6, 148–9, 153, 225
Naked flame, in mines, 83–4, 169
Nankivell, of Cornwall, 181
Naphtha, 140
Naracoorte, caves of, 268
Nasmyth, James, 20, 24, 40, 45
National, Coal Board, 169, 276; Geo-graphic Magazine, The, 225, 229, 231, 240; Geographic Society, 228–9; Speleological Society, 275
Neville, Russell Trall, 237–8, *249*, 250, 252, 256
New Almaden, mercury mines, 167
New Mexico State Land Office, 226
New Orleans Exposition, 163
Newsreel, 94, 238, 248–50, 256
Nicol, John, 41
Niépce, N., xviii, 59
Nissen, R.C.E., 244
Nitrate of potash, 44
Nitre, 4, 103; *see also* saltpetre
Nitrogen, 4
Noble, 247
Nuclear explosion, flash of, 276
Nullarbor Plain, 263
Nymeyer, Robert, 235, *236*

Ogof Ffynnon Ddu, *263*, 264
Old Salts Cave, 250–1
Opera houses, lighting in, 3
Orthochromatic emulsions, 119
O'Shaughnessy, John H., 50–1, 57, 60, 61, 68, 70
Ostermeier, Johannes B., 235
O'Sullivan, Timothy H., 73, 74, 75, 162–3
Otto, Henry, 248
Owen's College, 20
Oxygen, 3, 6, 21, 38, 50, 83, 85, 103, 104, 234, 258; compressed, 42; cylinder, 42, 176, 190, *192*; produc-tion, 3–4; rebreathing, 258
Oxy-hydrogen light, 72, 171, 186; *see also* limelight

Pacific & Atlantic, 249
Padirac, *see* Gouffre de Padirac
Palme, Arthur, 276
Panchromatic emulsions, 218
Paper, albumen-coated, 81; Armenian, 134; Bengal, 146; bromide, 196; collodion, 19; positive, 80
Paraffin, 189, 252; lamp, 85, 252; torches, 189
Paramount Picture Corp., 225
Partridge, Harry, 185, 187, 210
Patent laws, 42, 73; Bengal light, 267; calotype, xix; magnesium prepara-tion, 21–2; maps and surveys, 2; paper, 280; photogen, 4; portraiture, 4, 8; studio, 73
Pathé, 250
Paul, Robert W. 'Daddy', 243
Peak Cavern, xvii, 32, 192
Pecos River, 235

Percussion caps, 107
Perier, Albert J., 127, 273
Perry, Clay, 276
Perspective, 159
Petrol, 31, 103, 145
Pfühl, Fred, 114
Philadelphia & Reading Coal & Iron Co., 164
Phillips Co., 235; improvements in flashbulbs, 275
Phillips, Harry, 196
Phosphorus, 44, 50, 234; burning of, 21
Photogen, 4–5, 21, 31, 44, 104
Photogenic pistol, 105, 107
Photograms, 19
Photograph, dating, 289–90; largest underground, 167; manual, 219, 257; success rate, 179; underwater, 234, 258–9, 269
Photographic Society, of Edinburgh, 41; of France, 15, 141; of Great Britain, 267; of London, 179; of Scot-land, 28; of South London, 104; *see also* Royal Photographic Society
Photophane Co. of London, 166
Photowac, 259
Phroso, 251, 252
Pickard, Edgar, 20
Pictorial Stationery Co. Ltd., 198
Piffard, Henry G., 107
Pit, naked light, 182
Plate, advantages of, xx, 2, 264; Cadett Lightning, 175; Carbutt's Special (J.C.), 165; developing, 159–60; Dr Hill Norris Co., 36; drawing on, *124*, 175, 219, *226, 227*; destruction of, 181–2; dry, 80–3, 84, 99, 100, 107, 139, 149, 165, 170, 187; dry collodion, 29; sensitivity of, 84, 149, 165, 219, 264; Smyth's, 29, 40–1; success rate, 179; washing, 65, 68, 127; wet collo-dion, xx, 5, 18, 27, 33, 79–83, 84, 175; whole, 19; *see also* camera *and* film
Platinotype Co., 171
Platinum wire, 107
Platt, Mr, 23, 42
Pluto Cave, 86
Plymouth Mechanics Inst., 43
Pons, 142
Poole's Cavern, 102
Porth yr Ogof, *xvi, xvii,* 234
Portrait studio, xx, 5, 7, 48, 72–3, 79, 100–1, 123; neck-clamp, xix, 3
Portraiture, 4, 5–6, 8, 18, 32, 64, 102, 107, 266; of Mat Bransford, 54; by Brothers, 24, 31; by Nadar, 2
Postcards, 27, 116, 119, 160, 194, 199, 203, 204, 205, 208, 216, 219, 226, 235; Aggtelek Cave, 91; Cango Caves, *246*; half-tone, 196; in mines, 182; Postojna, 78; stereo, *69*
Postojna Jama, 75–8, 132–3, 139; *see also* Adelsberg
Potassium chlorate, 104–5, 109, 219; nitrate, 111; perchlorate, 109, 219
Pownall, Mr, 33
Prince and Princess of Wales, 44
Print, albumen, 81, 96, 108, 127; bro-mide, 196; contact, 40, 68; production by Brothers, 24
Proctor, George (of Kentucky), 70, 73
Proctor, George (of Mass.), 73
Proctor, John R., 50, 52, 54, 57, 59, 60, 61, 68, 70

Proctor, Larkin J., 50–1, 70
Puff lamp, *see* lamp, powder
Puttrell, James W., 189–90, *192*, 194, 201
Pyramidology, 41
Pyramids, 25, 27, 31, 45, 69, 101; first pictures in, *39*; of Giza, 25, 27, 28, 30, 36–40, 80, 103

Quarrying, 9
Quicksilver, *see* mercury

Radclyffe, xvii
Radio, used underground, 264
Railroad, 94–7, 100; accident, 242, 247; advertising, 95–7, 99; B. & M., 97; Baltimore & Ohio, *89*; to Cango Caves, 305; Chesapeake & Ohio, 118; Louisville & Nashville, 96, 115; to Mammoth Cave, 49, 94–5, 96; Norfolk & Western, *89*; North-Western, 96; Pennsylvania, *89*; Pennsylvania Central, 95; Santa Fe, 233, 248; Shenandoah Valley, *89*; Western Maryland, *89*
Rapid dry plates, 149, 175
Read's Cavern, 253
Rebreather apparatus, 258, *259*
Reed, Mr, *206*
Reflector, 24, 45, 57, 60–1, 63, 72, 240; card, 109; concave, 24, 57; foil, *238*; linen, 8; maintenance of, 67; on magnesium lamps, 42; magnesium ribbon, 86, *187*; mirror, 8; muslin, 6, 157; parabolic, 168
Registration of views, 59, 68
Regnard, 140; lamp, 140–1, 142–3, 145
Renauld, E., 143, 153
Resin, 140
Richter, J.E., 91
Riis, Jacob, 105–6
River Axe, 199
Roberts & Fellows, 99
Roger, of Nancy, *136*
Rope ladder, 137, 141, 184, 254
Roscoe, Henry, 20, 21, 22
Rothrock, Charles J., 237
Rowe, J., 127, 131
Royal, Arch Cave, 273; Arsenal Chemical Dept., 36; Institution of London, 21; Institution of South Wales, xix; Photographic Society, 267; Photographic Society of Great Britain, 179; Polytechnic Institute of London, 266; School of Mines, 168; Society of Arts, 168; Society of London, 20, 25, 45
Rupin, Ernest, *137*, 143, *144*, 148, 153

Sacred cubit, 25
Safety, 170, 182; lamps, 47, *168*, 169; rockets, 47
Salt, 22; mines, Salzburg, *180*
Saltpetre, 4, 49, 103, 140; mining of, 49
Samuel, William, 198
Sand Cave, 275
Sarawak Chamber, 264
Savage Mine, 75
Savory, Ernest Wyman, 207
Savory, James Harry, 205–15
Scale in photographs, 12, 14, 148–9, 219, 240
Schäber, M., *77*, 78
Schielbhabl, 75; *see also* Mariot

Schmidl, Adolf, 132–3
Sea caves, xix
Seebeck, 4
Serrin regulator, 7
Sesser, W.F., 96–7, *98*, 118
Sewers, 18, 75; Marseilles, 72; Paris, 8, 12–15
Shadows, 64, 82, 101, 111, 123, 128, 157–8, 159
Sharkey, John, 92
Shaw, A.E., 195, 274
Short, Harry, 243
Shutter, 186, 219, 235; in ciné, 242–3; in Smyth's camera, 29–30
Sibert's Cave, 120
Sidebotham, Joseph, 20, 24, 28, 40, 45, 103
Siebe Gorman & Co., 274
Silk merchants, 47
Silver, 21, 46, 163; mines, 167; nitrate, 10, 53, 81
Simpson, Eli, 204, 216
Simpson, Sir James, 45
Singley, B.L., *114*
Slave units, 261
Slavery, 49, 54
Smith, Al, 249
Smithard, F., 192
Smithsonian Inst. of Washington, DC, 245
Smokeless flash, compounds, 107; search for, 233–5; *see also* magnesium, smoke
Smyth, Charles Piazzi, 24–5, 27–30, 32, 36–41, 44, *46*, 49, 70, 80, 83, 101, 103–4, 219; camera, *26*, *28*, 29–30, 45; death of, 45; portrait of, *25*
Smyth, Jessica, 38, *39*
Sneath, R., 195, *216*, 274
Società Alpina delle Giulie, 133
Société de Spéléologie, 150
Societies, *see under individual names*
Soda lime, 258–9
Sodium, 22; hypochlorite, 24; hyposulphite, 53
Soldering lamp, 101; with magnesium, 43; with sand/magnesium, 102
Solomon, J. and Grant, A., 42, *43*
Sonstadt, Edward, 21–2, 23, 32, 41
Sopwith, Arthur, 168, 170
South, Crofty Mine, 169; Wales Miners Federation, 181
Southwestern Public Service Co., 240
Speedwell Cavern, 32, 189–92
Speleological Society of the District of Columbia, 275
Speleology, introduction of, 150, 184
Spiller, John, 36
Spirit lamp, 23, 101, 103
Spritsail Tor Cave, xix
Spruce Iron Mine, *250*, 252, 275
Spurling III, Stephen, 196
Stalactite Cavern, 198
Steam engine, 67; powering a dynamo, 87, 166
Stebbins, Benton Pixley, 86
Steger, John W., 275
Stereo, camera, 20, 33, 52, 60, 216; cards, *see* stereograph; lens, 60; photographs, 34; principle of, *114*; viewer, 69, 266
Stereograph, 27, 59, 61, 73, 83, 85, 91, 92, 94, 99, 112–21, 136, 195; advertising with, 50; on glass, *69*, *216*; loca-

tions of, 115; of Luray Caverns, *89*; of Mammoth Cave, 71, 121, 195; production, 30; publication of, 70, 125; of the pyramids, 40; registration of, 59, 68; sales, 75
Stewart, James, 93
Stockwell, Ira, 221
Stoping, *173*
Stormer, H.W., 97
Stowell, Mr, 245–6
Straw fires, 140
Street lights, 3
Strickler, J.D., *195*, 196
Stringer, Oliver, 204, 216
Strohmeyer & Wyman, *112*
Studio, *see* portrait studio
Suez Canal, 36
Sulphate of iron and ammonia, 53
Sulphur, 4, 104, 140; dioxide, 4; flowers of, 155
Sun pictures, 19
Superflash bulbs, 239
Surveying caves, 91, 163; Mammoth Cave, 55; *see also* Geological survey *and* Ireland, survey of
Swanson, P., 271
Swildon's Hole, 199, 201, 207, *211*, *212*, 213–14, 215, 216, 252–3, 258
Sylvania Electric Products, 238–9, 241
Symonds, Ralph, 276
Szepesbéla Cave, 91

Talbot, *see* Fox Talbot
Tanning, 81
Tax on photographs, 59
Taylor & Hessey, 25
Taylor, J. Traill, 104
Taylor, John, 25
Telephone, used underground, 142, 153
Temperance Movement, 190
Tent, used as a darkroom, *xix*
Theatre, 135, 139; lighting, 3, 4, 48, 73, *136*, 156; underground, *250*, 252
Theresa, Empress Maria, 72
Thomas, William, 172, 179
Thornton, J.E., 20
Thum, Mandeville, 78, *80*
Thurlow, 99
Tilley, Lamp Co., 252; lamps, 252–5
Timothy, Stephen, 181
Tin, 57, 103, *173*
Tinorau, Taane, 93
Tissandier, Albert, 150
Tomb, *see* burial vault
Ton Pentre level, South Wales, *181*
Tourism, 4, 75, *86*, 87, 100, 132–3, 136, 162, 163, 184, 196, 252; Blue John Caverns, 32–3; Cave of the Winds, 99; Jenolan, 91; Jewell Cavern, 118–19; Luray Caverns, 86; Mammoth Cave, 55, 78, *119*; Manitou Grand Caverns, 99; Padirac, *141*; Postojna, 76–7, 78; pyramids, 37; by railroad, 94–7; Waitomo Glow-Worm Caves, 93; Wyandotte Cave, 115; *see also* postcards
Tournachon, Adrien, 1
Tournachon, Gaspard Félix, 1; *see* Nadar, Félix
Towler, George, 204, *205*
Transistor, 261, 276
Transvaal Gold Mines, 247
Tratman, Edgar Kingsley, *211*, 213, 215, 252–6

Treak Cliff Caverns, 32, 216
Trickett, Oliver, 127, *129*
Tripod, 64, 82, 172, 209, 213, 223
Troup, R.D.R., 201

Udall, H.D., 86
Ulbach, Louis, 17
Underwater, cameras, 260; flash, 234; photograph, first in cave, 260; photography, 234, 258–60, 269
Underwood & Underwood, *112, 167*, 249
Universal, Film Manufacturing Co., 245, 247; Stereoscopic View Co., *168*
University of Bristol Spelæological Society, 216, 252, 254
Urdon, caves at, 112

Vallet, 145
Vallot, Joseph, 132, 139–41, 143, 145–8, 150, 152, 161, 184, 263
Van der Weyde, Henry, 100, 269
Van Wassenaar, *114*
Vandalism in caves, 93, 94, *214*, 233
Vandyke Press, 207
Vault, *see* burial vault
Veeder, A., 84, *85*, 87
Verboeckhoven, 17

Verein für Höhlenkunde, 133
Video, 264
Vierkötter, Paul, 235
Viré, A., 150, *152*, 153, *160*
Von Treisinger, Fr., 72, 268
Vyse, Col. Howard, 38

W.H. Jackson, 99
Waitomo Glow-Worm Caves, 92–3
Waldack, Charles L., 52, 53–71, 73, 75, 78, 94, 104, 112, 136; and Dandoy, 78; photographs by, 71
Ward, of Cambridge, 215
Washing plates, 65, 68, 127
Wass, of Derbyshire, 43
Watson, xvii
Wells Museum, 185
Wessex Cave Club, 254
Weyde, Henry Van der, 100
Weyer Cave, 117, 121
Wheeler, Stanley, 210
Whiskey, burned in reflectors, 63
White, Jim, 221–2, 225, *226*, 229
White Scar Cave, 216
White, William, 41–2, 101, 155
White's Cave, 244
Whiting, S.B., 164
Wightman, F., 189, 192, 194

Wiley and Wallace Ltd., 106
Wilkinson, C.S., 92, 94
Wilkinson, James, 44
Wilson, Edward L., 59, 67, 68, 100, 104
Wilson, Jeremiah, 91
Wilson, Washington, 313
Wind Cave, 97
Winn, Dr S.E., 167
Wookey Hole, 31, 183–5, 187, 199, 207, 209, *210*, 211–12, 259, *260*
Wooldridge, Jerry, 264
World Wonder Productions Ltd., 248
World's Columbian Exposition (1893), 178–9
Wright, A.C., 240
Wyandotte Cave, *115, 117*, 120, 121, 237, 250
Wyman, *see* Strohmeyer & Wyman

Xenon, 281

Yarrangobilly, 123, 196
Yorkshire, Ramblers' Club, 204; Speleological Association, 204, 216

Zinc, 7, 140
Zirconium, 235, 282